# ARCHITECTURE, ISLAM, AND IDENTITY IN WEST AFRICA

*Architecture, Islam, and Identity in West Africa* explores the relationship between architecture and Islamic identity in West Africa. The book looks broadly across Muslim West Africa and includes an in-depth study of the village of Larabanga, a small Muslim community in northern Ghana, to help the reader see how the built environment encodes cultural history through form, material, and space, creating an architectural narrative that outlines the contours of this distinctive Muslim identity. Apotsos also explores how modern technology, heritage, and tourism have increasingly affected the contemporary architectural character of this community, revealing the village's current state of social, cultural, and spiritual flux. More than sixty black-and-white images illustrate how architectural components within this setting express the distinctive narratives, value systems, and realities that make up the unique composition of this Afro-Islamic community.

**Michelle Apotsos** is an Assistant Professor in the Department of Art at Williams College, Massachusetts, USA, where she specializes in African architecture and the arts of the Afro-Islamic world. Her research focuses on the intersections between Afro-Islamic identity, architecture, and modernization as they are occurring in contemporary Africa. She received her PhD from Stanford University, USA, in 2013.

"Apotsos gives us a rich and nuanced story of one northern Ghanaian community's Islamic architecture and the dynamic relationships between its built environment and local Islamic practices and cultural identities. While these relationships are located within the long history of Islam in West Africa they are equally responsive to new building technologies, to post-colonial national heritage practices, and to a growing international tourism."

**Mary Jo Arnoldi,**
**Curator of African Ethnology and Arts,**
**National Museum of Natural History,**
**Smithsonian Institution, Washington DC, USA**

"A detailed and nuanced study of the built environment of a small rural community in northern Ghana, set within a broad discussion of the history of architecture in Muslim societies in West Africa and beyond. Apotsos successfully demonstrates how the ever-changing meanings people ascribe to historic structures contribute to shaping the identities of individuals, communities, and nations. A must-read for anyone interested in the visual cultures of Islam in Africa."

**Raymond A. Silverman,**
**History of Art and Afroamerican and African Studies,**
**University of Michigan, USA**

# ARCHITECTURE, ISLAM, AND IDENTITY IN WEST AFRICA

Lessons from Larabanga

Michelle Apotsos

NEW YORK AND LONDON

First published 2016
by Routledge
711 Third Avenue, New York, NY 10017

and by Routledge
2 Park Square, Milton Park, Abingdon, Oxon OX14 4RN

*Routledge is an imprint of the Taylor & Francis Group, an informa business*

© 2016 Taylor & Francis

The right of Michelle Apotsos to be identified as author of this work has been asserted by her in accordance with sections 77 and 78 of the Copyright, Designs and Patents Act 1988.

All rights reserved. No part of this book may be reprinted or reproduced or utilized in any form or by any electronic, mechanical, or other means, now known or hereafter invented, including photocopying and recording, or in any information storage or retrieval system, without permission in writing from the publishers.

*Trademark notice*: Product or corporate names may be trademarks or registered trademarks, and are used only for identification and explanation without intent to infringe.

Library of Congress Cataloguing in Publication Data
Names: Apotsos, Michelle, author.
Title: Architecture, Islam, and identity in West Africa : lessons from Larabanga / Michelle Apotsos.
Description: New York : Routledge, 2016. | Includes bibliographical references and index.
Identifiers: LCCN 2015047638| ISBN Subjects: LCSH: Islam and architecture--Africa, West. | Islam and
culture--Africa, West. | Cultural geography--Africa, West. | Islam and architecture--Ghana--Larabanga. | Islam and culture--Ghana--Larabanga. | Cultural geography--Ghana--Larabanga. | Larabanga (Ghana)--Buildings, structures, etc.
Classification: LCC NA2543.I74 A66 2016 | DDC 720.9667--dc23
LC record available at http://lccn.loc.gov/2015047638

ISBN: 978-1-138-19245-4 (hbk)
ISBN: 978-1-138-19246-1 (pbk)
ISBN: 978-1-315-63994-9 (ebk)

Acquisition Editor: Wendy Fuller
Editorial Assistant: Grace Harrison
Production Editor: Christina O'Brien

Typeset in Bembo
by Saxon Graphics Ltd, Derby

# CONTENTS

| | |
|---|---|
| *Dedication* | *vii* |
| *Acknowledgments* | *ix* |
| *Preface* | *xi* |
| *Foreword by Barbaro Martinez-Ruiz* | *xiii* |

    Introduction—Learning from Larabanga: Basic Lessons About Islam in West Africa    1

    *Framing the Subject and the Region: West African Islamic Architecture  5*

1   Locating Larabanga: Architecture and Contemporary Islamic Identity in West Africa    8

    *Afro-Islamic Architecture in Context: Definitions, Approaches, and Assessments  8*
    *The Shape of a Discipline: African Architecture Across Time and Space  17*
    *Moving Forward: Larabanga Within a West African Islamic Architectural Discourse  27*

2   The Road to Larabanga: A Short History of Afro-Islamic Architecture    35

    *Setting the Stage: Early Islamic Architecture and its African Reimaginings  35*

*Before* Bilad al-Sudan: *Islamic Architecture in North Africa and the Maghreb* 43
*Muslim Architecture at the West African Crossroads* 50
*Architecture, Islam, and the Gold Coast* 63
*British Colonialism and the Northern Region* 78

3   Mallams, Mosques, and Mystic Stones: The Story of Larabanga            91

*Locating the "Land of the Arabs" in West Africa* 91
*Constructing an Islamic Community from the Inside Out: Interactive Architecture* 95
*Architecture, Materiality, and the Kamara Identity* 113
*Architecture in Action: Performing Identity in Larabanga* 116

4   Building Across Borders: Larabanga in Transition            134

*Modernization and Larabanga's Shifting Landscape* 134
*Culture and Continuity in the Architectural Environment of Larabanga* 137
*Heritage and the Issue of Ghanaian National Identity* 156
*Tourism: New People, New Problems* 166

Conclusion—Lessons from Larabanga: The Future of Islam
and the Built Environment in West Africa            186

| | |
|---|---|
| *List of Figures* | *195* |
| *Image Credits* | *198* |
| *Bibliography* | *199* |
| *Index* | *210* |

*This book is dedicated to my wonderful husband, Alex, for his patience, humor, and at times excessive dedication to seeing me succeed, and to my lovely children, Will and Rowan, for their goofiness and for teaching me the art of ruthlessly efficient time management.*

# ACKNOWLEDGMENTS

Deep gratitude goes to Dr. Barbaro Martinez-Ruiz for his guidance, encouragement, and determination in helping me see this project through to the end. Additional mentorship from Daniel Abramson, Cynthia Becker, Sean Hanretta, Eva Hoffman, Liisa Malkki, Bissera Pentcheva, Peter Probst, and Bryan Wolf was crucial to its success.

I am honored to have received the following sources of funding from Stanford University to complete the research for this book: the O'Bie Schultz International Studies Dissertation Research Grant, the Vice Provost of Graduate Education Diversity Dissertation Grant, the Graduate Research Opportunity Award, the Abbasi Program in Islamic Studies Research Grant, a Research Grant from the Department of Art History, and the Mary Anne Bours Nimmo Graduate Fellowship. Thanks to Jill Davis for all of her assistance in obtaining this funding.

My colleagues at the National Museum of African Art in Washington DC, where I worked from 2013–2014, were invaluable to my progress. Thank you Christine Kreamer, Karen Milbourne, Smooth Nzewi, Raymond Silvermann, Janet Stanley, and Jeanine Systma. I am also indebted to all of my colleagues at Williams College, but would like to call out Benjamin Benedict, Holly Edwards, Guy Hedreen, Catherine Howe, Peter Low, Elizabeth McGowan, Julia Munemo, and Stefanie Solum specifically for their feedback and support at various stages of this project. Thanks, also, to Beverley Sylvester and Denise Buelle for making my transition to Williams smooth and facilitating my timely completion of this book.

For their help with images and the granting of permissions for this volume, I am indebted to Barbara Frank, David C. Conrad, Hayley Mahar, Amy McKenna, Charles Paquette, Thomas Seligman, Andrew Udell, Google Earth, and the Williams College Museum of Art.

I would not be an art historian today if it weren't for the passion I developed under the mentorship of Lynn Jacobs and the late Donald Harrington at the

University of Arkansas. I am indebted to the Peace Corps for giving me the opportunity to build a deep appreciation for West Africa in all of its diversity, and to my parents, Pat, Lynn, Michael, and Rita, for their support and encouragement. Alex, Will, and Rowan, with whom I have shared my greatest adventures—this book is for you.

Most importantly, I cannot express enough gratitude to the community of Larabanga, and specifically Hussein and Alhassan Salia and their families, who welcomed me warmly and openly into their lives. As such, any proceeds from this book will be forwarded directly to Larabanga's local NGO, Bambenninye Development Services, to support its ongoing commitment to the Larabanga community.

# PREFACE

This volume is the result of my long-standing interest in the ways that a built environment can convey the cultural identities, social conditions, and spiritual realities of a particular context as they manifest over time and space. Architecture is the primary mode through which we organize our physical reality and I have long been astonished at how the built environment can simultaneously hold both vast variety as well as tight specificity in its form and meaning across contexts and time periods. I find this to be particularly true within the Islamic architectural environments of West Africa.

I first encountered Islamic architecture during my Peace Corps service in Mali from 1999 to 2001, and I have maintained my connection to the region ever since. Throughout my encounters, I have found that differences in regional Islamic practice, which at first seem rather immaterial across contexts, suddenly become magnified when viewed through the organizational, material, and symbolic components of the built environment. These environments are expressive of the fact that each community has created unique solutions to the problems of performing Islamic identity in its particular context, where Islam not only acts as a religion but also as a culture, an ideology, and in some cases, a cause.

This book is an attempt to flesh out how these architectural environments and programs take shape as a result of dialogues that occur between cultural identity and incoming pressures and influences that rub up against these established systems. Towards this end, I have narrowed down my unit of analysis to focus on the community of Larabanga, a place whose history, culture, and religious identity is, like many in the region, shifting to accommodate various forms of modernization. These shifts have created not only new architectural forms but new symbols and meanings within the built environment as well. This in turn has positioned architecture as a product *and* a producer of cultural identity, to reference Mark Gottdiener, that channels human behavior into repertoires of

action towards maximizing the successful performance of Islamic identity within the community.[1]

Studies such as this one hold particular relevance in the contemporary period where shifts in the socio-political, cultural, and spiritual conditions of communities like Larabanga are creating rapid transitions in the ways that Islamic identity (and therefore its architectural environments) are being formulated in West Africa. As such, I hope readers will come away from this volume with a greater understanding and appreciation of the inventive and fundamentally flexible solutions that are being produced in Larabanga and in architectural environments across this region where Islamic identity constitutes one of the dominant cultural and religious forces today.

## Note

[1] Mark Gottdiener, *The Social Production of Urban Space*, 2nd ed. (Austin: University of Texas Press, 1994), xv.

# FOREWORD

Since Kevin A. Lynch's discussion of the language of architecture in his book *The Image of the City*, many publications on architecture theory, urban design and city planning have highlighted the specificity of each of these sub-disciplines. Uniquely, in *Architecture, Islam, and Identity in West Africa: Lessons from Larabanga*, Michelle Apotsos opts instead to align these sub-fields, reintegrating under a single theoretical umbrella their accumulated knowledge of how critical theory is best applied to specific architectural study. She then takes this unified approach further still, applying this broadened knowledge base to an emerging field of study within art history, examining Islamic architecture in Africa through the lens of African art.

Little academic work exists that examines Islamic architecture in Africa in great depth or social context. Though several writers have referred to religious forms and the use of graphic expressions, such as "Arabic" writing among the Asante people of Ghana, few have explored the meanings and uses of these communicative forms in a systematic manner and their implications for the study of architectural design and urban planning. Apotsos' research provides a detailed analysis of the social and religious histories of local visual and communicative strategies, from Arabic calligraphy to "modern" building practices as they exist today and lays the foundation for the further study of architecture as a complex mode of communication and its role in the Ghanaian culture.

In developing the theoretical backbone of this book, Apotsos draws upon several important notions from Lynch: the role of mobility in urban existence, the idea of a mental map of the town developed through collective use and routine, and the concept of a settlement as a readable space in which people can articulate histories, personal memories and present-day subjective experiences. Apotsos also skillfully pairs Lynch's notion of mobility in Western urban spaces with the idea of nomadism in northern Africa found in Labelle Prussin's *African Nomadic Architecture: Place, Space and Gender*. Bringing these strands together, Apotsos' fusion of divergent yet

complementary methodologies – one rooted in the west, the other in Africa – is an innovative approach that represents a substantial contribution to cultural studies.

In addition to expertly combining writing skills and critical analysis, *Lessons from Larabanga* employs key conceptual terms with great care and sophistication, and it is clear that the model Apotsos advocates treats culture as a contingent, situated performance. Partly this is a matter of how architecture's causal role is handled – the recognition, for example, that while Larabanga's physical structures certainly did contribute to Islamic architectural discourse in the region, one can also imagine circumstances in which change could have happened with enough energy and speed to overturn either the meanings of spaces or even the spaces themselves. It is also notable in the expansive view Apotsos takes to the directionality of influence, contending for example, that an account produced by a European colonial official about West African culture is not only essential to our understanding of Gold Coast visualities, but also more broadly serves a central role in the development of a framework for the study of African architecture and European portrayals thereof. By embracing such complexity and fluidity, Apotsos is able to wrestle with two central points often avoided by other scholars: the definition of the "canon of African Islamic architecture" and the role of class issues in African building techniques.

*Lessons from Larabanga* is an original and engaging consideration of changes in the discipline of art history over the past century, including its gradual embrace of African art. Unlike many art historians who concentrate in a particular period of "African architecture", Apotsos selects from across early primary sources and uses extensive contemporary fieldwork to illuminate the manner in which a wide range of moments across the history of "African architecture" can inform a specific case study. Her engaging writing brings these episodes to life and presents a compact, cohesive, and easily accessible argument about the peculiar temporality of architectural forms. Taken as a whole, this book effectively shines new light on the contemporary theory of the vernacular tradition and Islamic art and challenges the overworked concepts of creolization and syncretism applied to African visual culture, architecture, and urban studies. It is a welcome and overdue addition to the field.

# Introduction

## LEARNING FROM LARABANGA

Basic Lessons About Islam in West Africa

Attempting to put one's finger on the definition of Islam as it exists collectively in the contemporary global realm is largely an exercise in futility. Even the process of narrowing one's area of focus to a smaller and presumably more manageable unit of geography fails to disclose a clear view of this fluid entity. This is because close analyses of regional and even communal investigations of Islam invariably reveal a mosaic of personalities, identities, and realities that frustrate attempts to nail down a definition of Islam that is both manageable and broadly comprehensible. As Islam comes into focus, it becomes not only a religion, but a culture, a lifestyle, an identity, and even a political strategy. Thus, new methods of understanding and assessment are required in order to understand the unique space that Islam occupies in contemporary communities all over the world.

Islam in Africa, where it has existed and thrived for over fifteen hundred years, is no different. Over the duration of its existence across this vast region, Islam has assumed innumerable political, socio-cultural, and spiritual iterations, making it one of the most diverse, far-flung, and yet dominant movements on the continent. Currently, Africa contains a full third of the global Islamic population; roughly 40 per cent of the individuals on the continent identify as Muslim. In addition, much of Islam's growth in Africa is currently taking place in areas south of the Sahara in regions like West Africa, where a confluence of modernization, conversion, and a rapidly expanding population has created a surge of Islamicization in the past century. Within such regions, views of Islam have expanded to include alternate realities of the religion as both a mode of spirituality and a process, or a way of being in the world. West Africa, therefore, provides an important area of investigation for considerations of African Islam in the contemporary period and how it manifests itself in the material environment.

West Africa is unique in studies of contemporary Islamic culture largely due to the presence of enormously diverse populations who, over time, have displayed

astonishing degrees of flexibility in responding and adapting to incoming currents of influence. Indeed, these characteristics enabled Islam's singularly coherent, compelling narratives to embed themselves in the region as early as the ninth century. As such, Islam has been a West African phenomenon almost as long as it has been a Middle Eastern one, arriving in the region only two centuries after the death of the Prophet Muhammad (pbuh). Indeed, when Islam first arrived in West Africa, it spread with remarkable speed across various cultural spaces, implanting itself in multiple contexts and assuming numerous forms and identities towards becoming one of the dominant cultural and religious influences in the region today. Its ability to respond and adapt to various contexts and conditions allowed Islam to reproduce itself in various West African iterations towards fitting within the value systems and ideologies of particular environments. Helping this process along were systems of transfer, dialogue, and exchange already in place within the region before Islam arrived. As such, Islam itself was one of a number of catalytic forces present in the region that were filtered through various appropriative lenses before being assimilated into select cultural frameworks. Such processes undoubtedly helped lubricate Islam's passage into multiple cultural pockets not only in West Africa, but East and North Africa as well.

Thus, many of the most dramatic socio-cultural, spiritual, and material developments that have occurred in Africa have come at the hands of African Muslims, who have been shaping landscapes and mentalities for over a millennium, and have established powerful networks of Afro-Islamic influence in the process. Yet questions about Islam in West Africa remain. How has Islam, in all of its iterations, continued to maintain cohesion in the contemporary period? How has it continued to thrive despite the region's diversity and the often-fragmented political and socio-cultural conditions that have come to define the modern West African condition? The fact is that, despite the occasional view that Islamic practice is fundamentally opposed to the modernizing tendencies of globalization,[1] it has actually played a major role in facilitating contemporary processes of globalization in West Africa. The popularity of contemporary West African Islamism lies in its strategic position between spirituality and globalization; this enables it to continue to navigate the murky waters of the modern West African condition with a surprising degree of success while developing unique solutions to performing Muslim identity within increasingly diverse regional contexts.

One such solution is architecture, which is perhaps the most direct physical manifestation of the timeline of migration, alteration, and evolution that Islam has experienced over the course of its residence in West Africa. Architecture stands as the material mode through which Islam cultivated its ideological template in the region, as well as a key component that ensured the survival and proliferation of Islamic practice and identity, accomplished via the development of meaningful, dedicated spaces. Because of the fluid adaptability that has characterized Islamic culture in West Africa, Islamic spaces have taken on a number of different forms and shapes, each representative of the specific trajectories Islam has taken in various contexts.

Yet in order to identify key spatial and architectural elements that support the performance of Islamic identity in West Africa, it pays to first look at a singular case study as a way to access discussions of other types of Islamic architectural constructs. The space of a mosque, for example, is highly interactive space whose inhabitants are rarely passive occupiers. Mosque spaces often maintain the ability to shift and evolve while still following distinct protocols, one of which is a division between interior and exterior with a carefully maintained avenue of access between them. They can also be ephemeral—coming into being and then being deconstructed—because a mosque manifests whenever there is an intent to pray and subsequently dissipates once that intent has been fulfilled. Because of this conceptual and physical flexibility, mosque spaces can take form in something as complicated as a sprawling complex that has multiple functions (scholarship, socialization, and even political activity) or in something as simple as a back room, a roadside area, a bus, a rock-outlined space, or even a simple prayer mat. The mosque is both physically fluid and in tune with the needs, desires, and realities of its congregation; in this way Islamic spaces take on characteristics that represent the context in which they are embedded.

Along these lines, this book situates this discussion of Islamic space in the context of Larabanga, a cultural and architectural environment whose distinctive narratives, value systems, and realities are represented in diverse, contextually rooted ways. Larabanga as a case study is extremely important because it represents a cultural and architectural landscape committed to maximizing the successful performance of Islamic identity within the space of the town. In addition, it also demonstrates how Islamic identity and a modern condition can coexist within the evolving context of a single community. I offer two anecdotes as evidence.

In August of 2012, I was in Larabanga to observe Eid al Fitr, or the breaking of the fast at the end of the holy month of Ramadan. I had been in town for two weeks when, while sitting outside my rented house, I noticed one of the village elders coming up the road, dressed in a traditional embroidered white robe. He was carrying other religious accouterments, including prayer beads (*misbaha*) and a small copy of the Koran. As he walked, he held his hands in the air, and mumbled continuously under his breath. His focus was so intense that he took no notice of me as he passed. The man painted a picture of absolute religious piety, exemplifying exactly the type of tradition-oriented spiritual reverence I had hoped to witness on this occasion. Yet, just before he left my field of vision, I noticed he was holding a tiny, beaten-up cell phone in his upraised hands. He wasn't praying; he was cursing at it for its poor reception!

The second anecdote occurred a year earlier on a trip undertaken to study the village's ancient mosque, a highly sculptural earth- and timber-based structure that may have been built as early as the seventeenth century (see Figure 0.1). I had seen European tourists visiting the structure earlier, walking around it and snapping a picture or two. On this day, however, I was alone and could savor the structure's "authenticity" and its apparent resistance to architectural compromise as a tourist destination. Then, as I walked around it, I came across a small, concrete, box-like

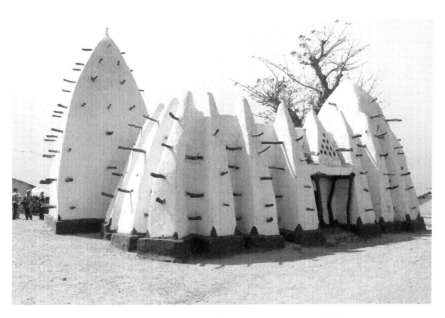

**FIGURE 0.1**  Ancient mosque, Larabanga, Ghana, renovated in 2002.

structure off to the side, painted in a similar fashion as the mosque. At first I thought it was a place for ablutions, or the cleaning of one's feet, hands, and face before prayer. But upon closer inspection I noticed two doors, labeled "male" and "female" in English, along with an illustrated image of a coiffed, unmistakably white individual (see Figure 0.2). It was a tourist bathroom.

The role that architecture can play in such a community is complex, and in this case built form made me aware of my own assumptions about the research I was conducting and what I expected to experience within this community. I had a very embedded notion about the type of Islamic culture and practice I would observe in Larabanga, and it was not one that made space for modernization or evidence of global influence. My former assumptions are likely echoed by the crowds of European and American visitors who come to Larabanga each year, expecting to experience untouched history. Instead, we experience day-to-day life that sometimes runs counter to our nostalgic imaginings. In fact, many tourists I spoke to considered these flashes of modernity to be jarring rifts in the "natural order" of things in Larabanga, rather than mundane occurrences in the everyday life of an actual rural Afro-Islamic community.

Yet such events make visible the reality of the contemporary Islamic condition in regions like West Africa. It is at once responsive and fluid, shaping itself to the contours of the social, cultural, and spiritual conditions in the society, while also transforming those contours into ones more suited to contemporary Muslim practice. Communities like Larabanga have developed a distinct Afro-Islamic identity attuned to the histories and realities of Islam as it has existed in this context over time. My research in Larabanga has shown me that Islamic practice never

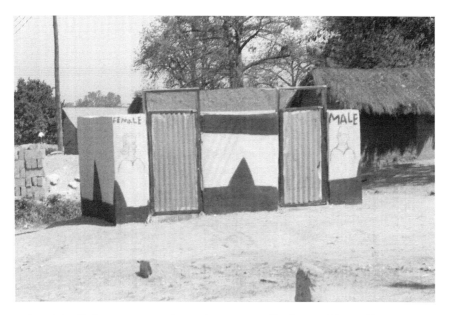

**FIGURE 0.2** Bathroom next to the ancient mosque, Larabanga, Ghana, 2011.

exists in stasis. Islam as a way of life is in constant evolution, embedded in a core set of values, but nonetheless responsive to pressures that catalyze transformation in its physical and cultural environment. Islam has not only been able to maintain a dominant hold on large cultural swaths within the region of West Africa, but also flourish more generally in the contemporary period as it engages with incoming global pressures and modernizing influences. And yet one must be careful about privileging Islam as a bringer of a global condition. The implication that a globalized condition is a new state for this region or this religion is false. In fact, history shows that West Africa, and Africa in general, has *always* been global, a condition that has been facilitated by systems like Islam, which have acted as circuit boards for the flow of information and influence. This leads to a reconsideration of the idea of globalization as a contemporary phenomenon, when in fact it is just the most recent label for a long-established practice of advancing societies within geographies such as West Africa through systems like Islam.[2]

## Framing the Subject and the Region: West African Islamic Architecture

Towards deconstructing the cultural and architectural identity of Larabanga using a top-down approach, the first chapter will frame conceptualizations of architecture as a fluid, evolving medium. I will argue that architecture in Islamic traditions includes unpredictable, but often candid, spaces designed to support and enable the successful performance of Islamic identity over the course of one's life cycle. The second chapter will outline the architectural timeline of Islam in Africa,

beginning in the seventh century with Islam's arrival in Egypt. Islam's history in Africa is particularly important because it identifies formative moments in Islamic cultural and architectural practice that eventually found representation in Larabanga's communal identity and built environment. By highlighting Islam's continuous encounters with a variety of diverse social, cultural, and religious conditions over the course of its long migration across the continent, this chapter underscores how Islamic thought and practice was continuously reinvented as it traveled through the lenses of numerous localized sensibilities and traditions. It also shows how Islam evolved as an inherently adaptive system whose encounters generated new cultural vocabularies and architectural repertoires as a response to various pressures. From these evolutions, Larabanga would develop its own unique brand of Islamic identity that found expression in the community's built landscape as a context-specific structural manifestations of cultural and religious identity.

The third chapter focuses on the architectural and spatial composition of the village itself, and frames it as a cultural and spiritual *Gestalt* of the community's identity. Founded in the late seventeenth century by the powerful holy man Ibrahim Braimah, and home to a significant number of spiritually efficacious objects and architectural constructs, Larabanga is a symbol of Islamic power and faith throughout West Africa. This role is amplified by the fact that it is also the only wholly Islamic community in Ghana. Even today, the village is thought of as a shrine, and the people within its borders the spiritually endowed keepers of that shrine. The cultural group that makes up Larabanga's core population, the Kamara, has a unique history and equally unique social traditions that have defined the particular character of their architectural spaces. The spirituality of the Kamara as a wholly Islamicized group is established emblematically within the village's built environment; the materials, styles, techniques, and organizational schemes are saturated with a rich symbolism that is intricately woven into the community's spiritual frameworks. Thus, from the organization of public areas and settlement patterns to the creation of domestic compounds and religious spaces, Larabanga's architecture represents a dedicated, purposeful infrastructure whose organizational elements support the programs, behaviors, and value systems that inform this community as a regional source of spiritual power and a touchstone for a storied West African cultural lineage.

The fourth chapter focuses on how these relationships and spatial expressions are evolving in the contemporary moment. I focus specifically on the rising tensions and complications within the community as Larabanga's reality shifts to incorporate two new careers: that of a national heritage site and as a tourist attraction. The uneasy rapport that now exists between Larabanga's historical identities and its contemporary realities has generated shifts in the village's architectural environment as new materials, building styles, and organizations vie with traditional components for physical and symbolic prominence. Yet the resulting patchwork of structural types, styles, and materials that currently defines Larabanga's built landscape points to the reality of the town's current condition as a community in a state of transition. It also suggests that the community is becoming increasingly self-conscious with

regards to the tactical nature of architecture as a mechanism for shaping and mediating relationships between historical and contemporary realities through explorative combinations of tradition-oriented and contemporary styles, materials, and symbolisms. Because of this, Larabanga's landscape is becoming progressively self-reflexive and is now consciously privileging the layered narratives that operate within village spaces as an affirmation of a current, globally engaged Afro-Islamic identity.

Thus, architecture in Larabanga, as a case study within a larger regional dialogue represents a strategic apparatus through which a community can create a more effective synergistic landscape. It also enables the development of a landscape that balances established architectural practices with anticipated developments for the future. Larabanga's built environment is increasingly mediating flows of history, memory, and developing narratives within the organization of the community's physical reality, and this has begun to effectively encode both established identities as well as their contemporary re-imaginings into the physical infrastructure of the environment. This supports the role of architecture as a producer and enforcer of cultural realities in localized settings. It also demonstrates the efficacy of the methods through which Islam, as a multi-faceted movement, continues to deploy architecture as a symbol and statement of identity. As such, architecture serves as an indication of the condition of the community as existing in a state of social, cultural, and religious flux. It is also a mechanism through which people can navigate this new confluence of tradition and modernity by organizing their physical environment along the lines of these influences, even within the increasingly complicated space of West Africa.

## Notes

1   Abraham A. Akrong, "Islam and Christianity in Africa," in *Africa in Contemporary Perspective: A Textbook for Undergraduate Students*, ed. Patrick Awuah Antwi (Legon-Accra, Ghana: Sub Saharan Publishers, 2013).
2   Kwame Gyekye, *Tradition and Modernity Philosophical Reflections on the African Experience* (New York: Oxford University Press, 1997), 280. Gyekye notes that the selective development and utilization of incoming influences and situational elements "bring[s] about the kinds of progressive changes in the entire aspects of human culture necessary for the enhancement and fulfillment of human life."

# 1

# LOCATING LARABANGA

Architecture and Contemporary Islamic Identity in West Africa

### Afro-Islamic Architecture in Context: Definitions, Approaches, and Assessments

Islam as a dedicated, cohesive religion and cultural way of life has thrived across numerous contexts within the West African region. In Ghana specifically, Islam has continued to create culturally and spiritually compelling narratives that have endured and even flourished within the contemporary period, in areas ranging from rural communities like Larabanga to the larger urban capitals of Accra, Tamale, and Wa. Importantly, these developments have occurred despite the various political disruptions and social tensions with which Islam has increasingly become associated, and one reason for Islam's continued success is its strategic use of space and the built environment, as apparatuses that individuals have used across religious, cultural, and social contexts to organize physical environments and craft lived reality.

In contexts such as Larabanga, architecture acts as a symbolic representation of ideals and traditions that have informed the specific cultural realities of the community, as well as a platform for engagement with incoming global influences. These conversations are encoded variously into the physical and spatial organization of the village as new registers of knowledge that create a palimpsest of history, identity, and reality, each colliding and negotiating with each other in different ways. As such, architecture stands as the articulation of the fluid and occasionally unexpected trajectories that Larabanga, along with many other contemporary Afro-Islamic communities, have taken as they struggle to bridge the gaps between established cultural identities and modern realities. But in order to understand how one can think through the reality of built form as it exists within these contexts, it is important to flesh out the modes through which architecture as a concept is capable of manifesting itself within the parameters provided by individual contexts of Wesst African Islamic communities.

The variety of Afro-Islamic architectural types that exist across North and West Africa provide important insights for understanding how the built environment in Larabanga has come to function as both a product and a producer of cultural reality. From the *ksour* of southern Morocco to the mosques of northern Ghana, this diversity of Afro-Islamic architectural form reveals the presence of highly specialized structural solutions that have been designed to address the problems of living within distinctive socio-political, cultural, spiritual, and climatic environments. In fact, the diversity is such that occasionally these forms push against many of the conceptual boundaries that have come to define "architecture" in its most basic sense as a three-dimensional shelter. The massive earthen mosques of the Niger Bend region in Mali, such as those in Djenné and proximate communities, blur the boundaries between structural form and sculptural object through their highly fluid, hand-modeled aesthetic. Specifically, they employ a building style whose form evokes distinctly haptic and optic senses through sensual combinations of protrusion and recession, form and void, all of which collectively create movement, visual interest, and dynamism through their dramatic manipulation of light and dark. Such structures literally manifest Bruno Zevi's classification of architecture as "a great hollowed-out sculpture which man enters and apprehends by moving about within it."[1] These forms also deemphasize the functional, traditionally "architectural" aspects that lie beneath these molded surfaces. Even the nuts and bolts of these spaces are capable of becoming part of aesthetic discourse. Locks, windows, doors, and even ladders have developed artistic identities of their own when they are displaced from their original contexts and reimagined as autonomous aesthetic objects within the institutionalized settings of Western museums.[2]

Towards challenging traditional notions of architecture even further, many of these forms also problematize two specific hegemonic qualities assumed to be essential to the architectural condition, namely permanence and presence. These two qualities require extensive reconsideration in the context of Afro-Islamic building practice. Permanence, as it is often thought of in European and American contexts, refers to "object-permanence," or the lasting aspect of a conventional architectural sign that preserves the signifier in a way that verbal and other forms of abstract communication cannot.[3] Cultural philosopher Walter Benjamin once considered this type of permanence an "Ur-phenomenon," "vital as a material 'witness' because it resists easy erasure and remains within the city as a reminder."[4] However, many populations in Islamic Africa are engaged in a continuous response to changing climate conditions, shifting kinship organizations, population migrations, military conflicts, and modernization, conversations that first and foremost emerge within the physical environment. These dynamic conditions require an equally dynamic built environment, one in tune with the current moment of the community and able to respond accordingly and occasionally with improvisation. As such, "permanence" in Afro-Islamic communities is often translated in the structural environment in ways relating to process rather than product. The tent structures of many North and West African nomadic peoples are

natural examples of this conceptual disconnect. Most Western scholars would consider these structures inherently impermanent because of their fundamentally transient reality. However, the tenacity of these nomadic architectural traditions, the symbolism of their structural components, the formal consistency of their construction and deconstruction, and the continuity of their functional and social roles in nomadic society all position the tent itself as a permanent structure in both process and practice, much more so than many other "modern" Western forms whose life cycle may end after a few years.

Materials also play a role in interpretations of permanence in historical African architectural forms. Structures such as the aforementioned Sahelian earth and timber mosques require regular upkeep from specialized local mason guilds and the broader community in order to withstand the stresses of time and the environment. As such, both permanence *and* presence are encoded within such structures not through their physical qualities or existence, but through the development of the complex communal social maintenance systems. The yearly replastering "festivals" that often accompany this maintenance reflect a continuity of ideology, tradition, and social cohesion within the communal sphere. Along these lines, there are also some areas in which the concepts of permanence and presence overlap. "Structures" such as rock-outlined desert mosques present in multiple Islamic contexts can hardly be said to be "present," much less permanent in a normative sense (see Figure 1.1).[5] They are composed of informal spaces demarcated from their surroundings by a simple outline of rocks placed on the ground. Yet both permanence and presence are encoded within these forms through the very durability of Islamic prayer

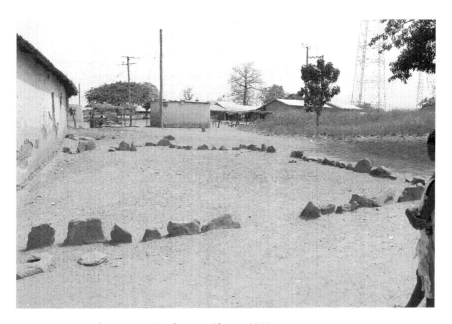

**FIGURE 1.1**  Rock mosque, Larabanga, Ghana, 2011.

protocols that require an architectural presence consistently located in time and space within a potentially featureless landscape. Lastly, there exist architectural forms that are even less direct and in fact stand as more of a "second order" space. These spaces encompass the involuntary traces, remnants, and material leavings of actions and performances left behind that provide symbolic evidence of past site-based events. Just as rocks outlining a mosque are conscious, declarative structural statements of presence, ashes from a past fire, collections of feathers and bones in an open area, and even trampled grass are the unspoken testimonials of a previously inhabited space. A specialized cultural knowledge is required to read and subsequently translate such a site as a place of action and habitation, whether it is ceremonial, ritual, or recreational. It is only by appropriately interpreting this possibly unintended, unconscious, or oblivious detritus that makes the identification of space possible and underscores the fact that almost every space contains components of its function, meaning, or existence. These accidental symbols indicate both the presence and definition of a space at a particular moment in time; such constructions allow many spaces to elide the form-to-function essentialism that often accompanies structural genres in other contexts. Through these examples, both permanence and presence are shown to exist within different Afro-Islamic spaces. Yet they are informed by decidedly different frameworks of interpretation that privilege the diversity of the environment in which they appear, whose political, social, and cultural conditions require specific "architectural" constructs to organize the landscape in ways commensurate with the requirements of its population.

How then can we connect these forms along a definable continuum with regards to Afro-Islamic architectural identity? Space becomes an extremely important element at the most basic level within manifestations of architectural form, which we will define as an object that makes a space "present" through demarcation. Whether one is looking at the coral walls of a Swahili house or the rock outlines of a desert mosque, at the heart of the architectural experience is a sense of "there-ness," a quality that allows an individual to recognize the occurrence of a specific space based on evidence as clear as discernible markers, or as vague as specialized knowledge. Because of its role in making space "present," architectural form is very important in the context of Afro-Islamic spatial analysis, and is one of the primary methods through which the human environment communicates in such contexts.

Within this rubric, another important quality of Afro-Islamic architectural form is that it has a number of different realities, each dictated by a Muslim sensibility. Human beings are simultaneously immersed in a cluster of social, cultural, and spiritual identities that subsequently manifest in the hybridization of various architectural identities as well, whether it is the physical space of a domicile located within a communal space, or the conceptual space created by ethnicity, gender, or class that dictates one's movements, interactions with, and ability to access a site. In each case, an individual's relationship with these areas establishes layers of identity that compose that person's reality. Moreover, these

spaces can overlap, as when individuals organize domestic and communal areas according to socio-cultural norms, ranks, and hierarchies within familial or communal frameworks.[6]

Manifestations of space are made equally interactive and multidimensional through one's awareness of and response to them. Such reactions are defined by the presence and experience of borders, boundaries, and peripheries established via tangible modes such as walls and ceilings, as well as more indirect devices such as visual symbols, objects, or bodies of esoteric knowledge. These boundaries divide, mix, and isolate bodies in space, but they also differentiate "in" from "out," center from periphery, and membership from exclusion. In doing so, boundaries make place a purposeful, motivated area by containing, enhancing, and providing avenues of action for "bodies in space doing purposeful things."[7]

Yet boundaries also do something very important, something that at first glance appears to be a contradiction to its tendency to separate and divide. Boundaries and borders also maintain penetration points, or areas of permeability, in the form of entrances and exits that enable movement from one realm to another. Scholars have long understood that such thresholds are required for a built space to truly become an "architectural" space, but the importance of their role in Afro-Islamic space cannot be underemphasized. These transformative openings maintain a particular brand of power as meeting points between the public and private, the foreign and the familiar, and the unknown and the known within Islamic contexts in Africa. These spaces are often interpreted as highly charged, generative areas that enable physical and symbolical transitions from one "world" into another.[8] The power of these passages as channels from interior to exterior charges these structural areas with a great deal of authoritative aura, a concept developed in other types of non-Islamic media such as the Kongolese *Nkisi* figure, whose architectonic body houses forces evoked by the presence of spiritually efficacious materials (see Figure 1.2). The forces of the *Nkisi* are discharged through the piercing of its bodily envelope, a penetrative occurrence that activates the power of the figure by providing a channel of access to the outside world, subsequently creating a threshold between inner and outer realms.

The potency of this threshold in architectural objects is obviously not specific to just Afro-Islamic architectural traditions. Numerous historical and contemporary architectural habitats around the world continue to deploy similar conceptual (and decorative) emphases on the entrance points of built forms, particularly religious architectures which seem particularly preoccupied with the type of agency that points of penetration can evoke towards manipulating subsequent experiences of the interior space. The entrance façades of Romanesque churches in medieval France, for example, received an inordinate amount of decorative attention towards optimizing the religious learning experience of congregants who would come to worship. This decoration also transformed these entrances into spiritual portals that actively burdened incoming worshippers with the weighty visual narratives of well-known religious parables, explicit scenes of judgment, and the punishments of leading a sinful life. Some scholars have even suggested that these images may have

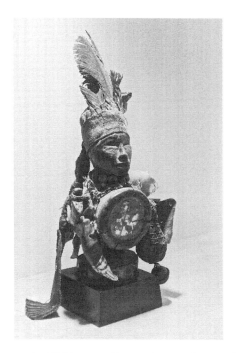

FIGURE 1.2   Kongo people, Nkisi power figure, nineteenth–twentieth century, wood, glass, glass mirror, leather, feathers, animal teeth, beads, brass, cloth, and string, 11 × 4¼ × 3 in. (27.9 × 10.8 × 7.6 cm).

indirectly been intended to evoke a protective spiritual presence as well, although such speculations cannot be proven.

But like these medieval European edifices, the creativity and diversity of expression and meaning displayed by Muslim building cultures on the African continent are equally nuanced representations of vastly different socio-political, cultural, spiritual, and environmental conditions. Some Afro-Islamic architectural traditions (particularly those in more northerly parts of Africa where Islamic traditions arrived more directly from the Middle East and southern Europe) have historically deployed ornamentation and symbolic reference as a safeguard against potentially malicious elements. North African *ksour* and *kasbah* structures, for example, are communal and single-family complexes that were often built along trans-Saharan trade routes in the southern regions of the Maghreb (see Figure 1.3). Because of their isolation and the fact that many acted as depots for trade goods coming across the desert, these structures were often targeted by nomadic raiders for supplies. They were therefore built with a number of defensive physical and metaphysical elements in mind. Large, thick walls were constructed of earth and stone and topped with pinnacles and cordoned off with corner towers as a first line of defense; few windows pierced these outer walls, and the ones that did were narrow, high, and specifically designed for strategic access. Beyond this, the interior was organized into series of narrow winding passageways that were bordered by

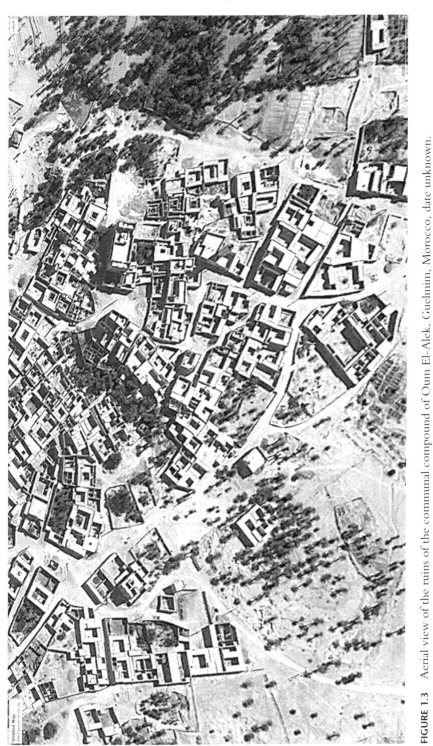

**FIGURE 1.3** Aerial view of the ruins of the communal compound of Oum El-Alek, Guelmim, Morocco, date unknown.

Source: © DigitalGlobe, Google 2015.

multi-story buildings and homes, putting invaders at an immediate tactical disadvantage from below. Connecting the interior and exterior realms were a handful of gateways, each large and suitably intimidating.[9]

Physical barriers aside, however, the penetration points located on the outer walls also incorporated additional defensive elements. Mystical symbols and iconographies were often inscribed on the surfaces of these areas or even integrated into the brickwork. These included Islamic visual devices and indigenous Amazigh signs that took form in geometric shapes, abstractions of natural objects such as trees, and specialized visual devices said to protect against the Evil Eye, such as the Hand of Fatima. Spiritually potent materials were occasionally included in or around the doorways of these structures to complement these protections.

This collective system of physical and symbolic defense was developed for the purpose of mediating access, regulating entry, and filtering negative elements from incoming influences. These systems acted as a type of preventative barrier or prophylactic against unsanctioned transitions across boundaries, whether human or spiritual. But even for sanctioned community members and visitors, the system at work on the exterior walls is only the first layer of regulated access within an intricate matrix of controlled movement within this communal complex. Once access to the interior is granted (or taken), the architectural complex continues to orient movement and behavior according to norms established by the role, rank, gender, and age of individuals. Based on these qualities, all individuals within this space occupy specific positions within the established communal hierarchy and these positions subsequently dictate a person's ability to access various spaces within this interior realm. When a stranger enters the front meeting parlor of a domicile, he or she is almost invariably denied access to the more intimate familial spaces located further within. Likewise, malevolent entities are often barred from the home via protective elements placed around access points. Conversely, ancestral entities are often welcomed and sometimes even outfitted with a space of their own in the form of a shrine.

In each case, boundaries act as methods of separation and filters of access that mediate the zones of interface between individuals and entities, and the interaction that occurs within these zones is based on pre-established, often hierarchical, relationships. To address one example from the primary case study of this project, Larabanga's ancient congregational mosque very effectively deploys a system of borders, boundaries, and penetration points that actively controls interaction with the structure itself (see Figure 0.1). One of the oldest classical earth-and-timber mosques remaining in West Africa, the mosque has long stood as a regional symbol of Islamic faith and a primary marker of cultural identity for Larabanga's main ethnic group, the Kamara. Towards this end, the mosque uses a number of restrictive languages to mediate access to the structure while simultaneously expressing and preserving the noteworthy cultural legacy of the Kamara as the community's primary cultural group. The nature of the barriers installed around the mosque are not just physical, but territorial and spiritual. They radiate out from the mosque in a ring-like fashion to filter incoming individuals through preventative

membranes that have been individually crafted to respond to specific qualities, conditions, and identities. Although many of these boundaries are common in Islamic architectural practice in Africa and around the world, some are specific to Larabanga and serve as a means of preserving the continuity of Larabanga's cultural and religious heritage through spatial languages of exclusion.

The first membrane in this system of segregation occurs when people initially enter the clearing in which the mosque is located. A village member is typically present in this area to filter individuals according to their residential status, the protocol being that village residents are able to visually access the mosque at any time, while visitors and foreigners must pay for the privilege. The next barrier allows only Muslims to enter into the actual mosque space, access that is further constrained not only by the gender-specific entrances that actively segregate men from women, but also by the small, exceedingly cramped doorways that only allow the petite, the extremely flexible, or the highly motivated to squeeze through. Once inside, men and women are confined to separate prayer spaces (typical in Islamic practice), but there is one remaining filter: doors are closed and those inside are separated from the outside world so effectively that few outside sights, sounds, or smells can penetrate into the cool, dark interior. The two-foot-thick earthen walls and minimal window and door penetration points eliminates almost all sensory stimulation. These aspects work to isolate the individual mentally, physically, and experientially from the "human world" in order to maximize one's communion with the divine. At the conclusion of prayers, individuals subsequently vacate this space as one would the birth canal, squeezing through the tight, claustrophobic channels to emerge into the exterior renewed as a Muslim and reaffirmed as a vetted member of the community.[10] The structural elements of the mosque actively mimic both the religious and the cultural parameters set in place by the community of Larabanga, and this allows the structure to act simultaneously as a spiritual marker and a cultural symbol.

Many of the barriers and filters just described are invisible to an outsider's eye. The mosque does not maintain entrance signs for men and women, nor has it traditionally indicated that visitors and foreigners are required to pay for the privilege of viewing the structure (although this has recently changed with the addition of a "price list" on a nearby wall). Many of these filters have historically been recognized only through knowledge of cultural and religious protocols active within this communal environment. This requires that one "comprehend" the structure of the Larabanga mosque and transform this information into appropriate action.

Similar systems of pre-established understanding are also often deployed in less architecturally identifiable spaces, particularly those without clearly defined structural borders and boundaries. These can necessitate tapping into certain knowledge bases as a guide for behavioral protocols in the space. The importance of symbolism and the establishment of symbolic systems of communication towards addressing and directing human response in such architectural environments cannot be overstated. To return to the rock outline mosque, located in Larabanga, its "wall" is composed of only a line of rocks in the sand, yet community members

avoid stepping over the stones and even include a break in the rock line "wall" as an "entrance" into the space. The symbolic suggestion of wall constitutes a powerful marker towards guiding action and behavior with regards to this space; it reinforces the concrete reality of the spiritual knowledge systems necessary to interact appropriately with and within the designated area. Within rock outline mosques, there is often either a semi-circular area or a slightly larger rock incorporated unobtrusively within one of these "walls" that acts as the *mihrab*, which in a more traditional structure takes the form of a niche in a wall and indicates the direction of Mecca and thus the direction one should face while praying. This small component within the architectural system at work carries none of the typical markers of significance that appear in other religious spaces, Islamic and non-Islamic alike, and is even subtle enough to escape the attention of the outside observer. Yet without it, the space could not function as intended. Much is required to understand this form, including the correct identification of its presence, and the translation of its purpose into appropriate action: the observer must draw on established systems of knowledge and subsequent translations of that knowledge to appreciate the existence of these markers, which are largely inconspicuous to individuals outside the know. This structure, in conjunction with the other Afro-Islamic examples given within this discussion, provide proof that one of the primary realities of Islamic architectural form as it exists throughout known building cultures in Africa is as a specialized apparatus for enabling cultural and religious practice and thus reaffirming communal identity.

The various physical, conceptual, and symbolic manifestations that architecture can take in Afro-Islamic environments across the continent make built form a highly effective mechanism for understanding Islam over time and space as part of a broader social narrative. As such, to flesh out the forms and meanings that architecture can take to embody the Islamic condition of a specific context, one must take a narrower view; hence, Larabanga as a case study. However, although the previous section went a long way towards fleshing out the particular modalities of Afro-Islamic architectural form as it occurs in various contexts across the continent, there is still little sense in how the Afro-Islamic architectural tradition fits in with broader structural practices within these regions as well. Such an understanding would further situate the specifics of Larabanga's built environment in the coming chapters within a broader architectural narrative. Thus, we will move on to discuss architectural practice in Africa as it has been addressed in scholarship towards fleshing out the implications of what "architecture" in African contexts truly entails and how it can be effectively used as a body of evidence in studies of contemporary Afro-Islamic cultural contexts like Larabanga.

## The Shape of a Discipline: African Architecture Across Time and Space

To begin, there are certain fundamental problems with regards to architectural studies in Africa as they have been approached thus far. While we can talk about "African

architecture" as architecture that exists on the continent, we cannot identify *an* African architecture, or a structural form, type, or style that is representative of the continent as a whole. In a land of over two thousand cultural groups and a commensurate number of languages, this is not terribly surprising. However, this diversity makes a methodology of studying the architecture of Africa particularly difficult and somewhat fraught. Architecture in Africa and by extension Islamic architecture in West Africa must be approached on its own terms, from a position that does not set it apart from architectural traditions of the non-African world but nonetheless acknowledges the fact that many standardized "universal" architectural components of the West are often retranslated in decidedly *non-standardized* fashions in other cultural geographies. Thus, studies of African architecture more generally should come from a system-based as opposed to a norm-based platform; it is the architectural mechanics rather than formal compositions that are important. To understand these mechanics, we need to parse how various architectural components, including the structural, the material, the organizational, and even the conceptual, are deployed within different cultural environments, and how these elements collectively encode cultural bodies of knowledge. Such an approach allows us to investigate how certain architectural forms, languages, and traditions have imposed a specifically tailored order on the surrounding environment. It will also demonstrate how various architectural modes construct meaningful spaces that contribute to the expression, understanding, and reinforcement of communal and individual identity, particularly within West African Islamic contexts.[11]

In theory, architecture can assume an almost infinite number of types within a geographic space, each intimately connected with its context through the functions and meanings it encodes. Although it is now largely recognized that conventional notions of architecture as a strictly three-dimensional sheltered space are obsolete, the sheer breadth of architectural diversity that occurs within vast multi-cultural spaces like Africa necessitate the development of a layered notion of architecture that positions it as a flexible medium able to maintain conceptual coherence in the face of extensive variation. Through such a framework, architecture becomes a construct as well as an artwork, an environment, a process, a demarcated space, and a symbol. One only needs to look at the non-Islamic Yoruba *ibori* (*ile ori*) for such confirmation (see Figure 1.4). The *ibori* problematizes the perceived barrier between objecthood and architectural form in that its function is as "the house of the head," or a protective shelter for the inner head that is often seen as the seat of one's power and destiny. Conceived as both a soft sculpture and a personal monument, the *ile ori* is both an artifact and an architectural sanctuary for the soul; it acts as a shelter and the sheltered, challenging hegemonic architectural conventions by simultaneously embodying both object and space and making the conceptualization of African architecture all the more complex. Objects like the *ibori* allow built form to participate more broadly in theoretical and methodological discourses outside architecture including anthropology, history, and sociology, towards mapping an area's legacies and programming them directly into the built environment in whatever forms it may take. This allows architecture to provide

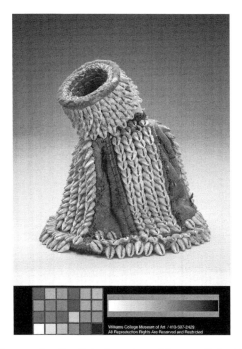

FIGURE 1.4   Yoruba people, Ile Ori altar piece (House of the Head), nineteenth–twentieth century, cowry shells embroidered on cloth over raffia, 7⅞ × 7¹¹⁄₁₆ in. (20 × 19.5 cm).

Source: Williams College Museum of Art, Williamstown, MA: Gift of Judith Schuchalter (91.46.2).

useful insights into the frameworks that actively shape the political, social, and cultural matrices of society.[12]

Implementing this renovation of architectural studies, however, requires pushing back against a significant body of architectural theory and analytical methodology that is rooted largely in non-African modes of thought. Such modes have been imposed on African architectural practice from the first recorded accounts of the continent into the contemporary period, casting built forms as objects of interest and classification that can be folded into larger agendas in strategic and sometimes micro-aggressive ways. Some of the first descriptions and nascent interpretations of architecture in Africa were recorded in the travelogues of early Arabic explorers such as Leo Africanus (1485–1554) and al-Idrisi (1099–1165), who included descriptions of numerous built forms as evidence of the cultural identities they encountered, often stressing the unsettling hybridization of local and Islamic practice they witnessed within. A few hundred years later, early European travelers like the Portuguese would add to these narratives as they established a nascent European presence on the West African coast through the construction of large forts and castles in the fourteenth and fifteenth centuries.

Subsequent European penetrations of Africa, the height of which occurred in the eighteenth, nineteenth, and twentieth centuries, would bring various amateur and

professional scientists to the continent who began burrowing industriously into the African interior in order to collect cultural and ethnographic data. These individuals would eventually produce a massive body of literature that included copious descriptions of indigenous structures, many of which would become stock iconic types in the European imagination. The stereotypical mud hut with a thatched roof is one such type, its ubiquitous usage in accounts and images of the landscape eventually making it an icon of the continent and an architectural standard in representations of African space. Yet this visual strategy would also make architectural forms like the mud hut a blunt symbolic instrument used to systematically shoehorn the cultural characteristics of an entire continent into a single architectural genre.

Europeans settling within the African landscape would also import a number of Western architectural styles that came with connotations of a superior culture, function, and aesthetic, which further cemented the hierarchical relationships established between African and European populations.[13] With Western architectural forms and, by association, Western culture positioned as the pinnacle of development, African models were largely subsumed. This process has continued into the "post-colonial" period, with the importation of modernist projects like the International Style and its industrial materials, modular design, and ascetic appearances effectively delegitimizing local architectural production and practice as appropriate for a modern society. Yet there are positive developments in the horizon. Architectural projects on the continent are growing more self-reflexive; many designs have begun to move away from West-centric architectural ideals towards more culturally and environmentally sustainable models.

But many scholars of African architectural studies, most of whom are non-African like myself, continue to privilege an inappropriate difference between African and Western architectural approaches. Terminology lies at the root of the problem and the prevalent use of the term "post-colonial" is one such example. It establishes colonialism as a primary point of origin around which other chronological and scholarly eras are situated and thus continues to support unequal hierarchies. As such, our failure, in the words of Dana Arnold, "to liberate non-western material from the colonizing frame" has allowed the post-colonial project to continue to "define [the non-west] by what it is not"[14] and thus persistently sap agency from African architectural environments and those who construct them.

The phrase "African architecture" also constitutes a symptom of this condition, particularly when it is used as an identifier rather than a field of study. In such a context, it entangles diverse groups of peoples and building cultures under a broad, singular heading. This creates the expectation of one universal, geographically based, structural group. By funneling diverse elements into an all-encompassing narrative, nuances in form, function, and meaning that separate built environments are erased. Many early studies of architecture in Africa attempted to approach the subject from a broad, highly inclusive perspective focusing on regional "traditions," and these projects often fell into the trap of vague non-specificity with analyses that were largely under-nuanced and methodological approaches that accomplished little beyond a surface treatment of the subject matter.[15]

Another problem that has affected architectural studies in Africa and, indeed, much of the Western world, is the tradition of "the grand study[ing] the grand,"[16] where a majority of "colloquial" or informal, everyday architectural forms are dismissed in favor of majestic "monumental" sites. Some scholars have defended this practice by arguing that value systems and ideals dominant within a society are represented through the extraordinary visual and spatial characteristics of these iconic forms and thus they are manifestations of a collective sensibility.[17] But the result of this viewpoint, which has long held a privileged position in the academy, is that now these iconic edifices and proclamative architectural spaces of the world compose what is largely considered "world architecture" and are viewed as representative bodies that encapsulate and subsequently collapse the dominant cultural characteristics of various localities into singular, highly specialized and often sanitized architectural forms or types.

Skeptics, myself included, also increasingly note the irony of the fact that so little of the actual architectural world is represented in this "world architecture." Andrew Ballantyne's criticism of the *Phaidon Atlas of World Architecture*, for example, is telling in terms of the volume's misrepresentation of content: instead of depicting "world architecture today" as it claims, it "selects 'the most notable' buildings, which is to say the most extraordinary [i.e. monumental] buildings," for display.[18] Ballantyne's reaction is representative of the general discontent surrounding the idea of "world architecture." By seeking out the distinctive and the exceptional and bestowing upon it the laurel wreath of "world architecture," scholars have created all-encompassing structural narratives where localized identities are subsumed by a "meta-narrative" of academic architecture.[19] Where has the individual gone in this "world" architectural discourse? And, more importantly, what has happened to their cultural identity, the supposed motivation for architecture's symbolic values? Such questions reveal the fact that more often than not the grand narratives of the monumental subsume the realities of the architectural everyday and ignore the importance of the practical built environment as a structural language that accommodates the immediate needs of society and whose creative, versatile, and often informal language typically represents a direct socio-cultural motivations and responses.

Yet even this realization comes bearing new problems. Scholars seeking to expand on this line of thought are handicapped by a lack of effective diagnostic vocabularies with which to comprehensively engage with these structures. The grand architectural narratives of the nineteenth and twentieth centuries gave rise to an elitist vocabulary that has left contemporary architectural scholars ill-equipped to interrogate alternative or non-normative structures that lie outside Western discourse. The result has been the development of a body of hastily crafted twentieth-century vocabularies designed to fill the interpretive vacuum, a motley assortment of "everything else" categories that have situated non-monumental and non-academic structures within convenient, accessible, and above all digestible classification schemes.[20]

The category of the vernacular is one such classification within this context and has proven particularly interesting and problematic. The term matured in the

context of nineteenth-century discussions of national identity in Great Britain, where it was reimagined as a category of the quaint, the popular, and the non-specialized, qualities that seemed to speak to the increasingly democratic industrial mindset of the British Empire at the time. "Vernacular" only became associated with non-Western contexts like Africa in the early and mid-twentieth century when individuals like Bernard Rudofsky gave previously obscure structural landscapes, such as the cliff dwellings of Mali's Dogon people, an "official" place within architectural discourse through major exhibitions such as "Architecture Without Architects" (MOMA, 1964). Following this revelation, scholars like Paul Oliver (1969) and Amos Rapoport (1969) developed the concept further as a way of reimagining architecture in areas such as Africa as three-dimensional maps of cultural space. Most recently, "vernacular" has been brought to analytical fruition in Thomas Carter and Elizabeth Cromley's *Invitation to Vernacular Architecture: A Guide to the Study of Ordinary Buildings and Landscapes* (2005), which compellingly explicates the practical functions of studying vernacular architecture as a tool for examining ethnographic narratives via the "artful" qualities of buildings.[21]

Yet, even as scholars continue to enrich the idea of the vernacular as it relates to architectures of the so-called periphery, they fail to eliminate the deeply entrenched distancing that composes so many aspects of Western scholarship when it attempts to engage with non-Western spaces. True to the origins of the concept of the vernacular, Carter and Cromley's work does not address non-Western forms, but sticks to Western vernacular examples and focuses on the North American vernacular, i.e. white Euro-American vernacular. This would indicate that architectural studies remain divided even within the field of the vernacular, a disappointing reality for a genre one would hope might be exempt from the politics of the Other. This also provides dismaying evidence of the possibility that an architectural form's very inclusion within these categorizations of the everyday, the non-monumental, and the immediate depowers its perceived interpretive value even further, as it becomes increasingly deprived of its analytical complexity and conceptual specificity over time. By trying to de-problematize these forms through their insertion into a carved-out niche for the study of everyday architecture, concepts like the vernacular may have led to a certain amount of interpretive *ennui*. This is evident in the overly comfortable, even sanguine attitude about using such classifications within all manner of architectural discourse.

But perhaps the biggest and most ironic danger in categorizations like the vernacular is that such taxonomies have begun to mimic the behaviors of elitist "world" architectural categories like the iconic by subsuming numerous diverse architectural paradigms under the umbrella of a collectivizing framework. Such sweeping classifications in the context of the vernacular are just as destructive as they are with regards to the iconic; they trivialize the contextually unique characteristics of various architectural traditions towards their quick and efficient containment within a singular categorical framework. Some vernacularists have pointed out that the term, by definition, is meant to refer to a common tongue and as such, has certain universalizing applications within the context of a specific

culture or built environment. However, rarely are such communities, particularly in today's globalized societies, so homogeneous. Even the "vernacular" as a majority language genre cannot account for the entirety of a community's communicative modes. In many African contexts, "vernacular" or local languages are only common to members of a particular social, economic, and/or gender group, whereas remnant colonial tongues like French and English are spoken only by an educated, predominantly male, class. Within architectural contexts, similarly, specific forms and materials are often only used by the elite, or those economically privileged enough to afford them, whereas individuals at the opposite end of the spectrum use different materials and therefore different construction techniques and organization patterns befitting available resources. Because vernacular languages and architectural forms are not capable of collectively accommodating the whole of society's norms, so-called vernacular architecture, through no fault of its own, is often no more capable of embodying a universally representative classification system than that of monumental "world" architecture.

Luckily, this problem has not gone unrecognized; a number of scholars have recently begun to reinvent architectural terminology, the vernacular included, along more interpretatively rigorous lines. One useful renovation has been offered by J. Deetz, who distinguishes the vernacular from academic modes of architecture that are characterized by conscious design, specialized execution, paradigmatic organization, and, ironically, a noted failure to respond to its inhabitants due to the distancing of the "social and cultural conditions of production." Vernacular, in contrast, is essentially an untutored, unscripted, popular building practice that is often an "immediate product of [its user]" and provides an index into lived realities.[22] In Deetz's view, vernacular forms are specifically constructed to function in accord with their cultural environment through organizational and spatial means; vernacular structures that don't get quickly replaced.

This argument is tempting, but in application, the line between academic and vernacular is not always so clearly defined. According to this line of reasoning, structures like the Djenné mosque in Mali or the Teleuk architecture of the Mousgoum people in Cameroon should be grouped under the rubric of the academic (see Figure 1.5). They require specialized building knowledge, training, design, and organization. Yet they are typically included in scholarly discourse not because of their "academic" nature, but because of their unique sculptural aesthetics, their value as world heritage objects, and their continuity within their respective cultures. The classificatory barriers that are erected between vernacular and academic architectural forms continually reinforce such interpretive biases. They eliminate the possibility of an analysis of these two genres in unison as a collective landscape that work collaboratively to reinforce the cultural conditions of a society at any given moment.

Thus, the boundaries of the vernacular concept continue to require a more productive challenge, and architects and scholars like Suha Ozkan and Antoni Folkers are making headway through the further breakdown of such terminology towards a closer examination of its specific localized iterations. Suha Ozkan has

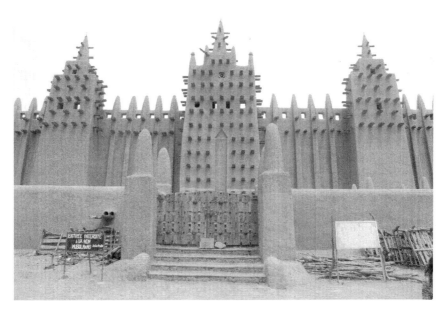

**FIGURE 1.5** Great Mosque, Djenné, Mali, current structure built in 1907.
Source: Photo courtesy of Barbara E. Frank, 2011.

been engaged in challenging the categorical mechanics of the term "vernacular" by building on Kenneth Frampton's concept of "critical regionalism," creating subdivisions of the vernacular that reflect culture-driven reactions to architectural modernism, thus tying the vernacular to modernism.[23] Pushing this concept even further is practicing architect Antoni Folkers, who classifies such reactions as either "derived" or "transforming" tendencies, which in turn results in either "vernacularism" or "modern regionalism."[24] Vernacularism in this case constitutes the traditional, unspecialized, local counterpart to academic architecture, but Ozkan goes one step further towards crystalizing this concept by dividing it into two additional groups, the conservative and the neo-vernacular. This subdivision is important because it brings discussions of the vernacular into direct contact with modernist conversations not only as an unofficial, local architectural practice, but also as a contemporary reaction to the incoming modernist architectural styles. Conservative vernacularism is defined as the reintroduction of conventional architectural materials, traditions, and techniques into a built environment to serve their original purposes, perhaps as an antidote to ill-fitting modernist schemes that have flopped in various African contexts. Neo-vernacularism, in contrast, uses these same conventional architectural forms in current structures for contemporary purposes as a type of adaptive architectural strategy. In each case, vernacularism is an architectural strategy that acts also as a fluid response to ongoing situations.[25]

But the final problem regarding terminology such as the vernacular and even associated ideas such as informal architecture or improvised environments is that so often they are linked to concepts of the "amateur," the "folk," and the "traditional."[26] Dumisani Mhlaba comments that certain architectural terminologies and systems of thought have become "particular" to Africa in contrast to the rest of the world:

> The undeveloped architecture found in poor rural areas is often defined as African "traditional" architecture, where "*traditional*" assumes an exceptional meaning. "Rural" is often understood as African and underdeveloped, with the exception of the white farmer's house away from the modern town. Furthermore, there is a general academic perception that architecture is only European; one can only speak of African dwellings, not architecture, or a homestead instead of a house. The list is endless.[27]

The connection of the vernacular and similar terms to the traditional and its associated connotations of stasis, fixation, and immobility have allowed certain primitivizing undertones to flavor discourse concerning architecture in Africa, eliminating it as a contender for serious scholarly attention.

Thus, in dealing with architectural terminology that has thus far been associated with built form in Africa and its connection with the ordinary, the nondescript, and the unspecialized,[28] it is important "not [to] colonize this new territory by mapping it using only our shop-worn western narrative structures."[29] If one is to engage in an analysis of architectural form within a specialized African context one must either deconstruct Western conceptual scaffolding with regards to the architecture of non-Western spaces or renovate concepts like the vernacular in order to reconstruct an approach that privileges perspectives from architecture's own unique context.

Luckily, in the past few decades, scholarship has begun moving in more constructive directions in this regard with developments on two fronts of interpretation. First, schools of African philosophical thought are increasingly being accessed to shed light on narratives regarding African expressive traditions as well as discrepancies between African/non-African modes of interpretive analysis. Over the past fifty years, this body of thought has provided compelling distinctions between African and Western modes of inquiry and cultural and material analysis. Beninese philosopher Paulin Hountondji, for example, has tackled the problem of ethnophilosophy, or the study of systems of knowledge specific to a culture that dictate the way said culture thinks, acts, and communicates. Ethnophilosophy as a concept was very popular in the immediate post-independence era, buttressing ideological movements like Léopold Senghor's *Négritude*, a theorized pan-African identity that was to be crafted from indigenous models rather than European frameworks towards achieving African "authenticity." Yet, one of the primary problems inherent in the concept of ethnophilosophy, Hountondji says, is its emphasis on the power of the collective over the individual in terms of belief and

action. Not only does this aspect disenfranchise the individual in determining the nature of cultural identity, but it also firmly locates the identity of a cultural group in the past, giving tradition and history precedent over current or ongoing narratives. All of this is in addition to the fact that such characteristics continue to separate African modes of being from those of the West in terms of the perceived individualistic modes of philosophic thought. The result of these connotations is that African thought, cultural, and material i.e. architectural production is "excuse(d) ... from having critical, reflective ... rational, scientific, and progressive content produced by individual thinkers in any significantly cross-culturally comparative sense."[30]

Ghanaian philosopher Kwasi Wiredu adds to this discussion by focusing more intently on the "Africa vs. the West" debate in his analysis of Western cultural scholarship and its tendency to categorize African folk life, tradition, and culture as the normative state of being on the continent. He also raises the issue of the fact that it is often these non-normative conditions that are compared with the contemporary scientific conditions in Western societies, also incorrectly positioned as a universal condition as well, towards creating a hopelessly unequal and primitivizing dialogue. Making folk culture a natural, dominant state of existence for all Africans regardless of context regresses African studies discourse across disciplines and makes it inescapably subservient in form and content to a progressively styled Western world.[31] One cannot compare an adobe African roundhouse with a New York City skyscraper; the samples are ill-matched on almost every structural, technological, and cultural level from conceptual organization, purpose, and genre, to precedent, materials, function, and context. The only identifiable variable connecting the two is their reality as three-dimensional shelters; thus, to make adequately comparative assessments of Western and African frameworks and modes of material and architectural production, the two must be equalized in terms of comparing folk spaces to folk spaces and modernized spaces with modernized spaces.[32]

The second development in the area of "decolonizing" African architectural studies has been through the creation of emergent frameworks of analysis and investigation for architectural forms on the continent. In the past three decades, a select group of scholars have taken some promising steps towards providing fresh frameworks of approach to architecture in Africa. In her 1974 article "An Introduction to Indigenous African Architecture," architect and historian Labelle Prussin attempted to equalize world architecture by defining it as "the total man-built environment ... derive[d] from 'man's identifying himself with what he builds, using it as a means of self-expression.'"[33] In addition, she approached architectural form as both a physical and a psychological construct towards expanding and renovating its definition and underscoring the interpretive limitations that had thus far been applied to considerations of African architectural form. Prussin in many ways laid the groundwork for further studies into the subject, including her own, while also influencing later scholars in the process.[34] In each case, the interpretive abilities of architectural theory have been pushed into new

areas that consider both the totality of the architectural process as well as the fact that architectural forms do not have stable identities. Architectural forms that have existed historically on the continent and continue to develop in the contemporary period are inherently flexible and able to maintain numerous meanings at one time depending on geographic and cultural context. Thus, by thinking through architecture as a layered object embedded in the specifics of its particular locality, it becomes increasingly apparent how architecture is able to articulate multiple identities across diverse geographies and cultural communities. It is this conceptual framework that allows architecture in Africa to tell multiple stories at once and respond so creatively and effectively to shifts within its cultural context.

Such approaches to built form in Africa allow us to come closer to a legitimate examination of meaningful space and its complexities of expression and reification as they are represented in culturally and spiritually embedded genres such as Afro-Islamic architecture. These complexities also allow us to question further how one even conceptualizes entities of "Islam" and "Africa" as they relate to architecture. Does the category "Afro-Islamic architecture" only include built forms created by Muslim individuals? Do these forms have to be located on the continent? And how can we think about Afro-Islamic architecture more broadly? Can domestic spaces, government buildings, and even alternative religious spaces be considered "Islamic," based on their authorship, influence, or simply by the fact that they are built in the midst of a culture informed by a Muslim sensibility? Is a non-Muslim capable of creating Islamic space? While there may not be any definitive answers to these questions (and this book does not propose to offer such answers), they nonetheless provide a starting point with which to begin piecing together an interpretive framework for approaching such questions more constructively, particularly in the context of a case study like Larabanga.

## Moving Forward: Larabanga Within a West African Islamic Architectural Discourse

The best place to begin a conversation about these topics is through a case study such as Larabanga. In particular, Larabanga's placement within Afro-Islamic discourse and its unique approach to cultural and spiritual identity through the medium of its built environment gives us an appreciation for the richness and complexity of architecture as the structural equivalent of a society's cultural values and belief systems. Within Larabanga's context, cultural and architectural narratives are woven together within communal space towards making the built environment a timeline of transformation and progression, beginning with its formative moment as a site of spiritual revelation in the seventeenth century and leading into its contemporary reality as a heritage destination and tourist attraction. These progressions are articulated in the style, organization, and function of its built environment, which exists in variously degraded, transitional, in progress, or completed stages as an evolutionary scale of structural steps towards responding to human needs. As such, the diverse architectural spaces of Larabanga collectively

act as essential texts, timelines of events, influences, and interruptions that make up the cultural fabric of society. As the ebbs and flows of the community shape these built forms, they become histories of action and reaction, of move and countermove. Architecture, thus, is a structural writing of the "now" in Larabanga, a three-dimensional conversation between past and present that continuously negotiates between each other and within society at large.

Yet Larabanga as a site of Afro-Islamic cultural and architectural identity does not stand alone in its responses to the pulls and pressures of a globalized world. Islamic communities all over West Africa, urban and rural alike, are dealing with similar issues catalyzed by processes of modernization and the tensions that arise when conventional practices collide and grapple with incoming exterior influences. The acute anxieties that in many ways define Larabanga's current condition as a community in negotiation with such forces are tensions felt in a number of areas, whose embedded Islamic identities are struggling to come to terms with the aggressive commodification of their architectural spaces as cultural "capital."

In some cases, the interweaving of established frameworks with progressive development has catalyzed a re-articulation of identity in ways that privilege both of these seemingly ill-matched components and gesture towards an unknowable yet progressive future. In others, however, these conversations have yielded less than ideal results, with architectural spaces sometimes becoming the collateral damage of a war between competing stakeholders and their various agendas. Larabanga thus far has managed to create a somewhat productive dialogue between these influences, preserving a sense of itself by maintaining the necessary degree of cultural autonomy to prevent the ingestion of its historical identity into a larger rhetoric of national and international heritage. The town of Djenné in the Niger Bend region of Mali, however, has had a somewhat different experience, particularly with regards to its fraught engagement with heritage rhetoric, an engagement that has inscribed itself on the built environment in a number of ways. Djenné has a very deep history as one of the oldest urbanized areas in sub-Saharan Africa and a site of great cultural, religious, and economic wealth that reached its climax during the fourteenth and fifteenth centuries as a regional trade center. Based on this heritage and the monumental architectural styles that would emerge from it, the Great Mosque of Djenné and some two thousand homes in what has become known as the "old town of Djenné" were inscribed on UNESCO's World Heritage List in 1988. This designation brought great prestige to the region as well as economic gain in the form of both tourist and development dollars; yet the preservation and conservation initiatives that followed have had an immobilizing effect on the structures in question. Preservation guidelines and protocols suggested by UNESCO and enforced by the Malian government have increasingly prevented Djenné residents from making changes to their homes in the form of expanding spaces to accommodate a growing or extended family or changing interior organizations to adapt to changing social circumstances because such changes would undermine the "authentic nature" of the structure. This has led to a dip in the quality of life for Djenné's residents, who are also not allowed to use

contemporary materials like cement to construct or buttress their homes, nor are they allowed to install modern drainage and sewer systems because that might interfere with the structural matrix of the building. But another aspect of this situation is the fact that "authenticity" as it has been defined in Djenné thus far has had little to do with definitions generated by the local population and this has left them unable to take any ownership over this process.

This situation came to a head in September of 2006 when a crowd of several thousand Djenné youth confronted a conservation team sent by the Aga Khan foundation to repair the mosque roof. It was later learned that this broad-based anger was directed at a perceived oppression by outsider stakeholders, which included the Malian state bureaucracy, UNESCO experts, and various other preservation groups like Aga Khan who moved and worked within Djenné space without appreciating the unique cultural circumstances informing the relationship between architecture and the social and spiritual well-being of the community. And so this raises the question of who has the right to determine the appropriate or "authentic" manifestation of these forms. Do these structures truly represent global heritage and thus, to an extent, global ownership and authorship? And if they do, what is the price of this ownership? The museumification of a living city and community for largely external consumption?

One result of this situation is that in some cases residents have simply opted to leave the city in search of more flexible, responsive living situations in surrounding towns. Others have begun developing architectural sites and compounds *outside* Djenné's city walls that are able to accommodate many of the modern technological advances that inhabitants in the main part of the city are unable to incorporate.[35] This has led to the creation of a new community, a "*third* Djenné" located adjacent to the old and representative of Djenné residents' response to the current state of their original city as a space in physical stasis.[36]

Situations such as Djenné are extremely relevant to investigations of sites like Larabanga, whose emergent role as a heritage site and tourist attraction put it at risk for similar types of ideological and strategic collisions between established identities and contemporary influences. Another site that has experienced such collisions with far more disastrous results has been Djenné's sister city of Timbuktu, which was occupied for nine months in 2012 by an Islamic militant coalition known as Ansar Dine. Composed largely of ethnic Tuareg, the group imposed Sharia law[37] on the region and destroyed numerous culturally and spiritually significant sites in the area, including area tombs, cemeteries, and monuments in the name of this doctrine. This focus on the architectural landscape of Timbuktu is key to understanding the motivations behind Ansar Dine's campaign: to many ethnic Tuaregs, the government's funding of wide-scale preservation initiatives was interpreted as yet another instance of neglect from authorities that have long marginalized Tuareg representation within the government. The funding of heritage initiatives over social and educational programming in northern areas, coupled with a history of violent suppressive campaigns against area cultural groups by the same government, transformed the architectural landscape of Timbuktu

into a highly symbolic canvas on which to inscribe a response to the various ills the Tuaregs have experienced in recent decades. In addition, the dominance of Sufi[38] practices in Timbuktu (long considered heretical by many orthodox branches of Islam) and the presence of architectural structures associated with it, including tombs, mosques, and other institutional complexes, made Timbuktu an effective vehicle for the fundamentalist agendas of the group; their religious program was effectively etched in the piles of rubble they left behind as they systematically destroyed Sufi architectural spaces over the course of their nine-month occupation. However, the expulsion of militants from the area in 2013 and the reinstitution of relative order in the region has catalyzed rebuilding, and for some an increased feeling of attachment to the landscape, a renewed appreciation for its importance, and perhaps most notably, an optimism for the future. As Abderrahmane Ben Essayouti, imam of Timbuktu's Djinguere Ber mosque, notes: "We have witnessed the destruction, we are now seeing the start of the reconstruction ... To us, it is a new birth for Timbuktu."[39] The situation in Timbuktu highlights the fact that even destruction can be generative, creating new spaces from traumatic ruins and subsequently encoding this space with new functions, meanings, and memories. Like Djenné, Timbuktu stands as a site transformed by the collisions that have occurred between multiple stakeholders and the various values applied to the built landscape as a marker of cultural identity. Larabanga also stands as such a site, and thus the questions of how past and contemporary values are being negotiated within the village space increasingly find transformative and sometimes iconoclastic representations within this landscape as well.

On a slightly different yet related note, the Sufi city of Touba, located in central Senegal, has been less affected by heritage rhetoric and the challenges of religious identity, and more by advances in technology. Touba has long stood as a beacon of success for the effective integration of religion and civil authority. The city itself was inspired by a divine vision received by its founder Cheikh Amadou Bamba in 1887, who was visited by the Archangel Gabriel during a period of ascetic meditation in the wilderness. Bamba would subsequently found Mouridism, a Senegal-based Sufi order, and the city of Touba, which became the "heart" of this order; it would eventually grow to be the second largest city in the country next to Senegal's capital city of Dakar. The organization and architectural development of the city has continued to advance along a carefully crafted trajectory designed to actively inscribe Sufi Murridiyya philosophies on to the landscape as a way of evoking *baraka*, or blessing.[40] Currently, Touba's population continues to grow annually by around two per cent, and the city has also experienced "New Information and Communication Technologies" growth.[41] These modern technologies have created a new physical reality for the city, enabling Touba to be a holy space that can operate *beyond* its geographic borders by expanding itself as a conceptual "territory" into a global digital environment.[42] This has generated a fundamental shift in the reality of Touba's conceptualization; it is no longer a geographically rooted architectural space but a flexible, mobile, digital terrain that is able to realize itself virtually beyond the boundaries of the city's physical space. It also continues to

channel the city's sacred power through this umbilicus of global interconnectedness and technological facility. The space that Touba occupies thus needs to be revisited through this lens of contemporary technology with questions asked in regards to how one can think about the reality of this Islamic space in the digital era. Along these lines, Larabanga is increasingly being drawn into digital conversations as well, not necessarily through its virtual extension into digital space but through both the development of technological infrastructures within the village and also, interestingly, the advertising of these technologies on the sides of architectural forms, which now act as billboards for major telecom companies.

As such, these case studies work in conjunction with Larabanga to express how Islamic identities are functioning in multiple contemporary West African societies with architectural forms acting as the gauges through which progress is measured and recorded. These studies also provide hints of how these identities are being challenged by a variety of contemporary circumstances, each of which has called on the built environment to adapt and respond flexibly to changing conditions brought on by increased dialogue with global communities. In each situation, Islam's progressive impulses are being actively encoded within various architectural environments whose responses have included renovating old spaces, constructing new spaces, and even reconsidering the idea of space on a fundamental level with regards to an increasingly techno-dependent world. Through such reorganizations, evolving conditions, needs, and desires are accommodated, proving yet again that architecture serves as one of the primary mediums through which Islamic identity in this context signifies its innovative spirit.

In the coming chapters, we will become acquainted with the specifics of the architectural situation in Larabanga, and will see how its Islamic frameworks translate communal elements and realities into a cohesive architectural environment, a structural "methodology for living" that channels behavior and interaction into culturally supportive roles. We will also see how architectural components collaborate in diverse, contextually rooted ways in Larabanga towards expressing the distinctive narratives, value systems, and realities that make up the unique composition of this West African Islamic community. Through this framework, architectural constructs including mosques, domestic spaces, public areas, and more become major texts in the material "biography" of the village, exhibiting transitions and transformations of knowledge, memory, and consciousness by imprinting registers of past and present knowledge onto the physical environment. In doing so, the built environment of Larabanga becomes both a historical document and a transformative landscape for cultural and religious practice and ideology, transmitting trans-historical narratives in a way that allows "renewed thought in different contexts over time ... especially in working out assumptions and drawing implications for contemporary thought and practice."[43] It also positions architecture as a fluid, evolving medium that continuously manifests identity even as the community itself evolves in unpredictable and occasionally abrupt ways, and provides a lens through which to engage in a reconsideration of Islamic architecture in West Africa as an

## 32 Locating Larabanga

interpretive apparatus uniquely capable of unpacking one of the most diverse and progressive movements on the continent today.

## Notes

1. Bruno Zevi, *Architecture as Space: How to Look at Architecture* (New York: Horizon Press, 1957), 22.
2. Labelle Prussin, "An Introduction to Indigenous African Architecture," *The Journal of the Society of Architectural Historians* 33, no. 3 (October 1974): 184.
3. Donald Preziosi, *The Semiotics of the Built Environment: An Introduction to Architectonic Analysis* (Bloomington, IN: Indiana University Press, 1979), 6, 147.
4. Patricia A. Morton, "The Afterlife of Buildings: Architecture and Walter Benjamin's Theory of History," in *Rethinking Architectural Historiography*, ed. Dana Arnold et al. (London: Routledge, 2006), 222.
5. This particular rock mosque is located in Larabanga, but is almost identical to those found in North and West African desert environments.
6. Amos Rapoport, "The Study of Spatial Quality," *Journal of Aesthetic Education: The Environment and the Aesthetic Quality of Life* 4, no. 4 (October 1970): 81–86.
7. Thomas Markus, *Buildings and Power: Freedom and Control in the Origin of Modern Building Types* (London: Routledge, 1993), 18.
8. Prussin, "An Introduction," 199.
9. See William J. R. Curtis, "Type and Variation: Berber Collective Dwellings of the Northwestern Sahara," *Muqarnas* 1 (1983): 181–209, and Salima Naji, *Art et Architectures Berbères du Maroc* (Aix-en-Provence: Édisud, 2001).
10. I was unable to enter the actual space of the mosque. However, I was able to construct this experiential narrative both through individual accounts of the interior as well as my personal experience entering a similar earth and timber mosque located in Nakoré outside the Northern capital city of Wa.
11. Thomas Carter and Elizabeth C. Cromley, *Invitation to Vernacular Architecture: A Guide to the Study of Ordinary Buildings and Landscapes* (Knoxville: University of Tennessee Press, 2005), xx.
12. Understanding the nature of architecture as it exists on the African continent involves recognizing its reality as a conceptually complex construct. Others who have explored the various thematic perspectives that have shaped the field of African architectural studies thus far (Nelson, 2007; Strother, 2004; Blier, 1987; Prussin, 1986; Prussin, 1995) have laid bare certain fundamental African architectural components that enable us to appreciate the structural possibilities of diverse cultures and lifestyles.
13. Dana Arnold, Preface to *Rethinking Architectural Historiography*, ed. Dana Arnold et al. (London: Routledge, 2006), xviii.
14. Ibid.
15. See Ernst Kühnel, *North Africa: Tripoli, Tunis, Algeria, Morocco: Architecture, Landscape, a Life of the People* (New York: Brentano's, 1924); Jane B. Drew et al., *Village Housing in the Tropics: With Special Reference to West Africa* (London: L. Humphries, 1947); and Betty Spence, *How Our Urban Natives Live* (Pretoria: South African Council for Scientific and Industrial Research, National Building Research Institute, 1950). These are only a select number of studies.
16. Carter and Cromley, *Invitation to Vernacular Architecture*, 1.

17  Henri Lefebvre, *The Production of Space* (Oxford: Blackwell, 1991), 222.
18  Andrew Ballantyne, "Architecture as Evidence," in *Rethinking Architectural Historiography*, ed. Dana Arnold et al. (London: Routledge, 2006), 45.
19  Dana Arnold, *Reading Architectural History* (London: Routledge, 2002), 102.
20  Carter and Cromley, *Invitation to Vernacular Architecture*, 6.
21  Ibid., xviii–xxii.
22  Arnold, *Reading Architectural History*, 102.
23  Suha Ozkan, "Regionalisme et Mouvement Moderne. A la recherché d'une Architecture Contemporaine en Harmonie avec la Culture," *Architecture & Behavior* 8, no. 4 (1992): 353–366.
24  Antoni Folkers, "The African House Today: Observations from Burkina and Tanzania" (paper presented at the African Architecture Today symposium, Kwame Nkrumah University of Science and Technology [KNUST], Kumasi, Ghana, June 2007).
25  The other architectural response noted is "modern regionalism," which, like vernacularism, can be divided into two categories: concrete regionalism and abstract regionalism. Concrete regionalism involves the adoption and transfer of certain traditional building types and styles on to modern structures using contemporary materials (Folkers, *Modern Architecture in Africa*, 166–168). Conversely, abstract regionalism is a little harder to define and does not borrow from tangible styles and design elements; rather, it incorporates the sensibility of architectural tradition into a built form. This sensibility is often informed by the specific locality in which this tradition took form. Folkers identifies elements of mass, proportion, light, and rhythm as key elements to this sensibility that are subsequently adapted and retranslated in contemporary architectural form (Folkers, *Modern Architecture in Africa*, 166–168).
26  See Paul Oliver, *Encyclopedia of Vernacular Architecture of the World* (Cambridge: Cambridge University Press, 1997); R. W. Brunskill, *Vernacular Architecture: An Illustrated Handbook* (London: Faber, 2000); Paul Oliver, *Dwellings: The Vernacular House World Wide* (London: Phaidon, 2003), 9.
27  Dumisani Mhlaba, "Approaches and Appreciation of African Architecture" (paper presented at the African Architecture Today symposium, Kwame Nkrumah University of Science and Technology [KNUST], Kumasi, Ghana, June 2007).
28  Carter and Cromley, *Invitation to Vernacular Architecture*, 7.
29  Dana Arnold, "Beyond a Boundary: Towards an Architectural History of the Non-East," in *Rethinking Architectural Historiography*, ed. Dana Arnold et al. (London: Routledge, 2006), 242–243.
30  Barry Hallen, *A Short History of African Philosophy* (Bloomington and Indianapolis, IN: Indiana University Press, 2002), 51.
31  Ibid, 17.
32  J. E. Wiredu, "How Not to Compare African Traditional Thought with Western Thought," *Transition* 75/76 (1997): 320–327.
33  Prussin, "An Introduction," 185.
34  See Suzanne P. Blier, *The Anatomy of Architecture: Ontology and Metaphor in Batammaliba Architectural Expression* (Cambridge: Cambridge University Press, 1987); Suzan B. Aradeon, "Maximizing Mud: Lofty Reinforced-Mud Domes Built with the Assistance of Supernatural Powers in Hausaland," *Paideuma* 37 (1991): 205–221; Z. S. Strother, "Architecture against the State: The Virtues of Impermanence in the Kibulu of Eastern Pende Chiefs in Central Africa," *Journal of the Society of Architectural Historians* 63, no. 3

(September 2004): 272–295; and Steven Nelson, *From Cameroon to Paris: Mousgoum Architecture in & Out of Africa* (Chicago, IL: University of Chicago Press, 2007).
35 See Michelle Apotsos, "Holy Ground: Mud, Meaning, and Materiality in the Djenné Mosque," *Rutgers Art Review* 27 (2011): 2–16.
36 Michael Rowlands and Charlotte Joy, "Can Djenné Remain a World Cultural Heritage Site? A Rhetorical Question?" (paper presented at the *Built Cultural Heritage* symposium series for the 33rd Quinquennial Jubilee, Delft University of Technology, 2007).
37 Sharia law is a highly conservative form of Islamic governance.
38 Sufism is a mystical form of Islam.
39 Francis Rihouay, "Timbuktu Seeks Rebirth After Islamist Militants' Destruction," *Bloomberg*, March 31, 2014, accessed September 20, 2014, www.bloomberg.com/news/articles/2014-03-30/timbuktu-seeks-rebirth-after-destruction-by-islamist-militants.
40 See Eric Ross, *Sufi City: Urban Design and Archetypes in Touba* (Rochester, NY: University of Rochester Press, 2006).
41 See Cheikh Guèye, "New Information and Communication Technology Use by Muslim Mourides in Senegal," *Review of African Political Economy* 30 (2003): 609–625.
42 It is probably no surprise that such expansions have also occurred in conjunction with recent deteriorations in the historically unproblematic relationship between residents of Touba and Touba's civil authorities who are also the city's spiritual authorities. The massive growth of the city and the necessity of developing it further led to one of the first instances of civil unrest in the city's history, when in 1997 the great mosque's merchants launched a protest against new taxes imposed by the administrative council appointed by the Caliph-General to fund development projects in the city. This rather unprecedented move against the supreme Mouride authority by citizens of the Holy city not only reflects an increased desire for greater accountability from politicians and a more decentralized approach to civil leadership, but possibly even a less "blindly obedient" citizenry that is increasingly globalized in composition (Beck, "Reigning in the Marabouts?," 602).
43 Dominick LaCapra, *History in Transit: Experience, Identity, Critical Theory* (Ithaca, NY: Cornell University Press, 2004), 18.

# 2
# THE ROAD TO LARABANGA
## A Short History of Afro-Islamic Architecture

### Setting the Stage: Early Islamic Architecture and its African Reimaginings

A cultural and architectural history of Larabanga must begin with the story of its formative component, Islam, and Islam's genesis, development, and growth on the African continent, which began in the seventh century of the Common Era. Indeed, an understanding of this narrative is crucial to pinpointing the seminal moments of Islamic progress on the continent, as well as how these key moments found renewed expression in Larabanga's cultural, spiritual, and architectural frameworks. Fundamental to this narrative is the fact that Islam's encounters with a variety of diverse social, cultural, and religious conditions over the course of its long migration in North and West African contexts set the stage for a continuous reinvention of Islamic thought and practice as it traveled through the lenses of numerous localized sensibilities and traditions. In fact, most scholars of Afro-Islamism agree that it is largely inappropriate to speak of "Islam" as a singular entity; as Osella and Soares have noted, "Africans have developed multiple ways of 'being Muslim'."[1] In addition, many of the Afro-Islamic conversations that have occurred over the vast space of the continent have also been informed by interactions with Europe, India, Southeast Asia, and the Americas during various periods in the context of specific political, social, and cultural conditions.[2] The presence of this broader conversation indicates that Islam as a system of living was and is an inherently adaptive one, whose encounters generate new cultural vocabularies and architectural repertoires in response to various pressures, influences, and inspirations. Here we will zero in on certain key components of Islamic cultural and architectural development that played a role in bringing Larabanga's cultural and architectural identity to fruition. Such encounters, architectural prototypes, and precedents provided Larabanga with the raw structural materials to create a distinctive built environment embedded with context-specific

meanings. This in turn provides us with a unique opportunity to both test the effectiveness of architecture as an interpretive methodology towards parsing the character of the Islamic identities that have developed in West Africa, as well as offering an alternative to documenting the histories of peoples without texts. In the context of Larabanga and other regional communities, built form acts as a narrative vehicle capable of displaying history not as a singular monolithic account, but as a series of stories made manifest within the architectural folds of structures, creating a candid portrayal of history as it is continuously deconstructed, altered, reassembled, and developed in meaningful, deliberate ways.

Islam originated in present-day Saudi Arabia in 610 CE after God's first revelation to the Prophet Muhammad (pbuh). Notable about this geographic setting was that Islam was, from the very first, positioned at the intersection of a number of monumental legacies whose influences allowed it to quickly generate a distinctive cultural and religious identity and develop a unique material culture with which to buttress and propagate its ideals. Born at the crossroads of ancient Rome, Sassanian Iran, and Byzantium, Islam's emergent personality took inventory of these legacies towards crafting an expressive culture that represented a distinctive fusion of these heritages renovated to fit the specific philosophic contours of Islam's developing political, social, cultural, and religious frameworks. This initial formative moment also provided a model for future interactions across multiple geographies as Islam expanded into new areas and began incorporating the iconographies, traditions, and architectural characteristics of newly acquired territories into its own material culture and architectural practice. In doing so, Islam was not only able to effectively embed itself within the diverse fabrics of multiple societies within its growing empire, but also collect a vast repertoire of aesthetic and architectural practices, which took on numerous iterations as Islam spread across Asia, southern Europe, and the northern half of Africa.

At this time, Islam would also enter the African continent through Egypt via a massive military campaign under the newly established Muslim Umayyad Caliphate; this occurred only a few decades after the Prophet Muhammad's death in the seventh century. Thus, Islamic culture in the Middle East and Africa formed something of a sibling relationship, developing both adjacently and in response to one another through complex networks of interaction and exchange, which enabled various material and architectural cultures to evolve. The specifics of Larabanga's development were in fact the result of this long collaborative process, which began in the Middle East and moved across the expanses of North Africa before taking root in the West African forest regions where the community is located.[3] Over the course of this migration, Islam's "whole package" approach, which incorporated not only Muslim economic, cultural, and spiritual programs but also the material infrastructures that went with them, were filtered and renovated to fit the molds of each site of contact.[4] The result was the creation of numerous contextually embedded systems that were individual in their Islamic sensibility yet structured around a group of core philosophies, a system that came together in the development of specific material/architectural cultures and traditions.

The aforementioned "core philosophies" around which Islamic identity in Africa would form began to take shape during the Umayyad (661–750 CE) and later Abbasid caliphates (750–1258). With regards to expressive culture, these two caliphates are often credited with initiating what has been characterized as Islam's "classical" period, a lengthy era responsible for generating one of the most composite bodies of Islamic material culture available for study; it subsequently catalyzed developments not only in Islamic material and visual culture, but also in the sciences and the humanities.[5] It was also during this era, known as the Middle Period (945–1500), when Islam's architectural identity began to take shape, a process largely defined by hybridity, synthesis, and evolution, which speaks to the creative impulse of a period.[6] In fact, it was Islam's particular architectural approach that came to be seen as manifesting the spirit of this age, incorporating experimental programs and aesthetic schemes that skillfully entwined newly established symbol systems with known artistic mediums and stylistic sensibilities towards creating a new, yet nonetheless accessible and digestible, Islamic "brand."[7] Such branding in some cases happened quite literally with the application of surface decoration to both objects and architectural forms in order to create a distinctive skin or patina.

This practice not only cemented associations between various iconographies and Islamic practice, but also linked the idea of a "decorative shell" with Muslim sensibilities and artistic development. Stucco became a particularly popular medium for this practice during the later Abbasid period, largely because of its cheapness, malleability, and ability to coat entire surfaces of buildings from top to bottom. Yet it was also an important medium because it allowed patrons to dictate the whole of the exterior visual program and allowed earlier buildings to be renovated along the lines of the aesthetic philosophies of new political authorities. The level of design and detail that stucco made possible allowed for the development of complex texture and relief patterns that blossomed across architectural surfaces, to the point where the intricacy of the designs appeared to dissolve the surface underneath and created "an art of illusion, which could make things look different from what they were."[8] Indeed, this decorative effect became iconic of the Islamicate style, its dizzying aesthetic interpreted as a visual conduit between human and divine realms that "purif[ied] the mind like music" through its "absolute beauty."[9] Because these complexly rendered designs required greater visual consideration, early Medieval philosophers such as Ibn al-Haytham saw them as a superior form of decorative art that evoked the contemplative gaze in favor of the inferior "glance."[10] Such interpretations were buttressed by the use of sacred Koranic script as an aesthetic device that was applied to multiple surfaces, objects, and structures ranging from mosque spaces to ornately inscribed volumes of *hadiths*. In many cases, the script became abstracted to the point that much of its linguistic function was lost; all that remained was the knowledge that these forms represented the words of God and thus were superior subjects of contemplative attention.

Yet this decorative program and the architectural forms it embellished also importantly acted as distinctive physical markers of Islamic presence, power, and cultural identity in the landscape; because of this, the value of Islamic architecture

as political apparatus was quickly realized and deployed. One of the earliest architectural manifestations of this political strategy was the Great Mosque in Damascus, built by the Caliph Al-Walid (668–715) in the Umayyad capital city of Damascus. Under Al-Walid, the Umayyad Caliphate expanded to become the fifth largest empire in the world, and it was also under Al-Walid that Umayyad troops first entered North Africa via Egypt. Thus, the Great Mosque at Damascus was meant to be a symbol of the aspirations of the empire, and as such a great deal of strategy went into developing the particular character of the structure, beginning with the selection of its building site. The Great Mosque sits on a site that was first a Roman temple dedicated to Jupiter before being converted in the fourth century to a Christian church dedicated to St. John the Baptist. When Islam first arrived in this area in 635, Christians and Muslims were known to worship together within this space; with the arrival of Islam, the church was pulled down to make room for the mosque. As such, the site was already pregnant with embedded associations of piety, spirituality, and history, elements that Al-Walid exploited to create its next architectural iteration of spirituality.

Al-Walid would also commission a decorative strategy that incorporated local, Islamic, Roman, and Byzantine sources towards creating a systematized distillation of Islamic expressive culture. Aesthetic elements and abstract design programs along with symbolically meaningful messages and contextually significant associations took visual form in mosaics with golden backgrounds and "hanging pearl" motifs, as well as *karma* (vine scrolls) and marbled panels. Combined within the context of a singular decorative program, these elements not only referenced the varied artistic legacies from which Islam was able to draw, but also endowed the mosque with a distinctive Islamic visual language all its own.

The distinctiveness of this visual language truly comes into focus through a consideration of the mosaic program at Damascus, which has long puzzled scholars. Many of these surfaces, which were created in mosaic by Byzantine artists that Al-Walid imported for the project, appear to dissolve the structure itself into a sea of color, with paradisiacal associations finding beautiful translation in gilded surfaces and mosaic work that seemed to glow with the power of God. Yet the beautifully rendered cities and village landscapes that appear in these works are strangely devoid of any human or animal life, and scholars have proposed that the composition is representative of the growing belief in contemporaneous Islamic religious circles that artwork showing human and animal figures should be avoided in sacred spaces. Yet others posit that the scene represents a city or a series of cities that the Islamic empire had conquered (hence they are empty of original inhabitants) or perhaps a paradise waiting to be filled by the Muslim faithful. While it is impossible to pinpoint the exact concept behind this tableau, each explanation supports the concept of this mosque as a symbol of Islamic religious and political power, whose decorative programs actively assimilated established artistic practices into the service of crafting a new, uniquely Islamic visual language.

The organizational layout of Damascus is yet another hybrid creation, a cross between a traditional Christian basilica form and the spatial ideals established by the

house of the Prophet Muhammad (pbuh) (see Figure 2.1). Constructed in a rectangular plan similar to the basilica, Damascus nonetheless deviates from the directional focus of the traditional Christian basilica in that there is no ritual focal point. Beyond indicating the direction of Mecca through a *mihrab* or niche located in the *qiblah* wall—the wall facing Mecca—mosque space is meant to be nonspecific. Damascus also incorporates a large rectilinear exterior courtyard (*sahn*) where ablutions before prayer are undertaken; such a courtyard, in theory, was also an important space in the house of the Prophet Muhammad (pbuh) where some of the earliest adherents to the faith gathered next to the covered areas of the home.

Thus, the Damascus mosque would become an architectural model for the development of later mosque forms across the empire that began incorporating and reinterpreting diverse local structural and visual programs to create architectural languages of Islamic authority and presence. Specifically, Damascus's physical organization provided a prototype around which religious structures often located on the "periphery" of the Islamic empire, such as those in Egypt and other parts of North Africa, were conceptualized. Islam entered this vast African geography early in the history of the faith, its incorporation lubricated by the fact that the coastal area of the region of East Africa had maintained trade relationships with Arab lands across the Red Sea and Indian Ocean for generations.[11] Thus, the area that eventually became known as the Swahili coast, which stretched over three thousand kilometers from the tip of Somalia down to Mozambique, would also become a point of penetration for Islam, the cultural diversity of the region actively molding incoming Islamic practices around established sensibilities and traditions. Importantly, Islam

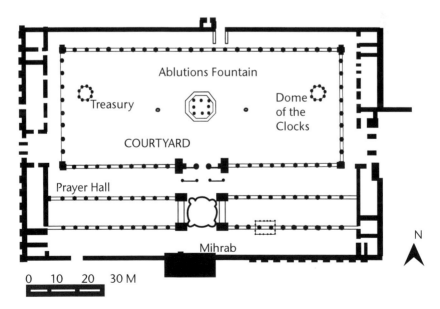

**FIGURE 2.1** Plan of the Great Mosque at Damascus, Syria, c. 715 CE.
Source: Adapted from Creswell.

came easily to this area largely because many East African inhabitants were already very familiar with the cultural and economic practices from which Islam was drawn. In fact, emergent Islamic ideologies and protocols may have been viewed initially as something of a standardization of these practices, particularly those related to commercialism and trade, which were carried out in accordance with Koranic law. Thus, early interactions with Islam may have been seen more as an organic evolution of trade customs rather than the introduction of a new way of life, enabling Islamic practices to insert and propagate themselves unobtrusively into local cultural and spiritual frameworks along the coasts of Somalia, Kenya, and Tanzania.

Supporting this sense of a natural progression is the fact that archaeologists exploring early sites of such interactions are often unable to distinguish Islamic sites from non-Islamic ones.[12] In addition, the later emergence of genealogical narratives (as a mode of authenticating Muslim ancestry) and oral histories connecting East African communities to Middle Eastern origins offers telling evidence of the success of Islam's integration. In areas like the Nilotic Sudan, such practices were not only acceptable but were expected and even the norm, largely due to the fact that proof of such lineage exempted one from enslavement per Koranic doctrine.[13] Later, colonial British forces would classify the "Arab" aspects of East African culture as superior to "local" components, which also catalyzed a rash of genealogical re-imaginings during the European imperial period.[14] Such forces were also responsible for cementing misinterpretations regarding early East African Islamic architecture. Regionally rooted architectural complexes, such as the Kilwa mosque and Swahili Stone Towns along the coasts, were wrongly identified as frontier Arab settlement sites that were implanted along the coasts as part of a colonization project. We now know these developed from the basis of a firmly embedded Arab–East African collaborative identity.

Similar misinterpretations have been made regarding Afro-Islamic architectural developments to the north as well, specifically in Egypt as the site of Islam's first official military foray into the continent. Egypt was a Byzantine territory at the time and a major source of food and capital for the Christian empire, which undoubtedly motivated the Umayyads to lay siege to the area, entering the coastal city of Alexandria between 640 and 645 CE. Because of the power of the Umayyad army under famed commander ʿAmr ibn al-ʿĀṣ, the conflict was short, and, subsequent to their victory, one of the first mosques to be built in Egypt's newly established Muslim capital, Fustat, was dedicated to the commander.

Although little of the original mosque remains, the mosque of ʿAmr ibn al-ʿĀṣ was the earliest Islamic structure in Egypt, built only a few years after the siege; as such, it was notably functional in design and has been described as a small, unadorned, and rather plain building with none of the usual decorative and material embellishments that had come to define mosque structures under the Umayyads. Structurally, the building also lacked minarets and apparently a *mihrab*—interior niche used to indicate the direction of Mecca—and was made initially of mud brick and palm sticks. These stylistic and materials choices are perhaps reflective of the building's primary author, an Egyptian convert who was also the nephew of

Fustat's then governor, al-Muqawqis.[15] Like most mosque structures built during this period, the rectilinear plan of the mosque is attributed to an adherence to the original plan of the Prophet's house (pbuh), a previously noted influence on the structural design of Damascus. This attribution also rationalizes the lack of minarets on the mosque structure in that the *muezzins*, or individuals who call Muslims to prayer, typically undertook the task from the rooftops of the mosque, rather than the large corner towers of the minarets.[16] Yet, local elements and architectural traditions should also be taken into account, particularly with regards to the effect that pre-Islamic Egyptian domestic architecture may have had on this newly minted form. One model of note might have been the Egyptian domestic compound, whose interior organization was also composed of a rectilinear complex with limited penetration points and an open courtyard that actively concentrated family living at one end (see Figure 2.2). This organization consolidated spaces of human activity in a manner very akin to the mosque form and had been dominant in Egyptian society since the New Kingdom (1550–1050 BCE).

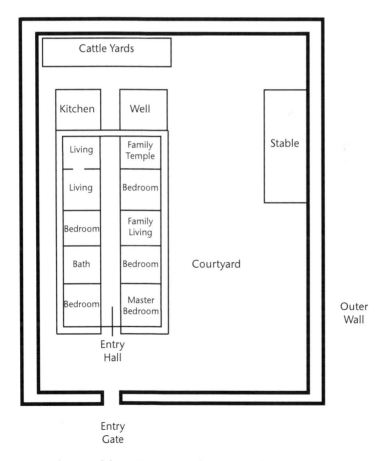

**FIGURE 2.2** Theoretical domestic compound, New Kingdom, Egypt, c. 1550–1050 BCE.

Likewise, social comparisons can also be made between these two structures. Both Islamic and pre-Islamic Egyptian cultures favored the division of interior and exterior space along gender identifications. The family unit in pre-Islamic Egypt was very important and typically oriented around an age- and gender-based hierarchy; this hierarchy was composed of the head of the household, his wife or wives, children, and any other dependents for whom he was responsible. Indeed, New Kingdom documents indicate that traditionally the woman's place was in the home and the man's place was exterior to this area. Such divisions imprinted themselves on the domestic template through both specific protocols that governed access into interior familial spaces and the types of activities that took place within them—primarily female-oriented chores such as cooking, washing, and caring for children.[17] Similarly segregated domestic spaces also developed in Islamic societies. Layers of visual and physical access to the interior were mediated by the placement of architectural elements such as exterior doorways and windows, and areas of the home were encoded as male or female. These similarities between Islamic and pre-Islamic Egyptian culture undoubtedly played a role in crafting new Islamic Egyptian spaces in accordance with established, normative, and thus readily understandable protocols.

But beyond physical similarities, connections between the functions these spaces addressed also deserve mention, and for this, we need to turn back to the question of minarets, or a lack thereof, in the mosque of Amr ibn al-'Āṣ. As previously mentioned, minarets were often the perch of the *muezzins*, who call the faithful to prayer from this lofty position. In numerous pre-Islamic contexts in this region, individuals known as community "criers" were already tasked with calling town members to meetings and other events, and they did this using voices and drums, while circulating throughout the village or finding a nearby high point from which they could "call down" to the town. The natural parallels between the functions and roles of the *muezzin* and the pre-Islamic town crier may have privileged rooftops as opposed to minarets as an appropriate space of performance for this role. And thus, it is possible that minarets were seen as superfluous to this emergent mosque type given the presence of corresponding traditions already in place in pre-Islamic Egypt.

From the basis of this discussion, it becomes much more difficult to view the mosque of 'Amr ibn al-'Āṣ solely as a transplanted form. The reality of the structure as it existed within the newly Islamicized context of Egypt is more likely that of a selective and strategic fusion of Arabic and Islamic elements, a rationale buttressed by the presence of numerous comparable pre-Islamic elements of Egyptian society already in place by the time Islam arrived in this area. These structural models and their attendant socio-cultural systems were reinforced by the coming of Islam and together created a mutually beneficial societal system that goes a long way towards dispelling the myth that Middle Eastern mosque designs were forced to "make do" with the materials and craftsmanship abilities of its current context; such an idea is as primitivizing as it is flawed.[18] As the offspring of newlywed cultural systems whose similar backgrounds, environments, and protocols allowed an easy cross-

fertilization of local architectural forms, the early mosque of Amr ibn al-'Āṣ became an emergent African interpretation of an Islamic architectural space, based on the systematic requirements of a Muslim prayer space reinterpreted through the lens of local architectural traditions and cultural parameters.[19]

## Before *Bilad al-Sudan*: Islamic Architecture in North Africa and the Maghreb

From Egypt, Islam moved across the face of the Sahara with Umayyad military forces towards establishing a nascent North African Islamicate. These military campaigns were largely made possible by the presence of the camel, the great "ship of the desert" that brought goods as well as people from one side of the continent to the other. These traversals were arduous, and because of the peril involved were made largely by soldiers as well as merchants who brought important supplies to these frontier posts. These commercial travelers also brought news and information from the wider world. Because of their role as purveyors of physical and intellectual commodities, traders quickly became influential vehicles of cross-cultural communication and fertilization, mobile units of knowledge and influence that deposited histories, cultures, identities, and value systems wherever they stopped. As the "cultural middlemen" of the Sahara, these individuals also often shaped impressions of the outside world for those within. Their own lenses, perceptions, interpretations, and information had wide influence; they were "catalysts of change" within and between contexts.[20]

Under the influence of these middlemen and other area groups, the members of the Umayyad military campaign also began recontextualizing their identities as they moved further away from the more direct influence of the Middle East and began adapting to the different physical and cultural environments. They generated new frameworks of Islamic identity based on life in North Africa, a condition dominated by the physical realities of a harsh desert climate and the socio-cultural challenges of military life on the move; theirs was an Islam shaped through movement, circulation, and the creation of avenues of exchange and interaction rather than an embeddedness in a singular idea of Muslim identity.[21] Thus, it was a highly fluid, military-based brand of Islam with which various North African populations first came into contact, a brand that was practiced in accordance with the ebbs and flows of the social, cultural, and environmental landscape.

The need for spaces that met the prescriptions of Islam as dictated by the Koran as well as the needs of a caliphal army on the move led to the development of specific spaces that both fulfilled these requirements and actively inscribed the landscape with the presence of Islamic authority. Rock mosques, as addressed in Chapter 1, became one feature of North African Islamic life. Because of their informal nature, these "structures" were placed at numerous points along the ancient routes that the Umayyads followed throughout their campaign and as such may have even acted as a complement to traditional systems of nomadic navigation already in place. Through their minimalism, anti-aestheticism, and

pure functionality, these simple outlines distilled the very concept of a mosque as a place of prostration, creating a highly effective architectural surrogate for a mobile congregation. This method of demarcation also eventually appeared in sedentary contexts in North and West Africa as well, often as a complementary prayer space next door to an "actual" mosque space.

But this incoming Islamic identity also made itself known in the creation of military installations organized around commercial and religious areas at strategic points along the North African Umayyad campaign trail. These spaces reflected the fact that the Umayyad conquest of North Africa was both a political campaign to usurp Byzantine power in the area and a spiritual campaign in which Arabic soldiers acted simultaneously as a military force and a holy army in a land of infidels. These multiple motivations had an important effect on the nature of these newly formed spaces and the Islamic practice that they would become associated with as well. The requirements of supporting and maintaining a large armed force meant that these encampments also became centers of business and trade. As such, Islam was able to further entrench itself as a systematized method of conducting commercial transactions that cut across ethnic, social, and familial lines.[22] In addition, the degree of commercialism that grew in these contexts quickly turned these military camps into bustling urban settlements. People from across the desert were drawn to them and merchants were again at the center, individuals whose well-rounded skill sets made them important cogs in the machinery of early North African Islamic societies. Indeed, because Koranic law was applied to all aspects of life, including both legal and ethical decisions, many Islamic merchants had dual careers as both traders *and* holy men. In fact, large caravans often employed such individuals for their comprehensive expertise and vast knowledge base in matters ranging from finance and legal issues to health and, of course, religion.[23]

Scholars also suggest that the activities of the North African tradesmen changed the conceptual nature of the Sahara from a physical barrier and an impoverished geographic void into a fluid space of interaction, mobility, and transfer, comparable to the "liquid continents" of the Atlantic, Pacific, and Indian oceans. While such statements effectively indicate the enormous impact that Islam had on North Africa, it should not be forgotten that financial and cultural connections existed within this vast region long before Islam made its dramatic entrance into North Africa. Indeed, the routes across North Africa used by the Umayyads and newly Islamicized merchants were established much earlier by trans-Saharan trade networks that created an intricate system of commercial circuitries across the northern half of the continent. It was these circuitries that provided the necessary conduits to facilitate Islam's transition westward and eventually southward as well.

Yet, Islamic social, cultural, and religious systems would also go on to find expressions in locally embedded forms, such as large communal complexes called *ksour* (sing. *ksar*) that were most notable along the Maghrebian trade routes of southern Morocco, Algeria, and Mauritania. These structures were built to support regional caravan networks and came in the form of large communities enclosed within thick high walls that were designed to both protect the inhabitants within

as well as facilitate the flow of goods across the region by providing spaces for interaction and negotiation. There were also smaller versions of the *ksar* form, namely the *kasbah*, which was a smaller compound that usually housed a single family in contrast to the communal composition of the *ksour*. *Ksour* complexes were often laden with various goods and supplies; therefore, they were natural targets for nomadic raiding parties and other opportunistic groups. Thus, *ksour* utilized a heavily fortified architectural framework to protect both the cargo and the members of the community from aggressive exterior forces.

The historical trading town (*ksar*) of Guelmim in the Wadnun region of southern Morocco is one such example, historically a major merging point for North and West African trade caravans that, according to archaeological accounts, was surrounded by a defensive wall pierced by five principle gates (see Figure 1.3). It is estimated that by the nineteenth century the town held over eight hundred houses and fortified palaces with at least three times this number of domestic spaces in outlying areas.[24] Such information about the organization of this settlement is important for two reasons. First, Guelmim's identity as a trading center was directly encoded into its built environment via the protective aspects of its architecture, aspects that subsequently enforced specific types of behavior directly relating to the security of the community from those both within and outside the complex. Second, the spaces in and around the complex and the placement of individuals within this organizational scheme provide us with evidence of the potential presence of social hierarchies that may have been enforced architecturally within the community. Traders and caravaners, who were the most transient and therefore least engaged members of the community, were typically located outside the protection of the compound wall (although they could reach it in the event of an emergency) and the more permanent residents of the community were placed within the complex. This division undoubtedly created categorizations between members, non-members, and perhaps even pseudo-members and enforced the physical separation of individuals. Such separations established protocols of social behavior and interface that were activated and mediated through physical layers of access. Even within the complex, there may have been class registers between community members that placed an emphasis of the location of one's residence within the complex, its size, and its decoration, so that in each case social position, behavior, and appropriate situations of interaction were encoded directly onto the built environment. It is likely that the fortified castles near the center of the complex belonged to community merchants who kept their goods locked away inside these walls. The less financially endowed probably lived in smaller, unfortified dwellings closer to the more vulnerable exterior walls of the complex. This undoubtedly enforced various social narratives at work in trading communities during the high periods in trans-Saharan mercantile activity.

As a whole, these massive complexes represent a narrative of social and defensive engineering through spatial and organizational manipulation, and undoubtedly created a visually arresting and intimidating impression for those approaching them from the harsh environment of the Western Sahara and mountain ranges. Seeming

to erupt directly from the ground, *ksour* provided structural inspiration for another early Afro-Islamic architectural type that developed in this region, the *ribat*. Although the early history of the term is much debated, the *ribat* has been described as a general Islamic architectural type and "a feature of the Muslim frontier"; it was essentially a fortress-like dwelling that housed Muslim militia and other "warriors of the faith."[25] *Ribats* often acted as the focal point for the growth of Islamicized urban areas, whose focus on commerce accommodated the needs of the *ribat*. In turn, they eventually became important anchors of economic power in the North African economy.[26]

Perhaps one of North Africa's most famous *ribats* is Monastir, in present-day northern Tunisia (see Figure 2.3). The story behind this *ribat* begins with the Umayyad general ʿUqba ibn Nafi, who was put in charge of the systematic conquest of the Maghreb and established numerous outposts along his campaign trail in the region. As was the case with many military establishments like Monastir, the area began with the Umayyad *ribat* "Al Munastîr" before developing into the *ribat*-anchored town of Monastir, which was established in the later Abbasid period by governor Herthouma Ben el-Aien on the site of the original Umayyad outpost.[27]

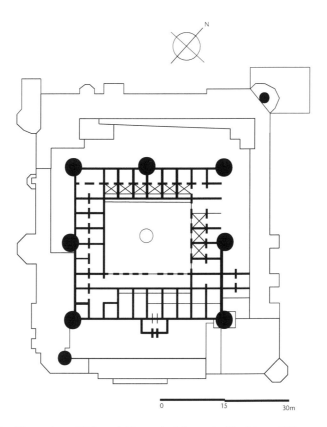

**FIGURE 2.3** Floor plan of Ribat el Monastir, Monastir, Tunisia, c. 796 CE.
Source: Adapted from Kiracofe.

The outpost at Monastir was originally the first line of defense against sea attacks by the Byzantines looking to sack the sacred city of Kairouan. As such, the *ribat* itself was a highly defensive structure, containing a twenty-meter watchtower that overlooked an inner courtyard surrounded on three sides by rooms and audience halls. It is thought that this structure provided the template for many later congregational mosques in Tunisia.[28]

Because the *ribat* was designed with its defensive functions as a priority, there are a number of similarities between the form of the *ribat* and the *ksar* of the Maghreb. The *ribat* was very effective at accommodating the social, cultural, and environmental needs of the soldiers, who were increasingly a mix of both Arab and local members. Like the *ksar*, the thick walls of the *ribat* contained only a few small openings, and these were useful for defending the structure against exterior attack, dealing with the severe climatic shifts of the desert, and providing a degree of privacy for its Muslim residents. In addition, the *ribat* plan exhibited at Monastir utilized a compact urban layout popular in the context of the *ksar*, whose cool alleyways and paths created a strong sense of civic identity due to people sharing walls within a densely populated space. Even though the North African *ribat* was a "new" form, it was only new in the sense that it repurposed and combined existing architectural languages and techniques towards creating a functional structure that was very much the best of both architectural worlds.

Outpost-turned-urban areas like Monastir also began to create a connection in North Africa between Islam and urban contexts. This gave Islam the identity of a "town" religion that had been brought by merchants to these areas, which subsequently developed into urban sprawls due to commercialism. Because of this, many people welcomed Islam, and the merchants who practiced it became harbingers of economic growth and prosperity. Within the areas where Islam had already taken root as an economic phenomenon, growing percentages of the population increasingly converted to Islam, and this led to another major architectural development in North Africa during this formative period: the North African congregational mosque.

Because of the large numbers of converts Islam was acquiring in these newly urbanized areas, congregational mosques were becoming something of a necessity. The eventual mosque forms that developed across the region underwent many of the same changes in organization, form, concept, and meaning that Islam itself had within this broad context. One of the earliest congregational mosques to be established in the region was the Great Mosque of Kairouan, located in the city of the same name for which the *ribat* in Monastir was built. Kairouan, appropriately, means "camp" or "caravan" in Persian and was established in 670 CE by the aforementioned Umayyad general 'Uqba ibn Nafi as the base for his operations in the Maghreb.[29] 'Uqba built this mosque to be the central point of the city, and it came to be considered a holy site as well as a pilgrimage destination for many North African Muslims. A popular legend claims that one of 'Uqba's soldiers came across a golden goblet buried in the sand that was recognized as one that had disappeared from Mecca many years earlier. When 'Uqba removed it from the

**48** The Road to Larabanga

sand, a spring appeared, whose water was said to have originated at the same source as that of the sacred Zamzam well in Mecca, which had been miraculously generated by the divine hand.[30]

The mosque is also important because it drew from an organization first established by the mosque at Damascus and subsequently set the structural precedent for other mosques that would develop in the Maghreb and eventually within West Africa as well. The mosque at Kairouan reflects a typical plan with an open courtyard and a columned or hypostyle prayer hall, but it also has a thick and intimidating exterior that denotes both a spiritual and a defensive function, an aspect I argue was pulled from *ksour* and later *ribat* forms (see Figure 2.4). Just as *ksour* structures had to deal with desert raiders and other aggressive forces outside their walls, 'Uqba's military was in continual conflict with a number of indigenous groups in the region such as the Amazigh peoples, who consistently pushed against Umayyad authority. Drawing from area architectural precedents, the Kairouan mosque's heavy, fortress-like walls and towers with thick pillars on the corners and along the sides provided familiar referents for area groups as a way to ease such tensions, while also ironically ensuring the protection of those within from these groups.

Thus, the multiple functions of this mosque required certain evolutions from the established genre to create an architectural apparatus capable of acting in other

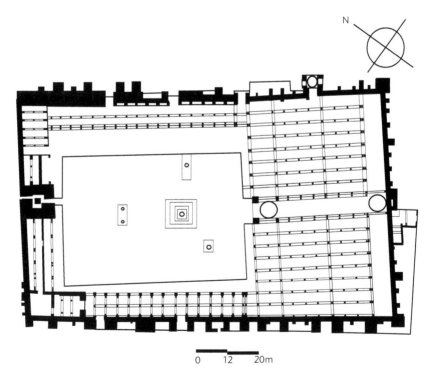

**FIGURE 2.4** Floor plan of the Great Mosque at Kairouan, Tunisia, c. 670 CE.
Source: Adapted from Fikry.

capacities. Pulling from the structural languages of the *ribat* and the indigenous *ksar*, the mosque was able to fulfill the multiple roles it was intended to play and become one of the most direct symbols of Islamic power and permanence in the region. In addition, this structure also provides an opportunity to revisit some of the problematic architectural histories and scholarly theories that surround it. The general narrative of this structure has it and others like it developing largely as a result of available architectural toolkits in the area rather than from deliberate decision-making processes on the part of the architects. In addition, their distinctive style and somewhat eclectic dimensions have also been explained as a result of the specific mode of knowledge transmission that led to their physical manifestation. Jonathan Bloom, for example, addresses Kairouan in his discussion of the transmission of mosque design in early Islamic architecture, noting that structures like the mosque at Kairouan, and eventually its offspring in Tunis, were developed from memory-based, rather than notative, sources. In other words, each represents the architects' attempts to "eyeball" the structure, as opposed to crafting it from written plans. Bloom's defense of this position lies in the irregular, almost trapezoidal floor plans that these mosques maintain, which contain "few, if any, exact parallels" with Middle Eastern mosques and none of the "accuracy" displayed in rigidly geometric structures like the Dome of the Rock.[31] Yet such accuracy, Bloom argues, was not needed, as neither of these structures was particularly complex, nor did they use standardized materials. In fact, he comments that "When the structure is simple and materials are scarce, one makes do with what one has, and each architectural elements is made to fit the others ... on site."[32]

However, such characterizations oversimplify the presence of a distinctive form of architectural logic at work at these sites, particularly relating to building location. When one looks at the floor plans of numerous *ksour* structures, particularly those of Ksar El Khorbat and, ironically, Ksar Ait Yahia O'Thmane in the region of Guelmim, one sees identical spatial configurations that create a distinctly trapezoidal appearance. Yet this type of organization and the architectural language that resulted from it were uniquely suited to building on uneven terrain. In fact, I will follow the analytical trajectory of Labelle Prussin's analysis of northern Nigerian Hausa domes and their incorporation of Fulani tent architecture (1976) to suggest that the irregular shape of these mosques and, indeed, the *ksour* themselves, owe something to the irregular rectilinear tent plans of North African nomadic groups, whose transitory structures were made to fit the landscape, maintaining a necessary flexibility in form and material that allowed them to accommodate as many environmental and terrain-oriented conditions as possible. The nomadic tent's numerous supportive buttresses, divided interior spaces, and recycling of materials from earlier buildings may have provided a perfect model for a prototypal Islamic architectural genre that was sensitive to its environment and that utilized a formal organization suited to its location. Yet at the same time, such structures were able to inscribe an Islamic presence on the landscape in a manner consistent with the cultural climate, so to speak, of the area.

## Muslim Architecture at the West African Crossroads

Eventually, Middle Eastern caliphal power in North Africa would give way to indigenous Islamic dynasties in the form of the Almoravids and the Almohads, who reigned in the Maghreb from the eleventh to the thirteenth centuries. It was during this period as well that iterations of Sufism, an esoteric mystical branch of Islam, emerged and went on to influence sub-Saharan regions in West Africa, again through the conduits of trade.[33] But even before these indigenous dynasties took hold, Islamic practice and influence had already begun making tracks into southern regions and manifesting architecturally in a number of ways.

A couple of centuries before the Almoravids, the first of three great West African empires, the Empire of Ghana, would come into power and develop active commercial activities with incoming Muslim merchants from the Maghreb. When North African Muslim traders arrived in West Africa, they did not find an empty, ill-developed cultural wasteland, but instead a vibrant indigenous empire that had developed a progressive and highly lucrative trade economy. The Empire of Ghana (not to be confused with the modern nation of Ghana, whose name was derived from this ancient civilization) was based in present-day southeastern Mauritania and western Mali. Although descriptions of the empire are somewhat scarce, early Arabic sources indicate that it was extremely wealthy and powerful due to an active trans-Saharan trade in gold and salt. As a result, a majority of its major urban centers, such as the capital city, Koumbi Saleh, were located on the shores of the Sahara and therefore convenient to trade activity coming across this great expanse.

However, the relationship between Ghana's established society and incoming Islamic influences in the form of these merchants was not as seamless as it had been in many parts of East and North Africa. Up until that point, the land south of the Sahara had been known in general Islamic discourse as *Bilad al-Sudan* or the "Land of the Blacks"; it was also largely considered to be *Dar al-harb*, or a region of infidels. Although the establishment of trade networks between this area and the north had opened up nascent dialogues between West Africa and the wider Afro-Islamic and Middle Eastern world, Islam's general acceptance into this empire was still questionable. Furthermore, the area was already heavily laden with deeply entrenched political, social, and spiritual systems that (at least initially) left little room for Islamic additions beyond those of the commercial variety. Such divisions can especially be seen in the organization of Ghana's capital city, Koumbi Saleh, and the particular components of its layout that suggest the entrenchment of various local social and political systems.

Koumbi Saleh was in fact one of the southernmost termini for caravan traders coming from North Africa, and Arabic explorer Al-Bakri wrote in 1067 that the city was actually composed of two settlements about six miles apart.[34] The more prominent settlement was known as Al-Ghaba, and it was here that the Ghanaian king's residence, a purportedly grand structure surrounded by domed buildings, was located near both a sacred grove of trees used for Soninke religious rites and

a housing complex for the priests who performed those rites. There was also a single mosque in Al-Ghaba, thought to have been used by visiting Muslim officials. The royal and spiritual significance of this settlement was also emphasized through the presence of a significant stone wall surrounding the complex that protected it from exterior threats, and also paradoxically erected a barrier between Al-Ghaba and its twin settlement. Reasons for this separation become more apparent upon investigating the second half of this capital city, the aforementioned "twin settlement."[35] Although this section has no recorded name, it had no fewer than twelve mosques, and was most likely inhabited by Arab and Amazigh Muslims. Composed of scholars, scribes, and Islamic jurists, a majority of whom were also probably merchants, this area of Koumbi Saleh was undoubtedly the capital's primary business district.[36] Yet the separation of these communities both through physical distance and, perhaps more symbolically, the creation of a wall around the administrative spiritual center implies a polite yet distant relationship between Ghanaian royalty and their Muslim community. Indeed, the phenomenon of the Muslim "twin city" later became a common urban practice in commercially significant areas of West Africa where Muslim traders settled and created domestic bases of operation. Sometimes, these "cities" took form in the development of a Muslim quarter or sector within an already established community. Others involved the creation of a separate community that coexisted alongside an urban area, like a type of infrastructural appendage. Over time, the development of these cities created a casual acceptance of Islamic presence and a recognition of Islamic contributions to West African communal contexts, particularly in the urban areas where Afro-Islamic cultural interactions and commercial exchanges were most likely to take place. Thus, Islam in West Africa was being reimagined again. This time it used architecture as a vehicle to deliver an identity used to surviving and thriving within African urban contexts. The subsequent success of this Islamic project became apparent in the hybrid social, cultural, and spiritual systems that eventually developed within these areas. While there were variations from one context to the other, early West African societies actively engaged themselves in processes of negotiation with incoming Muslim influences, a productive "working through" of the Muslim/non-Muslim dynamic that resulted in the creation of various successful, unsuccessful, and work-in-progress conditions of coexistence, adaptation, and fusion.

Eventually, the great Empire of Ghana fell in the thirteenth century, and was followed by two additional Sahelian kingdoms whose power and wealth penetrated the ideological divide between West Africa and the rest of the Islamic world. The vibrancy of the Malian Empire and its direct successor the Songhai were recorded by various medieval Arabic explorers and geographers, including the illustrious Ibn Battuta (1304–1368) who began journeying into this sub-Saharan "frontier" as early as the eleventh century. He described the existence of cosmopolitan West African mercantile communities, such as Timbuktu, Djenné, and Gao, whose geographic position at the convergence of caravans moving north and south made them financially successful and rich in social, cultural, and spiritual diversity.[37]

It was also during this period that some of the Malian Empire's heroic origin narratives were recorded, along with the various peoples, groups, and places that populated this great empire. One such group was the Kamara cultural group, forerunners of those currently living in Larabanga, who would play a significant role in the creation of the Malian Empire. As one of the earliest cultural groups in western Sudan, the Kamara, or Kamara Diomande as they are also called, arrived in Mali during the eleventh century from the north, settling in the Malian "heartland" between Bamako and Timbuktu, and establishing the major towns of Tibi, Tabou, and Kangaba. Faran Kamara, the son of the king of Tabou, was a great friend of Sundiata Keita (1217–1255), the founder of the Malian Empire, and sent numerous Kamara warriors to Sundiata's aid during his struggle to establish his kingdom. Once this was accomplished, Sundiata divided the empire up among his three comrades, Faran Kamara, Tiramaghan Traore, and Kakoli Kourouma, and declared a perpetual allegiance with the Kamara.[38] Under Sundiata, these groups eventually coalesced into the more broad-based Mandinka ethnic group. Over time, the Kamara Mandinkas began radiating southeast into the southern Malian provinces, and eventually established a type of capital city/religious center for their twelve lineages, "twelve" being a number of great spiritual power around which the Kamara would construct their communal "heartland".[39] These twelve lineages would eventually form the major clans or "houses" in subsequent communities like Larabanga, which will be addressed in Chapter 3.

Regarding the introduction of Islam, however, recorded histories indicate that the first documented ruler to convert to Islam in the mid-thirteen century was Koi Konboro, the Malian Empire's twenty-sixth king who was said to have turned his palace into one of the region's first mosques. A century later, King or *Mansa* Kanku Musa would make a famous pilgrimage to Mecca, spending so much gold along the way that he single-handedly affected the Middle Eastern economy and in doing so exposed the wealth of his West African empire to the rest of the Muslim world.[40] Although accounts claim that many of these rulers converted to Islam, it is important to recognize that "conversion" in these contexts probably meant adopting more of a central position between Islam and local practices and beliefs. It is in fact highly improbable that these West African rulers became orthodox Muslims; most likely, they walked the line between spiritual paradigms in order to rule the culturally and spiritually diverse populations they administered more effectively. This also enabled them to take advantage of the spiritual protections afforded by more than one faith.

Another major conduit for Islam's project of embedding itself within local culture was through material production. Like the decorative traditions of the wider Islamic world, regional West African visual traditions applied abstract, stylized, geometric ornamentation to functional objects and structures of everyday life. It was a mode of enhancing the object's aesthetic and purpose while encoding it with registers of cultural knowledge and identity.[41] These design programs were applied to a number of different surfaces, including doors and door locks, garments, weapons, containers, masks, bodies, and all manner of structure within the built environment. With the

arrival of Islam, the incorporation of Muslim iconographies into these local symbolic repertoires was one of the first signs of the transformative conversation that was occurring between Islam and local cultural practice. Its collaborative character actually made conservative visitors like Ibn Battuta uneasy due to these "strange mutation(s) of Islamic and non-Muslim" characteristics.[42] But it was also through such hybrid programs that the middle position—walked, as I've established, by both royalty and the general population—could be most clearly represented.

Perhaps the most obvious material manifestation of these various conversations appeared in the development of the architectural environment in this region, which functioned prominently as an organizer and as a symbol of the area's increasingly cosmopolitan identity. Indeed, architecture became a highly effective apparatus in mediating incoming influences, pressures, and identities through their adaptation and inscription within the built environment. Notable structural examples came in the forms of mosques, tombs, and shrines located in the major port cities of the region: Gao, Timbuktu, and Djenné. Each of these cities became key points of Islamic penetration in the region thanks to their location along the Niger River.

With regards to the city of Gao, little is known about its early political system, ethno-cultural population, or spatial organization; yet written sources refer to it as a major trading center, handling commodities such as paper, spices, salt, and textiles, and containing a mixed population of Amazigh, North African Muslims, and Sudanese or "black" Africans. Luxury items like ivory were also exported from Gao, primarily in the form of hippopotamus tusks, which were often preferred to elephant tusks because they were whiter and had greater density.[43]

But one aspect of Gao that goes without saying is that its cultural identity was very much an amalgamation of Islamic and local beliefs, practices, and ideologies that would find expression in architectural form. Early reports indicate that the city's Islamic philosophies were hybrid and quickly became endemic to the region. North African visitors like al-Muhallabi (c. 975–985) remarked that "their King pretends before them to be a Muslim and most of them pretend to be Muslims too."[44] Al-Bakri (c. 1014–1094) also noted that many of Gao's professed Muslims continued to venerate traditional objects, "as do the other Sudan."[45] In many ways, early Gao seemed to have resonated strongly with Koumbi Saleh, whose leadership also gave Islam a fair amount of lip service with no true evidence of wholesale conversion. Like Koumbi Saleh, Gao was also a twin settlement, one part indigenous and the other part Muslim. Known now as Gao *Ancien* (indigenous) and Gao-*Saney* (Muslim), these settlements were initially divided along religious lines, although the divisions quickly evolved into separation by class.

Within Gao-Saney, the settlement was composed of residential and commercial areas dotted with cemeteries, tombs, and other religious structures. Oftentimes, the domestic architectural styles of the Muslim community differed from non-Muslim populations, with Muslims favoring the use of square, sun-dried bricks, which typically resulted in rectilinear structures composed of earth and timber. Such structures were also uniquely suited to maximizing living space in congested urban

areas. In contrast, indigenous non-Muslims favored roundhouse building techniques that involved piling liquid mud into circular layers towards building up a cylindrical wall that was then topped with a conical thatched roof. This building style was useful in the creation of individual living units within the space of a circular domestic compound. Interestingly, such differentiations are found in multiple Islamicized areas around West Africa not just limited to Gao, and the regularity of this occurrence allows us to say with confidence that house form among Muslims and non-Muslims is correlated with cultural identity.[46]

The presence of such forms, coming together as they did within Gao's urban environment, was able to make manifest important statements about the city's diverse cultural fabric while at the same time provide a platform for the establishment of a new regional architectural language that gestured towards the identity of the empire in place. For one, the influences imported into this area, which contributed to the development of this style, were varied; possible sources include influences from Egypt and its traditional pyramidal forms as well as the contributions of a historical figure named Abu Ishaq el-Sahili, who may have introduced both the kiln-fired square brick and the building technique used in conjunction with it. While it is largely agreed that the components of Gao's style are a fusion of imported and local elements, perhaps the most direct contributors to this genre were architectural traditions coming out of the Maghreb, an unsurprising deduction given the history of interaction between these two areas. Not only had trade networks been firmly established between North and West Africa by the medieval period, but Moroccan forces would eventually invade the Sahel in 1591 and settle in Gao, Timbuktu, and Djenné, bringing with them a contingent of architects and craftsmen versed in the defense-oriented architectural styles of the North African region.

One such structure, built during the Songhai Empire in Gao and incorporating some of the aforementioned Moroccan militaristic elements, was the tomb of Emperor Askia Muhammad (1443–1538), which dates from 1495 and was made possible by the regional architectural legacies crafted first by the Malians and later inherited by the Songhai (see Figure 2.5). By way of introduction, the Songhai as an ethno-cultural group had long been an Islamicized constituency in the previous Malian Empire and as such were perfectly positioned to continue the region's Afro-Islamic cultural, material, and architectural legacy. In fact, this is why it is so difficult to pair structures and styles within the context of one or the other of these specific empires. Not only was the Songhai's inherited empire large and spread across a vast territory, but it was filled with specialized craftsmen and masons trained with the skill set to build upon the monumental architectural styles that the Malian Empire had been developing over the past few centuries. Furthermore, the region was the hub of a vast trading network driven by Muslim merchants traveling north and south. The Songhai thus became the heirs of an economically, culturally, and spiritually developed empire whose building culture was already firmly situated within a regional style.

Songhai Emperor Askia Muhammad assumed power in 1493 as a fully Islamicized ruler at the height of Islam's influence and presence in western Sudan. Yet even

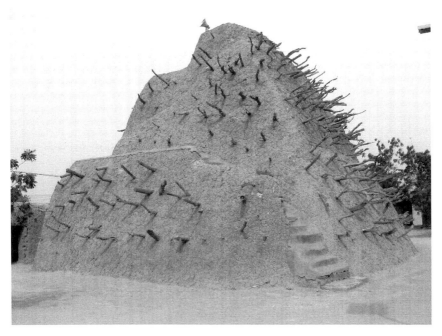

**FIGURE 2.5** Tomb of Askia the Great, Gao, Mali, built c. 1495.
Source: Photo courtesy of David C. Conrad, 2006.

within this vibrant period, his reign was still considered to be a particularly illustrious part of a golden age for Islam in the Niger Bend, a period of prosperity that was represented in the architectural developments that occurred during this era. Monumental architectural forms such as Askia's mausoleum, for example, have been compared to the early ziggurats of Mesopotamian history in form, function, and symbolism. Created by a series of diminishing stepped landings and requiring a vast amount of material, labor, and funding, ziggurats became the culminating symbol of not only imperial power and authority, but also religious doctrine as a link between earthly and heavenly realms.[47] Askia's mausoleum was equally striking, built using earthen bricks and a mud mortar that created a hollow sculpted form that was then covered with an earthen clay plaster whose composition included organic materials such as manure and straw, which acted as waterproofing agents. Bundles of timber were then inserted into the walls to provide both scaffolding for masons to replaster as well as aerators to wick moisture from the interior of the structure and preserve structural integrity. Most structures of this type also have heavily molded, almost sculptural façades, and collectively these forms compose an architectural style previously known as the Sudanese style, which originated between the thirteenth and fifteenth centuries in this region. While scholarship has problematized the "Sudanese" designation by highlighting its rootedness in French imperial terminology (the region was previously part of the colonial French Soudan), the aforementioned components act as fundamental signifiers of this style.

Askia's tomb also incorporated locally embedded references to the ancestors via the inclusion of the earthen pillar, which has long served as a physical representation of ancestral presence. Indeed, the mausoleum structure itself appears as an enlarged, geometricized ancestral pillar whose pyramidal shape gestures towards possible Egyptian connections and thus the broader practice of retranslating local forms through an Islamicized lens.[48]

Other instances of fusion between Islam and local belief systems occurred in the reconceptualization of local ephemeral spaces as well. The Songhai *musalla*, for example, was originally an informal sacred area for the veneration of Songhai ancestors. With the introduction of Islam, however, the idea of the *musalla* was quickly paired with the architectural form of the mosque/tomb complex as a kindred ritual space where one could pay homage to venerated figures whose presence was indicated by an actual structural body.

Yet these structural and conceptual conversations between Islamic and indigenous influences were occurring in other nearby areas as well, particularly Timbuktu and Djenné. Within Timbuktu, for example, comparable mosque/tomb complexes similar to Askia's tomb were also being developed; they assimilated pre-Islamic iconographic components like the earthen pillar, and repurposed it in a variety of ways. Within Timbuktu's Sankoré mosque, for example, towering earthen cylinders are embedded in the corners and on the tops of the walls, while the minaret itself, with its pyramidal form and firm geometric execution, again represents an Islamic modification on the local earthen pillar (see Figure 2.6). With regards to Timbuktu specifically, however, many of its architectural developments were also representative of the fact that the city was becoming a major center of Islamic learning and scholarship. It drew scholars from as far away as the Middle East to collaborate at the city's increasingly well-known educational institutions. Timbuktu's *madrasas* or Islamic schools were buttressed by the creation of public and private libraries, which fed into Timbuktu's established university system and its three primary institutions: the Sankoré, the Djinguere Ber, and the Sidi Yahya schools. Each was composed of a school, a congregational mosque, and a series of mausolea embedded both within the structure and even along their sides.

Each of the mosques associated with these schools was organized according to what at that point had become the conventional layout established by Damascus, which was composed of a standard central courtyard surrounded by aisles with a prayer hall located on one end. But, as architectural historian Labelle Prussin observed in her seminal work on the area *Hatumere* (1986) to which much of this narrative is indebted, indigenous anthropomorphic characteristics were also superimposed on these structures towards creating additional supplementary meanings. Taking the Sankoré mosque complex as an example, the structure incorporates ancestral pillar forms in the wall crenellations as well as in the minaret structure, as previously noted. Indeed, the space itself is said to be representative of the abstracted praying figure, the head represented by the minaret, the stomach by the courtyard or *sahn*, and the appendages by the galleries and the aisles along the

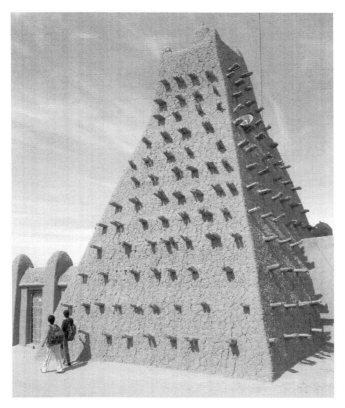

**FIGURE 2.6** Sankoré mosque, Timbuktu, Mali, built in the early fifteenth century.
Source: Photo courtesy of David C. Conrad, 2008.

sides, while the rows, aisles, and space *within* the structure represent a specific position in prayer or *salāt* as well.[49] Such conceptualizations reflect Songhai belief systems that held that architectural forms, individuals, and the cosmos were all part of an intertwined spiritual system and therefore one's physical reality should incorporate and privilege this infrastructure. Elements such as the anthropomorphization of architectural form, the organization of space according to a human anatomical template, and the incorporation of protective materials and amulets into the built form as a 'vulnerable' body were common practices.[50]

The material of these structures also plays a role in this anthropomorphization of space, as earth in many Niger Bend areas is considered the abode of the ancestors. Physical shelters built from this material thus by association become commemorative projects as well as ways of making the ancestors "flesh" once again.

The partnership of these conceptualizations in constructs like the Sankoré mosque complex thus provided a collaborative blueprint on which to continue to mold and read the built environment as a way of maximizing the spiritual potency of architectural forms and, in particular, embedding new conceptualizations of accessibility and spiritual interconnectedness into the region's most celebrated

structures. But an important component of this framework is the idea that through such meanings and associations, a very specific idea of "mosque" was created that was based within the specific context and time period of Timbuktu during the fifteenth century. Additionally, the layers of form, interpretation, and meaning that made up the complex conceptual surfaces of the Sankoré mosque and others like it within Timbuktu made each structure spiritually charged in a highly universal sense, able to respond and engage with various people on a number of different culturally and spiritually dictated levels. Thus, the complex accretion of form and meaning within structures like the Sankoré mosque represent the diverse cultural and spiritual landscape that developed during this period, whose social, cultural, and spiritual repertoires manifested within the "anatomical" features of the city's built environment and together created a living architectural entity uniquely attuned to its inhabitants.

Yet public structures like the Sankoré mosque complex were not the only projects in the built environment to receive this type of symbolic attention. Domestic structures also attained these types of significations, and were carefully geared to the particulars of their social location. Studies suggest that Timbuktu, like Gao and Koumbi Saleh, was also a dual settlement and the city's mosques acted as geographic markers of these divisions. The Djinguere Ber mosque was located in the "black settlement" of Timbuktu, which was composed predominantly of sub-Saharan Africans, while Sankoré's section was the North African or "white" section. The Sidi Yahya mosque acted as something of a halfway point between the two, and as such became a mediator between the two main sections of the Timbuktu population.[51] In addition, there were certain class divisions within these geographic divisions. The Sane-gungu quarter, for example, was once the site of the Songhai royal palace and a number of Moroccan-style *kasbahs* that were owned by Moroccan merchants living in Timbuktu who constituted the wealthiest of the city's inhabitants. Representative of these economic conditions are the various accouterments that were incorporated into building structures, such as Moroccan latticed windows and a heavily molded sculptural façade. However, local traditions and sensibilities still constituted an important part of the anatomy of these structures, often expressed through the building techniques and symbolisms deployed within the form itself. Like the mosque complexes, domestic structures also incorporated a number of anthropomorphic elements, notably on the front of the structure where the door and the parapet were interpreted as the "face" and the "turban" of the home, automatically gendering it male as a reflection of typical ownership.[52]

Cosmology also played a role in the construction and organization of the Timbuktu house, which was guided by principles of astrology, numerology, and other specialized spiritual practices that were often accompanied by various rituals performed during the construction of a home. Masons in Timbuktu began by outlining the plan of the house on the ground and orienting its walls in the cardinal directions, before burying a stone at each corner, under the main entrance pillar, and on both sides of the main door. The mason typically placed under each stone a protective object or amulet, usually commissioned from an Islamic holy figure.

Along these lines, a local myth in Timbuktu relates that at one time a chief of Djinguere Ber, a quarter in Timbuktu, buried a living Tuareg and his horse under the foundation of his structure as a way of "tie(ing) up the power of the nomads."[53] Here we see an emphasis on empowering physically and spiritually vulnerable areas with protective elements in which local spiritual practices and Islamic religious materials are combined.

Subsequent to outlining the home and endowing it with the necessary spiritual protection, the walls of the Timbuktu house were then raised in a specific sequence, dividing the space into nine rectilinear areas that included chambers surrounding a central open-air courtyard. Like the mosque form, each chamber had a counterpart with the human form, its layout corresponding in position to anatomical organizations of the human figure and in the process becoming a collective emblem for the body. Yet embedded within this anthropomorphic system is also the presence of specific rectilinear measurements and organizations of space called *hatumeres*, whose mystical qualities convey blessing or *baraka* on to an area. These patterns and designs are also found on objects and even textiles all over North and West Africa. It remains a pervasive component precisely because its organizational principles provide a decorative template suited to many different surfaces; it is a method of incorporating power and protection into the very reality of a demarcated space.

That being said, there are a group of stakeholders in this architectural process who have yet to be recognized: the masons. The masons responsible for constructing these forms are empowered through their ability to mold and shape spiritual materials such as earth into walls that stand of their own accord. The masonry guild of Timbuktu even has an origin story that begins with eight original masons working under the leadership of a pair of brother masons named Masa Ambeli and Mallum Idrissi, who arrived in Timbuktu from an unknown northern region in the Sahel. While Masa Ambeli decided to remain in the area with four of the masons, Mallum Idrissi went on to Djenné with the rest. This established an important architectural connection between Timbuktu and Djenné. It is also said that a descendant of this original group, an architect named Sidi Mahmoud, is responsible for creating the specific architectural style that grew in Timbuktu, and his son, al-Aqib, went on to build Timbuktu's three most famous mosque structures: the Sankoré, the Djinguere Ber, and the Sidi Yahya mosques.[54]

Yet moving on, Djenné, the third and final of our cities, was most directly responsible for establishing the cultural and architectural identity that eventually moved south into the forest regions of West Africa. Djenné, like Timbuktu and Gao, developed into a large commercial and cultural center during the Malian and Songhai empires, and developed a distinctive architectural style. Yet this style was an evolution of those that developed in Timbuktu and Gao largely because of the city's role as the primary point of convergence between northern and southern trade routes, and a space for the subsequent collision of influences arriving into Djenné from each area. Similar in form to the constructs of Timbuktu and Gao, the massive, earth-based forms that arose in Djenné became known as the Dyula

style, after local Islamic traders of the same name, and this style was notable for its particular incorporation of locally based sculptural sensibilities.

The original city, known as Jenne-Jeno, was first established around 250 BCE as a rudimentary market village.[55] Much like Timbuktu and Gao, Djenné's commercial and economic growth over time was largely due to its pivotal location as a terminus for trans-Saharan trade routes, an identity that later catalyzed the move to its present location around the fourteenth century. Some speculate that the move was also motivated by the presence of "non-Muslim practices" in the old town, practices that Djenné's newly converted Islamic population found extremely offensive.[56] Either way, between the thirteenth to the sixteenth centuries, Djenné became a hub of commercial activity and a minor center for Islamic learning based on North African Almoravid Maliki scholarship, a branch of Islamic thought that eventually worked its way into the West African forest regions.[57]

However, Djenné was different from Timbuktu and Gao. It maintained close ties with mercantile bodies not only in the north, but also in present-day Senegal, Burkina Faso, Ghana, Nigeria, and the other communities along the Atlantic coast. In fact, some of the most important trade routes that Djenné supported tapped into the gold and kola nut resources of the Gold Coast in present-day Ghana. Therefore, the history of Djenné is characterized by divergent influences that included imported Maghrebian traditions, local styles and practices, as well as imported resources from the southern forest regions. This is perhaps one reason why the Dyula style of Djenné, in contrast to that of Timbuktu or Gao, successfully migrated south and found new expression in the various cultures it encountered there.

To fully understand the success story behind this architecture style, it is important to understand its origins as a marker of regional religio-cultural identity. The Dyula style, like the styles of Timbuktu and Gao, was and continues to be characterized by monumental earthen forms composed of mud brick covered with an earthen clay plaster. Protruding timbers like those seen in both the Sankoré mosque and the tomb of Askia Muhammad are present, implanted along the sides of Dyula structures for the similar purposes of providing footholds for masonry work and drawing moisture from the interior. The Dyula style also continues to deploy the heavily molded, almost sculptural, façade organization, although a key difference between the Dyula style and those of its siblings in Timbuktu and Gao is that the Dyula also incorporated an unprecedented vertical element emphasized by a series of towering pillars and pinnacles along the walls and corners of structures. Thus the style is in some ways just as connected to North African *ksar* traditions, as it is to those of its regional neighbors.

This verticality, in conjunction with other sculptural elements of the Dyula style, has been made possible by the specific composition of the earthen materials available exclusively to Djennenke masons. Djenné is located on a floodplain that becomes inundated twice a year, making the town of Djenné itself an island for a period of time. When the water recedes, it leaves behind a wealth of mineral deposits, including lime and calcium from fish bones. Djenné masons mix these components with cow dung, straw, and chaff in order to create the specialized plaster that makes the molded façades of Djenné's buildings possible. These façades,

called *potige*, are notable for their dynamic surface characteristics, which include contrasting vertical and horizontal elements and protruding and receding surfaces (see Figure 2.7).[58] Composing these *potige* are standardized structural components that are specifically intended to declare or introduce both the residence and the identity of the individual who dwells within. The entrance to a domicile is typically composed of two large earthen columns that buttress a large earth-covered lintel, creating a composite structure called a *goum hu* or "mouth arch." On the register above this mouth arch, two "female" pillars or *sara fa wey* mark the dimensions of the main meeting area/bedroom (*hu gandi*) of the houseowner, which is often additionally demarcated by a Moroccan latticed screen or window covering (*soro funey*); the screen also visually emphasizes the importance and centrality of this space. This special room is additionally located between two female pilasters, possibly referencing legs, thereby making the room itself a womb-like space fittingly controlled and occupied by the male head of the household. Such accoutrements additionally reference North African influences that arrived when the Moroccans invaded the area in the sixteenth century and began building so-called "Moroccan"-style houses. However, the third register is locally resonant and consists of protruding timbers that mirror the number of engaged pilasters that are located above, eventually leading to jutting pinnacles along the roofline. Corner pillars are also installed on each end of the house to frame the façade, with the

**FIGURE 2.7** *Potige* (façade) of a Moroccan house, Djenné, Mali, date unknown.
Source: Photo courtesy of Barbara E. Frank, 2011.

overall composition of this frontal program reflecting both the skill of the mason and the affluence of the patron.[59]

This intensive sculptural focus is important because it sets the tone for one's experience of the interior space. Introductory architectural statements like the *potige* are necessary to make one aware of the significance of the transition from exterior to interior. Before one passes into the actual interior space of the house, one arrives in a waiting room, a liminal zone between the exterior and interior environment where greetings take place, relationships are established, and visitors are vetted before being filtered into the next space. This next area for visitors usually lies above the entrance hall in the meeting room, the aforementioned male-dominated chamber where business and politics can be discussed at a remove from the more potent familial spaces located further within.

Additional protective elements mediating access to the interior spaces of the home are less obvious but equally important. These take form in the numerous exterior structural references to the ancestors seen in the pinnacles, side pillars, and engaged pilasters of the *potige*. The anthropomorphic characterizations of the *potige* and the gendered nature of its elements all point to multiple registers of symbolic knowledge intended to maximize the efficacy of this structure as shelter, statement, sanctuary, and cultural marker. All of these elements find representation in both domestic and public spaces, one of the more notable structures being Djenné's Great Mosque (see Figure 1.5), which is located in the town's main market square.[60] Like other mosque forms in the region, the congregational mosque in Djenné follows the established hypostyle plan of the Prophet's home (pbuh) in Medina with a central square courtyard, slightly off center like that of Kairouan in Tunisia, with a congregational prayer space at one end. But the mosque also incorporates numerous sculpted *potige* that multiply the visual power of the singular façade by using it on each face of the structure. The mosque takes the traditional *potige*'s anthropomorphic elements even further by referencing regional masking forms in the voids and protrusions of the mosque's north façade (see Figure 3.17).

The function and presence of the *potige* in the Djenné mosque goes a long way towards reconsidering the perceived disconnect between West African and North African/Middle Eastern ideals of architectural surface treatment. The Dyula style, along with its stylistic kin in Gao and Timbuktu, represents a reimagining of these architectural patinas in a way more in tune with the cultural aesthetics and sensibilities of its context. The protruding timbers covering the structure's surface provide continuous visual stimulus from every perceivable angle. Furthermore, the endless geometric undulation of the walls creates a fluid, interrupting structure that appears almost mobile in its sculptural expression, dissolving the solid form underneath in much the same way as the decorative patinas of Middle Eastern-style mosques. In both cases, the surface form and organization transform the structure from a physical container to a divine symbol, encrusted with the iconographic residue of both Islamic and local legacies, thus enabling the structure to act as a spiritual and cultural center of the community. Djenné's earthen material aids in this symbolic process by buttressing visual references to the ancestors through the use of the material of their

abodes, and by following a tradition of using earth to create "sanctuaries" such as shrines, granaries, and similar constructs as a form of communion.

As such, the Djenné mosque and the city's domestic structures are unique in their formal and symbolic capacities, their sculpted façades, monumental verticality, and profusion of earthen pillars, which represent motivated responses to the specific cultural, spiritual, and economic conditions of its environment. However, the Moroccan invasion and subsequent occupation of Djenné and its sister cities in the late sixteenth century would have a significant impact on the region's cultural identity and architectural character. Many regionally based Islamic scholars were subsequently exiled to Morocco, which effectively ended the region's spiritual and educational reign. Furthermore, many of the cities were looted and Moroccan administrations installed.[61] This incursion brought an end to the series of Sahelian empires that had ruled the region for over five hundred years. Yet the cultures that had developed in the region of the Niger Bend found renewed expression further south in the forest regions of West Africa, where Islam once again reinvented itself to endure as a cultural and spiritual discourse.

## Architecture, Islam, and the Gold Coast

The Dyula merchants, for whom Djenné's architectural style was named, were largely responsible for carrying the Afro-Islamic philosophies of the Sahel and its associated architectural sensibilities into the forest regions of the Upper Volta and the Gold Coast, where these ideals were transformed and renovated according to their new contexts. As merchants, the Dyula brought with them numerous objects of Islamic assimilation, including prayer mats, manuscripts, and copies of the Koran, which acted as material buttresses for Islamic practice and constructive tools for the development of a regional Islamic identity.

To further contextualize this group, the Dyula, also known as the Wangara in the context of the Upper Volta, appear in many early accounts of sub-Saharan Africa, with Ibn Battuta noting their presence in a town to the south of Timbuktu assumed to be Djenné, where he described them as "Wanjarata ... with whom live a company of white men who are Kharijites of the Ibadi sect."[62] Additional names applied to the Wangara include the Dafing in present-day southern Mali and northern Burkina Faso, and the Yarse by the Mole Dagbani linguistic groups located in northern Ghana.[63] Interestingly, it is with the Wangara that the story of the Kamara in West Africa comes into focus. Early Kamaras living in the southern cities of the Sahel came into increased contact with these Muslim merchants, who were primarily responsible for facilitating trade on the borders of the forest region.[64] Eventually, both the Kamara and the Dyula/Wangara began taking point on the trade routes going south into the forest region along the coast, with the Kamaras often acting in a spiritual capacity as *mallams* or spiritual consultants who not only kept records of transactions but also conducted the necessary spiritual ceremonies to ensure a safe and successful journey. It was also these *mallams* that left "traces" of Islam along the caravan routes to germinate

in various communities towards the creation of numerous iterations of localized Islam.[65] The first major Kamara migratory movement south has been dated as early as the sixteenth century and the second potentially at the beginning of the seventeenth century,[66] which are accounts that are corroborated by political upheavals in the Sahelian region in the fifteenth and sixteenth centuries and the arrival of Europeans on the coast around that time as well. Both factors may have pushed the Kamara Mandinka towards regions that are now northern Ghana and Côte D'Ivoire in order to access new commercial trading markets, bring new goods into the interior, and escape the political tensions occurring in both the north and the south.[67]

Thus, both the Wangara and the Kamara had their roots in the Sahel as part of the primary ethno-cultural group of that area, the Mande. Interestingly, by the time of Islamic "penetration" to the south, Mande groups had been moving in and out of the Volta basin for centuries via pre-Islamic commercial networks; the Wangara and Kamara would eventually forge new routes into the area around the fourteenth century.[68] Thus, when they arrived in what is now northern Ghana and southern Burkina Faso, various Mande elements were already present and familiar to the cultures in the region, enabling these new groups to assimilate more easily into the physical and cultural landscape. These southern trade routes became decidedly more prominent in the fifteenth century when the Gold Coast became the main supplier of gold to North Africa and from there, the rest of the Islamic world.[69] Stretching from Djenné and Timbuktu in the Niger Bend to Kano and other areas in what is today contemporary northern Nigeria, these routes connected the interior of the Gold Coast to the rest of the trans-Saharan trade network, as both primary arteries of travel for commercial goods and natural resources, and also highways of political, social, and cultural exchange (see Figure 2.8).[70] As previously stated, these trade routes were largely responsible for bringing Islam into present-day northern Ghana, where it recreated itself yet again using familiar tools of interaction and exchange.[71]

As in the Sahel, Islamic merchants arriving in the Gold Coast began by establishing twin settlements in various new contexts as a way of activating reinventions of Islamic culture through the lens of more locally recognizable forms.[72] Incoming Islamic influences were saturated by a rich variety of pre-Islamic practices and material traditions that created unprecedented Islamic forms and identities that were specifically Voltaic in nature. Yet, for perhaps the first time, these reimaginings did not result in Islamic philosophy gaining a socio-political foothold in the area in ways that it had in the Sahelian region. It is possible that the political authority wielded at the time by the Asante Empire of central Ghana may have played a role in this. By the time these traders arrived and began to assimilate in earnest into the landscape of northern Ghana and the Upper Volta, the Asante were launching military campaigns into the Upper Volta in order to create a tributary state in the region as a steady source of enslaved people. The sheer military might of the Asante was more than enough to counter the largely passive project of Islamic development in the north, although Islamic influence experienced controlled growth within the capital of the Asante Empire itself. This

**FIGURE 2.8** Trade routes into the Gold Coast, sixteenth–eighteenth centuries.

was largely the result of the desires of the Asante king, or the *Asantehene*, for the valuable materials and spiritual skills of the Islamic traders, who were both merchants and spiritual healers well versed in Islamic mystical traditions. At the height of the Asante Empire's power, a small but vibrant community of Muslims was happily entrenched and thriving in the capital city of Kumasi. This community was composed of a surprisingly diverse mix of Muslims not only from other regional centers but also from as far away as Egypt and the Middle East.[73] Importantly, the spiritual rituals and practices utilized by these Muslims revealed an intimate knowledge of the Koran and associated mystical aspects of the Islamic faith, which complemented the pre-existing Asante focus on the management of natural and ancestral forces.[74] Nineteenth-century accounts of European visitors to the Asante capital of Kumasi often noted the "pervasive

'Moorish' influence" of the city. They further commented that Islam seemed to have taken root far into the depths of Asante civilization, beyond that of just visual and material production.[75] Islamic practice was made "official" with the enstoolment of Asantehene Osei Kwame (1777–1803), who formally incorporated Muslims into the royal retinue (*gyaasewa*) to serve as counterparts to the king's physicians (*nsumankwaafo*).[76] This was done in order to make use of the specific systems of Islamic spiritual knowledge in conjunction with more standardized Asante methods to create protective objects and textiles in the form of official regalia that was meant to guard the king's physical person through spiritual means while also symbolizing royal power. As such, his attire subsequently combined elements of artistry and beauty with an almost obsessive concern for magico-religious empowerment. Many of the hybrid amulets adorning his royal regalia contained Koranic passages enclosed in luxuriously modeled gold and silver casings, while the pendants and decorative pieces he wore were often cast in spiritually significant forms. Asantehene Kofi Kakari (1867–1874) once even referred to his sandals, which had been inscribed with Arabic script, as his personal "talismans."[77] In addition, Asante war tunics or *batakari* were also traditionally adorned with charms and amulets composed of powerful organic materials including skin, feathers, bones, horn, and others (see Figure 2.9). With the arrival of Islam, Muslim bodies of knowledge in the form of Koranic passages were incorporated in the creation of new power objects that combined efficacious natural materials with Koranic verses, enclosed within treated leather pouches that functioned as objects of healing, protection, and knowledge.[78] Koranic verse also went on to decorate or inscribe a number of culturally significant architectural structures to create "protective coat(s)" composed of Islamic "magic squares"

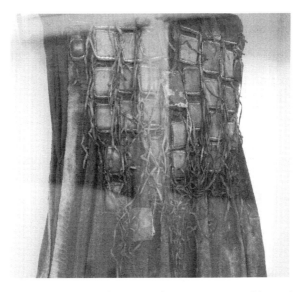

**FIGURE 2.9** *Batakari* (war dress), The National Museum, Accra, Ghana, date unknown.

and other geometric abstractions that acted as a defensive envelope for the space and the bodies within. It comes as no surprise to find that many of these symbols were placed on or around doorways and windows for added protection, combining West African "aesthetic sensibility" with the "literary and graphic potential of Islam" in the case of the Asante.[79]

Islamic influence even managed to penetrate the ritual events of Asante practice, as Joseph Dupuis' 1824 narrative relates. Dupuis, the first British consul in Kumasi, observed a particular ceremony associated with the ancestral rite of *Awukudae*, which is a highly important event in Asante spiritual practice. As Dupuis writes:

> The king himself was clothed in an undergarment of blood stained cotton; his wrists and ankles were adorned with fetische gold weighing many pounds. A small fillet of plaited grass, interwoven with gold wire and little consecrated amulets, encircled his temples. *A large white cotton cloth which partly covered his left shoulder, was studded all over with Arabic writing in various coloured inks, and of a most brilliant well formed character* [my emphasis]. His body in other parts was bare, and his breast, legs, the crown of his head, and the instep of each foot, was streaked with white clay ...[80]

The presence of white clay (*hyire*) on the Asantehene's body indicates that the king was in an intensely spiritual condition characterized by close contact with Asante ancestors.[81] The fact that the king was wearing a robe covered with Arabic script during this significant ritual suggests both the prominent role Islam had attained within the Asante ceremonial repertoire and Islam's active inclusion in the Asante's pre-Islamic spiritual narratives.[82] It also reveals the depth of Islamic ideological penetration into Asante ideology.

Additional evidence of Muslim influence can be read on the surfaces of the traditional architectural forms within Kumasi, many of which were unfortunately destroyed by the British during their punitive campaigns of the late nineteenth century. The Asantehene's palace and the traditional shrine houses were all made of earth and displayed intricate reliefs that have been described as "rude carvings," "Mauresque designs," "lace-like sculptures," and "religious symbols."[83] Although the meanings behind these architectural embellishments have either been forgotten or purposefully obscured, their visual similarity to traditional decorative Islamic aesthetics may be yet another result of the power of Islamic influence in the Asante capital in the eighteenth century.[84] However, even though Islamic elements and culture played a specific role within Asante culture, they never became dominant. Islam had greater success in the northern areas of the region, where it became more the substance of the quotidian than the preserve of the royal elite.

The eventual entrenchment of Islam into the lives and cultural matrices of the groups to the north was bolstered by the aforementioned influx of material goods such as leather, textiles, and utensils, whose surfaces became the billboards for Islam through their inscription with Arabic text and symbolism; these material tools of penetration further embedded Muslim culture, power, and visibility into

the surrounding material environment.[85] Indeed, Islamic signs became so ingrained in the general day-to-day order that many non-Muslim individuals began incorporating Islamic signifiers on to their material objects and structures without any official conversion activity. These signifiers were used because of their perceived spiritual potency and because the Muslims who lived within these contexts tended to be wealthier and better educated than their local neighbors. This gave Muslims certain status in society and thus their neighbors an impetus to emulate their manners, ways of living, and importantly their visual signifiers as a mode of association. In addition, because of Islam's distinctive lack of ethnic affiliation, becoming a Muslim sometimes offered a way for individuals to escape various traditional social constraints set in place to keep them within a certain class or caste in society.[86] Eventually, knowledge imparted by local Islamic holy men or *marabouts* allowed those seeking conversion to begin practicing Islam as a religion. Because these religious figures were so well respected, non-Muslims even found roles for them within intimate rituals such as marriage rites, birthing ceremonies, and funerals.[87]

Thus, in many ways, Islam was engaged in a largely non-disruptive and primarily opportunistic program of assimilation in the northern region of the Gold Coast. However, there were also sporadic bursts of aggressive integration as well. These came in the form of raiding parties composed of northern horsemen coming from the Sahel into the Upper Volta to plunder trade depots and traveling caravans within the Gold Coast. Evidence suggests that these raiding activities had been occurring for centuries and constituted one of the main ways that the region itself attained such cultural and ethnic diversity. However, there was one historic sixteenth-century military campaign that had wide-reaching effects in what is now central Ghana, specifically the establishment of the Gbanya state, or the Kingdom of Gonja.[88] Led by two northern Malian princes named Umar and Naba'a, also known as Ndewura Jakpe, this campaign was intended to exact retribution against the major commercial area of Beghu, which had been charged with withholding gold from Sahelian rulers to the north.[89] With the spiritual assistance of two Muslim *mallams*, or spiritual healers, Isma'il (Kamaghatay) and his son Muhammad al-Abyad, Naba'a was able to conquer the area and eventually settle in an adjacent region, which became the ruling state of the Gonja. Once the empire was established, it quickly assumed primary control of the trade routes that crisscrossed the region and established new commercial centers to accommodate the flow of goods and people traveling through the area.

As a result of this, in the centuries that followed, the area experienced increased trade and exposure to Mande traders coming from the north. This enabled the development of thriving Muslim communities within this context, even though the social and spiritual character of the region remained as diverse as ever. Along these lines, Islam developed a very specific character in this region, especially in terms of the relationship it forged with the emergent Gonja culture. The Muslim scholars of Gonjaland have historically been responsible for recording Gonja history in various annals such as the *Kitab Gonja* and the *Tarikh Ghunja*, both eighteenth-

century works that detail the history and traditions of the Gonja cultural group. In these volumes, there is no mention of Jakpe being a Muslim, although they mention the conversion of the "Gonja chiefly family;" yet if Jakpe did originate in the Sahel it seems likely that he was in fact a follower of the faith.[90] Regarding Jakpe's descendants, however, the only true evidence of conversion can be found in accounts of Gonja rulers adopting Muslim names as an early sign of Islamic presence and influence. Gonja chiefs were above all politicians and, as governors of mixed Muslim/indigenous populations, most were probably "half Muslim," taking advice from both imams and earth priests in their rule of the region.[91] This is, incidentally, extremely similar to the type of diplomatic ties forged in the Sahel. As part of this balancing act, the general chiefly protocol held that a Gonja chief should not "profess Islam" nor enter a mosque, but should seek out imams and *mallams* for advice as needed or called for. Yet, in almost all other ways, chiefs generally kept a polite distance from the Islamic faith.[92]

Yet these Gonja Muslims were not the only bringers of Islam that would come into the region. In the eighteenth and nineteenth centuries, a number of foreign Muslims began arriving in the area and formed separate communities from those already established there. This new Islamic contingent reflected strong hybridizing impulses and incorporated many local earth veneration practices into their iconographic repertoire, even creating various "medicine shrines" in Gonjaland that actively recruited supernatural assistance. Indeed, Levtzion notes that in some cases, old Islamic artifacts and ruins were transformed into shrines, and many of the descendants of these foreign Muslims became earth-shrine priests.[93] Such occurrences of religious intermixing would become something of a defining characteristic in this area where Christians, Muslims, and earth venerators lived side by side in Gonja culture.

This also meant that Islam, while gaining a foothold among the population, would still never became a true majority, although it seemed to be on a par with other religious affiliations in the central region of Gonja.[94] As we saw in the northern Sahelian region, Islam as it was realized within this newly established kingdom would come into contact with and occasionally subsume a variety of local non-Muslim cultural groups who had migrated into the area much earlier and established themselves within the region. Yet, there were also groups that did not convert, and these individuals eventually formed a "commoner" class within the Gonja social hierarchy called the *nyamasi*. These groups were not forced to change spiritualities; in fact, they were given religious autonomy to continue to worship as they saw fit, which primarily focused on earth veneration.[95] Other groups, such as the Vagella, the Anga, and the Tampolensi, were somewhat receptive (or perhaps more resigned) to this assimilation, while specific cultures like the Konkomba remained vehemently opposed to Islam despite its diplomatic gestures.

Yet, in each case, Islam maintained a generally passive approach, a legacy we've seen throughout its history in West Africa, and one that may have been buttressed by active Suwarian traditions in the region. The "pacific clericism" of the fifteenth-century Malian scholar al-Hajj Salim Suwari promoted a "quietist" attitude to

spreading the faith and focused primarily on education. This strategy assured both the spread of Islamic knowledge and the maintenance of peaceable relations with non-Muslim neighbors. In fact, this approach even instructed Muslims to yield to non-Muslim authorities so long as they did not stray from the righteous path. It has been suggested that the two Muslim *mallams* who helped Naba'a in his defeat of Ghana's central region, Kamaghatay and al-Abyad, were followers of this tradition.[96]

These Suwarian attitudes were also reflected in the roles of the *karamo*, or the Muslim class of the Gonja empire, which existed in conjunction with the commoner *nyamasi* class and the Gonja elite (*gbanya*).[97] Formed largely in commemoration of the two Muslim holy men who helped conquer the land, not only were the *karamo* responsible for helping the Gonja *gbanya* continue to defeat their enemies, but they also acted as spiritual advisors to the Gonja authorities. The closeness of this relationship is expressed in the recorded words of Naba'a after receiving aid from the *mallams*:

> By the name of Allah, I will give you a hundred horses, a hundred slaves, a hundred sheep, a hundred gowns, and a hundred trousers with its ropes. If you die, your people and children will take it after your death, and if I die, my people will be kind to you and your people after my death.[98]

It is said that this oath in many ways married the Gonja ruling class to the Muslim contingent, and even today the *gbanya* often refer to the *karamo* as their "wives."

In contrast, the Islamic philosophy that eventually took root in Larabanga was based on the Maliki school of thought, which will be addressed in Chapter 3. But it's worth noting here that the Suwari framework had an influence on Larabanga through its association with new regional types of political, social, and cultural identity. These were created within Muslim communities in the area to buttress the distinctive role and function they played within the established hierarchy. A subsequent step towards establishing themselves within this position, of course, was the development of new visual and spatial infrastructures within the region that both distinguished and propagated the *karamo* as a distinctive class. As expected, Muslims settling within this new region of Gonjaland often developed "twin cities" next to established non-Muslim settlements as a way of being part but not parcel of the community. Yet within these communities, the *karamo* also crafted distinctive sets of symbols and signifiers through which they both differentiated themselves and projected their identity on to the physical environment.[99] Styles of dress, eating habits, praying practices, and methods of conducting business were obvious modes of self-differentiation, but perhaps the most direct way of inscribing their presence and identity on to the physical and cultural landscape was through their built environment.

The development of architectural form to organize the distinctive lived reality of Muslims in this region allowed the built environment to become a tool of religious identification, personal status, and economic position, while also expressing the place of the *karamo* in the Gonja organizational hierarchy. It also enabled these Muslims to create cultural boundaries and borders through iconographies of form and the

regulation of movement through, between, and within these spaces. As such, the space of the Gonja Muslim settlement became a layered environment composed of multiple narratives that reflected the history and traditions that these groups brought into the central Ghanaian context. It also reflected the ways in which these matrices had been recast through the lens of a new Gonja identity.

The template of most general domestic structures in these Muslim communities resonated with the Sahelian styles of the north, specifically the Dyula style. Not only did it deploy a familiar and reproducible building technology, but the resultant forms were immediately recognizable as being of Sahelian origin; as such, they served as active structural markers of a Niger Bend-based Muslim identity. The standard square two-story house form of the Sahel with its projecting drainage pipes had long been a common domestic type designed to maximize water runoff and maintain the privacy of its inhabitants, as dictated by Islamic protocols. In addition, the Sahelian-style façade or *potige* emerged as a popular form as well, albeit a slightly modified form to accommodate the more humid conditions of the forest region. Along these lines, structures assumed a shorter, squatter shape, and their symbolic potential was also adapted to fit specific architectural situations. If one travels from the northwestern capital city of Wa down the Wa–Bole road through the western Gonja region, these regional variations of the traditional Sahelian *potige* form are both numerous and distinctive. In Wa itself, the traditional palace of the king of Wa or the Wa-Na (see Figure 2.10) incorporates this type of structural vocabulary. Built in the nineteenth century, this currently unoccupied structure reflects a traditional Sahelian-style mosque aesthetic, but with important variations that make it distinctly transcultural in style. For example, triangular motifs in the form of inverted reliefs have been carved into the earth above the lintels and are organized in a pyramidal shape, which may refer back to the protective symbols that were typically incorporated on North African *ksar* and *kasbah* structures. Another possible reason for these symbols was that they gestured to the surface embellishment often found on Islamic architectural forms in the Middle East, North Africa, and southern Spain that are embellished with extraordinary degrees of detailed tracery carved into the plaster and stucco molded around the structure's brick and timber infrastructure. However, because structures in a West African climate are primarily composed of earth, they are typically unable to either preserve extensive surface decoration nor are they able to support repeated piercings and inscriptions of its walls. The subsequent forms that developed in Northern Ghana utilized modified surface qualities as seen in the Wa-Na's palace, which incorporates minute windows in the shape of triangular forms and eschews verticality for a long horizontal structure that is able to more appropriately support this structural program.

This style also appears along the main routes moving south from Wa into central Gonja. Towns along the way, such as that of Tanina, have also made use of the *potige*, as seen in the chief of Tanina's palace (see Figure 2.11), which lies directly on the main road between Wa and Bole. According to the village elders, the palace itself is only twelve years old, but the iconography it incorporates is well-established in communal memory as an architectural mode of signifying the structure's

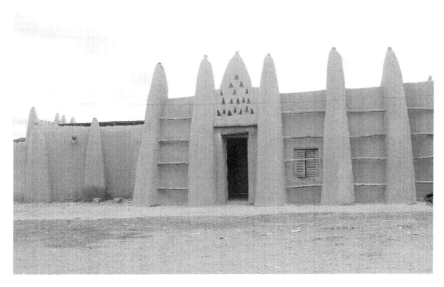

**FIGURE 2.10** Palace of the Wa-Na, Wa, Ghana, 2012.

**FIGURE 2.11** Façade, chief's house/community meeting house, Tanina, Ghana, 2012.

importance to the community. A replica of the Wa-Na's palace in miniature, the Tanina palace is notable for its Sahelian-style structural façade. And like the Wa-Na's palace, Sahelian iconography has been transformed to access both sacred *and* secular associations, connecting the two as an expression of the power and authority of the chief himself.

Along these lines, Tanina's palace has more than one function. It is not only the home of the chief and his family, but also a sleeping place for visitors as well as the official meeting place of the village elders. Beyond the main entrance of the palace is a large, covered, meeting hall, which contains numerous benches organized parallel to one another. In the corner sits a raised dais covered with various skins where the chief sits, the skins being very significant in the Gonja context as representations of the chiefly office and thus the surface on which the *wuras* or chiefs of Gonjaland sit in their official capacity. In the opposite corner sit a pair of "talking drums," which are played during meetings and constitute a means of relating historical narratives, proverbs, and judgments through a variety of deeply complex rhythms and beats (see Figure 2.12). Understanding this drum language is a highly specialized, esoteric brand of knowledge that few are able to acquire, and even those who do often differ in their interpretations of various drummed messages.[100] This chamber constitutes the political heart of the community that one accesses through a central portal whose architectural vocabulary connotes the significance and import of the space. Beyond the meeting room is the entrance to the chief's compound, through which one can visually access the space, although it is inappropriate to do so without permission.

The palace and the subsequent domestic compounds of the community are a hybrid mixture of Mande Islamic influences and local architectural traditions, a necessary marriage that was quickly realized as incoming Muslims entered the area

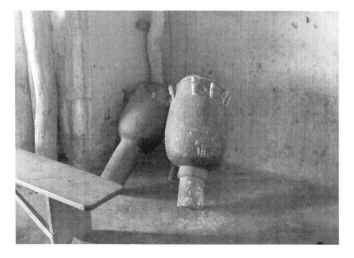

**FIGURE 2.12** Talking drums, chief's house/community meeting house, Tanina, Ghana, 2012.

and began to construct imported forms within the forest landscape of the Gonja region. Within this region, however, they soon discovered that many of its aspects were ill-suited to the social and environmental constraints of the region.[101] The humidity of the forest belt/rainforest climate of the Gold Coast made the construction of an earthen two-story building with vertically oriented *potige* entrances and monumental pillars unrealistic. Likewise, because Islam never developed into the socio-political authority in this region that it had in the Sahel, there was no need for the monumental architectural languages of power that had developed in the contexts of the Malian and Songhai Empires.[102] This conundrum necessitated the development of new forms based on available "toolkits," although Muslims in the new context of the central Gold Coast retained the square form as a nod to their northern cultural and architectural legacy. But here they were built on a much smaller, horizontal scale for both structural and perhaps socio-political reasons. This shift in Muslim architectural templates was most obvious in the creation of domestic compound space.

As discussed previously, the roundhouse hut was a ubiquitous structure in many non-Muslim areas in West Africa, and central Ghana was no exception. In addition, what dictated the different construction methods of round and square houses were the units from which they were composed. In the Sahel, particularly Djenné, the square brick gave rise to angular structures whose edges were softened by an earthen plaster applied to the exterior as a waterproofing agent. Roundhouse construction in contrast was created using a variety of methods that were often region-specific and typically involved either piling, ramming, or stacking earthen material, sometimes using molds or another type of physical framework. Within the Upper Volta, the oft-used "lapped mud method" involved applying batches of thickly mixed mud to prefabricated wooden frameworks or scaffoldings. After the earth had been stacked, a layer of lime-based clay plaster was applied to waterproof the surfaces, and finally a thatched roof was set in place.

Both the square brick and the lapped mud methods had advantages and disadvantages directly related to the nature of their forms and materials. Walls created with bricks tended to be thicker and more resilient, but were also prone to cracking. The less-dense lapped mud method, in contrast, allowed the structure to breathe more naturally, but did not have the longevity of the brick construction and was less easily repaired. Thus, many early generic Muslim domestic complexes often contained a mixture of the two forms.

Sudanese-inspired square buildings also became elongated to create natural compound walls, while round houses were often positioned as either free-standing structures within the compound or as structural joints that were located at corners and wall intersections (see Figure 2.13).[103] There were even hybrids of the two building types; square buildings with conical thatched roofs, for example, often worked better at the intersections of rectangular walls than the round house forms. In each case, these structures were organized around a central courtyard area reminiscent of northern Islamic complexes, but drew from local domestic organizational schemes that favored this central communal space. Thus, Muslims in

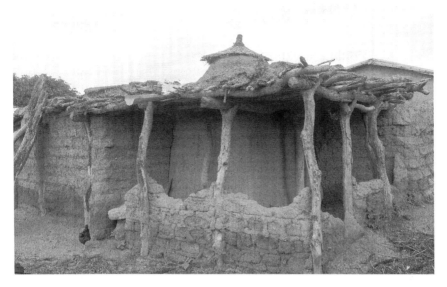

**FIGURE 2.13** Combination of flat-roofed square structures with rounded granary, Bodi, Ghana.

northern Ghana worked to create a forest-region translation of Sahelian domestic space, reworking domestic sites and organizations to incorporate both local and imported elements. By assimilating locally efficient structures like the roundhouse, and renovating their forms through a collaboration with the square house model, Gold Coast Muslims were able to craft an environment that acted as a symbol of Islamicized Mande identity and thus demonstrated "the efficacy of technology as a symbol" itself.[104]

Yet, just as these newly crafted domestic environments acted as an inscriptive device for the cultural identity of its occupants, emergent Muslim religious spaces in this area also functioned as markers of identity in the central Ghanaian landscape. In particular, the mosques that arose in northern Ghana were some of the last iterations of the transplanted Dyula style to develop in the forest region, having undergone numerous evolutions and re-imaginings as they traveled south into the Volta basin. In one of her earlier works on Islamic architecture in West Africa (1968), Prussin identified a number of key stylistic types within this evolving Dyula style that occurred within specific geographies and seemed to correlate with Islam's advance into the forest region. Although Prussin's model is a little too efficient to be entirely plausible, she nonetheless identifies major stylistic types that appear to maintain a regional basis.[105] The first two major southern subtypes to develop from the template of the Dyula were the Bobo-Dioulasso and the Kong styles. The Bobo-Dioulasso style was the more northern of the two, located in the district of Bobo-Dioulasso in Burkina Faso (see Figure 2.14). This style continued to maintain the verticality and monumentality of the Dyula tradition, but became noticeably wider and thicker—characteristics noted previously in transplanted

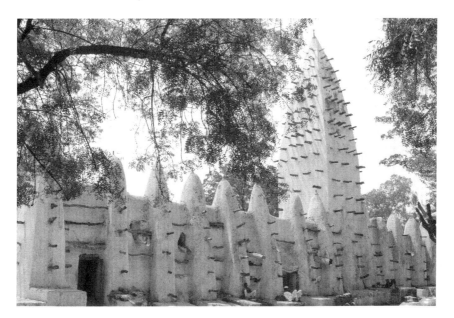

FIGURE 2.14    Grand mosque, Bobo-Dioulasso, Burkina Faso, built in the late nineteenth century.

Source: Photo courtesy of David C. Conrad, 2011.

domestic styles that also took root in the forest landscape. Supplementary buttresses and other added structural modifications were incorporated into mosque walls to further stabilize the structure; these took form in protruding and horizontally placed wooden timbers that provided additional scaffolding for maintenance work.

The more southerly of these two new styles, the Kong style, was bulbous and can be seen in Larabanga's mosque (see Figure 0.1). The increased humidity of the forest required a thick, squat form with minimal openings into the interior.[106] Named after the town of Kong in Côte D'Ivoire, the Kong style, like the Bobo-Dioulasso style, had heavy, thick buttresses lining the walls that were supported by horizontal timbers and wooden beams protruding from the surface. The walls themselves also began to taper towards the center of the structure in a way that gave the mosques of this style an almost trapezoidal appearance. The interior was no longer a semi-open space, but was divided into small, cramped chambers to maintain the structural integrity of the building. The main minaret, which used to house stairs leading to the roof, was no longer capable of fulfilling that function, and most agree that its purpose at that point became largely symbolic.[107]

Many of the changes to the original Dyula model expressed by these two styles are the result of shifting climate patterns and environmental conditions. The increased humidity and rainfall of the savannah and forest zones made it harder to maintain monumental earthen structures, particularly the two-story, terraced forms that were so popular in the Sahel. Other changes were probably due to political, social, and cultural shifts. Because Islam never developed into the socio-political authority in

these regions that it had in the Sahel, the need for the authoritative architectural languages such as that of the Djenné mosque were no longer necessary.[108]

There was one further iteration of the Dyula style in the forest region, which would develop after the Bobo-Dioulasso and the Kong. Called the Kawara style, its mosques no longer functioned as architectural shelters and became instead entirely sculptural, a symbolic landscape with prayer activities taking place in the demarcated spaces next to it (see Figure 2.15).[109] Perhaps more than any of the other Afro-Islamic styles that developed from the Dyula model, this style speaks to the power of local influences and traditions on incoming cultural and architectural templates. Potential influences include the architectural traditions of local groups like the Lobi, who created unique, highly "sculpturized" ancestral shrines that are extremely similar to the pinnacles and pillars that line Sahelian-style structures. In addition, practices of earth veneration in this area were supported by the presence of gathering spaces within the vicinity of sacred sites; earth shrines themselves often took the form of demarcated natural areas, such as groves and tree stands that worked in conjunction with constructed spaces. This dual importance of both interior and exterior spaces for purposes of religious practice in these local earth veneration traditions may have also further facilitated a modified version of the Dyula mosque to take root here. Not only did such spaces serve the function of a congregational prayer space, but they did so in a way that was actively sympathetic to religious traditions and practices already in place.

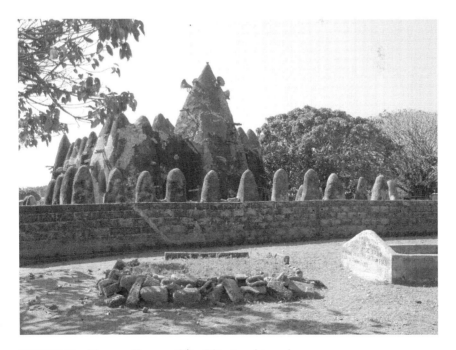

**FIGURE 2.15** Mosque, Kawara, Côte D'Ivoire, date unknown.
Source: Photo courtesy of Barbara E. Frank, 2011.

As such, local traditions throughout the Upper Volta region contributed extensively to the renovation of incoming Afro-Islamic cultural and architectural templates. They shaped a localized Muslim identity that complemented cultural and religious systems already in place. These mosque transformations in particular represent the necessity of reconsidering the idea of "mosque" as a religious architectural concept within this context; both the structures and the practices associated with them were made sustainable by an environment already saturated with localized spiritual and architectural traditions. This is why the Kawara style, in contrast to the Bobo-Dioulasso and Kong styles, largely abandoned the delicate balance between sculpture and architecture in the mosque form; such balance was not a relevant concern within localized spiritual practice. Collectively, these styles illustrate the continuous development of an Islamic paradigm in the region of the Gold Coast that passed the structural referents of Sahelian architectural traditions through a filter of Voltaic sensibilities. These forms firmly moved away from their northern legacy to incorporate cultural systems and support architectural constructs that allowed Islamic identity to entrench itself physically and culturally into this new context. It became a locally defined reality, connected to, yet distinct from, its northern antecedents. It is from this collective platform that Larabanga would eventually construct its own cultural, spiritual, and architectural identity.

## British Colonialism and the Northern Region

Of course, architectural and cultural influences did not just flow between the Sahel and Voltaic areas north of the coast. European presence along the coastal regions of West Africa began as early as the fifteenth century, with Portuguese naval forces and traders settling along the coast and establishing permanent communities. Such situations transformed the built environment into billboards for subsequent conversations, negotiations, and contestations of identity, not only through the construction of castles and forts but also through the development of hybrid European residential structures that revealed a willingness to assimilate local forms into transplanted European domiciles. For example, when the early Portuguese settled along the coast of Senegambia in the fifteenth century, they created a distinctive "Luso-African" identity. Not only did they take local wives, but they developed a hybrid domestic house type geared at first to accommodate the lifestyles of merchants before growing to become a symbol of a distinctive "Luso-African" culture that differentiated itself from local groups in terms of class and social station.[110]

But the Portuguese were only one of a number of variable European influences that would eventually arrive on the continent and impact African cultures, identities, and architectural forms in diverse ways. Such impacts were heightened during the nineteenth and twentieth centuries when European presence in Africa, particularly West Africa, was at its zenith. Different European contingents approached the "problem" of West Africa and its inhabitants in different ways, resulting in the tailored imperial programs of each country. With regards to relationships with the people they had colonized, however, arriving Europeans

almost universally instituted tactics of exclusion with regards to separating bodies in space. One major example was the segregationist tendencies exercised by the various architectural components that Europeans deployed. Their systematic use of architecture as socio-cultural boundary became a means of establishing hierarchies between Europeans and Africans, drawing on Western understandings of architecture as a class-making apparatus and a method of encoding social position within the physical and cultural environment.

Such tactics were notable within British colonies such as the Gold Coast. Although the northern areas of the Gold Coast were less affected by incoming British ideologies, areas along the coast and in close proximity to the European forts were more susceptible, consistently exposed to incoming Euro-Christian cultural attributes and the architectural infrastructures that would support them.[111] In addition, the colonial administrators, who were prolific documenters of indigenous groups, produced copious amounts of information concerning different cultures, their traditions, and notably their built environments. From these records, an architectural narrative of the area emerges that reveals the particularly stressful political, social, and cultural conditions under which many savannah and forest region kingdoms lived in West Africa during the eighteenth and nineteenth centuries. Armed conflict and slave trading had decimated populations throughout the West African interior, an observation supported by the records of early European explorers and, later, colonial administrators. War atrocities and the resulting communal trauma also gave rise to altered settlement patterns and architectural landscapes that included new defensive elements such as village walls, corner towers, and stockades. These architectural additions became so pervasive that it is difficult to find a European account of the period that does not make a note of defensive housing concessions and other militaristic dwelling spaces. European explorer René Caillié noted that all the houses he encountered within the areas of southern Mali were surrounded by some type of wall, whether a mud brick wall, hedges, an enclosure of rails or posts, or simply straw. Boundary and the separation of exterior and interior indicate the presence of specific narratives of survival and self-preservation that were the architectural order of the day, narratives that catalyzed the installation of various architectural infrastructures across the region.

Evidence of this is particularly obvious in accounts of central Ghanaian villages during the period of the transatlantic slave trade and other internal regional conflicts that occurred in of the area, often in connection with the militaristic Asante. An early Dutch report of the embattled city of Beghu in 1629, for example, describes the residents "dwelling 'in fortifications.'"[112] In addition, the town of Bute, which lies just east and south of Larabanga and was often the target of Asante raids, contained numerous large "fortress-like" three-story domestic structures that Wilks et al. calls "tower houses" as a defense against Asante warriors.[113] Although some of these structures were still standing in 1969, when Goody recorded them,[114] they were quickly dying out as the original need for them was no longer present and the people of Bute had begun to adopt the easier, less maintenance-dependent regional compound style, i.e. a series of single rooms clustered around a central courtyard.[115]

Yet these accounts also had another function beyond documentation: they helped colonial officials more accurately "map" cultural geographies across the region using architectural traditions and structural environments as evidence. Caillié's accounts, for example, provide a thorough canvassing of the architectural spaces between Timbuktu, Djenné, and the Upper Volta. He, like the bulk of European explorers in the area, tended to follow pre-established trade routes. Despite his tedious Euro-centric descriptions of what he considered the poor construction quality and general filth of the "Moors", Caillié's accounts still provide us with a cultural and architectural narrative of the Islamicized Mande. He describes in great detail the general earth-based house types he encountered, many of which, he writes, had a singular entrance and a roof laid with timbers and earth—a flat-roof house.[116] He observed that several houses of this type were often located within a single compound in conjunction with a "little round store house made of earth and thatched with straw"—a granary.[117] A mud wall roughly six and a half feet high typically surrounded the compound; it was created with a mixture of mud and cow dung, a composition still used in rural contexts thanks to its waterproofing capabilities.[118] Caillié's accounts confirm the presence of a domestic complex design associated with Islamic identity, helping us understand how well it flourished in the West African savannah and forest region in the early nineteenth century. Caillié's accounts of a central plan loosely organized around a rectilinear and round house combinations connected by walls fits the description proposed earlier: a type of hybrid domestic space developed by Muslim merchants when they began settling in these southern regions. Caillié also contributes to discussions of the religious structures present in the region with his description of a mosque in the village of Kankan, in Mali. He observed that the mosque maintained three entrances to the west, north, and south (presumably corresponding to entrances for the imam, the men, and the women) and the interior supported by a series of posts reminiscent of the hypostyle mosques of both North Africa and the Sahel.[119]

Such accounts were important in providing colonial powers with intelligence regarding the territories they hoped to assimilate. By the late nineteenth century, British interests in West Africa covered present-day Gambia, Sierra Leone, Ghana, and Nigeria and composed an area that became known as the British West African Colonies. Within this protectorate, the British constructed infrastructures including roads, railways, and storage facilities, as well as various residential sectors that were geared primarily towards segregation and the establishment of a white socio-economic superior class.[120] Most of these structures were produced by the Public Works Department (PWD), whose architects were trained in the latest techniques of tropical architecture design and whose aim was to create comfortable, familiar living environments for incoming European settlers.[121] This architectural specialization eventually led to the development of a colonial "classical" style, which was deployed in both residential sectors as well as government buildings and businesses as a way of "instill[ing] confidence in the populace" through the symbolic use of European engineering prowess.[122] But in addition, this colonial style with its large roomy areas, big windows, cool interiors, and verandas came to

represent an imperial "architecture of power," imprinting European architectural value systems onto the African environment as a mode of colonizing space, both physically and psychologically.[123] The success of this manipulative campaign can be seen in the various ways it was incorporated into imported architectural frameworks along the Gold Coast ranging from steeply pitched roofs to the popularization of L-shaped modular house forms with surrounding verandas.[124]

Such architectural forms became entrenched within colonial Ghana's coastal regions, which constituted the seat of British administrative power. As such, colonial tropical architectural elements were continuously buttressed, strengthened, and emphasized by the active British presence in the area. However, further inland, away from the seat of colonial power and presence, British influence began to peter out as it approached the northern frontier area of the Gold Coast, its infrastructures falling apart in the absence of a legitimately concrete colonial presence. Within such areas, local structures tended to take precedence in both form and function for reasons related to both the physical inappropriateness of British architectural models in this area as well as a fundamental difference in cultural identity between these two groups.

The nature of the colonial British architectural style—even with its popularity and triumphant inscription in the colonial coastal landscape—was conceptually ill suited for efficient living within this more northern context. Despite its structural openness, European tropical architecture generally was still an architecture of segregation, designed to separate and thus reinforce the division between European and African bodies. Thus, its enclosed spaces and strongly demarcated sectioning created a natural organizational conflict with many local communal and domestic paradigms in northern Ghana, whose strong interpersonal relationships required equally interpersonal, interactive spaces. British colonial styles also focused too much attention on enclosed, sheltered, interior space as the primary area of human presence and activity, an orientation that clashed with a traditional focus on the exterior domestic courtyard as the center of familial life. These forms constituted a fundamental disconnect between local and colonial architectural spaces, and as a result colonial forms were only successfully implemented when a strong reinforcing social agent was present. Thus, there is irony in the fact that many of these colonial architectural features gained increased popularity *after* Ghana's independence, during a period when colonial political, social, cultural, and architectural legacies were being actively dismantled. During the colonial period, these forms served as structural metaphors of cultural wealth, power, and status, as well as enforcers of boundary, division, and segregation. After independence, they became invested with new meanings that refashioned the old architectural vocabulary of imperialism into a statement of African modernity, expressive of the vibrancy and technological potential of a new nation.

But to return to the conversation between British and northern Ghanaian cultural and architectural systems, it was also in this frontier area of northern Ghana where the British colonial administration and many of the Muslim populations of the Volta region engaged in a series of uneasy interactions. By the time Britain had established its authority in the Gold Coast, Muslims had had at least two centuries

to craft a distinctive regional identity in the north, which had become solidly embedded within the cultural and architectural landscape. In addition, because of the north's perceived lack of resources and the difficulty of travel from the coastal region to this area, the northern region of the Gold Coast was largely left to its own devices as a pseudo-autonomous territory, with the concentration of British colonial power remaining to the south along the coast. This effectively divided the territory of the Gold Coast along an invisible line that created a gap between the largely Christian south and the largely Muslim north in terms of infrastructure, financial support, and services, a gap that continues to exist to this day.

Despite the fact that the British presence in the northern part of the colony was minimal, the few colonial administrators stationed there continued their project of documentation of ethno-cultural groups in the region. They used standardized systems of classification that imposed new cultural boundaries and ethnic conceptualizations, subsequently creating further divisions within previously unified groups and landscapes. The Muslims of the northern region were one such group, and initial assessments of their cultural character were founded on information taken from travelogue literature, whose self-awarded authority was responsible for the propagation of any number of oppressive cultural stereotypes.[125] Because many of these Muslims had arrived from the Sahelian regions to the north, they were often called *Mandingoes*, or those of Mande origin, and were generally described as brave, courageous, and "capable of a high degree of civilization."[126] However, their Islamic dispositions as "Mohammadians," also made them generally cruel, oppressive, and tyrannical, as well as possessing a hatred of those considered infidels, particularly Christians.[127] Paradoxically, Muslims were also described as energetic and intelligent, and this gestures towards the ambiguous position African Muslims occupied in European colonial thought. Islam and its adherents were at once an inherently destructive element of African society, "propagated with fire and sword by northern tribes of Arabic descent,"[128] who also acted as a bridge between the savage "paganism" of indigenous African natives and the "apex of theological, philosophical, moral, and ethical standards" of Christian Europeans.[129]

Material evidence was often used to buttress such claims, focusing on modes of dress, religious practices, and especially the built environment. Because of architecture's lofty position in European enlightened thought, structural form was seen as easily accessible and above all *objective* piece of physical evidence for such stereotype-producing projects. Like the cultural characteristics mentioned before, it also became a prime canvas for the inscription of Euro-centric presumptions and biases that reflected the unsettling and anxiety-producing effects that Muslims had on the European mind. Many of the beautifully sculpted early earthen mosques and other religious structures in Muslim-occupied northern Volta areas were credited to Islamic influences coming from the north rather than being the product of local innovation. Even the areas of the Sahel themselves—large, prosperous commercial centers—were thought to be the result of incoming North Africans and transplanted Arabs. In other words, these well-organized, thriving

states with technically superior architectural forms could not have been created by the "Negro African."[130]

This also had the effect of setting up the Sahara as a cultural, racial, and developmental boundary between North and sub-Saharan Africa; the desert became a dividing line between peoples, and this idea became firmly cemented in Western thought concerning the nature of the Sahara and its position between northern and western regions.[131] In the colonial territories of Mali, Mauritania, Senegal, and others, the French began differentiating between the Islamic practices of the "Moorish" Muslims, or those of North African descent, and black Muslims from sub-Saharan territories. James MacQueen, in his nineteenth-century account of what is today a Muslim-dominated region of northern Nigeria, declared that white North African "Arabs" ruled this area, not "black" sub-Saharan Muslims. His argument was that the Hausa states and the empire of Bornu were far too developed to have been the creation of "Negros."[132]

These racially motivated divisions and classifications, and their expression in the built environment, were perceived as being scientifically verifiable, objective, and therefore airtight evidence of the necessity of imperial control and habitation. For even as colonial administrators defined the cultural traits of various groups through the material culture they produced, this material culture was then turned back on the same groups as evidence of their barbarism. Interestingly, however, in the northern regions of Ghana, such classifications as the "Mohammadians" were not so easily cut, dried, and applied. In fact, colonial officials were flummoxed by the type of Islam they found there, one characterized by a fusion of local and Muslim elements, which was a reality that flew in the face of their belief that there was only one type of Islam, universally governed by interpretations of the Koran and therefore resistant to any type of modified practice.[133] The subsequent hybrid nature of their architectural environment was equally confusing in that, like the Islamic culture practiced in the region itself, it was not possible to identify original forms; each structure seemed to combine any number of influences and elements ranging from historical trends to imported influences, many of which were in place long before the arrival of the European colonial project.[134]

These aspects, combined with the general physical inaccessibility of the northern region of the Gold Coast and its lack of resources, limited British colonial influence beyond the central area of the Asante Empire. As such, there is little information about the "Muslim north" in colonial files aside from a few dedicated reports attempting to classify these groups. This indicates the nonintegrated nature of this region into colonial frameworks.[135] Yet even though British influence was limited in many northern areas, the idea and institutionalization of the division between north and south has continued to reverberate long after the end of the colonial period. Because Eurocentric architectural and cultural standards were introduced and institutionalized as a mode of reinforcing European colonial goals using spatial means, some scholars hold that this forcible weakening of historical methods of organizing the physical environment has caused the extinction of tradition-oriented modes of thought and the self-reinforcing spatial aspects that come with them.

However, I suggest that, in contrast, colonialism merely added additional fodder for the selective mental filters already deeply embedded in the area with regards to incorporating incoming influences into established models. Indeed, in the post-independent period, individuals have taken numerous imported vehicles of cultural imperialism and transformed them into expressions of self-identification.

This was particularly true during the period immediately following independence, as a number of post-colonial nations all over the continent began experimenting with crafting national identities removed from the colonial legacy and based on the idea of an underlying cultural current flowing within society. Under Ghana's first president, Kwame Nkurmah, the newly independent Republic would move firmly away from colonial political and social institutions yet preserve and progress various architectural infrastructures as buttresses to the modern nation-state. Unfortunately, the historic division that had existed between north and south for generations even before colonialism would remain, and would continue to manifest in the unequal politics, economics, infrastructure, and education of the northern region. In the contemporary period, the north consistently lags behind the south in terms of technological progress, resource management, and sustainable agricultural programming. Some in the south even view the two regions as essentially independent states, associating the "Muslim northern contingent" as a foreign presence, largely inscrutable to the predominantly Christian coastal population and disassociated from the contemporary condition of Ghana. Because of this cultural gatekeeping, the northern region remains disconnected from the "national historiography," leading to the creation of two culturally and environmentally distinct regions.[136]

Yet even within this division, conversations occur and manifest in the built environment, to the point where a number of pseudo-standardized architectural forms have begun to become associated not only with a culture but with a region as well. In rural areas around the country, rectangular, thatched, clay-based structures have become associated with the southern, primarily Christian, areas, whereas curved "roundhouses" are primarily found in northeastern parts of the country. Lastly, the "rectilinear, flat-roofed, cellular houses" of predominantly Muslim population are located in the northwest.[137] Because the larger urban areas are concentrated in the south, along with most of the population, architecture there is decidedly more variable in terms of materials, technologies, and the establishment of formal properties. But in the north, where the population is thinner and less urbanized, such differentiations become decidedly more noticeable and useful towards fleshing out the cultural and architectural natures of specific areas, such as Larabanga.

## Notes

1   Filippo Osella and Benjamin F. Soares, *Islam, Politics, Anthropology* (Chichester: Wiley-Blackwell, 2010), 12. For the sake of accessibility, the term "Islam" will be deployed carefully and self-consciously in reference to a general Muslim condition whose multiple iterations and reifications are connected by a set of core Islam situated beliefs.

2   Roman Loimeier, *Muslim Societies in Africa: A Historical Anthropology* (Bloomington, IN: Indiana University Press, 2013), ix.
3   It should be noted that this narrative is not meant to imply that influences were flowing in only one direction. The cultures and peoples of West Africa were key figures in crafting influences that would move north along trade routes, adding their voices to the various conversations moving back and forth across the continent. Yet, for the purposes of this investigation, the movement of Islam into West Africa along a north to south trajectory will be emphasized.
4   This is a relatively recent conceptualization of Islam in studies of Africa, contradicting older colonial conversion models that position Africa as an empty container waiting to be filled by the spiritual and cultural bounty of Islamicism, and newer models as well that see Islam as an inherently foreign interloper that deployed itself upon a population as opposed to engaging it in cultural discourse. This also counteracts studies that would position Islam's arrival within the African context as a singular encounter or a series of singular encounters that occurred over the course of centuries.
5   Marshall G. S. Hodgson, *The Venture of Islam: Conscience and History in a World Civilization, Volume 1—The Classical Age of Islam* (Chicago: University of Chicago Press, 1974), 59.
6   Marshall G. S. Hodgson, *The Venture of Islam: Conscience and History in a World Civilization, Volume 2—The Expansion of Islam in the Middle Periods* (Chicago: University of Chicago Press, 1974), 3.
7   Oleg Grabar, *The Formation of Islamic Art* (New Haven, CT: Yale University Press, 1973), 1.
8   Ibid.
9   Gülru Necipoğlu and Mohammad Al-Asad, *The Topkapı Scroll: Geometry and Ornament in Islamic Architecture—Topkapı Palace Museum Library Ms H. 1956* (Santa Monica, CA: Getty Center for the History of Art and the Humanities, 1995), 193.
10  Ibid., 189.
11  Timothy Insoll, *The Archeology of Islam in Sub-Saharan Africa* (Cambridge: Cambridge University Press, 2003), 45.
12  Ibid., 26.
13  Ibid., 89. In Muslim practice, one Muslim may not take another Muslim as a slave.
14  Ibid., 149.
15  There is some debate as to the actual identity of Al-Muqawqis in terms of the time period in which he ruled and in what capacity. Within the context of this narrative, it is assumed that he was governing Egypt at the time of the erection of the mosque of al-'Āṣ on behalf of the Umayyad Caliphate.
16  Doris Behrens-Abouseif, *Islamic Architecture in Cairo: An Introduction* (Leiden and New York: E. J. Brill, 1989), 47.
17  Candice Goucher et al., "Ordering the World: Family and Household," in *In the Balance: Themes in Global History*, ed. Candice Goucher et al. (Boston: McGraw-Hill, 1998), 302.
18  This comment is made in reference to a statement made by Behrens-Abouseif in which she indicates her belief that this mosque was probably created by a local craftsman "familiar with sophisticated architecture" (implying that such familiarity was probably imported) and that because of this the mosque was not an "entirely primitive" building (*Islamic Architecture in Cairo*, 47).

19  Although early Egyptian mosques like al-ʿĀṣ were in tune with both local and core Islamic philosophies operating collaboratively within the environment, later ninth- and tenth-century Egyptian mosques like that of Ibn Tulun (879 CE) and Al-Azhar (972 CE), both located in Cairo, grew progressively larger and more ornate, reflecting later Abbasid and Fatimid influences. Over time, the al-ʿĀṣ mosque also became increasingly embellished with the addition of the architectural and decorative trappings of more mainstream Middle Eastern mosque styles that favored minarets, stucco, and surface embellishments in all manner of precious materials.
20  Ghislaine Lydon, *On Trans-Saharan Trails: Islamic Law, Trade Networks, and Cross-Cultural Exchange in Nineteenth-Century Western Africa* (Cambridge: Cambridge University Press, 2009), 107–108.
21  Eva Hoffman, "Pathways of Portability: Islamic and Christian Interchange from the Tenth to the Twelfth Century," *Art History* 24, no. 1 (March 2001): 21.
22  Grabar, *The Formation of Islamic Art*, 351.
23  Lydon, *On Trans-Saharan Trails*, 224. Muslim clerics accompanying caravans were responsible not only for spiritual matters, but also the physical health of the caravaners, giving out medicine in addition to prayers and magical devices like amulets.
24  Ibid., 164.
25  Grabar, *The Formation of Islamic Art*, 122.
26  Ibid.
27  "Ribat El Monastir: The Bastion of Arab Conquerors," *North Africa Times*, October 20, 2007, accessed November 12, 2011, www.alarab.co.uk.
28  Ibid.
29  The present mosque stands on the original site of Uqba's first mosque and was erected by Aghlabid governor Ziyadat Allah between 817 and 838; however, it is still referred to as the mosque of Uqba ibn Nafi.
30  This story typically appears in informal accounts regarding the development of the mosque and cannot be verified as being a legitimate historical narrative of the site.
31  Jonathan Bloom, "On the Transmission of Designs in Early Islamic Architecture," *Muqarnas: Essays in Honor of Oleg Grabar* 10 (1993): 22.
32  Ibid.
33  Loimeier, *Muslim Societies in Africa*, 11–12.
34  The presence of continuous habitations between them might indicate that eventually these two areas merged into one.
35  Insoll, *The Archaeology of Islam*, 225–226.
36  Ibid.
37  Ibid., 209.
38  Andreas W. Massing, "The Mane, the Decline of Mali, and Mandinka Expansion Towards the South Windward Coast (Les Mane, le déclin du Mali, et l'expansion mandingue vers la Côte du Vent méridionale)," *Cahiers d'Études Africaines* 25, no. 97 (1985): 21, 38.
39  Ibid., 41. This gives evidence to the fact that the twelve houses in Larabanga were not necessarily a tradition established by Braimah, but instead go back to the very foundational kinship structure of the Kamara ethnic group, adopted into the Larabanga origin story as a mode of coalescing facts into an understandable narrative.
40  Ghislaine Lydon, "Writing Trans-Saharan History: Methods, Sources and Interpretations Across the African Divide," in *Sahara: Past, Present and Future*, ed. Jeremy Keenan (London: Routledge, 2007), 10.

41  Claudia Zaslavsky, *Africa Counts; Number and Pattern in African Culture* (Boston: Prindle, Weber & Schmidt, 1973), 173.
42  René A. Bravmann, *Islam and Tribal Art in West Africa* (London: Cambridge University Press, 1974), 47.
43  Insoll, *The Archaeology of Islam*, 241. Interestingly, little of this ivory trade is mentioned in Arabic sources, possibly because the animals from which the tusks were taken were not killed in a ritually prescribed manner and thus the practice was denounced by more conservative Muslims.
44  J. F. P. Hopkins and Nehemia Levtzion, *Corpus of Early Arabic Sources for West African History* (Cambridge: Cambridge University Press, 1981), 174.
45  Insoll, *The Archaeology of Islam*, 233.
46  Ibid., 241.
47  Labelle Prussin, *Hatumere: Islamic Design in West Africa* (Berkeley, CA: University of California Press, 1986), 128.
48  Ibid., 131.
49  Ibid., 153–154.
50  Such ideals resonated strongly with mystical modes of Sufi Islam coming in from the Maghreb, which used metaphysical spatial designs like the *hatumere*. Hatumeres are rectilinear configurations that convey blessing through their numeric components and can be inscribed on multiple material and architectural surfaces to configure space.
51  Insoll, *The Archaeology of Islam*, 257–258.
52  Prussin, *Hatumere*, 144.
53  Viviana Pâques, *L'arbre Cosmique Dans La Pensée Populaire Et Dans La Vie Quotidienne Du Nord-Ouest Africain* (Paris: Institut d'ethnologie, 1964), 268–269; in Prussin, *Hatumere*, 144.
54  Prussin, *Hatumere*, 148.
55  James L. Newman, *The Peopling of Africa: A Geographical Perspective* (New Haven, CT: Yale University Press, 1995), 109.
56  Insoll, *The Archaeology of Islam*, 328.
57  Lydon, *On Trans-Saharan Trails*, 72.
58  All Bamana names for the architectural components listed for Djenné's Moroccan style house are taken from Prussin's seminal work *Hatumere: Islamic Design in West Africa*.
59  Prussin, *Hatumere*, 193–194.
60  The categorization of the Djenné mosque as a legitimate example of a regional architectural style has been problematized because the present structure was built under French colonial patronage in 1907 (Prussin, *Hatumere*, 184–186). However, the construction itself was undertaken by Djenné's established masonry guild and embodies a "fluid engineering approach" more in line with local practice and evident on structural compliments elsewhere in the region (Morris and Blier, *Butabu*, 196–197). I would add that variations of this style appeared in West Africa's southern forest regions prior to the arrival of the European colonial machine, providing evidence of the presence of a "type" of Afro-Islamized architecture that traveled into this area via transcontinental trade activity.
61  Insoll, *The Archaeology of Islam*, 260.
62  Ibn Battuta, Said Hamdun, and Noel Quinton King, *Ibn Battuta in Black Africa* (London: Collings, 1975), 32.
63  Nehemia Levtzion, *Muslims and Chiefs in West Africa: A Study of Islam in the Middle Volta Basin in the Pre-Colonial Period* (Oxford: Clarendon Press, 1968), 3.

64  Massing, "The Mane," 41.
65  Levtzion, *Muslims and Chiefs*, 23. Given that the caravans were also accompanied by a contingent of military personnel, one might consider the possibility that Prince Jakpe, the founder of the Gonja empire, was not on a campaign, but was in fact part of a military escort responsible for conquering commercial opposition from local ethnic groups (Massing, "The Mane," 41, 44.).
66  Massing, "The Mane," 35.
67  Ibid., 40.
68  Bravmann, *Islam and Tribal Art*, 7.
69  See Lydon, *On Trans-Saharan Trails*, 144, and Holger Weiss, *Between Accommodation and Revivalism: Muslims, the State and Society in Ghana* (Helsinki: Finnish Oriental Society, 2008), 50.
70  Labelle Prussin, *Architecture in Northern Ghana: A Study of Forms and Functions* (Berkeley, CA: University of California Press, 1969), 8.
71  Bravmann, *Islam and Tribal Art*, 8.
72  Weiss, *Between Accommodation and Revivalism*, 52.
73  René A. Bravmann and Raymond A. Silverman, "Painted Incantations: The Closeness of Allah and Kings in 19th Century Asante," in *Golden Stool: Studies of the Asante Center and Periphery*, ed. Enid Schildkrout (New York: American Museum of Natural History, 1987), 94.
74  Ibid.
75  Ibid.
76  David Owusu-Ansah, *Islamic Talismanic Tradition in Nineteenth-Century Asante* (Lewiston, NY: Edwin Mellen Press, 1991), 4.
77  Ibid., 19.
78  John R. Bowen, *Religions in Practice: An Approach to the Anthropology of Religion* (Boston: Allyn & Bacon, 1998), 173.
79  René A. Bravmann, *African Islam* (Washington, DC: Smithsonian Institution Press, 1983), 19.
80  Louis Dupuis, *Journal of a Residence in Ashantee* (Henry Colburn, 1824), 142; in Bravmann and Silverman, "Painted Incantations," 95–96.
81  Ibid.
82  Ibid.
83  Thomas W. Livingston, "Ashanti and Dahomean Architectural Bas-Reliefs," *African Studies Reviews* 17, no. 2 (September 1974): 438–439.
84  Ibid.
85  Labelle Prussin, "Traditional Asante Architecture," *African Arts* 13, no. 2 (1980): 61.
86  Bravmann, *African Islam*, 62, 75.
87  Labelle Prussin, "Fulani-Hausa Architecture," *African Arts* 10, no. 1 (1976): 18.
88  Weiss, *Between Accommodation and Revivalism*, 43.
89  Ibid., 54.
90  Levtzion, *Muslims and Chiefs*, 54.
91  Ibid., 54, 56.
92  Esther N. Goody, *Contexts of Kinship: An Essay in the Family Sociology of the Gonja of Northern Ghana* (Cambridge: University Press, 1973), 10.
93  Levtzion, *Muslims and Chiefs*, 66.
94  Weiss, *Between Accommodation and Revivalism*, 84–85.
95  Ibid., 70.

96  Ibid., 58–59.
97  Ibid., 63.
98  Ibid., 73.
99  Ibid., 56.
100 See Esther Goody and Jack Goody, "Creating a Text: Alternative Interpretations of Gonja Drum History," *Africa: Journal of the International African Institute* 62, no. 2 (1992): 266–270.
101 Prussin, *Hatumere*, 25.
102 Labelle Prussin, "The Architecture of Islam in West Africa," *African Arts* 1, no. 2 (Winter 1968): 72.
103 Although a wall may have been an aspect of many traditional architectural practices in this area, its widespread adoption in the eighteenth and nineteenth centuries may have been due to the extensive slave raiding that was occurring during the time period as noted by many European accounts.
104 Prussin, *Hatumere*, 36.
105 Prussin's model seems to position Islamic penetration into an area more as a singular event than an ongoing process of continuous negotiation and interaction. I am more inclined to believe that patterns of shifting but constant interaction led to a perpetually evolving Afro-Islamic architectural imprint.
106 Prussin notes that as Muslims settled in the area, they were in many ways culturally and geographically isolated from their neighbors and thus somewhat marginalized within the community. Thus, their new social position did little to warrant the construction of proclamative architectural form as markers of identity and presence.
107 Alternate albeit unverified functions for this form have also been suggested, including acting as a hidden storage space for both goods and individuals seeking to avoid horsed raiders and slavers, a theory supported by the circumstances of the time period in which the mosque style developed as well as its placement along avenues of commercial activity. The presence of wooden stakes may also have given the mosque something of a defensive appearance, although no physical or architectural evidence has been found to verify these narratives.
108 Prussin, "The Architecture of Islam," 72.
109 This mosque apparently predominates in the rural savannah but I have yet to see any present evidence of it. It is possible that this type of mosque has disappeared or manifested as something else, given the propensity of modern mosques that now cover both the rural and the urban landscapes.
110 See Peter Mark, *"Portuguese" Style and Luso-African Identity: Pre-colonial Senegambia, Sixteenth–Nineteenth Centuries* (Bloomington, IN: Indiana University Press, 2002).
111 Peter L. Brent, *Black Nile: Mungo Park and the Search for the Niger* (London: Gordon Cremonesi, 1977), 13.
112 Ivor Wilks, "The Northern Factor in Ashanti History," *The Journal of African History* 2, no. 1 (1961): 29.
113 Wilks et al., *Chronicles from Gonja: A Tradition of West African Muslim Historiography* (Cambridge: Cambridge University Press, 1986), 143.
114 It is unfortunate that such structures and descriptions of them no longer remain, as it would have been interesting to compare their architectural vocabulary with that of the North African *ribat* as evidence of continuity in defensive architectural organization.
115 Goody, *Contexts of Kinship*, 32.

116 René Caillié, *Travels Through Central Africa to Timbuctoo and Across the Great Desert, to Morocco, Performed in the Years 1824–1828*, Vol. 1 (London: Henry Colburn & Richard Bentley, 1830), 437.
117 Ibid.
118 Ibid., 356.
119 Ibid., 257. Unusually, Caillié says the women were not allowed in this mosque and instead had their own mosque and that it is not much frequented. It is unclear whether this is a misinterpretation on the part of Caillié.
120 O. Cordelia Osasona and D. C. Hyland Hyland, *Colonial Architecture in Ile-Ife, Nigeria* (Ibadan: BookBuilders, 2006), 11–12.
121 Ibid., 13–15.
122 Ibid., 23.
123 Ibid.
124 Ibid., 50.
125 Mark, *"Portuguese" Style*, 24, 106, 141–142.
126 W. Moister, *Africa: Past and Present—A Concise History of the Country, its History, Geography, Explorations, Climates, Productions, Resources, Population, Tribes, Manners, Customs, Languages, Colonization, and Christian Missions* (New York: American Tract Society, 1879), 172.
127 Ibid., 174.
128 Ibid., 190.
129 Weiss, *Between Accommodation and Revivalism*, 193.
130 Philip D. Curtin, *The Image of Africa: British Ideas and Action, 1780–1850* (Madison, WI: University of Wisconsin Press, 1964), 256.
131 Lydon, "Writing Trans-Saharan History," 312.
132 Ibid., 205–206.
133 Weiss, *Between Accommodation and Revivalism*, 191.
134 Prussin, *Architecture in Northern Ghana*, 6.
135 Weiss, *Between Accommodation and Revivalism*, 15–16, 31.
136 Ibid., 21.
137 Prussin, *Architecture in Northern Ghana*, 4.

# 3

# *MALLAMS,* MOSQUES, AND MYSTIC STONES

## The Story of Larabanga

### Locating the "Land of the Arabs" in West Africa

The idea of location—geographic, cultural, spiritual, and historic—is particularly important when considering Larabanga. Its architectural environment is a cartographic blueprint of the political, social, cultural, and spiritual histories that motivated the physical development of the village. From a geographical standpoint, Larabanga, or "the land of the Arabs" in the local language, Kamara (also known as Larabansi), is located in Western Gonjaland in the northern region of Ghana. It is an area that experienced extensive trans-Saharan trade traffic from caravaners cutting east to west through the towns of Techelei, Mognori, and Morog before heading up to Burkina Faso and eventually the Sahel.[1] Spiritually, it is the only documented 100 percent Muslim community in the nation. It has often been described as a "town full of *mallams,*" or individuals with exhaustive knowledge of the Koran who act as spiritual advisors and healers. People journey to Larabanga specifically to take advantage of their gifts. In addition, the origin story of Larabanga has endowed the town with a number of "mental landscapes" upon which its unique spiritual powers are actively inscribed.[2] As such, there are numerous geographies based on spiritual, cultural, and historical identities that are layered within Larabanga's physical space.

Understanding these elements, however, requires knowledge about the Kamara as a cultural group and the primary ethnic group in Larabanga. They have played roles in the key formative moments of the town's history and in the region itself, particularly with regards to the Islamic identity that would manifest here. Further, understanding the specific ways that the Kamara of Larabanga have both assimilated and consciously departed from established regional traditions through the maintenance of specific traditions and structures within the space of the community highlights both the uniqueness of the group and the village as the regional pivot of Muslim spirituality in northern Ghana. These connections become apparent in the context of Larabanga's origin story.

As seen in the previous chapters, Larabanga was one of the final episodes in a long and illustrious narrative of Afro-Islamic development that began almost a millennium before in the northeastern corner of Egypt. The town arose in the sixteenth century as a spiritually empowered community whose architecture played an important role as a physical and symbolic manifestation of the value systems that resulted from Islam's extensive evolution over space and time. Larabanga's origin story—like many orally transmitted histories—contains a number of moving parts and possible readings as they relate to the individuals who are telling them and the lens of the time period during which they are being retold. It is also an origin story that requires an understanding of the cultural identities and relationships at work in the creation of this community as well as the processes involved in its formation.

This narrative in its most cohesive form begins with the founder of Larabanga, a powerful *mallam* named Ibrahim Braimah (also known as Yidan Braimah),[3] who journeyed with his older brother Abu Kabir into what is today the northern region of Ghana in the sixteenth century.[4] According to various local accounts, the soon-to-be founder of the Gonja Empire Jakpe received a prophecy that he would never be monarch in his own country (Mali), and that his "fortune lay in foreign lands."[5] Thus, he left Mali and proceeded southward to engage in a series of raids along what is now the eastern border of Ghana and into Côte d'Ivoire in the hopes of establishing his new empire. However, at an impasse at the Côte d'Ivoirian town of Kong he solicited the aid of an imam who called on his associates Braimah and Abu Kabir, the notable "descendants of Ayuba in South Arabia at Medina"[6] for spiritual intervention. These holy men proceeded to create charms that eventually allowed for the defeat of Kong and the establishment of a new Gonja Empire. In return, Jakpe bestowed upon the brothers and their future descendants a powerful position of authority as the spiritual advisors to Gonja royalty, gaining them the appellation "Kongote," which means "Kong is finished." This special relationship also exempted the newly formed Kongote from assimilation into the emergent Gonja collective, which was composed largely of conquered ethnic groups.[7] This was something they greatly desired, for even though they were invited to settle in the newly formed capital of Nyengye, the elder brother Abu Kabir refused the offer on the basis that the Gonjas were essentially infidels and that he and his brother could not live and marry among them.

This story provides the basis for the intimate relationship that the Kamara of Larabanga have long enjoyed with the larger regional group, the Gonja. It is a relationship documented through Gonja drum histories[8] as well as in written narratives such as the *Kitab Ghunja* and the *Amr Ajdadina*. It is also from the basis of this relationship that the Larabanga Kamaras have historically contributed members to a Muslim *karamo* contingent within the Gonja Empire known as the Sakpare,[9] descendants of both Muhammad Al-Abyad and the "Kamaghatay lineage," i.e. the Kamara cultural group, who are regarded as the "wives of the chiefs"[10] and act in a spiritual as well as an advisory capacity to the Gonja ruling class.[11] While the Sakpare/Kamara do not involve themselves in the politics of the Gonja Empire per se, they are nonetheless crucial in matters of spiritual import.[12]

Yet even with this intimate relationship, which is based largely on a shared history and a political association, the Kamaras of Larabanga continue to maintain a friendly yet separate relationship with the Gonja and to some extent the Sakpare as well, even though they have historically been a part of this group. One potential reason for this separation from the Sakpare is that Sakpare Muslims as an autonomous group are increasingly assuming roles previously held by the imams of Larabanga and its sister city, Dokrupe; this has generated a certain amount of anger among the elders in each village.[13] Yet the distance between the groups has been present long before their relationship began to deteriorate. In most Gonja contexts, the Sakpare continue to coexist with the Gonjas in shared "twin" communities; the Kamaras, in contrast, maintain an autonomous village in Larabanga. Such organizational patterns have led to linguistic differences as well, with the Sakpares speaking the language of the Gonjas and the Kamaras maintaining as much as they are able their original dialect.[14] Along these lines, although the Kamaras do not share a language with the Gonjas, they share standard greetings based on a mutual Mande dialectical history.[15] Yet beyond these greetings, the linguistic sharing stops, mimicking the social, political, and spiritual relationship between these two groups, as societies linked by a common history and mutual respect (enough to warrant a shared, understandable greeting) but maintaining a certain degree of formality and separation, and thus distinctively separate identities.[16]

This separation finds its historical justification in the remainder of Larabanga's origin story. After they left the company of the new Gonja leader, the brothers decided to settle further east and establish more Islamically orthodox settlements.[17] The brothers traveled for a long time, until Abu Kabir, who was by now quite elderly, could not go on. They eventually came upon an area that was populated by both the Dagomba cultural group, who arrived in the thirteenth century from northern Nigeria, and the Mamprussi, an ethnic group that originated in northern Ghana and Togo. Kabir established a community here with the goal of both embedding Islam in the region and protecting the easternmost borders of the new Gonja empire from the threat of invasion.[18] This village became known as Dokrupe (which means "old man's house").[19] When Kabir was firmly established, he ordered Braimah to continue on and found another settlement to defend Gonja borders.[20] "In case of war coming from the east," Kabir is said to have told Braimah, "you will be there to help the Gonjas. I'll help from the west."[21] When Braimah asked which direction he should go, the two brothers prayed, and a rainbow appeared in the sky.[22] Then Kabir took up a spear and threw it, declaring that wherever that spear should land, that is where Braimah must settle. Braimah followed the spear for many days until suddenly it embedded itself in the ground. That spot became the first town quarter of Larabanga, fittingly named "Yirikpani," or "the landing of the spear." This is also the site where Braimah built the first village mosque (the same mosque that continues to stand today), placed there because Braimah detected a white aura or brightness around the area of the spear's landing and took it as a sign of the presence of great spiritual power.[23] Braimah settled and eventually took a Mamprussi wife, and through the couple the twelve "houses" or clans of the

Larabanga Kamara eventually descended. These houses—the Yidanyiri, the Pasabu, the Sundarra, the Sandee, the Kandasuree, the Banga, the Dagbong, the Dgafong, the Mankarabu, the Lamayiri, the Kambeeyo, and the Dokurugu—compose the patrilineal lineages of the Kamara people, and each name has specific meanings, although there is not consistent agreement on them.[24] But another important element of this particular narrative is the fact that in taking a Mamprussi wife, Braimah initiated the development of a kinship-based relationship with the Mamprussi cultural group as well, which allows the two groups to maintain something of a "joking cousins" relationship, a level of social intimacy that allays any potential political or social tensions that may arise between them.

The next formative moment in Larabanga's spiritual development was Braimah's acquisition of Larabanga's ancient Koran, which is still in the village today. As he was constructing the town, Braimah prayed to Allah for a Koran with which he could spread the Islamic faith. A remaining resident of the people who had occupied the area before Braimah's arrival told him of a nearby site known as "Zugbeni," or "base of the mountain," that was believed to have spiritual powers.[25] Braimah went there and prayed that a Koran be delivered to him; at that point, a large Koran fell from the sky into Braimah's waiting hands.[26] At the time, there were supposedly only seven Korans in existence, "all of them lengthily written by hand and bound into no less than sixty Hinzibs each and kept wrapped bulkily in many blankets stored in large calabash bowls far away in Mecca."[27] It is believed that Braimah was rewarded with one of the original seven, making the Koran in Larabanga one of the oldest compiled Korans in Africa. It is kept in the village under a custodian's care and is brought out each year during the *Jintigi*, or Fire Festival, when the new Muslim calendar is celebrated. Both Muslims and non-Muslims come from all over the region to hear spiritual readings from the book, which have great power and reveal insights about the coming year.[28]

Supporting Larabanga's spiritual reputation as well is a late nineteenth-century account of Guinean warrior Samori Touré's encounter with the power of Larabanga, an encounter that would ultimately result in his demise. At the time, Touré was an extremely powerful West African military leader, having founded the short-lived Wassoulou empire (1878–1898) and successfully resisted French colonial oppression for over two decades.[29] However, Touré was also a ruthless despot whose reputation for subjugating and massacring numerous local populations across the region during his campaign made him widely feared and reviled; it was said that even the trees collaborated with him in his mercenary campaigns. Yet for all this, Touré had been warned by his grandfather early on in his campaign that although he would have many victories "he would one day come upon a place he should not venture to capture."[30] Sure enough, when he and his army attempted to pass through the area of Larabanga on a regional military campaign, his horses sank into the ground up to their withers along the road next to Larabanga. At that point, Touré sent a message to the elders of Larabanga in order to establish a peaceful resolution to the situation. However, the elders were naturally wary and devised a plan to test Touré's sincerity. The military leader would be invited to a

village feast, at which one of the elders would be wearing an enchanted hat.[31] If Touré attempted to appropriate the hat for himself, he would subsequently face regional military defeat. If he did not, he would be able to pass on. Unfortunately for Touré, his greed overwhelmed him, and he did indeed take the hat; soon after, his campaign came to an untimely end and Touré was exiled to Lamborene, Gabon, where incidentally he died in the company of none other than Cheikh Amadou Bamba.[32]

The latest spiritual activation of Braimah's prayer site occurred in the 1950s, when the Ghanaian public works department began constructing a road between the towns of Bole and the regional capital of Tamale. The road was sited to pass directly through this sacred area, which subsequently and perhaps unsurprisingly triggered a mystical response from the site. Surveyors and workers in charge of the project found their efforts to clear the space consistently obstructed by a large rock that kept appearing in the center of the construction site. Every attempt to remove the stone proved unsuccessful, as it would continually reappear the following day. One account even holds that the stone was once taken as far away as Côte d'Ivoire, only to return again the next day.[33] Eventually, the road was rerouted to avoid this site, and aerial views of the road reveal a massive curve that skirts around the site where Larabanga's "Mystic Stone" (see Figure 3.1) now sits. The site is considered an umbilicus, in the words of Hussein Salia, connecting Larabanga to the heart of the Islamic faith in Mecca, and while some have obviously questioned the authenticity of this tale, its value to the continued reputation of Larabanga as a site of power remains the key component to the continued propagation of this narrative.

## Constructing an Islamic Community from the Inside Out: Interactive Architecture

From the arrival of Braimah to the contemporary period, the power of the Islamic faith as it has manifested in Larabanga has continued to act as a type of homogenizing force that has shaped the cultural and spiritual aspects of the community. In fact, Islam as it exists within this context is one of the principle organizational paradigms of the village, molding the physical aspects of the community in the image of an ideal West African Islamic space. Along these lines, Islam has contributed to the unofficial establishment of various "hearts" within the village space. While these are not necessarily *geographically* centered areas, they are ideologically centered in the sense that they are symbolic pivots around which the community revolves (see Figure 3.1). The idea of the center is, in fact, key to Islamic faith and practice across multiple contexts and geographies, and is represented in numerous ways through the use of architectural and decorative elements that gesture towards a central point of focus. The most direct architectural manifestation of this ideal in the Islamic world, generally speaking, is the Ka'aba, a cubed shrine near the center of Mecca that is considered the most sacred site in Islam and the perceived point around which the Islamic faith orbits; this relationship is echoed by the circumambulatory movements of the thousands of pilgrims around this central point each year during

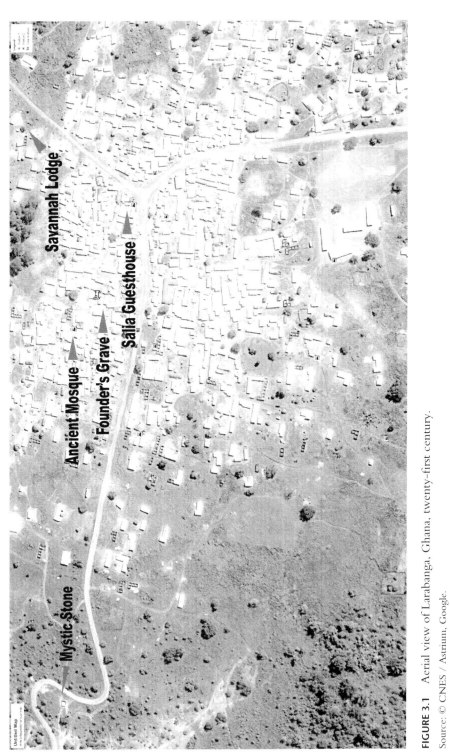

**FIGURE 3.1** Aerial view of Larabanga, Ghana, twenty-first century.

Source: © CNES / Astrium, Google.

the *hajj*, or pilgrimage to Mecca. This ideal also extends across multiple branches of Islamic philosophy, including Sufism, where the notion of the *qutb* evokes the metaphor of an axis or a bridge between physical and spiritual worlds. Such concepts find traction in the "hearts" of Larabanga, which are predominantly oriented around the structures and spaces from which Larabanga draws the bulk of its spiritual power; these are the ancient mosque, the "Mystic Stone," and the grave of the founder, represented by a large stone placed in the middle of a major thoroughfare only twenty feet away for the clearing of the mosque (see Figure 3.2). These forms actively channel the spiritual power of the Ka'aba from Mecca as metaphysical conduits, inscribing and implanting sacred aura into the landscape and also empowering the individuals within as conveyors and operators of that force.

This idea of center and, by association, periphery, and the spiritual ideals expressed through it, have also governed the way that Larabanga has expanded over successive generations as a physical space. Larabanga is organized into four sections, Tugbeni, Yirikpani, Fourufura, and Zuguni, and each contains at least one mosque and an imam, who is also a member of the council of elders. Importantly, each mosque has also traditionally formed the ideological "center" of each quadrant.[34] But ideas of center and periphery also manifest on a more intimate level too, particularly with regards to the organization of a clan or family line within their allocated land. Within each section of the village live at least two of the twelve Kamara clans, and each clan is given land based on their membership. Along these lines, clan settlement patterns often mirror hierarchical familial relationships, with the central areas often being the sites of the compounds of senior or elder members of these families. From these central points, other family compounds radiate outwards around and usually in deference to this central or

**FIGURE 3.2** Founder's grave, Larabanga, Ghana, 2011.

"grandfather" compound, creating a system of satellite compounds, an organization that has a natural resonance with the types of fractal patterns seen across Islamic material and architectural culture (see Figure 3.3). The centrality of the Kamara familial structure with its emphasis on the importance of elder members finds architectural manifestation and reinforcement, thus, through the symbolic creation of "descendent" compounds that radiate out from this familial point of origin.

However, while such organizations continue to function in the contemporary period, some of these patterns have become decidedly irregular due to increasing spatial restrictions, particularly in the older, more densely packed areas of town. The result is that familial compound patterns have become less nuclear, branching out over a wider area and in an unpredictable trajectory. Yet, the ideological perception of a cohesive clan area remains and is enforced through the protocols of land ownership in Larabanga. Should a stranger who is not of the Kamara cultural group move to Larabanga and want to build, he must have an intercessor from the village who can speak on his behalf to the rest of the clan. In this way, "a stranger cannot take what is not theirs and a member of the community cannot give what is not theirs."[35] Thus, the conventional familial developmental pattern with its numerous layers of centers and peripheries is not only effective at maintaining divisions among themselves, but also mediating interactions with outsiders.

Ideas of center/periphery and the fractal elements involved in their physical manifestation are also obvious in the modes through which the community's physical space interacts with the non-communal spaces surrounding it. The boundaries of many rural villages, including Larabanga, are not absolute. These borders are shades of grey, perhaps better understood as stages of civilization, that range from the outermost limits that are marked by domesticated agricultural fields, areas for livestock, and sometimes fencing, before moving inward into areas that show signs of habitation such as the thinning of the brush and the occasional path or outlying hut. Eventually, outlying compounds begin to appear, isolated from but nonetheless connected to the village proper, before more regularly spaced compounds become consistently encountered. Eventually one arrives at the village center, where the vegetation is usually sparse save the occasional tall tree outfitted with platform benches where people can rest and talk in the shade. Compounds are often densely clustered in these areas and typically share walls, while major traffic pathways run alongside these spaces. These are also the social and market areas for the community, where one can typically find townspeople engaged in lively conversation, conducting business, or watching the traffic. Passing through the village center and continuing onward, one will experience a reverse of the previous sequence, compounds becoming increasingly sparse and then giving way to fields before leaving the village behind all together.

Yet even though villages like Larabanga "occur" in stages, which is suggestive of a dedicated system of community development, there are also certain fundamentally flexible elements within this system that create cohesion and interaction between these spaces and individuals that inhabit them. Although the village manifests in stages of civilization, the community space itself contains no such organized plan.

**FIGURE 3.3** Theoretical compound with satellite complexes, Larabanga, Ghana.

There are no straight lines or grid patterns in the village, and Larabanga in fact resembles a highly informal yet somehow balanced configuration (see Figure 3.1) where community members consistently encounter and interact with one another. Indeed, in walking through the denser areas of Larabanga, it is quite possible to accidentally stroll into someone's compound area; there are few physical or conceptual "warnings" that one is traversing a barrier from public to private space. In other less densely populated areas, domestic compounds sometimes do not exist at all, in the strictest sense; they are located in an open area with no modes of demarcation between exterior and interior. Likewise, some sections are separated by pseudo-demarcations, such as clearings, grassy areas, and trash dumps, while others are signaled by alleyways bordered by blank inward facing walls.[36] There are also spatial divisions that are largely invisible to the naked eye, known only to members of the community or those who have learned of these boundaries over time through repeated exposure to them. When these intuitive spatial parameters are not followed—for example, someone builds a structure in the middle of a thoroughfare—it can greatly interrupt the particular organizational mood of the built landscape and provide a jarring note in the orchestration of architectural signs. However, recognizing these rifts in the natural architectural order requires a specific register of knowledge; those without it may pass these areas by unperturbed.

All of these systems at work build intimacy, familiarity, and openness while re-establishing communal bonds that echo their kinship under a single ancestral founder. These organic layouts also in some ways equalize community members, who are not traditionally differentiated by material wealth but instead by reputation, wisdom, and age. The informal fluency of public and private space in the village reinforces the idea that there can never be a true separation within Kamara culture, only amorphous borders and suggested paths (this is in contrast to modern structural developments in the community, which are increasingly changing the architectural and cultural horizon of the village, the subject of Chapter 4).

However, this is not to say that distinctions between spaces do not have important social, cultural, and spiritual functions within the community. Indeed, the centralized yet informal plan of the village is one that is repeated in microcosm in the space of the domestic compound itself, emphasizing the importance of the spatial system in place. Within the familial compound, a centrally placed open-air courtyard acts as the focus of activity, interaction, and familial performance while the more individuated living areas surround and enclose it. As such, it is the courtyard that contains the detritus of everyday life: pots, clothes, chairs, tables, stoves, and even livestock. Many areas of the courtyard are also worn smooth, indicating high traffic areas, while others are kept studiously clean, swept clear of debris, which might indicate a cooking or an eating area. However, the fact that the courtyard has remained a central focus even in the face of changing house forms and styles in the contemporary period speaks to its continued importance even as the courtyard faces increasing challenges from the varied compound layouts that are currently being developed. Compound organizations range from

largely rectilinear organizations to a more tradition-oriented mixture of rectangular forms and round huts enclosed by a mud or brick wall (see Figure 3.4). The most recent development, however, is an L-shaped rectangular complex with no clearly demarcated courtyard area; there is typically only a clear space in the front of this house form. These organizations reveal that Larabanga compounds do not have a typical "style." Yet even with these variations and shifts in organization, family activities and interactions remain rooted in a dedicated exterior space that, walls or not, remains the focus of life and the point from which all things familial expand.

In conjunction with ideals of center and periphery as expressed by the courtyard, however, also come aspects of border, boundary, and the layers of permeability that exist between the exterior public space and the interior familial space. This subject was discussed in the first chapter and finds apt representation in the architectural spaces of Larabanga. Entrances into these familial compounds, as diverse as they are, nonetheless utilize similar forms largely because many still privilege an organization based around a central, open-air courtyard. Traditionally, the buildings forming this outer perimeter have been connected by walls or other structures; yet in some instances, these spaces might remain open as points of entrance into the compound, often covered by some type of roofing as a way of including the entrance in the architectural program of the compound. Spaces demarcated in this way constitute a "formal" channel into the compound, or an entrance singled out by architectural gestures that notify visitors that this area is an

**FIGURE 3.4** Compound composed of formally diverse structural units, Larabanga, Ghana, 2011.

accepted point of penetration into a compound. However, there are also less formal "borders" in these compounds in the form of holes in the walls or cracks between buildings that allow children to run through and neighbors to come and go as they please, an "off-the-record" entrance point that has the somewhat coincidental effect of promoting a sense of community, kinship, and interconnectedness. In addition, the use of impermanent or mobile structures such as screens, curtains, and other "soft" architectures create semi-enclosures that can be adjusted easily and thus are often used in temporary or fluid transitional areas like doors and windows. Importantly, these combinations of both soft and hard boundaries allow each domestic compound to craft a particular identity, which in turn gives each village a distinctive identity as well.

Yet these formal and informal sites of penetration are also areas of potential growth for the compound; they are flexible spaces or spaces-in-waiting that can be potentially filled with additional housing units should the need arise. Flexibility of space is in fact an extremely important component in Larabanga; as such, it is a concept that not only manifests in domestic spaces but also public and religious ones as well. Like Larabanga's domestic compounds, the ancient mosque is also a structure that can accommodate growth and adaptation within the congregation through the addition—in the clearing next to the structure—of informal prayer hall spaces. This mobile and transient mosque space is made possible by the fact that the idea of a "mosque" itself as a simple space for prayer is not bound by any particular architectural or even three-dimensional form. Generally speaking, wherever a Muslim decides to pray in effect becomes "mosque" for the duration of the prayer; however, the development of formal, "acknowledged" prayer spaces has given the mosque the imagined reality of a dedicated structural space. Areas outlined with stones, soccer fields, storefronts, covered prayer spaces, even swept ground, in addition to actual three-dimensional architectural structures, have, can, and do serve quite effectively as mosques as the need dictates.[37] The key to the success of these architectural spaces is in the actions and behaviors of the faithful that catalyze their creation as "physical units" used to "orient [the] behavior" of the congregation.[38] The ritualized process of "creating" and participating in ephemeral mosque space reinforces the social order of a community through the organization of bodies in space according to age, gender, and religious hierarchy. It also reaffirms communal cohesion through their collective performance of this choreographed event.[39]

As such, the transitional nature of these forms, largely supported by the nature of their permeability, is also an effective way to map time and social practice within Larabanga, particularly in domestic structures. In terms of time, the older compounds in the denser areas of the town are more enclosed and less permeable than newly constructed compounds on the outskirts, and this aspect will be explored more comprehensively in Chapter 4. With regards to social practice, however, the permeability of a compound also reflects a particular cultural dynamic within the village, with regards to established social practices of interaction and the ways that they are articulated architecturally.

Familial hierarchies, for one, find structural expression in the organization of bodies within compound space, and how bodies penetrate and occupy space at different points in life. With regards to the creation of familial spatial divisions, the process begins with marriage, a ceremony that involves the ritualization of specific interactions and relationships between architectural spaces and women in particular. Marriage in Larabanga among the Kamara is a highly ceremonial affair governed by a series of protocols that occur in a specific order. Historically, a contract of engagement must be created between a potential husband and the parents of the bride, after which a dowry or "bride price" is determined and a period of engagement is agreed upon. The news is then shared with the rest of the bride's extended family. But during the period of engagement, a sequence of actions are expected to take place that involve a series of procedural crossings and re-crossings of architectural boundaries and thresholds. The husband-to-be is expected to visit the compound of his future in-laws each Friday, bearing small gifts. Near the conclusion of the engagement period, the husband-to-be is also responsible for assembling *laife*, which is composed of items of attire, food, and money to send to the bride's house as a sign that he is ready to fulfill the marriage contract. After this, the day of the wedding is decided upon, and the bride now begins her preparations. This again catalyzes a series of traversals as well as containments across and within architectural barriers. The parents of the groom visit the bride at her family's compound to perform *Lele*, which is the application of henna to her skin, indicating that she is now "captured." At this point, the bride is confined to her parents' compound until her wedding day. Two days before the wedding, the village elders convene to bless and officially recognize the marriage; the night before the wedding, the bride bathes in special herbs in order to cleanse her for her wedding day. And finally, on the day of the wedding, she is carried to her husband's home on the shoulders of a capable man, during which she performs *Kadua*, a dance in which she holds and moves horsetails in each hand. Upon arriving at her husband's home, the celebration commences and the couple spend their first night as man and wife in her husband's home. The bride is expected to have retained her virginity and, if this is found to be the case, the news is spread throughout the village the next day by the female members of the bride's family. At this point, the husband's family awards the bride a white cloth called a *Tumba*.[40]

The process of marriage within the Kamara cultural system is a significant investment whose success is largely based on dialogue and exchange. But it is also a process deeply embedded in various transitions between and across architectural borders and boundaries, during which human bodies are contained and then released, allowed to exit and then to enter spaces. Over the course of the engagement, the husband-to-be is regularly expected to enter his in-law's house and provide gifts, a situation that places him in a socially disadvantaged position as an outsider attempting to find a way in. At the conclusion of the engagement period and after the arrival of the *Lele*, it is the bride's turn to experience this physical and psychological transition as she becomes physically confined within the space of her family home. Architectural and social boundaries are what prevent her

from transitioning further until the time is right. But her agency is still not returned when she is freed from her confinement on her wedding day; she is physically transferred from one domestic space to another—that of her husband and her husband's family. Although the physical transition from one architectural space to another is what activates her transition from an unmarried woman to a married woman, it is the wedding night itself that seals it, the husband entering the "house" of his wife as a familiar.

The ideas of border, boundary, and familial bodies in space continue as these newlyweds begin their married lives, usually within a room in the compound of the parents of the groom but also occasionally in their own compound. Once a child is born, the mother and child typically stay in one room, while the husband moves into another. Following the birth of another child, the mother and her children continue to occupy a single room until the children are older. Once the children are older, or at least one child is old enough to look after the others, the children are collectively moved to a room of their own, and sometimes a new room will be constructed for this purpose. At this point, the mother maintains a room of her own, typically with the youngest child, who might still need assistance, and the father continues to maintain his own chamber. After male children reach puberty, they are often given a room of their own, or one to share with other adolescent males with whom they will live until they get married or leave the area. The female children will occupy a room of their own as well, often with the younger children (both male and female), until they are married. Thus, the changing of rooms often coincides with the achievement of certain age-related milestones within the family unit, such as birth, puberty, or marriage. In some ways, the physical structure of the familial compound becomes a metaphor for the female body itself, nurturing the growing family and maintaining the flexibility needed to expand and produce as the need and opportunity arises, yet essentially remaining a space occupied by husband and children.

The idea also finds traction as an important component in the distribution of spaces in polygamous households, polygamy being a common social practice, particularly in Islamic areas, although its extent and the modes in which it is practiced vary from community to community. It is, nonetheless, a familial structure that necessitates a carefully considered organizational plan within a compound that both accommodates the specific relationship of the man with his wives as well as the interpersonal dynamics between the wives, their children, and their subsequent families.[41] In polygamous households in Larabanga, there typically exist extremely collaborative relationships between wives, although there remains a largely age-related hierarchy among them. Harmonious relations are encouraged architecturally through the organization of democratically sited living spaces among the wives as a way of creating accord within a compound. In this way, room occupancy not only articulates the narrative of a family and its current stage of life, but also the concept of an ideal familial relationship, a "dream" of unity. This aspect is also mimicked in other regional cultural groups as well. For example, in the traditional courtyard of the Islamicized Dagomba king or Gulpke Na of Tamale

(see Figure 3.5), which is the regional capital of Ghana's Northern Region, his ten wives' individual huts are organized in a rough semi-circle around a shared cooking and water area. The head wife's house lies directly to the left of the primary audience hall of the king, and subsequent wives' huts are lined up after hers. The children of the Gulpke Na in turn occupy a compound adjacent to the wives' compound. The elliptical organization of the complex indicates the presence of a plan that has been modified over time as additional wives—and subsequently huts—joined the family. Thus, family cycles in both Larabanga and other communities and societies in the region are made manifest within the architectural spaces of the compound.

But to move away from the dynamics of space within the familial structures for a moment, another way communal social dynamics are expressed using borders, boundaries, and divisions is through the establishment of categorizations of the insider and the outsider or "other." There also exist numerous stages of being or gradations between these two, but borders in such situations are important because they enable the performance of social dynamics that form the basis of relationships between these individuals and subsequently the personality of the community as a whole. Cromley notes, for example, that open-plan types, or compounds that allow direct access to the exterior, are typically associated with communities that are defined by "close, interpersonal relationships"; in contrast, domestic spaces that are "closed" reflect "a social system based on rank ... [that] ... establishes order for both strangers and inhabitants."[42]

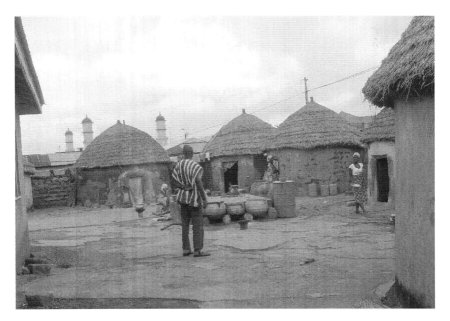

FIGURE 3.5   Courtyard of the Gulpke Na (traditional ruler of Tamale), Tamale, Ghana, 2012.

Along these lines, the presence of these borders and the way they classify individuals as either "belonging" or "not belonging" have resulted in the creation of performances and behaviors required by individuals to traverse these borders. This, over time, has established norms of interaction and the creation of a cohesive interactive protocol. In terms of gaining access to an interior space, protocols often dictate a set of culturally oriented actions that allow individuals on both sides to engage in an initial interface based in shared, locally contextualized knowledge.[43] This initial interaction sets the subsequent trajectory for further interactions to take place (or not).

Such processes of architecture dictating the conditions of human interface are extremely strategic within compounds located within the congested interior space of Larabanga, where exteriors are necessarily demarcated in ways that allow for the effective management and delegation of space. Many of these structural aspects echo tradition-oriented Islamic settlement plans, which tended to favor internally focused areas and specialized access points into the interior. Along these lines, many of the walls in Larabanga that face communal walkways and thoroughfares in the village have no penetration points, or if they do they come in the form of minimal window openings and rarely any doors. Entrances are also traditionally placed in the center of a compound wall located away from the main structures of the compound and sites of activity within; this placement obscures a direct line of sight into the compound and thus protects the privacy of the inhabitants. However, because many compounds still also maintain the aforementioned "unofficial" permeable areas in corners and other breaks in the wall, the organization of many of these compounds seems somewhat paradoxical. However, perhaps it is better to read this plan as suggestive of the fact that protocols for entrance are guidelines rather than actual rules, and that a civilized individual and one not intimately familiar with the family should have the good grace to use the "official" entrance. Along these lines, identifying the "official" entrance can sometimes be challenging, as many points of entry into compounds can look the same. However, the "primary" entrance is often identified by its position in relation to the degree of activity going on outside. In other words, if a compound is organized along a high traffic route, the entrance facing that route will typically assume the status of "primary entrance" by virtue of its proximity to a primary conduit of village movement.

Important to note as well is the fact that in addition to obscuring direct lines of sight into these compounds from the entrance, these entrances also typically privilege sight from the *interior* as opposed to their exterior. These points of penetration typically consist of a doorframe under a lintel, a passageway of a few feet, or simply a space between buildings, but they nonetheless only typically allow incoming visitors a constricted glimpse of familial space. Conversely they themselves are framed by this entrance space and thus fully exposed to interior dwellers. In some cases, the acoustics of the compound also cause visitors to be heard before they are seen. The entrances in many ways act as the ears of a complex that funnel exterior sounds into the relatively contained interior. The minimal amount of penetrative points along the compound wall also actively minimizes noise pollution in the interior.

However, it is these points of access where the tone of encounter is set between the outsider and the insider, establishing a framework for subsequent interaction. These conduits between interior and exterior are highly charged frontier spaces that require specific actions and reactions from both parties for this theater of performance to continue further. Because of the importance of this event, the protocols involved for entering are not just physical, but verbal as well. The greetings offered when one enters a compound are a reflection of the culturally dictated procedures for transitioning from a public to a private space, a practice common to the region as well. As Goody notes in relation to the Gonja, "how to greet, when to greet, and whom to greet are among the first lessons to be mastered in Gonja."[44] The greetings one gives are also nuanced by factors including time of day, status of the giver and receiver, specifically tailored information concerning health, family, and the like. Yet because of the Islamic frameworks through which the Kamara greet, initial greetings in Larabanga are often less nuanced, lacking the strict differentiation between men and women, for example, and thus appearing more casual and informal. In Larabanga, one gives the universal Muslim greeting "Salaam Alaikum" (Peace to you) before entering a compound or a room. After one is greeted with the response "Bismallah" (In the name of God), which is used to welcome, one can enter a space and announce one's business. Interestingly, this more relaxed approach to greeting also seems to be reflected in the generally more permeable nature of the domestic compound. Yet while this greeting as a screening procedure may seem woefully insufficient, it is only the first part of a broader, much more extensive performance that sets the stage for additional interaction. Verbal sayings at this point are complemented by additional nonverbal actions, which include body language, gestures, eye contact, and tone, all semiotic gestures that acknowledge any hierarchical relationships between two parties and set the next piece of the puzzle in place for the future of the interaction.

Thus, in many ways, both verbal and architectural vocabularies are necessary to establish the type and quality of the social interaction that occurs within this transitional space. Architecture, though, provides the initial platform of interface, followed by verbal interactions that subsequently establish the foundation on which one builds the "real" conversation. Importantly as well, the physical establishment of the interactive area of the entrance for these individuals positions and organizes bodies in space. As such, different interactive areas catalyze different types of interaction. A closed door, for example, necessitates an alternate approach to successfully gaining entry in contrast to an open space in the wall. The protocols of greeting as a method of social maintenance and control are also different here. A crack in the wall that allows one to enter easily into an interior familial courtyard is typically not utilized except by the very young or those intimate with the family. Conversely, the presence of a physical barrier such as a door or curtain blocking an entrance into a compound or room indicates that one should remain outside until invited in. This initiates the process of announcing one's arrival through verbal communication and reciprocation, and then often taking one's shoes off before entry as a further sign of respect. All of this points to architecture as a tool of social

maintenance, evoking social protocols at key structural points of interaction to create normative performances that in turn support cohesive communal relationships.

There is, however, a final aspect that needs to be mentioned with regards to architecture as a platform of communication and a space of interface between individuals that moves beyond issues of center/periphery, border/boundary, and flexibility of space. Strategies of the surface in the form of decorative but also fundamentally communicative features also play an extremely important role in conveying knowledge about an individual's condition and/or reality, and thus defining the nature of relationships and interactions that can be had with such individuals.

Surface schemes in Larabanga in the form of pattern and script also each play a role in crafting interactive events between individuals via the medium of architectural form. The application of pattern to the plaster of a wall has long been a popular practice in West Africa and has assumed form in Larabanga and surrounding areas as delicate pointillist decoration, sometimes accompanied by embedded decorated calabashes, which are applied to the surfaces of structures primarily by women and children (see Figure 3.6). Although it is practiced less and less in the contemporary period, this type of decoration has played an important role not only as an exterior aesthetic but also as a communicative tool.

These designs also effectively demarcate compound space as gendered space.[45] The interior areas of the family compound in Larabanga and most other Islamic communities as well have historically been the realm of women, who are often single-handedly responsible for making it function as a space for family life. Within Larabanga, women enhanced this domestic territory by inscribing abstract pointillist designs around the entrances and on the exterior walls of the family compound as a statement of this authorship. These complex pointillist designs, made by the pressure of women's fingers into the soft material of fresh plaster, often covered entire wall surfaces (see Figure 3.6) and also occasionally incorporated waved and zigzagged lines. These compositions have been interpreted variously as a calendar or record of events,[46] an indication of the owner's occupation,[47] or even a functional device to interrupt rainwater flowing down the wall and thus protect the structure's integrity from erosion.[48] Yet these marks also resemble citricization designs, which are made by making cuts into the skin and then inserting material and/or medicines to make these cuts heal in a raised pattern. Traditionally these marks were used to delineate clan or family membership, although at other times they were also sites where medicines had been inserted, often at the temples, to protect newborn infants from illness.

Yet in each case these designs speak of the impetus towards an "all over" aesthetic devoid of empty space, a popular Islamic artistic sensibility that also tended to privilege the abstract over the representational. Through these designs, a decorative envelope is created for an architectural body that is capable of communicating occupations, identities, and important dates, while also potentially singling out important areas of the compound as well. To this end, these designs were often concentrated around the doorways, re-emphasizing yet again the importance of

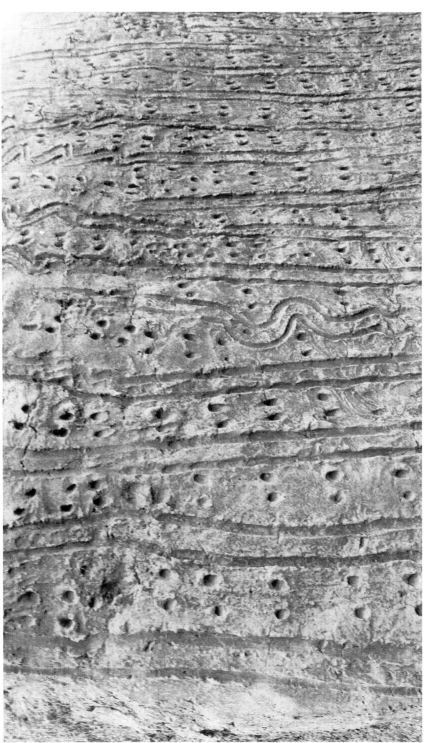

**FIGURE 3.6** Pointillist decoration on an exterior compound wall, Larabanga, Ghana, 2012.

this area as a zone of transition from the interior to the exterior and thus site charged by the potential for interactions.

A complementary decorative practice to this pointillist program that also graced architectural surfaces but was generally limited to Afro-Islamic communities like Larabanga is the utilization of Arabic script, which can be found scrawled somewhat sporadically across the major exterior walls of familial compounds. Arabic text has a long history within Islam-based communities across the world as a script endowed with spiritual efficacy, able to empower surfaces with blessing and/or authority. In the case of Larabanga, Arabic script acts in capacities that are directly related to the specific circumstances in which it appears.

Oftentimes, the presence of Arabic script indicates that an individual within has completed one of the most important pillars of Islam: the *hajj* (pilgrimage) to Mecca. Such an undertaking is extremely expensive and time consuming and often requires a great deal of planning and commitment on the part of the traveler. Therefore, one's successful completion of this holy task is a source of great pride and prestige in Larabanga. The inscriptions themselves are meant to announce this accomplishment, appearing as a visible, exterior sign on the surface of the compound usually along an uninterrupted portion of wall that allows the script to flow unimpeded across the surface. Script also often appears on the sides of walls facing outwards towards exterior communal spaces as a way of advertising this information.

Along these lines, this text, much like the architecture it adorns, works to provide a point of entry not necessarily into the physical compound, but into the specific values, ideals, and meanings that characterize the identity of the individual within. The script often indicates the dates of the *hajj* as well as the name of the person who undertook it, accompanied by a blessing (see Figure 3.7). Less directly, though, this text also identifies the spiritual commitment of the individuals living inside, their level of literacy and education, the social and cultural codes they live by, and the daily and yearly cycles that govern their life "routine." "Polysemy,"[49] to use Turner's term, or the multiple significations of a single symbol, are intended to be economical in their signage, and within cohesive environments in which a symbolic paradigm is not only widespread but also actively reinforced and reproduced, such multiple meanings become possible. The presence of this script thus not only conveys information about the individual, but also potentially the protocols of respect that are required to interact with the person.

It is important to note, however, that there are few in Larabanga that have the necessary skills to read this text. Although children in the village regularly attend Koranic lessons and thus learn to recognize Arabic script, few except those dedicated to a life as an Islamic scholar progress towards a fluent understanding of the language itself. In addition, some of the Arabic characters used may be incorrectly formed and words may also be misspelled. Thus, Arabic text acts less as a communicative device and more as a semiotically significant mark of Islamic identity as well as a symbol of the status and even potential self-fashioning. Although such indirect signification occurs more readily in verbal exchanges, it is an interesting question to consider from an architectural point of view the idea of

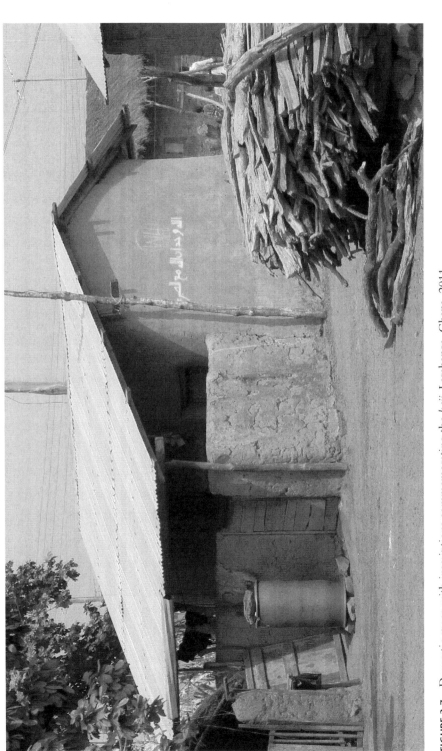

**FIGURE 3.7** Domestic space with inscriptions commemorating the *hajj*, Larabanga, Ghana, 2011.

"face." "Face," more commonly known as one's reputation or standing, is a universal human concern that is often maintained, enhanced, and presented powerfully in one's interactions with people. Yet one's ability to maintain face often depends on the cooperation of those with whom they interact; thus, a community's mutual understanding of and collaboration with an individual's self-image is not only necessary to establish social hierarchies within a community, but also to govern the interactions between community members.[50] These Arabic inscriptions, displayed broadly on the sides of domestic compounds, undoubtedly act as "face-enhancing" tools that not only reflect the identity of the individual inside but also the specific expectations this individual may have for those that would choose to interact with them.

Yet Arabic inscriptions in the context of Larabanga also have an alternative meaning that is directly related to the identity of the Kamara as a spiritually empowered group. To provide some context for this broad-based reputation, the Kamaras have historically been regarded throughout West Africa as highly empowered spiritual advisors and healers. There are supposedly six Kamara communities in West Africa,[51] all of whom are descended from a Saudi Arabian ancestor named Abu Ayyub Ansari (also known as Al Ayuba or Muhammad al-Abyad), who came to the Sahel from Mecca early in the histories of the West African empires and was, in turn, said to be descended from the biblical figure of Abraham, the great uncle of Job.[52] Yet despite the illustrious history and influence of the Kamara broadly,[53] Larabanga remains significant among Kamara communities for its spiritual efficacy, and has historically been a pseudo-pilgrimage site for other West African Kamaras seeking the source of their unique ethno-spiritual identity.[54]

Along these lines, many members of the Larabanga community are active *mallams* who, like the founder Braimah himself, use mystical knowledge systems to heal a variety of physical, social, and psychological maladies (see Figure 3.8). As such, additional script-oriented and image-based decoration often appears on the residences of *mallams* as well, depicting the specific iconographies of their trade and thus providing the initial framework for interactions between potential clients and the practitioner. In terms of their trade, Larabanga's *mallams* also use collections of Arabic texts called *isims* to develop treatments for clients in need. *Isims* is Arabic for "names," and refers to the names of God. The *mallams* pair a client's problem with an appropriate *isim* and other Koranic verses to create individually tailored remedies, some of which may also require a sacrifice, the collection of specific herbs and plants for bathing or consumption, or the avoidance of certain activities for a specified length of time. Clients may also be required to copy Koranic phrases on to a slate, which they will then wash off, using the blessed ink water for bathing or cooking. The degree that Larabanga's healing systems depend on the word of God and the presence of Arabic text in these practices is crucial, yet not unique to the region. Raymond Silverman observed similar conventions in the town of Bondoukou in northeastern Côte d'Ivoire, where healers use similar practices.[55] However, important to note is the role that architectural ornamentation plays in advertising and in many ways also

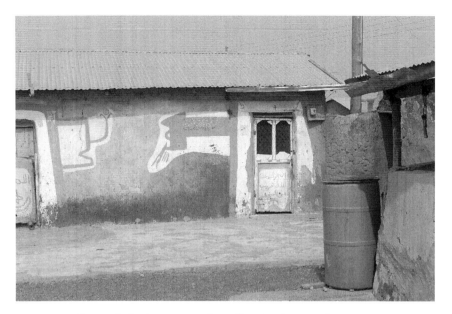

**FIGURE 3.8**  Domestic/business space of a *mallam*, Larabanga, Ghana, 2011.

authenticating the professional and spirituality identity of the person within, while also tying the person more directly to the distinguished legacy of the Kamara culture.

## Architecture, Materiality, and the Kamara Identity

Larabanga also derives its fundamental spiritual, cultural, and physical character from the material nature of architectural form itself and how the village's ideals and identities are made manifest through it. The materials and techniques used in constructing architectural spaces in Larabanga allow structures to communicate specifically through their conditioning of the form itself, a quality that has long provided a medium of dialogue and symbolic representation in Larabanga and many other rural areas in West Africa. Earth in particular has been an important functional component. Not only it is a useful and readily available construction material, but earthen material has also developed the communicative capacity to create original displays of ideological content for the target audience. These elements have made earth much more suited to necessarily flexible, communicative Afro-Islamic environments like Larabanga than alternate materials such as timber or stone. Timber, for one, is not prevalent enough to contribute to full construction projects and is thus mainly deployed for roof reinforcement (see Figure 3.9). In addition, many of the larger trees in the area that would be suitable for architectural construction are typically congregational spots and rest areas that provide much needed shade on hot days. Stone is also problematic due to the necessity of having specialized tools and training to handle it. In addition, stone construction does not give itself to the type of fluid building required for growing and shifting

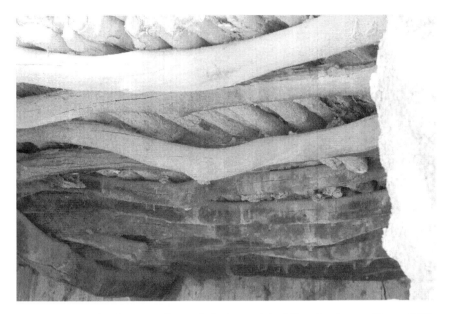

**FIGURE 3.9** Timber beams in the roof of a domestic building, Larabanga, Ghana, 2011.

compounds; stone enclosures and walls make growth and adjustment difficult and time consuming.

These aspects have allowed earthen architecture to flourish in the West African savannah and take on a number of different forms and meanings based on the diverse characteristics of the contexts in which it appears. Because earth as a building material gives itself freely to the stresses of time and the environment, earthen structures are noted for their ability to disintegrate. While this may sound like a fairly ominous quality in architectural construction, this finite life space allows relatively quick changes in a built environment, which is important should a structure fail to maintain necessary relevance within the community. Structures can disappear quickly without leaving rubbish behind, and such processes allow structural landscapes to remain uncluttered and functional towards maximizing the successful performance of the built environment within the cultural lifestyle of the community.

This ephemerality has also resulted in the development of specialized schedules of seasonal upkeep within Larabanga that necessitate the involvement of the community. This is particularly true of public structures like Larabanga's ancient mosque, whose annual communal replastering has traditionally accomplished three relevant goals for the village. First, the mosque receives the maintenance to remain structurally solvent for another year. But the exercise itself also becomes an exercise in social cohesion that actively reinforces Kamara identity through a shared sense of responsibility. In addition, it also underscores the significance of the mosque as a primary symbol of the Islamic identity of the community as well, making the replastering a performance of spirituality as much as communal unity. Indeed, the

maintenance of large-scale religious structures and the associated social and spiritual benefits have a long history in Afro-Islamic practice. Unlike domestic structures that are typically renewed by single families, communal involvement in the maintenance of these structures is an affirming exercise on multiple social and spiritual registers, an aspect seen in other regional Afro-Islamic architectural traditions as well. The annual replenishment of the Djenné mosque in Mali, for example, is a frantic communal maintenance exercise that occurs each year in a festive tradition that results in the mosque's physical renewal and symbolizes the regeneration of the land after the seasonal rains. The mosque's renewal also allows the community to refresh their ties with the earth and their ancestors while simultaneously upholding Maliki building tenets that stress that mosques should be built from earth, as the Prophet's house (pbuh) was.

Within Larabanga, the composition of the plaster itself as well as the act of coating the surface of a structure also has social relevance. Traditionally, the plaster used to coat structures in Larabanga was made of both clay and cow dung, cow dung being a popular regional ingredient because of its waterproofing qualities. However, shea butter is also traditionally mixed into the plaster in the village to give it a distinctive peach brown color called *purubee*, a color seen as both beautiful and indicative of the superiority of the plaster itself.[56] But the region itself has a broader historic tradition of incorporating various materials in construction to make the buildings spiritually efficacious. Among the Gonja, for example, historical accounts indicate that Gonja founder Jakpe incorporated numerous "power" elements into the earthen building material of his domestic spaces, including honey,[57] "kneaded" oil,[58] and even blood, which has long been considered a potent material in Sahelian regions and was often placed around doors and entrances as a protective measure. Yet even these architectural practices, which Jakpe may have brought with him from the Sahel, already had regional counterparts within the central area of the Gold Coast. One fifteenth-century account in the region details the existence of a defense wall in the town of Nalerigu (northeast Ghana) that was built from mud, blood, and honey by a powerful Mamprussi chief, the Mamprussi being kin to the Kamara of Larabanga.[59] Thus, tradition-based practices such as the incorporation of important symbolic materials into architectural forms have a number of cross-traditional resonances within the region of what is now northern Ghana. These practices collectively transform architectural form into more than just a structure; through these additions, architectural form becomes a symbolic and often spiritual medium, empowered through the utilization of potent spiritual materials.

Many of these materials are incorporated into the plaster of a structure, which is applied after the general process of building itself is completed. This process of building in Larabanga has historically utilized a variety of earthen building techniques that vary from structure to structure, but the two most common types are the puddled-mud technique, which involves building up a wall by layering mud in repetitive registers, or the use of mud bricks, which involves stacking bricks and putting earthen mortar between them. Although the puddled-mud technique is

116  *Mallams, Mosques, and Mystic Stones*

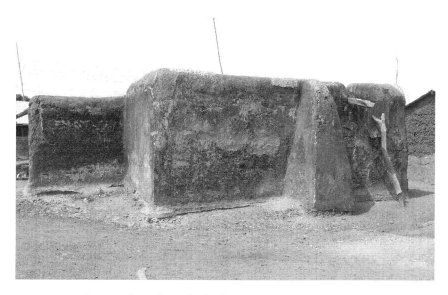

**FIGURE 3.10**  Buttress along the wall of a domestic space, Larabanga, Ghana, 2011.

capable of creating both circular and rectangular structures, mud bricks almost invariably yield rectilinear forms for obvious reasons.

Regardless of the method used, however, most traditional structures also required massive exterior earthen buttresses to keep the walls from collapsing (see Figure 3.10). These squat forms, some of which are still present along walls at various intervals around the village, seem haphazard in their placement, but were actually placed at key points of structural weakness, weaknesses that were often caused, according to Prussin, by the common combination of the two different types of wall construction on a single building.[60] But these buttresses were also necessary because many of these forms, at least until the late 1960s, were still topped with flat roofs created by a platform of heavy timber that was topped with a thick coat of mud. This system placed an enormous amount of outward thrust on these walls and created an additional need for these buttresses, sometimes as tall and thick as the walls themselves. Although some flat-roof constructions are still present in the village today, they have largely been replaced by cantilevered roofs, traditionally made of thatch but now increasingly constructed in corrugated iron, although both resulted in a greatly decreased amount of horizontal thrust on the walls.

## Architecture in Action: Performing Identity in Larabanga

All of these elements—center/periphery, border/boundary, spatial division, surface communication, materiality—come together in community-wide demonstrations of identity that often occur on major religious holidays. During

such events, many architectural components are activated towards creating efficient flexible spaces that maximize the successful performance of a communal Islamic sensibility. Often too, the architectural forms that are utilized for these events take on forms that push beyond the original boundaries of what a built environment is thought to be. Within Larabanga, there are three major annual communal events oriented predominantly around the Islamic calendar that use architecture in highly community-specific ways. There is Ramadan, which occurs in the ninth month of the Islamic calendar, followed by Eid al-Adha, or the Sheep Festival, exactly one month later. There is also the Fire Festival, which has over time become a hybrid of the first day of the Muslim calendar and an agricultural festival for indigenous earth-oriented spiritualties.

To focus on Ramadan, or more specifically the breaking of the fast, it is characterized by communal interaction and engagement with different types of architectural spaces over the course of the event. The month of Ramadan is a period of fasting and spiritual reflection. The evenings and nights during Ramadan are characterized by intensive prayer, usually taking place in mosques scattered throughout the village. The month culminates in the celebration of Eid al-Fitr, or the feast of the breaking the fast. People start preparing for the feast days before Eid, buying food and livestock. New clothes are finished and men's hair is cut. Sometimes people rub soot on their foreheads in a gesture of piety because extremely devout individuals often have similar marks on their foreheads from placing them so frequently on the ground during prayer. Shortly before the Eid prayers begin (around nine o'clock in the morning), people from each section of Larabanga begin to assemble in a flurry of elaborately decorated but predominantly white robes, shoes, and hats. At a signal from the leading imam of each quarter, each procession begins moving towards the soccer field en masse, calling the name of Allah and praising God as they walk. As the processions arrive, the space of the field is quickly transformed into a mosque, as prayer mats are laid and speakers are affixed to the goal posts that conveniently (or perhaps strategically) face east and thus act as the *mihrab*. Once within this space, incoming processions quickly orient themselves as they would within a congregational mosque. The elders and other respected community members sit in the front rows towards the center and radiate outward in linear rows that recede from the front of the field (see Figure 3.11). After the last row of men, there is a space, followed by rows of adolescent boys on one side and women on the other. At this point the hierarchy between individuals is not so clearly identified and the organization feels more randomly assigned; yet it is possible to detect age delineations, with older women sitting in the middle and younger women radiating out from them along the row. At the very end of the field is the children's section, filled with boisterous chaos. Although some of the older children try to establish similar types of hierarchies seen in the adult section, they have little power, and it becomes a game to see who can finagle the best seat.

Eventually, a group of men composed of imams, notable *mallams*, and elders stand at the *mihrab* of the mosque and welcome people by chanting verses of the

**118** *Mallams*, Mosques, and Mystic Stones

FIGURE 3.11    Men organizing themselves for the morning prayer during Eid al Fitr, Larabanga, Ghana, 2012.

Koran into a microphone. A chorus of cowbells in the distance signals the arrival of the chief imam Abdalla Seidu, who enters the space under an umbrella surrounded by other elders and members of his family (see Figure 3.12). The chief imam, a slight, robed figure with a white beard, makes his way to the front of the congregation, where he is greeted by the assembled elders before sitting down.

FIGURE 3.12    Arrival of the chief imam Abdalla Seidu for the morning prayer during Eid al-Fitr, Larabanga, Ghana, 2012.

The congregation sits until the moment when the imam rises and begins to lead them in prayer. With synchronized movements and voices, the congregation follows his instructions, which are repeated through the microphone so that the entire gathering can hear it (see Figure 3.13). The prayer itself lasts for about thirty minutes, and the sustained hum of so many harmonic voices reverberates up through the ground. At the conclusion of this prayer, the children are released, and their boisterousness becomes background noise for the additional parts of the ceremony that are strictly local in function, involving the collection of donations for the mosque, for prayers, and other related issues. The imam, surrounded by the village elders, also gives a special blessing for the village (younger men often try to linger among this group, but are typically shooed away).

At the conclusion of this prayer, the field mosque, which has thus far maintained cohesion via the participation of the congregants, begins to move as the community escorts the imam to the next site in a mass of umbrellas, cowbells, and cries of joy from the women. The "mosque" slowly winds its way through the labyrinth of the village to the founder's grave, which is the next "mosque reification" site. Here, the sacred space is reasserted, as individuals organize themselves once more by hierarchy around the grave (see Figure 3.14). The form this time is slightly irregular, as the congregation has to fit within the confines of the space, and to promote wider viewing, hierarchical seating is re-established along a different template. The elders and the chief imam sit directly in front of the grave along the wall. The group of imams, *mallams*, and elders stand to their left, with many other village men directly behind. The women are to the right, along with other onlookers, latecomers, and the occasional art historian around the edges.

Once the space is established, elders and learned men take turns invoking the greatness of God, reading passages from the Koran, and offering prayers to the grave of the founder. Then the mosque disperses for a time, as people leave to spend the rest of the day preparing feasts, delivering food, and visiting family and neighbors. But the mosque coalesces again in the evening, this time in yet another fashion, as congregants gather around the open area beside the ancient mosque to dance. While outsiders may not be as quick to see another version of the "mosque" in this event, congregants nonetheless move around a focal point, a central set of drums, while women and children dance in concentric, synchronized rings radiating outwards (see Figure 3.15). Within Larabanga, this is a performative mosque space in its truest and perhaps most *Islamic* iteration. It fundamentally deemphasizes the idea of "mosque" as a three-dimensional form and pinpoints the fact that a mosque can occur anywhere under specific circumstances. This iteration in many ways mimics a mini-*hajj* for those present who have not made the pilgrimage to Mecca. Circling a central focus in a repetitive performative rhythm, in proximity of objects and sites that emit the sacred aura of Mecca, congregants transform the space of Larabanga into the Islamic holy city; the space of the mosque becomes the Kaʿaba through its circumambulation within the context of an empowered environment. It is perhaps also not

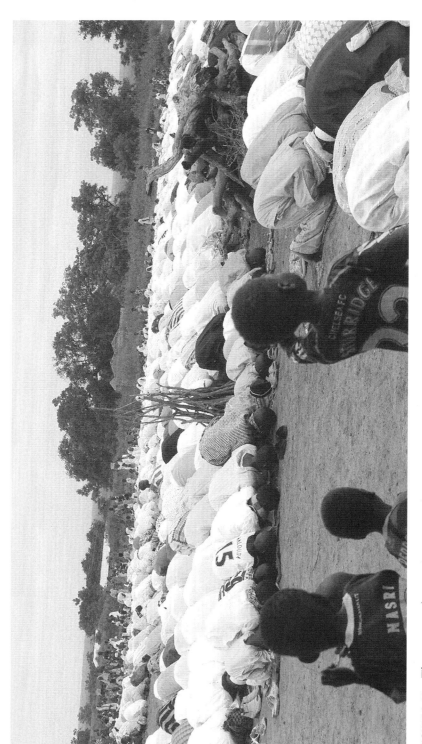

**FIGURE 3.13** The communal prayer in progress during Eid al-Fitr, Larabanga, Ghana, 2012.

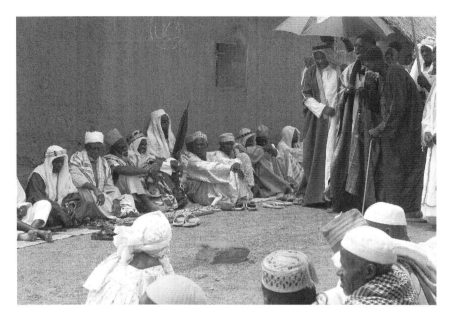

**FIGURE 3.14** Prayers during Eid al-Fitr continuing at the founder's grave, Larabanga, Ghana, 2012.

**FIGURE 3.15** Evening celebration/dance in the clearing next to the ancient mosque, Larabanga, Ghana, 2012.

coincidental that this type of organization appears at almost every level of Larabanga's cultural, spiritual, and architectural life, as we have seen.

Yet important to note is the particular nature of the architectural forms that are created during events such as Ramadan. The soccer field mosque, the founder's grave mosque, and the mini-*hajj* at the mosque: these are architectural events at their most conceptual, manifesting as a result of desire, necessity, occasion, and action. They appear just as easily as they dissipate, always existing in limbo waiting to be evoked. Central is the understanding that such conditional architecture can also appear during routine religious occurrences, such as Friday congregational prayers when the mosque extends outward from the physical structure to encompass the surrounding area, allowing congregants who cannot fit into the dedicated space of the mosque to take part in communal worship.

Larabanga's transient and ephemeral architectural spaces work in conjunction with more permanent, three-dimensional forms to create a spiritual environment uniquely capable of accommodating all types of spiritual events. This collaboration between the tangible and the intangible also finds expression in a number of indirect spatial containers in spaces within Larabanga, notably at gravesites. Traditional gravesites in Larabanga are rarely marked by a physical object, and knowledge of their location depends on memory. One exception is the founder's grave in Larabanga, but even it is still marked by a rather small, unspectacular rock placed in the center of a main thoroughfare running next to the ancient mosque (see Figure 3.2). While this marker may be casually acknowledged on a day-to-day basis, it remains a largely passive object until it suddenly bursts into consciousness when it becomes either a meeting area for the elders of the village, or a mobile mosque site during Ramadan and Eid.

To talk about this marker's role as a generator of space during meetings of the village elders, the space around the stone becomes a reification of the political hierarchies that structure the leadership matrix in the village. The political structure of Larabanga conforms to the structure originally set down by Ibrahim Braimah, which is again largely based on cultural membership passed down through the paternal line. The main political and religious force in Larabanga is the chief imam; he and imams from each section form an "executive team" to the council of elders. Next in authority is the Tinkpamah, who acts as the keeper of village traditions. This position is circulated between the twelve houses as a method of keeping peace.[61] The third and final authority is the Bendugu, whose role is to mediate disputes and carry out the orders of both the Chief Imam and the Tinkpamah.[62] The Bendugu is also a secular official whose role may have been created during the British colonial period as a method of indirect rule, although the history on this is a little obscure. Supporting this idea, though, is the fact that it is not a role that has any attachment to the Kamara cultural paradigm, nor did it exist in the pre-colonial period. Because of this, though, anyone deemed fit for the post can fill it.

This political hierarchy is not only made physically manifest through meeting spaces such as this, but also during public festivals and important events. It typically takes form through seating arrangements where the chief imam occupies the

central position, the Tinkpamah sits next to him, and the Bendugu sits with the rest of the council of elders.[63] In this way, it creates an organized spatial parameter similar to the mosque, where human bodies create an architectural boundary around a central object that acts as an anchor for the occurrence of this ephemeral structure. Thus, the founder's grave marker itself exists as a conditional architecture, emerging as required.

Other graves around the village act in a similar capacity. Some are located nearby around the mosque; these are also largely marked by stones, but their organization is random enough to obscure their function almost entirely. It takes a seasoned eye to tell the difference between a grave space and a simple rock on the ground, and few can identify specific graves due to the sheer volume of those interred within the landscape. This system also extends to familial compounds, where family members are often interred. In some older compounds, the ground is so saturated with grave sites that individuals digging a new one will often run into interred bodies and have to either dig somewhere else, dig around the bones, or in some cases move them to the side to accommodate the newly deceased.

But the issue of tangible versus intangible space comes to the fore during a ceremony called *Nyegbari*, which is a funeral rite performed over the seven days following a death. When a death takes place, the news is first spread by women and children, who circle the village twelve times in reference to the twelve houses or kinship groups of the Kamara. The burial itself is carried out almost immediately within the compound, and for the seven days and nights following the burial funerary drumming and dancing is performed. During these seven nights, representatives from each of the twelve houses come to sleep in the yard of the deceased to pay their respects and keep company with members of the deceased's family. On the eighth day, the drummers and dancers of the twelve houses converge on the house of the deceased for a final closing session that includes a choreographed eighth-day dance, the killing of a cow, and rites carried out by a village imam.[64] The domestic space in this case becomes a space of healing, closure, and communal mourning, as familial members in death are embedded within the domestic space as a permanent part of the infrastructure. And it is here where the line between tangible and intangible begins to blur. While the physical space in which an individual is buried is not privileged, the fact that he or she is *present* within this space becomes key; his or her memory or aura serves as the latest chapter in the narrative of the family, house, and larger culture. We see this when, after the seven-day funerary ceremony, the funerary "infrastructure" dissipates and the space returns to its familial function as a courtyard. But now it is newly infused with the memory of a deceased family member.

The tangible and the intangible additionally find modified expression in the space of Larabanga's ancient mosque as well. Its conceptual and functional fluidity enables it to maintain a number of different realities including sculpture, container, environment, symbol, shrine, and sanctuary. As a sculptural form, the mosque is built on a quatrefoil plan, or a plan composed of four overlapping circles that create a bulbous rectangular shape (see Figure 3.16). Surrounded by conjoined conical pillars and studded with timbers that aerate the solid earth interior, the mosque not

**124** *Mallams, Mosques, and Mystic Stones*

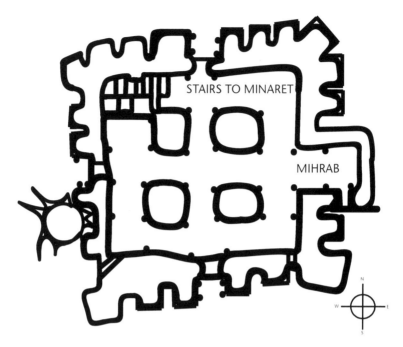

**FIGURE 3.16** Floor plan of the ancient mosque, Larabanga, Ghana.
Source: Adapted from the World Monuments Fund.

only references architectural traditions but also sculptural traditions as well that can be found along the trade routes from the Niger Bend to the Upper Volta. As Prussin notes, the northern face of the Djenné mosque mimics the forms and voids of Dogon masking traditions and more southerly traditions such as the N'tomo masks of the Bamana (see Figure 3.17). The protruding pinnacles that erupt from the forehead of a majority of these masks, and the connection of many of them to the life cycle and the ancestors as well as numerological elements present in the Islamic faith, make a strong case for the presence of a hybrid sculptural/architectural impetus connecting them.

The idea of architectural form having multiple identities is also seen in the fact that the mosque in Larabanga, and the town itself, has often been treated as a type of shrine or amulet, and rumors abound that the mosque in particular has healing powers. Such associations are potentially buttressed by its appearance; the structure is considerably larger than its surroundings, with unusual formal qualities and a white patina that makes it stand out like a beacon or strange alien ship completely divorced from its variousl surroundings (see Figure 0.1). Because objects and structures so quickly become beige, orange, or brown in the dusty, windy environment of the savannah, the appearance of the stark white structure of the mosque is visually arresting. The brilliance of the structure reacts so strongly with the sun that one is tempted to shield the eyes. Its pristine appearance seems to embody and radiate the "aura" that Ibrahim Braimah first detected upon

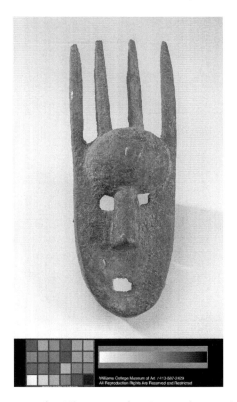

**FIGURE 3.17**  Bamana people, N'tomo mask, nineteenth–twentieth century wood, mud 16¾ × 6⁷⁄₁₆ × 5¾ in. (42.5 × 16.3 × 14.6 cm).

Source: Williams College Museum of Art, Williamstown, MA: Anonymous gift (93.1.5).

approaching the site where this mosque would be built. It becomes a physical manifestation and reification of this spiritual event, mimicking the transcendent theme of light that infused the architectural skins of traditional Islamic surfaces to evoke connections with the divine.[65] This effect is strategic: the color white is associated with Islam as a symbol of peace and purity, which is largely why individuals on the *hajj* wear white; further, white is a powerful spiritual color throughout West Africa, often used to represent the state of being in close contact with ancestors and other members of the spirit realm. Diviners often rub white clay across their eyes to aid their spiritual sight, and the previously mentioned anecdote from British officer Joseph Dupuis emphasized the white clay worn by the Asantehene during his ritual association with the ancestors. White, thus, constitutes a color pregnant with meaning and contextualized associations; thus, its presence on the mosque signals the identity of the form as more than just a three-dimensional structure. It is also a spiritual object and, with its efficacious powers, also potentially a talisman.

Extensive local and regional evidence also supports the role of architecture in the town itself as a shrine environment. The idea of the shrine has a great deal of power

in many West African contexts; within Gonja traditions, the shrines of earth priests and Islamic mosques are officially recognized as universal sanctuaries for people requiring refuge from a conflict. Their purpose is to "provide a breathing space so that tempers could cool, and the case be reconsidered."[66] There exists one account of a British officer during the colonial period, a Major Abby, who was to be executed for some unrecorded infraction. An imam by the name of Limim al-Hajj Hamadu saved Abby's life by first hiding him in his room, and then commanding his people to deliver Abby to Larabanga because, to quote Haight, "Larabanga was a sanctuary."[67] Important to note is that this account doesn't identify the *mosque* of Larabanga as the sanctuary, but the *town* itself. This also corroborates a much discussed aspect of Gonja culture that within Gonjaland, the most important regional shrines are the Senyon Kupo "commoner" shrine, the royal burial place of Mankuma (Jakpe), and the town of Larabanga. This last fact speaks to the unique role the village plays within this region as a site or sanctuary of spiritual import.

This type of categorization also reveals a regional conceptualization of architectural forms, sites, and communities as objects and areas capable of multiple identities, functions, and signification. The burial site of Jakpe, for example, which is located in the town of Buipe, was in fact originally a mosque. But the structure has since evolved into a shrine that people from all religions now venerate.[68] The idea of a mosque acting as a shrine that is actively worshipped runs counter to orthodox Islamic practice, yet in the context of a region defined by such an extraordinary degree of cultural *metissage* it makes sense that such structures would become liminal zones in which various belief systems enter into and out of each other. Along these lines, almost every site associated with Jakpe's life has become revered as a shrine or sanctuary.

Yet, to revisit the general condition of Larabanga, the spiritual, cultural, and architectural condition of the community endows it with the unique ability to walk a fine line between communal space and a "shrine" as defined by the various regional paradigms. Larabanga does this not only by maintaining spiritually effective structures, but also by being a point of convergence for multiple architectural styles in the region, an aspect that gives it the necessary cultural and architectural universalism to continue to fulfill this general spiritual role. When studying the architectural character of Gonja communities from the east to the west, it is impossible to miss the slow architectural transition from rounded building forms, thatched roofs, and walled woven or mud compounds in the east to more Sahel-based square flat-roofed buildings with high mud brick walls to the west.[69] Thus, central Gonja—where Larabanga is located—acts as a point of meeting and mixture for these styles, incorporating an amalgam of various elements that collectively compose what can be thought of as a Gonja style. These structures reveal the various cultural influences that have been prevalent in various areas over time, from the "Islamic" square buildings with flat roofs to "Dagomba" rounded mud huts with conical thatched roofs and all of the hybrid space in between. They also offer people in the region a broad structural selection from which to craft a customized architectural palette tailored to specific cultural contexts and the unique needs of the individual or the community.[70]

To conclude, architecture in Larabanga as both a system and a symbol connects the social, spatial, and spiritual domains of village life along a trajectory whose basis lies in the origins of the Kamara history and whose continuation relies on its practice and reification in communal life. Architecture allows people to identify their places and positions within a communal network. It allows them to organize themselves socially, politically, and spiritually while also enabling communication through a variety of nonverbal cues. The physical characteristics of Larabanga's architectural reality include components such as settlement patterns, spatial organization, and building materials and techniques. They also include conceptual characteristics made manifest through the establishment of borders and boundaries relating to gendered spaces, social divisions and linkages, and spiritual matters. All of this produces a textual landscape whose unique dimensions represent the contours of the historical, political, social, cultural, environmental, and spiritual narratives that together compose Larabanga's contemporary cultural space. Even now, as Larabanga, Ghana, and West Africa generally increasingly look to modernization, many of these concepts remain constant. However, the dynamic shifts that are increasingly taking place within historically embedded cultural and architectural landscapes like Larabanga are having dramatic impacts on both its cultural and built environment.

## Notes

1   Hussein Salia, interview with the author, December 17, 2011.
2   Lydon, "Writing Trans-Saharan Histoy," 304.
3   Much of this narrative was compiled by Hussein and Al-Hassan Salia, two brothers who run the town's NGO, Bambenninye Development Services, and school. I've also been able to verify much of its accuracy through available Gonja texts as well as interviews with Dokrupe elders and additional members of the Larbanga community, most of whom have a rough idea of the origin story and the basic facts surrounding the origin of the sacred mosque, Koran, and the town's "Mystic Stone." It is an interesting question, however, to consider whether these individuals know these narratives due to the stories being passed along or because they have learned them to promote tourism in the area.
4   This date is according to the *Kitab Ghunja*, the earliest written account of Gonja history, which is also supported by an even earlier source, the Kano Chronicles, which refer to a region of "Gwanja" in regards to commercial activity in Katsina (Haight, "Bole and Gonja," 2). There is some debate about this, though, with the authors of the Chronicles of Gonja saying that it was probably founded in the sixteenth century (Wilks et al., *Chronicles from Gonja*, 2). Others say it was founded as late as the seventeenth century (Goody and Goody, "Creating a Text," 7).
5   Wilks et al., *Chronicles from Gonja*, 21. This narrative counteracts an alternate account that Jakpe was sent to punish the leader of the town of Beghu for his refusal to engage in gold trade; yet the one privileged in the text is the more widely circulated. In addition, because "Jakpe" is in fact a title, there is some debate about whether or not all of the incidents accredited to Jakpe Ndewura in the Ghana region were in fact accomplished by him, or they are the compilation of a succession of Malian rulers engaged in a lengthy campaign in Ghana's Northern Region.

6   Various accounts of Fatu Murkpe give evidence to the fact that Murkpe may have, in fact, been Muhammad Al-Abyad, also known as Ayuba, the supposed ancestor of the Kamaras. Muhammad Al-Abyad, translated from the Arabic, means "Muhammad the White," while Fati Murokpe, or Fatigi Morukpe in Mande, means literally "the White Learned Muslim" (Levtzion, *Muslims and Chiefs*, 52). This adjustment would support an alternate origin story proposed by Levtzion that before beginning his campaign into the forest regions Jakpe journeyed to Medina to receive blessings. When he left, two "descendants of Abu Ayyub al-Ansari" accompanied him: Yidana Bureima (Ibrahim Braimah) and his brother Dokurugu (Abu Kabir) (Levtzion, *Muslims and Chiefs*, 72).

7   In each conquered town, the Gonjas subsequently set up an administrative system that was headed by a sub-king of sorts, known as a "wura." However, both Larabanga and Dokrupe are exempt from this practice, being wholly autonomous with regards to Gonja rule.

8   The Gonja are a cultural group that often convey historical narratives and other important information through pairs of "talking drums" (see Goody and Goody, "Creating a Text," 1992).

9   The relationship between the Kamaras and the Sakpare Muslims has been interpreted in a number of ways. Some of these accounts actively retool Larabanga's origin story. Such alternate histories have Yidan Braimah spending a good deal of time in Mamprussi on his way to Gonja with Jakpe, or another indicating the Kamara were in fact brought from the Mamprussi region to aid those fighting against Jakpe. Once they were defeated, the Kamara were made to pay an annual tribute, and thus differ from the Sakpare Muslims who fought with Jakpe and enjoy privileges from the Gonja chiefs. Another tradition says that Larabanga was founded by a former imam to the Mamprussi chief of Janga (Levtzion, *Muslims and Chiefs*, 74). Yet these final speculations are very much contested by most accounts of this situation, Kamara and Gonja alike, with the Kamaras of Larabanga and Dokrupe both claiming that the Sakpares were in fact "animist" before the arrival of the Kamaras, and, upon Jakpe's conquering of the land, the Sakpares were converted and their roles and the Kamaras, as spiritual advisors to the Gonjas were combined.

10   Weiss, *Between Accommodation and Revivalism*, 74.

11   Hussein Salia, interview with the author, August 22, 2012.

12   Weiss, *Between Accommodation and Revivalism*, 74.

13   Dokrupe elders and imams, interview with the author, August 19, 2012.

14   Levtzion, *Muslims and Chiefs in West Africa*, 75.

15   Both use "*an soma*" as a morning greeting, which is an equivalent to "*ini sogoma*" in the Mande Bamana dialect. In addition, further greetings—"ini tile" for "good afternoon" and "owni oula" for "good night"—are rough equivalents for "ini tilay" and "aw ni oola" in Bamana, meaning the same thing. There are some additional linguistic resonances, although not as strong, with "owo" in Kamara, meaning "fine," and "owo" in Bamana, meaning "yes."

16   Al-Hassan notes that because the Kamara population is so small they are often not recognized as a legitimate cultural entity and thus often refer to themselves as "Gonja," particularly when filling out government forms. Only within the context of the village and within Gonjaland do Kamaras identify themselves as Kamaras.

17   At the time, most spiritual leaders in Braimah's position followed the Maliki School of Islamic law, a branch of Islamic jurisprudence that relies on the Koran and the hadiths

as primary sources of guidance, and which became dominant in North Africa during Morocco's Almoravid empire.

18  Although the brothers and the Gonjas supposed defeated these settlers, they still had regular commercial contact with them, and there was apparently a town that the new settlers had contact with on a trade-related basis. They named this town Bumberape, meaning "seeds," due to the fact that this was where they got their seeds. But still, the Dokrupe people did not mingle with them.

19  Based on this narrative, Larabanga and Dokrupe maintain an intimate ancestral connection. As one of the Dokrupe elders told me in an interview: "Larabanga history and tradition is not complete without Dokrupe." This connection continues to manifest itself even though the villagers themselves currently do not maintain an active kinship relationship. Both have founder's graves marked by stones near the sites of the first mosques of the village, and hold the sites to have special spiritual and ceremonial significance. Each town maintains twelve houses of the same name, as all Kamara populations in West Africa (there are supposedly six) do.

20  The story of Dokrupe was documented during a meeting of the elders in the village of Dokrupe during which they explained the origin of the Kamara people as a supplement to the Salia's story as well as providing another piece of the puzzle of the founding of Larabanga. The original inhabitants of Dokrupe remain Muslim, but, unlike Larabanga, Dokrupe is a mining town that has brought numerous foreigners into the area. As such, the Kamaras of Dokrupe have mixed with Gonjas and other ethnic groups and their specific traditions have hybridized over decades. The basis of each culture remains, but the people of Dokrupe no longer speak the Kamara dialect as those in Larabanga do, although they still understand it. In addition, until only three years ago, they had a mosque that was an exact replica of the mosque currently in Larabanga, and almost as old. Yet because of the high degree of maintenance necessary to maintain the structure, they tore it down in order to build a modern concrete mosque.

21  Levtzion suggests that Dokrupe may have been formed after Larabanga as a route linking both Gonja divisional and major commercial capitals, in addition to its establishment as a gold town in the eighteenth century. If the two were formed at the same time, Levtzion suggests, then there would be a greater difference between the two (Levtzion, *Muslims and Chiefs*, 75). However, it remains to be proven what degree of difference should be present in order to establish a timeline or origin. In addition, the dually comparable roles that both Dokrupe and Larabanga imams play for the Gonja ruling class seem to imply a shared bond based on an equivalent historical relationship. For example, just as the chief imam of Larabanga goes to meet and pray for the Yagbum-wura (the paramount chief of the Gonja), the Dokrupe imam does the same for the Senyon-wura, the chief councilor of the Yagbum-wura (Levtzion, *Muslims and Chiefs*, 76).

22  It is an interesting case study to compare Larabanga, a Kamara community whose commercial industry primarily draws Western foreigners, and Dokrupe, whose gold mining industry draws mostly Ghanaian and Nigerian workers, in terms of the way each community has evolved over time due to differing influences and the degree of hybridization. Larabanga has remained predominantly Kamara and Dokrupe has mixed with the Gonjas and other ethnic groups to the point that it has changed their traditions and even their language. Interesting, they also couldn't understand my English, because apparently I "speak through my nose."

23 From this origin story, it can be assumed with a degree of confidence that the narrative acts to "telescope" the histories of Al-Abyad, Larabanga's founding, the Jakpe campaign, the foundation of the Gonja empire, and the multiple attacks on Kong that happened over a significant period of time. The resulting single heroic narrative subscribes to a historical format that allows for ease of remembrance and simplicity (Levtzion, *Muslims and Chiefs*, 53). Certain "hiccups" in the narrative also give evidence to this type of prefabricated narrative template, particularly small details such as whether or not Jakpe journeyed to Medina to find these men or, as the *Tarikh Ghunja* has it, that these men were journeying to Jakpe and he met them and lodged them in the house of Fati Murkpe before giving them land to settle on. Braimah in this version incidentally was responsible for transcribing the village Koran and then passing it on to his descendants, who regard this Koran as a shrine (Levtzion, *Muslims and Chiefs*, 72). According to *Tarikh Ghunja*, the Koran was a "great book ... bound in two volumes, each containing thirty hizabs. He embellished it with different colors of ink: black, red, green, and saffron" (Wilks et al., *Chronicles from Gonja*, 159–160). Yet even though the facts expressed in the narrative are distilled through the process of telling and remembrance, it nonetheless highlights the essence of the political, social, cultural, familial, and spiritual relationships that were formed and continue to exist within the present narrative of the region. As Levtzion, Wilks, etc. point out with regards to histories like the *Tarikh Ghunja* and the *Amr Ajdadina*, these works effectively "legitimate the authority of ruling and Muslim estates" and "codify social and political structure" (Wilks et al., *Chronicles from Gonja*, 25).

24 In order to be considered a "proper" Kamara, one needs to be part of at least one clan. Although there are some intermarriages between Kamara people to outsiders, most marriages occur within or between clans, thus preserving to a surprising degree the nuances of the traditional Kamara language and cultural traditions. Unsurprisingly, individual Kamara people can typically trace relations to every clan, which acts to consistently reconnect the community as a kinship group, clan, and cultural group.

25 I was told that these people were Zuriyiri, which loosely translates to people of the land.

26 This is an interesting story because it seems to eschew the incorporation of the angel Gabriel as a mediator for this interaction. Many West African narratives that involve the divine deliverance of messages, signs, or objects to individuals are done through the archangel, who has long acted as the primary mediator between God and man. Perhaps the most well known narrative of this type has to do with Sheikh Amadou Bamba, who received a vision from Gabriel to construct the holy city of Touba at the site of his retreat. Yet within the origin story of Larabanga, however, this does not seem to be the case.

27 Hussein and Al-Hassan Salia, "The Cultural History of Larabanga," unpublished essay, 2008.

28 Wilks et al., *Chronicles from Gonja*, 166. When Ivor Wilks came to Larabanga during the Ashura festival in the 1970s to see it, he was told that it was only brought out one day a year, for it was "much too heavy for one man to carry."

29 Brian Peterson, "History, Memory and the Legacy of Samori in Southern Mali, c. 1880–1898," *The Journal of African History* 49, no. 2 (2008), 261–262. Accounts of locals in Larabanga today indicate that part of Touré's campaign was against the Gonja kingdom as well.

30 Hussein Salia, interview with the author, December 15, 2011.

## Mallams, Mosques, and Mystic Stones  131

31  This hat was supposedly prepared by the Salia's grandfather's grandfather, a man named Abayba.
32  Confirmed narratives that Touré was captured in 1889 and sent into exile in Gabon, where he died in 1900, are different from those provided to me in Larabanga, where it is claimed that, shortly after his escapades there, Touré was killed in battle in the town of Busunu in northern Ghana. This indicates that narratives placing Touré in proximity to Larabanga serve a very specific purpose in the context of Larabanga's identity as a buttress to its hyper-spiritualized reputation as a site of Islamic power.
33  Jones Kofi Apawu, "Senses and Local Environment, the Case of Larabanga in the Northern Region of Ghana," (M.A. Thesis, University of Ottawa, 2012), 38.
34  It's important to note that this organizational pattern has changed in recent years; Larabanga now boasts a total of seven mosques and seven imams—the result of the spread of the village into the surrounding countryside and available land.
35  Hussein Salia, interview with the author, December 17, 2011.
36  Goody, *Contexts of Kinship*, 36.
37  I received eloquent proof of this hypothesis when I asked my cab driver in Wa to take me to various mosques in the area, and he not only took me to physical structures, but also to covered prayer spaces, domiciles with prayer areas out front, and little cordoned-off areas on the street.
38  Goody, *Contexts of Kinship*, 26.
39  Ivo A. Strecker, *The Social Practice of Symbolization: An Anthropological Analysis* (London: Athlone Press, 1988), 14.
40  Hussein and Al-Hassan Salia, "The Cultural History of Larabanga," unpublished essay, 2008.
41  Prussin, *Architecture of Northern Ghana*, 18.
42  Carter and Cromley, *Invitation to Vernacular Architecture*, 68.
43  Strecker, *The Social Practice of Symbolization*, 213.
44  Goody, *Contexts of Kinship*, 42.
45  Only men are allowed to build the structures of the home. Although women and children bring water and decorate the surfaces, they are barred from participating in the actual building process. When asked about this aspect of building, a common reply is simply "it is not done."
46  Inusah Salia, in discussion with the author, August 19, 2012.
47  Kojo Alewa, interview with the author, August 15, 2012.
48  This aspect was noted as a possibility by Chris Kreamer in a conversation held on February 22, 2013.
49  Victor W. Turner, *The Forest of Symbols: Aspects of Ndembu Ritual* (Ithaca: Cornell University Press), 50.
50  Strecker, *The Social Practice of Symbolization*, 61.
51  These communities include the towns of Buna in Côte d'Ivoire, whose origin story suggests that its members actually migrated from Larabanga. Other reported settlements/communities are located in Cameroon, Guinea, Djenné, and possibly Niger, although this information is questionable. However, there is also some disagreement as to how these Kamaras came to be in Buna. The *Gonja Chronicles* place the ancestor of the Kamaras, Muhammad Al-Abyad, in the Ghana town of Be'o as opposed to Saudi Arabia, but I have been unable to find information on Be'o beyond references to it as a town in Ghana. There is also evidence that the Kamaras, or the *Kawntay* as they are sometimes known, were also present in the ancient trading town of Beghu located in

western Ghana/eastern Côte d'Ivoire (Wilks, "Wangara, Akan, and Portuguese," 1982).
52  Wilks et al., *Chronicles from Gonja*, 128, 166. The name Job, in Arabic, is translated "Ayuba," and there are two Ayubas in biblical and Koranic traditions. The first existed in the time of Abraham and the second came after the reign of the Prophet Muhammad (pbuh) (the Kamaras are descended from the second). Ivor Wilks documented this history in an interview with al-Hajj Mbeima, the chief imam at the time, in 1966; Mbeima had documented his descent from Braimah for ten generations, making Braimah a contemporary of one Fati Morukpe, who will be discussed shortly, and corroborating Larabanga's origin story in conjunction with several written sources of Gonja historiography.
53  The regional influences of the Kamaras has been significant within West Africa, with many local histories from Liberia and Sierra Leone detailing actions of Kamara groups that inform many cultural traditions that remain today. Even the notorious invader Samori Touré, whose story will be related shortly, was himself said to be of Kamara descent (Massing, "The Mane," 42–43).
54  Historically, these far-flung communities engaged in regular dialogue with one another, although these interactions seem to have died off in the past century or so. In addition, although Larabanga is possibly the only Kamara settlement that still speaks the Kamara dialect, most members of these other communities still understand its basic root and attribute a spiritual significance to it.
55  In an interesting but perhaps not surprising coincidence, Bondoukou is only 150 kilometers away from one of six remaining Kamara communities in West Africa, called Bouna. In the past, the community of Larabanga, along with its sister village Dokrupe would send delegates to Bouna for special events including weddings or deaths of prominent community figures. In recent times, however, this interaction has fallen out of practice.
56  Hussein Salia, interview with the author, August 18, 2012.
57  Jack Goody, "The Overkingdom of Gonja," in *West African Kingdoms in the Nineteenth Century*, ed. Cyril D. Forde and Phyllis M. Kaberry (London: Oxford University Press for the International African Institute, 1967), 201.
58  Wilks et al., *Chronicles of Gonja*, 161.
59  Government of Ghana official website, accessed November 10, 2011, http://ghana.gov.gh/index.php?option=com_content&view=category&layout=blog&id=37&Itemid=190.
60  Prussin, *Architecture in Northern Ghana*, p. xx.
61  The Dagbon clan, who maintain a somewhat ambiguous connection with the earth priest contingent in the region, are not allowed to hold either position because of the strange liminal zone they occupy between Islam and traditional indigenous religion, although they do claim to be Muslim.
62  Levtzion, *Muslims and Chiefs in West Africa*, 75.
63  Even though the positions are rotated between the clans, there is occasional squabbling as to who should hold the post of the next imam. This problem has supposedly been resolved over the years by instituting a "senior" policy, in that the senior individual will receive the post.
64  Hussein and Al-Hassan Salia, "The Cultural History of Larabanga," unpublished essay.
65  Gulru Necipoğlu, "The Dome of the Rock as Palimpsest: 'abd Al-Malik's Grand Narrative and Sultan Suleyman's Glosses," *Muqarnas* 25 (2008): 190.

66  Goody, "The Overkingdom of Gonja," 195.
67  Bruce M. Haight, "Bole and Gonja: Contributions to the History of Northern Ghana" (PhD diss., Northwestern University, 1981), 31.
68  Levtzion, *Muslims and Chiefs in West Africa*, 60–61. This is an interesting situation, as traditional descriptions of Jakpe's grave do not identify it as a mosque *per se*, but indicate that at one point it was "higher and fenced about with stakes," making fairly clear references to a Sudanese-style mosque type.
69  Surprisingly, this differentiation still exists in primarily rural settings, although not so much in the medium to large towns.
70  Henry Glassie, "Eighteenth-Century Cultural Process in Delaware Valley Folk Building," in *Common Places: Readings in American Vernacular Architecture*, ed. Dell Upton and John M. Vlach (Athens, GA: University of Georgia Press, 1986), 38.

# 4
# BUILDING ACROSS BORDERS
Larabanga in Transition

## Modernization and Larabanga's Shifting Landscape

As we have seen, the numerous architectural components within Larabanga's structural environment are the result of long processes of migration and influence involving the selective assimilation and transformation of incoming components. Many of these components were filtered through lenses of numerous cultural identities along the way in order to eventually contribute to a Larabanga-specific sensibility. In addition, these processes allowed the Kamara of Larabanga to develop the necessary structural vocabulary to layer their physical environment with the narratives of their distinctive cultural paradigm. This is a paradigm that has been understood largely through the constructs of faith, origin, kinship, and language. Architecture has supported the maintenance of this identity by embedding it as an artifact and a memory shaped into physical form, a narrative fleshed out through the organization, layout, and utilization of space within the community. These elements have enabled Larabanga's architectural environment to map its own unique location in time through an ordering of facts with regards to the village's fundamental components of identity, allowing historical narratives to become visible and accessible via the community's shared participation in a collective past.[1] In addition, the act of creating these forms in accordance with clan ownership practices, rules of spatial demarcation, and protocols that enforce Islamic tenets of living have catalyzed the built environment to function as a continuous mediator between multiple contemporary currents supporting, collaborating with, and sometimes even pushing against this lifestyle. In this way, a coherent cultural system in sustained within Larabanga's structural landscape.

The contemporary period has offered new challenges to Larabanga's architectural and cultural identities. Technological development and the increased mobilization of the population, especially the youth, out of the area has resulted in shifts in gender roles and family dynamics. Influences are also coming *in* to the

village as a result of the growth of heritage tourism and technology, each of which include new attendant physical and ideological frameworks. Both forces are actively reshaping the village's identity through progressions, ruptures, and unpredictable and sometimes haphazard developments within the community's architectural infrastructures. Yet even as this happens, the built environment continues to plot these developments using visual and structural systems that have defined the building culture of this village across time and space. In programming these interactions within the spaces of the village, architectural form incorporates them into the village narrative as a representative core sample of the identities and realities at work in a space. This process includes the use of contemporary materials and forms that encode the present reality of Larabanga as a globally engaged community.[2] As such, the purpose of this final chapter is to examine how architecture in Larabanga has continued to evolve in the contemporary period to shape and mediate these relationships, exploring combinations of symbolism and style that create a synergistic if occasionally eclectic landscape that balances established architectural practices with anticipated developments for the future. Larabanga's built environment is now more than ever acting as a strategic vehicle to moderate the flows of history, memory, and contemporary realities within the community's cultural, social, and spiritual identity.

Yet, in order to understand the nuances of the contemporary situation in Larabanga, we must understand the current regional conditions in West Africa, particularly with regard to how modernization is shaping various conditions of being. Modernity has produced two particular qualities within cultural contexts across the region: a lack of predictability concerning the movements of peoples and goods inside and outside of established spaces, and—with this increased mobility—a distancing from familial, communal, and inter-cultural networks. Ironically, this distancing is occurring simultaneously with the dismantling of various borders and boundaries that have long separated individuals across national and continental lines, brought about by an increasingly mobile global population. This new mobility has also catalyzed new iterations of diversity and cultural pluralism in Ghana, where foreign attention in the form of heritage preservation, tourism, technology, and foreign aid has often incentivized such developments.

One of the most notable effects of these new mobilities is the growth and development of satellite communities abroad. Such groups abstractly expand the borders of localized communities and establish new communal networks that cut across geographic boundaries and are supported by the presence of inter-human connections including familial ties, business partnerships, and cultural memberships.[3] Youth from areas like Larabanga who now travel abroad for financial and educational opportunities often find the necessary cultural and logistical support they need through the presence of communal "outposts" in large urban areas like London and New York. These spaces often replicate or at least imply the cultural imprint of particular societies in terms of neighborhood organization, infrastructure, and social protocol. Modern technologies have buttressed these developments by helping these populations sustain core identities through communication technologies that enable

continuous and consistent interaction with societies of origin.[4] In the Northern Region of Ghana, cell phone towers now appear at regular intervals in rural areas, even though many of these communities don't even have electricity.[5] These advances in communications have allowed communities to redraw territorial lines of membership and expand communities abroad, extending the conceptual margins of groups that have until recently been bound by geographic space.

Within communities that remain on the continent, however, modernizing practices allow for an increased pluralism. People moving back and forth across these borders create, erase, and redraw divisions between spaces, initiating the development of new socio-cultural terrains that exist in the liminal zones left behind. This newly acquired mobility and communications technology also brings about rather ambiguous shifts in the political, social, and cultural natures of society as well. Cell phones are changing socialization patterns in Larabanga, enabling communication across vast distances, but also affecting how people interact locally; individuals now are more likely to call a neighbor on his or her cell phone than walk across the road to talk in person. Technologies are also affecting established economies through the development of new markets of commercial activity. Cell phones, batteries, phone credits, and accessories are all new necessities, and new spaces for selling these wares are now just as prominent as more conventional spaces that have traditionally sold food, clothing, and household goods. This has put the two on equal footing in terms of customer priorities.

But perhaps some of the most notable effects of technology are socio-political. In opening up avenues of influence and information previously unavailable in more isolated rural areas like Larabanga, technology has increased exposure to both national and global political language, which has led to a heightened politicization of identity within Ghana. Many individuals in Larabanga believe that the advent of democracy and the development of two primary political parties within Ghana have divided the country irrevocably down the middle. These opinions are based largely on reports coming in over television and radio channels. In fact, during a heated political conversation concerning the propensity of people to conform to political ideologies that are advertised on media like television, the radio, and, in many cases, the internet, Hussein Salia, one of my key collaborators for this project, exclaimed, "People are becoming donkeys!"[6] Such politicizations of identity also bleed into the religious dimensions, examples of which appeared in 1995 and 1996 when a series of conflicts broke out between Christians and Muslims in the central and northern towns of Kumasi, Tamale, and Takoradi. It is speculated that the root of these conflicts lay in the current democratic political organization of the country, which has often rubbed uncomfortably against traditional Islamic hierarchies.[7]

But beyond political and religious movements that have been catalyzed by contemporary developments, social practices and behaviors are also being affected as well, often by global media and exposure to Westernized influences. Some Muslim girls and women in northern Ghana now wear American or European clothing brands with no head coverings, particularly in urban areas where social

controls are perhaps a bit more casual. In addition, urban areas also have become destinations for many young women from rural villages, who journey there to work as porters in the main market areas, carrying items ranging from luggage to food for a few cedis, the Ghanaian currency. These girls are commonly called "*kiyiyo*" girls, but the term itself is derogatory and implies they are selling other, more intimate services, as well. Because of this, many of the older generation see modernization as a tool for creating negative and potentially exploitative environments for the nation's young people. But the effects of modernization are varied from context to context. In rural areas, marriages are no longer a negotiation between the groom and his future in-laws, but a "conversation between three people," with the bride's voice being just as important as the original two parties'.[8] In addition, as men journey further abroad for employment opportunities, opportunities for women to fill the social and administrative voids open up. Certain traditional social roles and formats are sometimes strategically "remembered and forgotten" as women take on more decisive roles in the social and economic running of the household.[9]

Collectively speaking, slippages brought on by modernization are increasingly pushing against established binaries such as male/female, sacred/secular, and interior/exterior. They are mediating changes in normative behaviors and in the process creating hybrid cultural landscapes where the distance between urban and rural, local and global, has been increasingly eliminated by modern technology; this in turn has enabled new modes of identity making. In addition, the growing mobility and connectivity of an exploding population is reflected in the architectural environment as well. The physical infrastructures that make these new relationships and engagements possible demand the introduction of new forms, materials, and vocabularies in the built environment. This involves the creation of new signs, meanings, and messages in the landscape, yet these forms also require new tools of analysis with which to think them through. Because modernization has been a largely uneven and unpredictable process across contexts, architectural landscapes have responded in different, highly localized ways, combining old and new, established and experimental, along trajectories that are governed by the unique political, social, cultural, and religious ebbs and flows at work in a society. The lens of modernization allows us to understand these developments and interpret the built environment as a symbol of established identity as well as a landscape built in anticipation of the future.

## Culture and Continuity in the Architectural Environment of Larabanga

Several key components about how architecture is manifesting in Larabanga and the broader West African Islamic context in the contemporary period rise to the surface in the context of this discussion. As we've seen, combinations of symbolism and style have been essential in tracing how Islamic architectural impulses that first entered the northeast corner of Africa subsequently moved through and within a

variety of cultural and architectural frameworks from the Sahara down into the forest regions of West Africa. Once these elements arrived within the space of this particular community, they provided the basis for a built environment that was constructed along regional stylistic lines with an ingrained sense of symbolism formulated to buttress Islamic practice and embed fundamental cultural and spiritual value systems into the physical space and thus mental template of the community. It is these same components that will provide a platform for a contemporary discussion on how such systems are responding to modernizing forces that are increasingly entering into Larabanga's airspace.

Let us now consider Larabanga in the contemporary period. The community's current cultural and spiritual condition is reflected in its architectural environment, which in turn reflects its potential future trajectories. The situation has framed architecture as a structure of the present as well as one in anticipation of the future, whose strategic and exploratory adoptions of modernizing processes and conditions maximize engagement with current global trends while still maintaining established modes of cultural practice and identity. The town has undergone a series of rapid transformations in the form of organizational, material, and social changes. As structures across the region become more modernized in terms of usage, climate control, and building materials, they are paradoxically becoming more prone to accommodating only a specific function or utility; in other words, these structures are becoming so specialized that they are not capable of functioning beyond their original intention. While there are a handful of mono-functional spaces in pre-modern architecture in Larabanga, their numbers are definitely increasing in the contemporary period.

In addition, Larabanga is progressively expanding outwards from the central area of the community and breaking through informal parameters that previously marked the community's edge. Although Larabanga was never established with any type of definitive template in mind (few rural communities are), it did maintain various ideological centers and was parceled between four primary sections that developed chronologically. The first section of the town where the ancient mosque and the grave of the founder are located, and the three subsequent sections of the town that formed afterwards, constitute the nucleus of the community.

Now, the unofficial and largely informal borders that separate town and clan lands from the surrounding environment have begun to take on an amorphous shape as individuals move away from the town center and into the outskirts. There are two primary reasons for this. The first is that within the past few decades a new section of town has attached itself to the western periphery of the village, informally known as the Zongo section. The term "Zongo" has historically been used to refer to settlements of foreigners and strangers in the community, but in the period following independence it began to refer to settlements set up primarily in the central parts of Ghana to accommodate workers coming in from the north as well as outside the country. Although the Zongo area in Larabanga is actually now composed mostly of Kamara, the area was originally created for a non-Kamara man working on the electrical lines into the village. Thus, the area became "Zongo,"

differentiated in space and name from the "established" areas of Larabanga, and growing larger as time has passed.

The second reason that individuals are moving outwards, however, is simple expansion: there is not enough room in the primary areas of the town to accommodate further growth. Perhaps inspired by a new setting, individuals building on the outskirts of town have also made a strong move away from traditional building methods and are using cement and corrugated iron sheeting roofs. The attraction of such materials over more traditional ones is motivated by two impulses, one practical and the other ideological. Contemporary materials are seen as more economical and sustainable. Corrugated iron is easily (and somewhat cheaply) transportable. It is also durable, lightweight, easily recycled for further use, and does not necessitate a pitched roof form; it can be laid flat across a wall foundation. Cement block and plaster are quickly replacing the two primary traditional earth-building materials for similar reasons. Cement does not require the extensive maintenance that earthen structures do and does not deteriorate during the seasonal rains. Although both earth and cement construction create load-bearing walls, the horizontal thrusts of traditional earth and timber flat roofs in this area have, as previously noted, required the addition of buttresses and pillars along the sides of walls to counteract these forces. In contrast, concrete blocks and plaster combined with a pitched as opposed to a flat roof decreases horizontal thrust to the point that additional supporting elements are no longer needed; the walls are easily freestanding (see Figure 4.1).

In addition, the rectangular, modular shape of contemporary houses encourages formally similar interior elements as well. Thus, square "European" bed frames, shelves, chairs, tables, and other wares are now "standard components" within these modern rectangular units.[10] These increasingly rectilinear forms have also

**FIGURE 4.1** Contemporary domestic compound, Larabanga, Ghana, 2011.

given rise to new compound organizations. There is movement away from the traditionally hybrid design that incorporated rectilinear and round earthen forms, towards a singular rectangular building with an open yard out front. Although many of these new structures do not maintain any sort of wall or barrier, which might seem to signal a more open space, the situation is very much the opposite. This organization has the effect of maintaining perceived separations between the "interior" and the exterior of the compound, by eliminating the transitional entrance space between the courtyard and the exterior environment. The removal of this transitional space, which long acted as an interface or a place of meeting between bodies, has motivated the development of new protocols for making contact that do not depend on this space to initiate it. It is now a solid door rather than a suggested barrier that creates the boundary between the family and those outside the domestic unit; now one knocks to gain entry rather than verbally announcing one's self.

Modern materials and forms are the product and the producer of a number of ideological changes within the social frameworks of the community as well. The building and upkeep of conventional earthen structures was traditionally a collective familial exercise, sometimes even requiring additional help from members of the community to see the project successfully completed. This made traditional house-building a familial and/or communal event as well as an exercise in social cohesion.[11] With the use of increasingly specialized modern materials, the communal aspect of building has largely been taken out of the equation; most construction is now contracted out to professionals. Thus while building is no longer the social event that it once was, the situation has led to an increase in vocational training due to the fact that materials like cement require a certain skill set; job specialization is now common. There remain individuals within the community who are still "good builders" in terms of traditional mud-and-thatch architecture; however, building has become largely an economic enterprise in the contemporary period.

This particular development affects traditional patterns of community activity as well. Because modern building materials like concrete and corrugated iron are permanent in a way that earth and thatch are not, there is no longer a building season *per se*, during which individuals repair and build necessary architectural infrastructures between farming periods. Cement blocks are still typically made during the traditional building season, which is usually drier, but they are often left at a site for months at a time until it becomes convenient or economically feasible to build. This makes the temporal character of building in the community much more oriented around an individual time frame as a communal one. In the contemporary period, architectural projects are finished as time and money allow, which provides more flexibility in terms of scheduling and resources. In addition, because cement doesn't erode the way earth does, there is no drive to finish a cement structure within a specific time frame. However, this also has the effect of creating a largely cluttered environment. Larabanga is becoming a village of brick piles and half-finished structures, a cubist landscape that seems to linger in some strange transitional, almost primordial, state, half-formed and almost skeletal in appearance (see Figure 4.2).

FIGURE 4.2  A series of half-finished structures and brick piles, Larabanga, Ghana, 2011.

These processes of modernization and separation are also increasingly coming to symbolize divisions and stratifications within the community along economic lines as well. Almost all of the houses being built on the outskirts of town belong to so-called "Libyan boys," young men in Larabanga that over the past few decades have traveled to North Africa, particularly Libya, to work on construction and agricultural projects. Recent events in Libya, however, have caused many of these young men to return to the area, creating a massive decrease of capital in many Larabanga households and a difficult economic situation for the community at large. Yet, these young men are still more economically advantaged than most in the village, and use concrete and iron to create modern homes, which are increasingly considered very fashionable. These young men have been going back and forth between Larabanga and Libya for at least fifteen years. As such, they build house forms that mimic North African styles and embellishments, instituting new architectural ideals into the landscape, and providing emergent social ideas based on more contemporary conceptualizations of wealth (see Figure 4.3). For example, in the past, a man was wealthy when he was considered knowledgeable. When one's opinion matters and is sought, then that in itself is wealth. As Hussein Salia, another key collaborator in this research, related to me, his grandfather was considered one of the wealthiest men in the village, even though he did not "own a single cow." His generosity was such that one might think he had money from the way he would give it away, when in fact he was a very poor man.[12] The idea of wealth that Libyan boys and their new architectural vocabularies are promoting in the contemporary period is rapidly changing both Larabanga's social environment and in turn its built landscape, as materials begin to speak louder than words. Building in mud and thatch has been long been synonymous with poverty even

FIGURE 4.3 "Libyan boy" house, Larabanga, Ghana, 2011.

before the phenomenon of "Libyan boys" developed; one could say it began during the colonial period. Yet, new methods of building are starting to directly signify socio-economic class and as in all things material, there are levels of wealth expressed in the gradations that occur within architectural forms, predominantly in terms of how and with what materials one builds. In Larabanga, the poor still build almost entirely in mud, whereas the slightly more well off often use cement plaster applied over mud brick. The financially comfortable, in contrast, build entirely in cement. Thus we see that changes in building materials and technology have led to changes in social ideals with major cultural impacts coming from new material arrivals.

Yet these materials are often used even by individuals who can't afford them, and when asked why, the most cited reason behind the preference for concrete and corrugated iron over mud and thatch was still economical. Building with cement is generally considered to be more practical in terms of the time spent building and the physical effort involved, and as such, cement and corrugated iron sheeting are simply easier to deal with on a regular basis than mud and thatch. Yet the second reason given, oftentimes with a minimal amount of explication, seemed to hold more weight. Many people noted that they preferred cement and iron because they were "better." The word "better" seemed to have a couple of different meanings in these conversations. One is that these materials were thought to last longer and need less frequent repairs. But another more subtle reason seemed to be that cement is a more attractive medium than traditional earth and thatch.

In addition, these reasons were defended with full knowledge of the disadvantages of using concrete and corrugated iron in the climate of northern Ghana. This area rests on the border between tropical and savannah belts and is characterized by hot, mostly dry climatic patterns with occasional humidity. Earthen construction is thus an enormously effective insulator in this context; it absorbs the heat of the day and keeps the interior comfortable, then disperses that warmth into the interior at night when temperatures drop. In contrast, cement and corrugated iron have few positive insular properties for this type of climate; interiors tend to be uncomfortably warm during the day and the heat stays trapped within the structure throughout the evening as well, often forcing those with electricity to buy expensive air-conditioning units or fans. What, then, is the reasoning behind the use of construction materials that are so ill-suited to this environment?

Perhaps this relates back to the idea of one's self-fashioning in society. As I noted in Chapter 3, the idea of "face" or a self-image that one presents to the public is an extremely important component in one's interactions with people and is often enhanced through material and architectural means. Thus, although it may seem impractical to spend money on unnecessary and largely ill-suited materials such as cement and corrugated iron to build one's domicile, particularly when there is a wealth of natural materials available, cement and corrugated iron have gained deeply symbolic meanings in the contemporary period. The very ability to afford these materials represents a certain level of achievement and financial establishment,

a level of "comfort" brought about by one's economic achievements. Paul Oliver discusses the idea of comfort in the context of "vernacular" architectural systems, expanding the definition beyond physical comfort to situate it as deeply relevant to one's psychological well-being as well. Many European colonists in Africa, for example, filled their domiciles with objects and pieces of furniture from home, many of which quickly grew moldy and musty in tropical climates. Yet these environments were nonetheless meticulously maintained because of the psychological comfort they provided.[13] In Larabanga's case, it would seem that earth and thatch are no longer perceived to be culturally representational or "comfortable" in its newly modernized context. With concrete and corrugated iron sheeting, individuals retain the time and effort previously spent repairing traditional earthen structures and gain a more permanent, and thus more functional, architectural structure. Such reasoning provides a more practical defense for slightly less rational motivations emerging from changing social conditions and the symbolic paradigms that they are initiating. Not a single person I interviewed lamented the potential eradication of traditional skills of local architectural craft, the apprenticeship systems that went with them, or the communal investment in these conventional architectural practices. Many of the youth in Larabanga are unable to explain how to build a traditional earthen structure, mostly because the process no longer plays a role in their lived reality. Thus, this shift in materials feels like a sign of the fundamental changes that are going on in Larabanga's communal reality, whose transition to materials like concrete and iron are only the first step in a socially and architecturally evolutionary process.

Yet, even as modern materials like cement and corrugated iron signify wealth and status, they still seem to have an inordinate amount of flexibility with regards to *how* they signify. This is particularly true of cement, whose material blankness provides a largely vacant surface on which one can inscribe individual needs and desires via a wide array of textures, colors, and images.[14] However, regardless of its responsiveness to creative energies, cement has been shunned by many Western architectural purists for its artificial qualities and a lack of what might be called "ideological integrity." "Vernacular" materials like earth have a good deal of ideological integrity, responding uninhibitedly to time and nature and subsequently maintaining a certain material honesty or truthfulness connected to the fact that it wears its inherent material qualities proudly on its surface, even as that surface quickly and often gracelessly erodes. In contrast, cement is an industrial material indifferent to the natural world, inorganic, anti-aesthetic, and undiscerning. It has no identity of its own but mimics multiple forms, colors, and surfaces, existing fundamentally as a material simulacrum and relying on the appropriation of other material characteristics to craft its own identity.[15] In addition, because cement enables structures to sustain themselves much longer, indicators of age, history, and material quality are no longer so majestically etched onto the surface.

Yet, for all of earth's "integrity" and ability to attain some astonishing sculptural forms in many West African contexts, it nonetheless evokes historical narratives of dwelling, "traditionalism," and membership within a specific cultural milieu. Such

symbolisms can make building with earth very unattractive in the contemporary age, especially when compared to materials with blank patinas that give themselves so readily to multiple representations. Cement, in other words, is a material with potential.

As such, contemporary cement surfaces in Larabanga are becoming increasingly common, a development that has both advantages and disadvantages. Because of their increasing prominence, decorative programs are now being developed that attach signification to cement not only because of its material qualities, but also its ability to provide a vacant surface on which to inscribe subsequent markers of identity. Larabanga's architectural forms now display all manner of new forms and symbols, few of them encoding any significant cultural meanings but enthusiastically displaying knowledge of contemporary global pop culture and entertainment. Such transient, trendy types of information are perhaps fitting for a surface skin that can be so quickly modified. It is rare to see the abstract, pointillist designs that were once inscribed in the mud plaster of a wall; the advent of cement has replaced textural designs with painted ones. Instead, one sees cartoon characters, animals, and text adorning the major surfaces of domestic compounds around the village (see Figure 4.4). These decorations act as examples of individual expressions of creativity and are additional gestures towards the modern condition. While such images are not part of any established or formative symbolic system, they nonetheless create a new kind of textuality within Larabanga's architectural landscape, one that does not necessarily provide specific individual or cultural information, but instead points to contemporary engagements with global popular culture as a state of

**FIGURE 4.4** Building at the Savannah Lodge decorated with various cartoon characters, Larabanga, Ghana, 2011.

being modern.[16] In addition, many of these contemporary wall decorations are not being painting by the women of a household anymore; the job has been allocated to children and adolescents. This represents a major shift in conceptualization of the act of wall decoration as no longer being defined by culturally inflected gender roles, but instead an expression of individual creativity, taste, and global exposure.

Many contemporary houses in fact now resemble theme park attractions, covered as they are with exuberant splashes of neon color (see Figure 4.5). The pinks, purples, blues, and additional hues that find their way onto Larabanga's contemporary architectural patinas reflect the variety of interactions with exterior influences that have come to characterize Larabanga as a community in social, cultural, and economic transition. Still, one can find the greatest concentration of color oriented around the penetration points into the structure, particularly the doors and windows (see Figure 4.6). The continued emphasis on the entrance as a transition area into the interior compound seems to indicate an ongoing preoccupation with issues of penetration and the importance of threshold in Kamara society. Even though surfaces and materials may be changing, they are in some ways merely the latest physical tools in one's available toolkit whose purpose is the production of contextually defined, community-specific space. With this transformation, these spaces become hybrid fusions of established and newly developed symbolic paradigms, and the newest exploration of how more contemporary methods can still convey, and in fact buttress, culturally embedded meanings.

FIGURE 4.5 Domestic space of a *mallam* with neon paint, Larabanga, Ghana, 2011.

Building Across Borders  **147**

**FIGURE 4.6** Window demarcated by neon paint, Larabanga, Ghana, 2011.

Perhaps the most obvious architectural patinas devoted to advertising the presence of modernization in Larabanga are the "telecom houses" (see Figure 4.7). In peripheral villages such as Larabanga, the main thoroughfares are increasingly lined with houses and complex walls decked out in the eye-watering neon colors of red, blue, yellow, and green that telecom companies have painted for free to advertise their services. West Africa is one of the fastest growing telecommunications markets in the world, and many of their clients are in rural areas that are becoming rapidly connected to the rest of the world through improvements in transportation and communication. A major reason companies are marketing themselves so forcefully in areas such as Larabanga is because these areas mark some of the last potentially untapped customer populations, a group that also perhaps has even more enthusiasm than those in more urban spaces to connect to a broader community.

In the Northern Region of Ghana, telecommunications brands are strategically denoted by easily recognizable neon colors that are all distinct from one another. Vodaphone (red), MTN (yellow), TIGO (blue), and Glo (green) are all geared towards imprinting themselves on the memory through color rather than a logo, text, or even the brand name. This is highly tactical in rural areas because some potential clientele are unable to read and the overpowering fields of neon color are striking and memorable. Buildings covered by the "brand" color of each telecom company are enveloped by the glow of their über-modernist patina, and almost become unrecognizable for what they usually are: functioning architectural

**FIGURE 4.7** "Telecom" house, Larabanga, Ghana, 2011.

constructs, often homes. Perhaps coincidentally, this is reminiscent of the older Islamic decorative practices discussed in Chapter 1, in which surfaces dissolved under the visual weight of ornamentation.

Although the residents of these spaces aren't paid to have their homes advertise for these companies, the symbolic power of the brand often evokes a certain status connected to modern life, similar to the utilization of cement and corrugated iron. One might question why such advertisements would appear on houses instead of billboards, which are another growing visual presence along northern Ghanaian roadways. It may in fact be cheaper to paint a house than erect a billboard, but I believe there is another reason for this practice. The implied association between brand and abode gives the brand—especially one oriented around communications—an accessible, local feeling that takes advantage of associations connected with the home and family. The situation of telecom houses benefits both parties: the home gets a visual facelift, its residents get a status update, and the business gets free advertising space on the main vehicle through which people organize their physical reality.

Changes to the social and cultural aspects of Larabanga have been accompanied, perhaps unsurprisingly, by changes in the spiritual infrastructures of the community as well. Practicing *mallams* have also begun decorating their doorways and walls with brilliant neon colored Islamic texts and signs that continue to incorporate benedictions, information about their services, and their contact information (see Figure 4.5). In addition to this, many contemporary mosques are beginning to channel the vivid forms and colorful palettes of contemporary visual culture into their representative rubric. Vibrant pinks, greens and oranges are common hues to be found on mosque forms both rural and urban, such as this mosque in Wa, which has a minaret in the shape of a pineapple (see Figure 4.8).[17] In addition to this progression of architectural aesthetic, there has also been a decline in the number of earthen mosques being built in the style of Larabanga's ancient mosque. This is mainly due to the amount of labor required to maintain the structure and a lack of the necessary specialized knowledge. As a result, new concrete-based Middle Eastern-style mosques are popping up all over the northern part of Ghana in both urban and rural areas, their construction often funded by Middle Eastern associations and the designs representing a standardized template that can be expanded or contracted according to the needs of the community (see Figure 4.9). Yet in addition to these new three-dimensional forms, there has also been a continuation of more intangible spaces using modern materials that continue to act as highly functional sites within many contemporary contexts. Rock-outlined mosques, for example, have assumed new form in urban "half mosques"—open areas with a concrete half wall and a roof—in conjunction with other enclosed but uncovered areas that are often demarcated by an image of a half moon painted on the side. These in fact are becoming increasingly widespread because they are an easy and cost-efficient way to provide a convenient prayer space for a growing populace. Such mosques are sometimes even part of a family's domestic space, or built into the side of a business. One memorable mosque in Wa was built into the side of a gas station and had matching color schemes (see Figure 4.10). This represents a

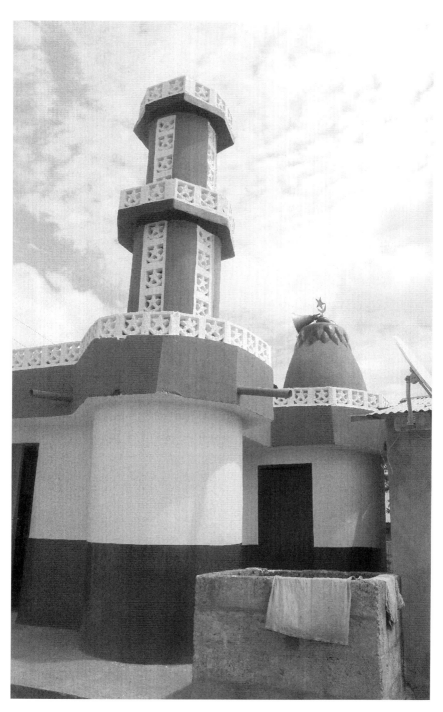

**FIGURE 4.8** Mosque with "pineapple" *mihrab*, Wa, Ghana, 2012.

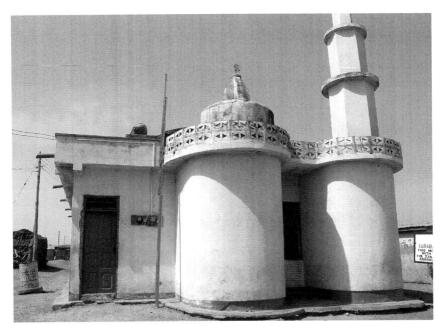

**FIGURE 4.9** Mosque built via a standardized contemporary template, Larabanga, Ghana, 2011.

**FIGURE 4.10** Mosque/gas station, Wa, Ghana, 2012.

shift back to an everyday, practical, and accessible mosque form that has more directly manifests Islam both as a religion and a central part of traditional lived reality. But it is also a result of the modern dispersal of the community into landscapes beyond communal borders, which makes large, centrally located congregational mosques less convenient and a series of small mosques spread far and wide more amenable to fulfilling one's faith-based duties. Hypothetically, a number of small mosques as opposed to a few larger ones would also seem to complement increased feelings of individuality that come with growing occupational diversification, mobility, and a move away from a family- or community-centered lifestyle.

But to take a step back for a moment, these collective changes to the built environment need to be considered as part and parcel of a larger movement, rather than a series of individual occurrences that have emerged as the unexpected results of a somewhat haphazard process of modernization. This is particularly important towards gaining a constructive understanding of Larabanga's environment whose specific qualities are being deployed in new, yet nonetheless, culturally cognizant ways. Symbolism, for one, is a key tool in structural representation and communication in the contemporary period in Larabanga, but is most often effective when it uses particular vocabularies that are familiar to a specific audience. Architecture in the contemporary period can thus be an occasion for either communication or miscommunication depending on both the audience translating its vocabularies or the effectiveness of the sign.

In Larabanga, current architectural symbols are becoming increasingly layered with numerous meanings and messages, and distorting established definitions with contemporary implications. This has led to problems of both communication and representation for a number of reasons. In contrast to verbal communication, which uses objectively measurable systems of signifiers, symbolic communication in architecture uses more abstract visual and spatial units as an interface. It encodes registers of cultural knowledge into recognizable symbols. These symbols are culturally defined, as a necessary condition for people to be able to interact with them in any type of meaningful manner. As we have seen, culture saturates material production in contexts all over the world and, in terms of communication, maintains degrees of locale-oriented specificity that goes beyond simply "toss[ing] the conversational back and forth," to quote Hall.[18] The layers of meaning relayed through symbol systems that were made through the medium of culture and inserted into material forms like architecture allow communication to happen and keep it on a particularly clear frequency to a specific audience.

So how does a community like Larabanga ensure effective communication through architectural symbols in the contemporary period, when so many established symbols are experiencing both renovation and intensive layering in response to increasingly modernized community-based conditions? One way that has its basis in many historical traditions and takes a more tautological stance is fractalization, or "the repetition of similar patterns at an ever-diminishing scale."[19] This mode as a tool of analysis has worked particularly well in architectural studies because built form is often shaped by subunits of itself, i.e. a rectilinear brick creates rectilinear

structures which in turn create rectilinear communities and so on. Mathematician Ron Eglash has made particular use of this method to chart both physical and cultural trends in the African material environment, drawing from architectural dwellings as well as design and aesthetic systems in order to reveal the presence of persistently similar repertoires of embellishment across cultural mediums. Eglash posits that such formal connections act as potential evidence of culture-specific systems of knowledge that have been programmed within a society's expressive systems. Fractalization thus acts as an organizational force that encodes physical implements like architecture with the social values, cultural relationships, and even individual identities of a community through repeating structural components like placement and scale.[20] Architecture as a three-dimensional form is capable of taking this symbolic scheme even further by displaying these cultural qualities both in the round and at different levels of a structure's physical reality, from house shape and compound organization to spatial hierarchies and even construction materials. As such, each component within a fractal system is capable of representing the values that shape the individual lives and mental realities of a society.

Yet despite its quantifiable characteristics, fractalization as an investigative apparatus may be limited by its occasionally linear readings of space and its failure to adequately attend to incidents like technomorphism, which occurs when forms occur repetitively through technique as opposed to conscious design. Textiles provide an excellent example of this in that actual weaving processes tend to make certain shapes like diamonds or lozenges easier to produce. This results in certain shapes becoming dominant in weaving traditions and over time assuming culturally significant meanings.

But to nuance this discussion a bit, perhaps the reproduction of meaning should be considered through the lens of the repetition of culturally "replete" practices, where precedents are used as symbols of cultural identity. Suzanne Blier operationalized this theory in her work with the Batammaliba (1987), where she observed that the notion of precedent plays a major role in Batammaliba building culture. The Batammaliba typically incorporate previous forms into current structures as a way of symbolically revisiting the past and gaining a more comprehensive understanding and appreciation of their cultural legacy.[21] The methods through which symbol systems become collective within the context of a community or cultural group is important when attempting to unpack environments like Larabanga, which also developed from the basis of an extensively realized, historically embedded building culture.

With regards to Larabanga's architectural environment, early signs of life for a tautological approach began with Prussin's 1969 survey of architecture in northern Ghana, which she called "a material manifestation of a culture's symbolic system" from which the values and principles operating within a community could be deduced.[22] Architectural forms within their "home" contexts were not singular entities but cogs within the larger machinery of a cultural context, and her initial arguments received later support by scholars like architect Amos Rapoport, for whom architecture expressed a series of relationships between human, material,

and architectural bodies that could not be considered "in isolation."[23] Thomas Markus also proposed that buildings provide evidence of narratives operating within the structure itself and across the wider society, evidence of which we've seen in the Larabanga mosque. Its layers of physical access read like an architectural microcosm of the larger cultural narrative of the Kamaras in Larabanga. Thus, the mosque becomes a cultural document, a conceptually fractalized version of the larger identity-making apparatuses in place in the community. This interpretation expresses the potential intimacy of the relationship between architecture and textuality, the former, with its attendant formal, spatial, and stylistic properties, in many ways becoming a vessel for the latter.

Another important component to considerations of the value of precedents as an important informer of contemporary reality is the component of style. According to Broadbent, the creation of stylistic genres represents a "social contract between people," encompassing precedents and the symbol systems that inform them. Style as a system reflects agreed-upon meanings that are translated into observable elements in the built environment with a set of guidelines for their usage.[24] To do this, the components of a style may reach back into established systems of representation towards reiterating the normative standards by which individuals have traditionally shaped the collective environment (as with the Batammaliba). They may also display transitional forms that mark shifting normative trends within the community that require new modes of symbolic representation in order to establish a sustainable communicative system for the future, as we see now in Larabanga. In either case, style should be coherent enough to be identifiable but also "changeable enough to have a 'story;'"[25] it should be able to represent a process of social exchange at a particular time. Stylistic components in architecture become, in the words of Alfred Gell (1998), social agents that both express and reinforce the aesthetic, social, and cultural conditions in which they were created.

To focus on the relationship between style and tautology for a moment, style establishes relationships between forms through their repetition within a built landscape. Because the built landscape often coordinates human mobility and interaction, style also plays a role in fostering dialogues between individuals based on its reinforcement of recurring practices and behaviors. Larabanga's compound organizations and demarcations of entrances, for example, have led to a system of greeting and social protocols required to create dialogue between those inside and those outside. Anthropologists have often used "style" to describe the general framework of collective behavioral practices they observe within a cultural context. Style has a multi-faceted role in the architectural environment as an indicator of cultural/architectural type as well as the relationships that exist between types. It is a useful tool in both identifying particularly dominant characteristics and, as a unifying "institution," subsequently connecting them within an environment to create cohesive communal narrative.[26]

Within dialogues of style, the individual in society represents an important variable that can create minute deviations within a community's stylistic "mean." Regardless of his or her immersion within a communal narrative, the individual

maintains a sense of self that is reflected in the ways that he or she constructs their material environment. The contemporary appearance of cartoons and neon paint in Larabanga are all examples of this sense of self in the current period. One might expect that because of this, communities would over time become highly idiosyncratic landscapes of mixed, diversified architectural forms. Yet historically speaking, this has not been the case, and there are specific reasons why. The first is that the architectural toolkits and skill sets present in the area often give rise to particular forms that are physically and logistically sustainable. The second reason is the fact that style is often inherently hegemonic in nature; more often than not, individuals filter their flashes of inspiration through the dominant value systems that are active within their community. As a result, architectural and material forms end up as collaborations between individual and collective value systems, with individual elements adding variation to a collective communal palette while still operating within established stylistic parameters. This creates a unified landscape, yet it also textures the landscape with individual modifications that work as complements, not obstacles, to the dominant stylistic framework. In fact, the strength of a particular style comes from its ability to both define the parameters of a particular formal system and also maintain the flexibility to be translated through a variety of individual lenses. Each lens is informed by specific gender-related, social, political, and spiritual layers of identity. Such layers profoundly affect the way individuals read and interpret culture-specific structural styles, and thus these layers create the various stylistic flavors or dialects that appear within a communal architectural corpus, representing moments of individual identity, creativity, and even artfulness that tempers established paradigms with divergent yet complementary tastes.

As the fabric of everyday life changes, so too must the stylistic languages of the built environment in order to continue to enable the successful performance of culture and identity in society.[27] Thus, the acquisition of new architectural symbol systems across time and space allow layers of meaning to accrue on architectural structures and produce a patina encrusted with registers of knowledge. Over the course of this process, style becomes a timeline of evolutions, transformations, and upheavals that occur throughout history within a context, whose expressions within structural languages are brought into subsequent conversations and dialogues with new incoming influences and narratives.

This interpretive method has long been utilized to understand other communicative forms in Africa, particularly graphic writing systems, whose visual symbols are composed of combined layers of history, ideology, and identity. In the graphic traditions of the Bakongo people of Central Africa, for example, writing is organized as a collaborative, culture-specific, communicative system that incorporates gesture, language, symbolism, history, tradition, and material objects as a mode of "organizing daily life, enabling interactions between humans, nature, and the spiritual world ... preserving cosmological and cosmogonial belief systems."[28] In addition, graphic writing for the Bakongo is an architectonic practice that creates meaningful worlds through processes that are fundamentally

constructive. As a body of assembled, constructed knowledge that in turn perpetuates that knowledge, graphic writing provides structural blueprints for future realities and identities by creating symbol systems that catalyze further reenactments of these cultural systems and identities.[29] Architecture, as a culturally dictated vessel for many such systems, functions in a similar physical and symbolical fashion. It acts as a regulatory body that reinforces the practices, protocols, and value paradigms dictated by society, and accommodates shifts within those paradigms by undergoing adjustments as a way of remaining current and thus relevant to its locality. A logical conclusion to draw from the discussion of style and symbolism in architecture is that built form rarely functions effectively without signifying something. The information it encodes is shaped by its cultural environment, which is in turn produced and reproduced through stylistic elements.

In contemporary Larabanga, these exchanges are currently being reformulated through newly established technologies and channels of communication and influence. This process is in turn creating hybrid systems that, when expressed in the architectural environment, range from patchwork symbolic landscapes to cohesive architectural fusions. These areas thus become reservoirs of known emblematic types that correspond to registers of cultural knowledge and a careful selection of incoming influences that are assessed and adapted to fit existing cultural frameworks. These later fusions gesture to the development of progressive symbolic paradigms firmly situated in the contemporary sphere, which are fundamentally responsive to the ebbs and flows of society, becoming crystallizations of context-specific relationships that exist in times of both stability and change.[30]

## Heritage and the Issue of Ghanaian National Identity

The architectural developments and transformations occurring in Larabanga are creating an iconography of modernization. It is a symbol system that incorporates both actual signs (telecoms and visual imagery) and materials (cement and corrugated iron), connecting their associated forms and the diversification of structural genres such as domestic space and the mosque with subsequent connotations of modernity. In each case, symbolic capital grows and shifts to represent a changing reality. But there are two influences becoming increasingly dominant in Larabanga's cultural and architectural space that are affecting its meaning-making functions, particularly with regards to the village's ancient mosque. These are the growth of national and international heritage programming and a developing tourist presence in the area.

Larabanga has recently begun what might be called its second career as a national heritage site. The change has come over the past two decades, as the Ghanaian government continues to decide how it wants "Ghanaian national heritage" to appear. This process for Larabanga was catalyzed by an event that occurred in the late 1970s: the mosque in Larabanga was covered with a layer of waterproofed sand-based cement. This move effectively trapped moisture within the earthen core, leading to rot. Termites added to the problem and destabilized the structure

further. Eventually, a major storm in 2002 caused the minaret and the *mihrab* to collapse, which caught the attention of national and international preservation organizations in Ghana and Europe. The Larabanga mosque was added to the World Monument Fund's list of 100 most endangered sites, and a team of members from the Ghana Museum and Monuments Board (GMMB) and the French earthen architecture institute CRA-Terre EAG arrived to help repair and restore the mosque alongside a local, community-based committee. These groups were collectively interested in restoring the structure to its original state using established materials and techniques; in addition, CRA-Terre held training workshops for newly established village "masons" to learn to continue the preservation after the project was complete. The project itself was funded by grants from international organizations such as American Express, reflecting the degree of ideological capital generated by this endeavor and supported by lofty predictions about the future trajectory of the mosque and earthen architecture in the region more generally.[31]

But this project in fact had a number of problems, and various components of the narrative need to be further unpacked to explicate them towards understanding the true impact of this venture on both the village and national heritage rhetoric. There is only one article that has addressed this project in any type of detail, and that is Suzanne Blier's article "Butabu" in UNESCO's *Icon* magazine, published in 2003, less than a year after the project was completed. Blier's account is informative, engaging, and paints a positive future for the newly renovated mosque. But it fails to mention that the initial addition of sand-based cement, identified as the most direct cause of the structure's demise, was not done by the community of Larabanga. In all likelihood, that was implemented by Ghana's National Public Works department; evidence of this lies in the fact that a number of other mosques in the region were given the same treatment around the same time.[32] Failing to highlight this fact seems to implicate Larabanga's community in the structural failure of the mosque. Groups like GMMB and CRA-Terre are subsequently perceived to have sailed into view in the manner of a preservation-oriented cavalry to fix the situation. The article also positions the renovation of the mosque as a return to a previous glorified or authentic condition, a sense evoked by statements that the project had "reawakened" an interest in traditional earthen architectural construction, and that the mosque has now "resumed its vital role in the spiritual life of Northern Ghana."[33] I would argue that it had never lost its vital role in the "spiritual life of Northern Ghana"; it had, however, been allowed to display the effects of time and the environment on its surface, a process that is fundamental to understanding how the form was operating within its cultural environment. Natural degradation, active dismantling, or the transformation of spaces into those that continue to respond to human needs: all of these components are purposeful communicative devices whose reality transcends a rather simplistic assumption that a community is simply ill-equipped to engage in the appropriate maintenance of a structure. Thus, in considering architecture not only in its pristine form, but also in its nascent, deconstructed, decayed, and renovated state, built form becomes a repository of the histories, narratives, agendas, and legacies that inform a society,

a timeline of events, influences, and interruptions that make up the cultural fabric of society and that subsequently governs how they choose to respond to the disintegration of an architectural form. In looking at structures like the pre-preservation mosque, it becomes important to ask about the motivations behind its current state; this allows the structure to become not a symbol of lack, but a register of knowledge that documents cultural movements and developments through form, surface, and space. Architecture in this way can more broadly be understood thus as a "cultural history of the built environment,"[34] a reality that went largely unacknowledged in Larabanga with regards to the newly established physical form of the mosque. It was constructed through a process that in the end potentially acted as more of an intervention than a collaboration on the part of the heritage organizations involved.

Evidence for this lies in the fact that collaborations between CRA-Terre, GMMB, and the committee acting as the community's liaison were fraught in many ways. In fact, the finished structure is very much a physical document of the miscommunications and differing agendas that occurred between these groups during the restoration project, conversations which are largely missing from public accounts of the collaboration.[35] Most of the disagreements stemmed from differing opinions about the final exterior appearance of the mosque, or, more specifically, the type of surface aesthetic most appropriate to the region's architectural history. GMMB and CRA-Terre felt that the mosque surface should reflect the palette of the earthen clay plaster from which it was made, a more naturalistic presentation of material medium and also potentially a way of making the mosque more of an aesthetic extension of the rest of the built landscape. The community disagreed, arguing that the structure should be whitewashed with a lime or clay plaster to give the mosque a more spiritually referential patina and connect it to larger regional Islamic practices throughout history.[36] Extensive evidence from area histories and numerous pre-colonial regional narratives support the community's claim, including details about Sudanese mosques in the Niger Bend that were whitewashed with lime or clay plaster and colored with ash. Mungo Park, in *Travels in the Interior of Africa*, described the Malian city of Segu (present-day Segou) as having "whitewashed mud houses and numerous mosques."[37] Moreover, white is a spiritually significant color to Islam, symbolizing purity and devotion to God. Lastly, there were also concerns about the time and economic commitment involved in upkeeping the mosque in its "traditional" state.

Despite such concerns, the mosque was finished in earthen tones, a move that altered the regional history of Islamic architectural practice. It is thus unsurprising that a few years after the project had concluded, the community replastered the mosque with a new coat of sand-based cement to ease the maintenance issues involved in its upkeep and also repainted the mosque in white. It needs to be stressed here, however, that the community of Larabanga was not ignorant about the physical and material ramifications of this action; they well understood that the surface would eventually crack as the concrete absorbed water during the rainy season. However, they determined that it would be more cost- and time-efficient

to repair the structure on a case-by-case basis, removing and re-cementing sections as needed and giving the structure a new coat of paint each year rather than engaging in a comprehensive all-over reparation on an annual basis.

It is also important, however, to note that the layer of cement on the Larabanga mosque does not radically change how the mosque looks and this supports the idea that only a past "reanimated through present efforts" can attain contemporary relevance.[38] More often than not, new architectural forms reference older forms as a mode of making them more digestible and readable, playing into the aforementioned aspects of style and the idea of precedent. However, this evokes problematic discussions with regards to the highly fraught idea of "authenticity." Although few scholars waste time attempting to wrangle this term into submission in the contemporary period, there is still a largely unspoken assumption that once an object or performance has become identified/commodified as a focus of tourism, its authentic "aura" is diminished.[39] Assuming that such an "authentic aura" exists, it depends largely on a site "being believable rather than being original," to quote Xie, an idea particularly pertinent with regards to the cement surface of the mosque. As we have seen, cement is capable of acting as a highly flexible representational medium, and because of this it has been increasingly used for monuments and shrines around the world in the contemporary period.[40] As a material capable of multiple forms, colors, surfaces, and textiles, cement gives itself to endless mimetic properties that can induce multiple sensorial and subsequently conceptual interpretations depending on the context in which it appears (see Figure 4.11). Thus, cement is an infinitely accessible material, which is particularly

**FIGURE 4.11** Detail of the cement surface of the ancient mosque, Larabanga, Ghana, 2012.

useful in constructing commemorative forms that are based on contemporary interpretations of past personages, events, and ideologies. Because such structures are inherently of the present, they will never be able to adequately convey historical truths. Contemporary monuments, shrines, and commemorative structures like the mosque thus in some ways say more about the present than the past, operationalizing vehicles of identity-making towards the creation of a sense of what it means to be "X" in the context of "Y."[41]

However, there were also strong ideological reasons *for* incorporating cement into the mosque; indeed I argue the decision was not only logical but even somewhat predictable, particularly if one subscribes to the view that architecture is a structural manifestation of the reality and the contemporary values, protocols, and social relationships of a community. The construction of the mosque using both earth and concrete, as opposed to just earth, is a highly appropriate semiotic system for Larabanga because it balances the village's historical identity as an ancient seat of West African Islamism with its contemporary reality as a community situated within the currents of global modernization. Many contemporary preservation processes tend to place architectural forms in a type of physical and material stasis by institutionalizing their original aesthetic, materials, and techniques; structures are therefore kept "traditional," but they are also prevented from evolving in ways that allow them to remain relevant and useful within their cultural environment.[42] The addition of cement to the ancient mosque not only provides a practical solution for the structure itself, but allows the Kamara to "reinvent themselves for themselves" by establishing new modes of self-representation that allow both their cultural and architectural identities to evolve.[43]

To many in Larabanga, the mosque, in conjunction with the founder's grave and the Mystic Stone, constitutes the root of the Kamara identity; therefore its preservation with cement can be interpreted as saving the past from decay. However, some have argued that by encasing the structure in a material as ageless as cement, the mosque itself is robbed of the value that comes from its fundamental reality as, essentially, a historic building made out of historic material. In addition, the ways in which Larabanga residents have exercised control over these cornerstones of their cultural identity have had their problems. Covering the mosque in cement has necessitated contracting specially trained workers from outside the village to make the structural repairs. In the past, individuals residing in Yidanyiri, or the first section of town in which the mosque is located, were responsible for repairs to the mosque. However, recently members of this area have begun claiming that tourism funds from the mosque should be provided to them as payment for this custodianship. This development has actively divided the town along political and economic lines. There have also been problems at the Mystic Stone site as well. The Dagbani clan, the only house to have connections with historic earth priest traditions, were responsible for building the compound around the Mystic Stone and placing a keeper at the site to guard it and collect the tourist fees. The clan has recently stopped giving this money to the community,

instead funneling it to themselves on the claim that their clan has an ancient connection to the stone that excludes the rest of the Kamara.

Yet to return to the mosque, the addition of the cement also has a more symbolic component that we've seen play out in its application on domestic structures. In the contemporary period in Larabanga, cement is a material of prestige. It signifies wealth, a connection with modernity, and a fundamental orientation towards an anticipated future; it is a way of fashioning the self through architecture in a positive way. As such, restoring the mosque using this material couples it with these connotations, signaling the fact that this structure is extraordinary and necessitates a new contemporary symbolic repertoire to make this elevated status known.

Thus, while the current state of the mosque is not the idyllic solution the GMMB and CRA-Terre undoubtedly had in mind when they completed the project in 2002, it is nonetheless strategic. Through its material and formal qualities, the mosque has allowed both established and contemporary identities to become space. By inscribing an older architectural form with a new material element, the mosque taps into a pre-established code of understanding that nonetheless has additional layers of contemporary meaning. As such, it provides a way to reference and preserve the past that is commiserate with the present reality and does not unduly burden the population. The current mosque structure and the disintegration of traditions with regards to its maintenance, for better or for worse, are reflective of the community's general move towards interpersonal independence and individuality and away from the communal networks that have long linked this community. As we have seen, new symbol systems are created as more individuals move to the outskirts of the village and build in styles that restrict intensive personal interaction with materials that do not require outside involvement. Some of these systems come from older forms and are refashioned in more appropriately contemporary ways. This is also true of the mosque, whose current state points to the legacy of the primary stakeholders in this process, the Kamara, and how *they* wish it to be construed to an outside world. This subsequently moves us into broader discussions as to how the Larabanga mosque is signifying to a larger public audience as a national heritage site that, by its definition, belongs not just to the Kamara but to every Ghanaian citizen.

As a part of the visual iconography of Ghana's budding national heritage culture, Larabanga's mosque has been increasingly deployed to portray a "national identity" that has yet to be concretely defined. The concept of a national heritage in Ghana began during the colonial period under the British administration, shortly before the start of the Second World War. Thurstan Shaw, an English archaeologist, was appointed as the part-time curator of a small museum institution at Achimota College in the greater Accra region in 1937. Its collection at the time was primarily composed of objects obtained by colonial officers and amateur archaeologists. The Monuments and Relics Commission was established in 1948, followed by the founding of the National Museum, which was housed in a complex that later became the University College of Ghana, Legon. When Ghana won independence

in 1957, the Ghana Museum and Monuments Board (GMMB) was established to "manage archaeological and cultural resources" as "part of nationalists' desire to develop a national identity for the emerging nation state." The aims of the Ghanaian Museum and Monuments Board, according to the National Liberation Council Decree 387 of 1969, were to identify, register, and preserve any object, structure, or area that it deems to be of "national importance" and defines archaeological heritage in terms of objects, environments, crafts, texts, and architectural structures.[44]

Because of this initiative, the Larabanga mosque's visage now graces the main wall of the entrance terminal of the Kotoko International airport in Accra (Figure 4.12) and can also be found on postage stamps and even in government buildings (Figure 4.13) as well. Previously functional elements, such as the protruding timbers that wicked moisture from the mud walls and provided scaffolding to aid in maintenance, now also act as references to an architectural "canon," which makes it recognizable when it appears in other media. By casting these forms as "a specific set of ideals,"[45] they present an ideological template that can be recycled and reinvented in the contemporary period as a vetted form rooted in a grand historical and cultural past.

These repeated images of the mosque indicate the cultural capital that the mosque has gained in the current period as both an iconic architectural form and part of a historic canon. But it also points to the fundamentally fraught issue of identifying a unified national heritage and the problems of doing so within a multicultural area like Ghana where rhetorics on ethnicity and cultural membership are currently rife. Beginning in the 1960s, the term "ethnicity" gained traction as a nationalistic antidote to the colonially rooted "tribal" terminology of the British. It was thought to be capable of generating more flexible modes of crafting postcolonial identities based on cultural mobility and newly acquired rights of self-definition. In the past few decades, the term has been increasingly mobilized to influence groups and populations towards certain political agendas, subsequently creating social memberships through the establishment of borders and boundaries along the margins of ethnicity.[46] Most recently, however, it has become a tool of power, agency, and cultural gate-keeping that has become increasingly complicated as individuals define and deploy the concept along new strategic lines. Ethnicity is now a concept increasingly associated with fabrication, reinvention, and strategic usage as it is assumed, reshaped, and wielded as an implement for enhancing the legitimacy of one's belonging within specific contexts.[47]

With regards to heritage, performances of ethnicity such as festivals, religious occasions, material culture traditions, and architectural landmarks are currently being used as modes of authenticating the state's "semi-articulated policy of multiculturalism," through which the government chooses, tweaks, and subsequently promotes specific tradition-oriented practices as legitimate examples of Ghana's cultural heritage.[48] Through the reenactment of these cultural performances under the aegis of national identity, they reveal that heritage is a largely arbitrary categorization and that once a performance has been categorized as such, it becomes the providence of not one group but multiple communities

**FIGURE 4.12** Mural of Larabanga's ancient mosque, Kotoko International Airport, Accra, Ghana, 2012.

**FIGURE 4.13**  Center for Community Development, Bole, Ghana, 2012.

around the country,[49] each one taking ownership of the tradition and assigning it different significations and narratives depending on the contexts in which such assignments are occurring.[50]

This focus on crafting a discernible national heritage from a patchwork collection of tradition, performance, and landmarks, has brought a number of challenges to the GMMB and its supervisory body, the National Commission on Culture (NCC). Some problems are associated with development and the growth of tourism, while others are internal problems involving a lack of stable leadership, and broader questions the definition of a national heritage itself.[51] As such, many potential heritage sites and objects throughout the nation are still very poorly documented. The Northern Region has been especially neglected, undoubtedly because of the inordinate amount of national focus on more southerly areas around Accra, Kumasi, and Cape Coast. Only one site has been identified as a national heritage site in the Northern Region—the Larabanga mosque. Along these lines, within the northern parts of the country more generally, most of the preservation work that has been untaken has been oriented around the handful of similar Sahel-style mosques.[52]

Interestingly, the dialogue around government action to preserve such sites rarely privileges local efforts that have historically played a large role in safeguarding these traditions. Memory, for one, has been a major facet of preservation in West African societies, taking shape in oral histories, aesthetic canons, and architectural traditions. In fact, many of these established historical practices are intended to "preserve the past, which in many instances are linked with their view of history as an uninterrupted continuum" through modes of cultural, religious, and familial systems. As we have seen, these are often embedded in both material culture and

Building Across Borders  **165**

constructed and/or natural environments, paradigms that are deeply resonant within Larabanga.[53] As such, the freezing of a tradition and the objects related to the tradition in a state that doesn't change or evolve, is untoward in many cases, because it privileges the physical object over the cultural system and/or spiritual impetuses that created it i.e. where the real value lies. Through the "institutionalization" of this moment, history is replaced by memory.[54] As Ergut notes, "the heritage industry denies historical process and radiates only historical surfaces."[55] Likewise, this immobilization of physical heritage objects and sites still does not address the problem of the definition of national heritage as a "representation of Ghana tradition and values."[56] What "values" are being expressed by these sites and objects? And how do these forms make tangible what seems at this point to be a very nascent national imaginary?

This is not a problem unique to Ghana. In West Africa, a number of nations are struggling with the problem of unifying diverse groups under the banner of a national identity. In the mid 1990s, for example, the Konaré government in Mali launched a massive building campaign that was intended to represent that country's "new political, cultural, and economic vibrancy" under Konaré's leadership, using architecture as its primary tool. The forms that arose out of this campaign referenced a number of regional architectural styles and incorporated them into government buildings, educational institutions, and public sculpture using contemporary materials. In using an accessible architectural language that was recognizable on a national scale, the campaign meant to encourage the idea of a shared history based on an iconic architectural legacy (see Figure 4.14).[57] Moving back to Ghana, the

FIGURE 4.14   API Mali (Agence Pour la Promotion des Investissements), Bamako, Mali, late twentieth century.

Larabanga mosque is an emergent heritage apparatus; yet its revisualization on numerous surfaces and media has the effect of cementing (pun intended) this form as an iconic historical architectural style and a distinguished cultural lineage into popular memory through repeated visual exposures and the creation of links between image and nation. These repetitions attempt to enroll people in a nationalistic rhetoric by amplifying the visual signature of the mosque on surfaces associated with the idea of modern nationhood, and in the process move beyond previous colonial-era markers of identity that actively divided populations. The aforementioned "ethnic" boundaries or borders that are being deployed in the contemporary period are instituting similar levels of division and stratification.[58] The mosque and other current heritage symbols are intended to stand as transcendental representations of something fundamental, credible, and authentic. The development of a "cult of heritage," to use Reigl's term (1903), seems to be on Ghana's horizon.

## Tourism: New People, New Problems

The power of forms like the mosque as repositories for cultural values has also transformed them into venues for a growing tourism industry in Ghana.[59] Their value as objects of both historical import and continuing contemporary use have given them increased commodity value as certified sites of cultural "authenticity;" in other words, they become worthy of tourism-based attention. The mosque in Larabanga, the Mystic Stone, and even the town itself as a spiritual center and an area of cultural significance are all now part of a growing trend in international tourism that focuses on engaging with areas of rich cultural heritage located on the "periphery." Groups of mainly Western tourists, diplomats, businessmen, and volunteers (although an East Asian contingent is growing) have penetrated locations like Larabanga as newly identified centers of the authentic. They are motivated by a desire to know groups of different social, cultural, and ideological backgrounds through an experience of both their material and human "artifacts."[60] Such tourist experiences are thought to represent glimpses of "real" life and as such, tourism often takes on a neo-colonialist role as a consumption-oriented experience that deploys the power of the gaze to possess and digest these communities even as such groups actively define themselves against it.[61] Tourists today have come to dominate space not through guns, germs, or religion, but through the power of their ability to commoditize culture.

As a tourist location, Larabanga meets all the qualifications of perceived authenticity in terms of what it contains and the general experience it provides. The degree of travel required to get to Ghana, and then the subsequent local travel (and the nature of that travel) required to reach Larabanga give the entire experience an aura of legitimacy, adventure, and exoticism. The village lies in a remote region far from major commercial or urban centers, and can only be accessed through a lengthy, uncomfortable ride down an unpaved, rather treacherous road lined with nostalgia-inducing rural villages. Such remoteness and inaccessibility gives Larabanga a sense of being "in and out of time … where direct experience of the

sacred, invisible, or supernatural order" can happen at any moment.[62] The process of "roughing it" by taking public transportation, and the subsequent "going it alone"-ness of it all, bestows an additional degree of "authenticity" to the experience by legitimizing the adventurous spirit that one seeks to recognize within themselves through taking such a trip.

Larabanga also sits five kilometers down the road from Mole National Park, the largest nature and wildlife preserve in Ghana. Mole combines all of the zoological iconographies expected of a classical Africa constructed by a Western mindset: it contains elephants and other "typical" wildlife, but also focuses on modern concerns centered around the preservation of ecological resources. Mole also appears on posters, billboards, guidebooks, and brochures, all of which are media implicated in the modern condition (see Figure 4.15). Thus, the combination of Mole and Larabanga provide a heady mix for the tourist seeking to gain a "true experience" of Ghana, which I once overheard tourists label as "Africa for beginners."

"Africa for beginners" or not, tourists with the means come and go in their own vehicles, often large SUVs like Land Rovers and Land Cruisers, which are needed to accommodate the road and have the added benefit of confirming the legitimacy of the trip as a verified adventure. Such vehicles harken back to nostalgic images of European explorers and other outsiders journeying across the savannah, braving the African terrain and all that lies within. Cast in this role, such vehicles can act as canisters of culture that emit Western stereotypes wherever they go. In Larabanga, such vehicles blow through the village around twenty times a day, stopping occasionally so the people can venture out like cultural cosmonauts to get water and take in the mosque and Mystic Stone. They then quickly leave town just as they entered, failing to engage with anyone on a meaningful basis and kicking up a rooster tail of dust that coats everything in its wake.

Although such tourists as they have been described in the previous paragraphs seem ignorant and undoubtedly foolish, they nonetheless have a particular type of power in these situations of encounter. Specifically, they deploy an "ethnic panopticon"[63] onto the village, its inhabitants, and its heritage apparatuses, which may seem somewhat paradoxical but is essentially the reverse of the Foucaldian apparatus. Individuals are not forcibly contained, nor are they in a position where they cannot return a gaze. However, the tourist holds power because they control what is deemed "authentic," and wield this power in the form of their patronage. Tourists also govern the types of cultural performances and views that are offered within these contexts and in doing so establish something of a neo-colonial utopia in which cultures are transformed into "a set of things that are at once symbolic of the Western pursuit of the exotic 'Other,' and the commodities of modernization."[64]

Occasionally, however, communities refuse to be digested in a mode compatible with tourist expectations. When this happens, unpredictable and occasionally volatile situations occur. Over the past decade, Larabanga has attempted to come to terms with a tourist body that attempts to simultaneously preserve the heritage structures in the community while also digesting and consuming them at will, and

**FIGURE 4.15** Billboard for Mole National Park on the road between Wa and Bole, Ghana, 2012.

the results have not always been favorable. In the 2010 edition of the Bradt Guide, a popular guide book for English-speaking travelers "tackling unusual destinations,"[65] there is a section entitled "Lament for Larabanga," in which the authors detail "how poorly tourists are treated" due to the tensions that the recent influx of foreigners has caused in the community.[66] Comments from previous visitors include, "This town could be the staging area for one of the country's best attractions, but they are completely clueless (Sam Kalter, March 2007)," and "This is not a project that should be supported until the people accept that they must offer something in return for their demands of money. Until they organize themselves, Larabanga is best avoided (Karen Palmer, May 2007)." Although these comments were recorded a few years ago and most agree that the situation in Larabanga "is much better than it used to be (Barend Doorduin, February 2009)," there is still an unmistakable aspect of enforcement here, as if there are agreed upon rules to one's tourist experience that must be followed, and failure to follow these rules and organize one's self appropriately for the consumptive gaze of the Western Other is grounds for castigation. It is also important to consider the character and actions of tourists as they penetrate Larabanga's physical and cultural airspace; it is the tourist gaze that transforms structures like the mosque from its "normative" reality as a prayer structure to that of a "large artifact" accessible and consumable to all.[67] It is such a gaze that transforms a community into an exhibit.

Yet, does this mean that all types of tourism are invasive and fundamentally opportunistic? Are there situations where tourism can be a journey of understanding, knowledge, and aesthetic appreciation? Does a search for the "authentic" always necessarily have to be an exercise in exploitation? Scholars in the field of tourism studies are approaching these emergent issues from a number of different perspectives—one lens is that of religion. In reality, Larabanga receives a number of tourists who are not seeking a cultural experience, but have come to the village on a religious pilgrimage. Individuals who cannot make (or afford) the trip to Mecca often come to Larabanga as a mini-*hajj*. As one of the earliest seats of Islam in the savannah, and also an area of concentrated, "pure" Kamara culture, Larabanga and its religious apparatuses (the ancient mosque, the founder's grave, and the Mystic Stone) constitute a sacred cartography for the visiting pilgrim. His or her presence and activities transform these infrastructures from their everyday communal reality into sites of spiritual significance for the individual. We also see this on a communal level during Eid, when the grave of the founder becomes the focus of intensive communal attention and prayers, and the mosque is transformed into a manifestation of this guiding spiritual force. Even the everyday reality of the Mystic Stone is transformed into, or remembered as, a site of universal spiritual power during the Fire Festival. The pilgrim thus engages in a similar transformative experience through their interaction with the spiritual infrastructure of the town.

However, there is another type of visitor to Larabanga beyond the tourist and the pilgrim whose role in the space of the village is not as clear-cut in terms of the strategic nature of their presence, and this is the "volunteer." Every year, young people come from abroad, predominantly Europe, to fulfill university-dictated

student teaching requirements. They typically teach at a small school on the outskirts of town run by the Salia family, who also operate the village's developmental NGO, Bambenninye Development Services. These volunteers live at the Salia's compound, located right next door to the school where they stay for several months. They eat with the Salia family, get to know the village children very well over the course of their work, and generally become immersed in the life of the school and the village.

Yet these volunteers inhabit an interesting position in Larabanga in that they are considered to be more "legitimate" visitors than the average tourist because of their role within the town, yet they are less "authentic" than the Islamic pilgrim because they cannot access the town's specific spiritual identity. But what's even more interesting is that many of these volunteers imprint themselves on the built landscape by decorating the exteriors of their huts with various designs, images, and of course their names, dates, and their countries of origin. Viewing these inscriptions, one is strongly reminded of a group selfie from a tourist locale, which brings home forcibly the fact that even though these volunteers are engaged in legitimate work in the context of the village, they are also engaged in their own adventure. And like a selfie, these inscriptions act as a mode of authentication (see Figure 4.16). By inscribing their presence onto the built environment through names, dates, and often whimsical abstract imagery, they place their metaphoric flag on the moon. This flag is also somehow more legitimate because it constitutes a lasting sign of their presence, a sign that most visitors do not have the authority to leave because they do not have the time-related agency or investment. This trace of presence, embedded within the architectural language of the area, is left in

**FIGURE 4.16** Decorations left behind by Western volunteers on the exteriors of the guest houses at the Savannah Lodge, Larabanga, Ghana, 2011.

highly visible areas and therefore on view for all who come after to see. In this way as well, the reification of their presence in Larabanga does not rely on the memory of the community members for its authentication; it relies on a physical inscription on the built environment, reflective again of the particular cultural lens that many visitors bring to this area. Memory has very little relevance in many contemporary cultures, while in Larabanga it is evoked by historical, cultural, and architectural narratives. Thus, in the case of Larabanga, it would seem that these volunteers view the surfaces of the architectural environment as a series of blank slates, both physically and conceptually, on which to inscribe their identity and identify the community itself, however indirectly, as a site of Western fantasy and fulfillment.

Although many contemporary anthropologists have called tourists "modern pilgrims in search of the authentic,"[68] this categorization feels slightly slipshod. After all, if one defines pilgrimage as Bowen does i.e. "travel to a sacred spot for an act of religious devotion,"[69] this means that any number of activities ranging from going to the Super Bowl to attending Comic-Con qualify as "pilgrimages," each acting as subjectively affirming, possibly even transcendental, experiences for those involved. There is the sense that individuals within the technologically saturated world increasingly seek retreats from their reality in order to reestablish and renew some sense of themselves.[70] This process can manifest intensely colonizing overtones in journeys to rural communities in Africa where tourism companies provide action-packed adventures that also incidentally provide a "temporary elevation of status for the traveler" and allow them to "accumulate social capital" within the world that they left.[71] It is not even truly necessary that one emerges changed by such an experience; what is important is the *perception* that one was altered or heightened by the experience.[72] And herein lies the difference between the idea of pilgrimage and what might be better described as religious tourism. Pilgrimage is undertaken for a transformative experience of the self, whereas religious tourism is oriented around the observation of sites that have resulted in the transformative experiences of others with the potential to act in a similar way for the visitor.[73]

But regardless of the reasoning, Larabanga is developing ways to market their culture and heritage through methods that allow them to retain greater control of the tourist gaze and more effectively direct agency back to the village. The building of two guest accommodations by the Salia brothers Hussein and Al-Hassan, the only accommodations available at the time of this writing in the community, has furthered this goal in very particular ways. These accommodations are composed of two complexes, one the Salia Guesthouse, which is located in the center of the town along the main route, and the other the Savannah Lodge, located about one kilometer outside of town on the road to Mole National Park. Each provides two distinctly different architectural experiences for the visitor: one of a traditional rectilinear compound with minimal access points and a fully enclosed courtyard, and the other a compound of traditional round huts with an informal courtyard and a largely open plan.

However, both of these accommodations actively mediate tourist experiences in specific ways, predominantly in terms of the types of interactions they encourage

**172** Building Across Borders

between tourists and residents. The guesthouse, for example, which is located in the geographic center of the village along the main road, maintains barriers similar to those instituted in the mosque, except in this case it is the visitor who is the privileged entrant, not the villager. Thus, the barriers created by the spatial organization of the Guesthouse and the institution of specific boundaries in the structure create an insulated experience for tourists (Figure 4.17), that mimics the clustered architectural environments of North African and traditional Islamic settings where one has to penetrate multiple barriers before arriving in the interior space. The only visible entrance to the hotel faces the main road and leads to not one but two antechambers, which constitute the main living spaces of Al-Hassan Salia's family. Once one passes through these chambers, visitors exit into a small open courtyard from which the tourist rooms can be accessed (Figure 4.18). Undoubtedly, this design was employed in part for the safety of the guests, but it also has the affect of separating bodies and limiting spontaneous, unmediated contact between the visitors and the visited. Because of this, the Guesthouse in some ways seems to empower tourist stakeholders over community members through the development of spatial and architectural borders and boundaries that are permeable to tourists but impermeable to community members. This effectively creates "us" and "them" categories enforced through both traditional barriers in the form of minimal penetration points and small raised windows, and modern additions to these barriers such as the installation of iron window grates. In addition, visitors can access the roof from the interior courtyard and view the town at their leisure, whereas community residents are not afforded a similar viewing privilege; residents are only able to see into the small courtyard from rooftops nearby. This

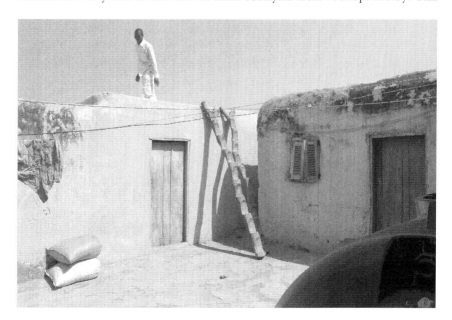

**FIGURE 4.17** Interior of the Salia Guesthouse, Larabanga, Ghana, 2011.

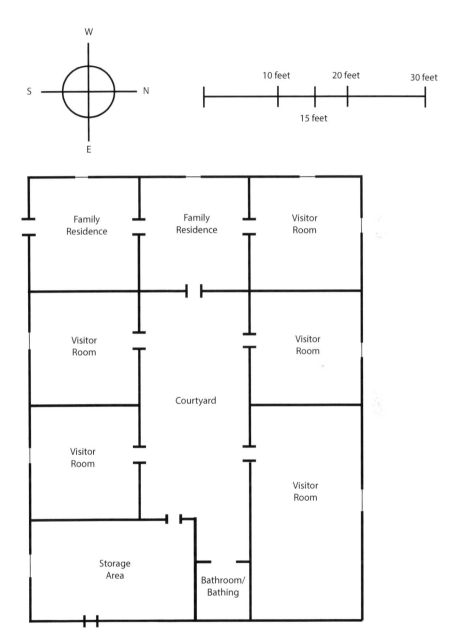

**FIGURE 4.18** Plan of the Salia Guesthouse, Larabanga, Ghana, 2012.

separation of tourist and community members unconsciously underscores differences between the two and hinders cross-cultural collaboration in favor of "voyeurism through a clear demarcation between the tourist and locals."[74] In many ways, the division that these boundaries create generates panopticism by endowing the environment with a foreignness and distance that enables touristic ideals of unmediated authenticity to flourish.[75] This also helps preserve the type of easy nostalgic experience that so many tourists seem to expect to collect on such journeys,[76] reinforcing the "romantic gaze" that they bring with them.[77] Yet, it is also important to realize that such strategies of separation simultaneously control the information actively consumed by the tourist gaze. Thus an important point to ponder here is the possibility that this architectural infrastructure manages tourist consumption even as it provides the illusion that tourist consumption is essentially unmediated.

In contrast to the Salia Guesthouse, the Savannah Lodge is so far removed from town that there is little danger that the tourists staying there will be casually "accessed" or in turn be able to access town elements. Sometimes an interesting role reversal takes place when the Salia-run school, which is located next to the lodge, is in session and tourists are transformed into the "tourees" as children loiter outside occupied units and practice their English with choruses of "Hellohowareyou?" Yet generally, because the lodge is away from the populated areas of town, it is isolated, with a domestic plan that is very open and much more comparable to traditional compound structures. As such, it institutes a different level of separation, insulation, and controlled interaction; the lodge is in an open compound split in half between the familial areas and the accommodation areas (see Figure 4.19). The familial half consists of two independent rectangular concrete structures with corrugated iron sheeting roofs organized into the typical L form, and one concrete round house that is unusually topped with a corrugated iron roof. The rectangular structures contain the bedrooms of the adults and children with a kitchen, while the round house is the main office and TV room. The tourist areas on the other side of the compound, in contrast, are all traditional round houses with thatched roofs that share an enclosed bathing area in the form of a roof-less walled square with a single entrance (Figure 4.20). Although they have been covered with a coat of cement, these houses are still earthen structures at their core, and thus retain many of earth's thermodynamic elements, which make them enormously pleasant to stay in. The houses themselves are organized in a semi-circle, which provides the experience of a traditional compound and enables visitors to interact with each other as well as the Salia family within the space of the small courtyard.

From the outset, the strategy behind the lodge is obvious and elegant. Not only does it promote cultural authenticity by accessing tradition-based architectural forms, materials, and organization, but it also sanitizes this experience by remedying the less romantic aspects of traditional living, which have historically precluded conveniences like electricity. Each hut is equipped with light, electrical outlets, a Western-style bed, a fan, and a cement floor. There is a modern bathroom a short distance away. Such concessions are necessary to find the appropriate balance between novelty and familiarity. Veer too far towards the novel, and tourists might

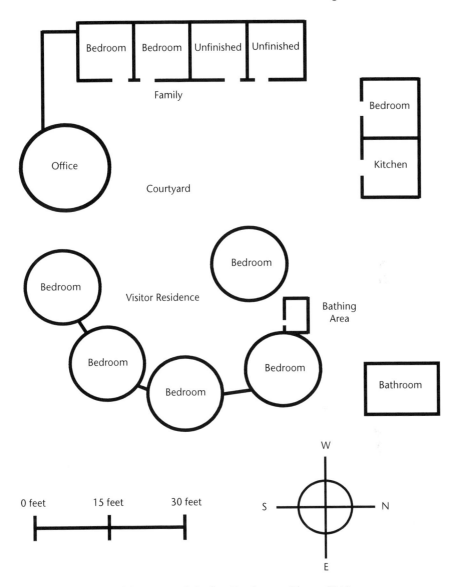

**FIGURE 4.19** Plan of the Savannah Lodge, Larabanga, Ghana, 2012.

become alienated; veer too close to the familiar, and the experience is not authentic. Thus the Lodge provides an experience based on a set of representations and expectations that conform to outsider ideas of an African experience. Tourists come in wanting a "package vacation" that has just enough discomfort to make it real, therefore "reinforcing the nostalgic images they hold," while at the same time "filtering untreated strangeness."[78]

But spaces like the Lodge and to some extent the Guesthouse also engage in a subversion of these colonizing tendencies by manufacturing what visitors perceive

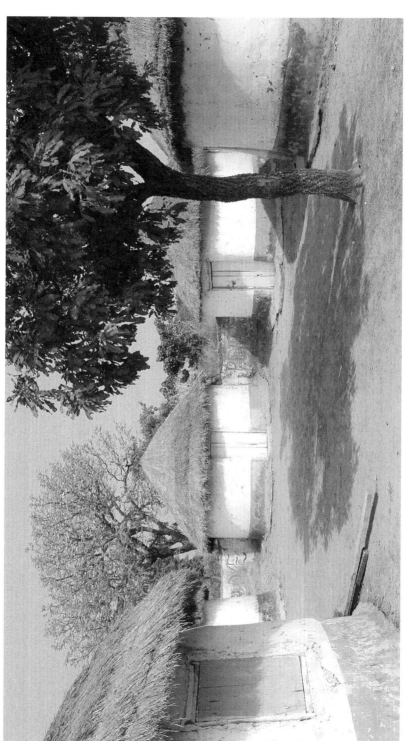

FIGURE 4.20 Round guest houses at the Savannah Lodge, Larabanga, Ghana, 2011.

to be "authentic experience." Each space manifests varying levels of separation, insulation, and controlled interaction through the utilization of diverse spatial organization schemes and the institution of protocols of consumption that are not always in favor of the tourist. Similar infrastructural adaptations have also been made to the main tourist attractions of Larabanga in order to strategically market culture and meet tourist expectations, while also simultaneously controlling the information consumed by the tourist gaze. At the mosque site, the costs to view certain aspects are neatly printed on a wall along the informal corridor leading into its clearing (see Figure 4.21), and visitors must sign a logbook. Each of these elements becomes a tool for legitimizing and normalizing touristic experience while also mediating the ability of tourists to reinvent areas like Larabanga into a sensorial imaginary produced for consumption.[79] Likewise, the clan responsible for maintaining the mosque installed the aforementioned bathroom next to it, designed and painted like a "mini-mosque" but with visages of a Caucasian man and woman to denote the male and female toilets. Finally, tourists are not allowed to go inside the mosque, and this plays a very important role in asserting agency over those who would consume these experiences. The community has instituted safeguards against unauthorized commoditization by controlling access to the interior of the mosque (and charging to view the exterior), thus relegating onlookers to the role of outsiders, particularly during "performances" like Ramadan. Tourists have no agency in the creation of such spaces, places, and events. Such barriers are also in place at the Mystic Stone, although these are expressed more literally by a protective wall encircling it in an effort to control visual access. Another barrier is the custodian, who waits under a tree nearby to collect donations from visitors (Figure 4.22). For now, the founder's grave is openly visible and thus

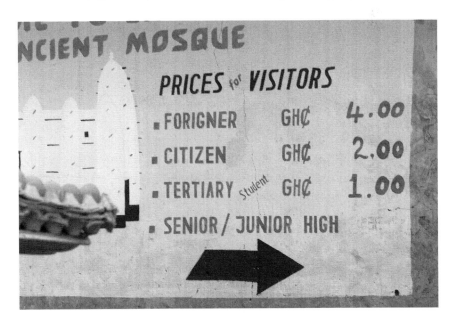

FIGURE 4.21  Visitor price list for the ancient mosque, Larabanga, Ghana, 2012.

**FIGURE 4.22** Balow and Tete Salia standing in the compound of the Mystic Stone, Larabanga, Ghana, 2012.

"free" to the public, probably because it consists of a relatively unimpressive stone planted in the middle of a widely used public thoroughfare. Thus, the physical barriers the tourists encounter at each site—barred entry, walls, selective participation—all actively route agency back to the residents through the use of established methods of asserting authority within both West African and Islamic traditions. These are also buttressed by certain psychological strategies involved with the control and flow of information and who has access to it. The role of secrecy in particular is a strategy of power in many aspects of African visual culture and material production; knowledge of a secret is the key to advancement and inclusion within a particular system.[80] This is especially true within Afro-Islamic practices of using the esoteric knowledge of the Koran and its efficacious passages within the space of an amulet, or an object that has various protective powers. Understanding such practices and systems of knowledge is indicative of membership within a select group of individuals that participate in these processes of making. Similarly, in Larabanga, one's ability to penetrate the structures of the mosque and the "house" of the Mystic Stone comes as a result of their membership within a religious and/or cultural community; all others must pay.

Yet even without such physical barriers in place, there are also experiential and phenomenological barriers present that are fundamentally connected to the Kamara identity, i.e. they cannot be accessed by one outside this reality. Regarding the physical experience of the mosque, it's been described to me as a cool, dark interior space with no sharp corners or edges, almost like stone that has been smoothed and tempered over time by flowing water.[81] Small yet

somehow cavernous, the interior is quiet and intimate, with minimalistic lanterns and overhead lighting that was very recently installed. Outside sounds are deadened by two-foot thick walls necessary to support the massive weight of the structure, and a person gets the feeling of being contained within a space that is somehow removed from reality.[82]

This experience creates a specific narrative about the mosque that relates both to the spiritual importance of the structure and the privileges of village membership. As an experience largely limited to those in the community, the phenomenology of the mosque is in many ways a part of the spirit of being Kamara, not only through the presence of borders and boundaries that actively filter non-Islamic individuals from participating in this encounter (see Chapter 1), but also through the presence of encoded architectural symbols and meanings that have been adapted to communicate various messages. Thus, immersing one's self in spaces like Larabanga's mosque and having the appropriate cultural knowledge to interpret the sensual messages activated by this experience are fundamental to Kamara identity, thus adding yet another reality to the mosque as both a tangible and an abstract "document" of Larabanga's cultural narrative. As such, it would be next to impossible for tourists to access the true experience of the space because they do not maintain the necessary spiritual or cultural membership. This point is emphasized in many subtle ways throughout the tourist experience.

However, this is not to say that there have not been frictions within the village itself, which have come about as the result of clans competing for marketable cultural resources; this has been seen in the situations where clans have bickered over mosque maintenance and the proceeds for the Mystic Stone. In fact, some of these arguments have even been made manifest in the creation of fabricated origin stories and new mythologies to defend claims of rights and ownership. For example, a large tree sits next to the ancient mosque in Larabanga. It is associated with the communal functions of the mosque because it provides a large shaded area that can accommodate a number of people. Recently, the clan responsible for the maintenance of the mosque began circulating a "history" that one of the clan's ancestors had in fact been buried under the tree and had decreed that only his descendants should be allowed to eat its fruit. This new "history" has created a great deal of tension within the current socio-political context of Larabanga through its proclamation of an unauthorized hierarchy that places one clan above the other.

As such, the stratifications created by the logistics of operating a communal tourist area have caused divergences within the community. Because cultural condition of the community and the architectural constructs that spring from it are developing in anticipation of the future, they cease to reflect and adequately respond to the needs of the present. Old languages and signifiers are being coopted and retranslated in the modern context to operate for different purposes, yet new meanings are still in the translative process. The community itself has become future-focused, existing in the aspirations, desires, and dreams of an anticipated state in the making.[83] Because of this, people increasingly feel that traditional

modes and communal systems are failing to supply solutions to the needs of modern living and norms; the people of the village and the environment in which they live currently exist in a massive state of collective flux.

However, such problems are being recognized, and conversations have started to address many of the social, political, and cultural problems that have arisen in the past decades. At the time of this research, community leaders were in discussions towards the potential creation of a community tourism committee and the development of an eco-tourism model, which nearby communities have already adopted. There has also been talk of developing a village cultural center designed to highlight Kamara cultural history more broadly, and more efficiently incorporate the mosque, the Mystic Stone, and the founder's grave, objects that have thus far been treated on a singular basis, into a larger communal narrative. Likewise, there has been talk of building additional tourist infrastructures, including a restaurant and another hotel, and formalizing a system of homestays, although only time will tell whether this talk will eventually translate into action. However, it does highlight a collective recognition that a working plan for handling the pressures of tourism must include recognition that Larabanga's reality combines historical identities with current lived experience. These components must be collectively embraced and made to coexist collaboratively with the understanding that each contributes to the continued existence and relevance of the environment they compose. In highlighting and privileging multiple narratives as part and parcel of a collective reality, Larabanga enables these elements to coexist as equal contributors to the town's unique heritage and legacy.

This model has worked in other successful conservation/tourism projects in Ghana as well. The Cape Coast castle and museum site did extensive work towards highlighting the multiple stories that structure tells in addition to its infamous history as a depot for enslaved individuals. The registers of history that layer this context are underscored in the introductory museum text:

> This exhibit places the forts and castles within broad economic, political, and historical contexts and includes the legacy of the slave trade, clearly one of the more tragic chapters in the history of Africa and the Americas. It also includes Ghana's emergence to lead the continent in its struggle for freedom, realizing her own independence in 1957 [though this is not emphasized in the exhibit]. This exhibit speaks to the heroic history and offers a glimpse into the Central Region with its rich cultural heritage.[84]

The recognition of the castle as a layered construct whose multiple narratives contribute to its different identities and realities is necesssary towards appreciating its significance. Such ideas seem to be finding traction in current discussions in Larabanga with regards to fleshing out its cultural and touristic capital beyond its identity as the site of the ancient mosque and the Mystic Stone.

Larabanga in the contemporary period functions as both a sacred and a secular attraction, increasingly able to accommodate the various agendas and desires of

multiple publics who each seek a different authentic experience based on the village's architectural infrastructures. Because of the diverse agendas that Larabanga's built environment has had to accommodate, the village itself have been transformed into a collective space of diverse meanings and messages.

Tourists are not the only stakeholders in this process of transformation and redefinition. As we have seen, national heritage programs and dialogue are increasingly endowed with Larabanga's architectural environment, specifically the mosque, with new significations beyond its established role. Through the transformation of local forms into national icons, current governmental programs and preservation bodies are increasingly looking to structures like the Larabanga mosque and cultures like the Kamara to help interpret a broader national legacy and craft a platform from which to develop a unified national identity.

Larabanga's contribution to contemporary national dialogues, however, is mediated by its own community. Larabanga's built environment currently occupies a liminal zone between established convention and contemporary innovation. Processes and products of modernization have been in increased dialogue with established traditions and practices in Larabanga, which has resulted in changes in the political, social, and cultural currents running through the village, as well as shifts in architectural form, material, organization, and symbolism. The community is increasingly exploring and implementing new societal norms about gender roles, education, and mobility; emergent experiments in architectural fusions between established structural forms and meanings, and between new materials and practices, continues to enable flows of history, memory, and cultural identity within the village's physical reality.[85] Through the creation of these architectural programs, and the development of new symbol systems, the contemporary cultural condition of the community is articulated through its structural environment. Past and present merge in a productive and progressive ways. While the architectural environment still confirms the cultural and spiritual significance of the site, it does so in a language amenable to a contemporary sensibility and through the presentation of a modern face to the world. Through this articulation of cultural and architectural identity, the community regains agency in crafting its own self-definition and representation, and architecture continues to act as a reflection and extension of this identity.

## Notes

1 Histories and the cultural identities that come with them are reified through the treatment of space. Yet because the past and its traditions are recreated through the lens of an ever-evolving community, this framework is subject to change and reinterpretation as the communal character changes. This does not make contemporary reifications of historical space a less legitimate material manifestation of cultural character, but qualifies it as an interpretation informed by a specific moment in space and time.

2   Carola Lentz, "Contested Identities: The History of Ethnicity in Northwestern Ghana," in *Ethnicity in Ghana: The Limits of Invention*, ed. Carola Lentz and Paul Nugent (New York: St. Martin's Press, 2000), 146.
3   James Clifford, *Routes: Travel and Translation in the Late Twentieth Century* (Cambridge, MA: Harvard University Press, 1997), 248.
4   Ibid., 247.
5   On a personal note, I only have to think about the situation in which I wrote these very words—sitting in a mud hut on a mattress under my mosquito net, having just taken a cold bucket bath, but nonetheless working on my computer and even accessing the internet because my host had a portable USB drive modem and an outside electrical outlet.
6   Al-Hassan, Hussein, and an unnamed village elder, interview with the author, August 21, 2012.
7   See Weiss, *Between Accommodation and Revivalism*, 2008.
8   Hussein Salia, interview with the author, December 23, 2011.
9   Clifford, *Routes*, 259.
10  Folkers, "The African House Today."
11  Labelle Prussin, "Architecting a Life, a Building, a Nation, and a Conference" (paper presented at the *African Architecture Today* Symposium, Kwame Nkrumah University of Science and Technology [KNUST], Kumasi, Ghana, June 2007).
12  Hussein Salia, interview with the author, August 18, 2012.
13  Paul Oliver, "Tout Confort: Culture and Comfort," in *Built to Meet Needs: Cultural Issues in Vernacular Architecture*, ed. Paul Oliver (Burlington, MA: Elsevier, 2006), 88.
14  Adrian Forty, "Concrete and Memory," in *Urban Memory: History and Amnesia in the Modern City*, ed. Mark Crinson (London: Routledge, 2005), 94.
15  Ibid., 75.
16  It will be interesting to see how these shifts in surface semiotics continue to develop. Given the nascent stage of Larabanga's tourist and heritage development schemes, it would not be surprising to see the contemporary decorations and materials including colored paint, images, and words at some point shifting back towards the type of abstract design seen more historically on structures.
17  The tropical plant in this mosque may in fact be a pineapple, a symbol of hospitality in many areas.
18  Edward T. Hall, *The Hidden Dimension* (Garden City, NY: Doubleday, 1966), 5.
19  Ron Eglash, *African Fractals: Modern Computing and Indigenous Design* (New Brunswick, NJ: Rutgers University Press, 1999), 5.
20  Ibid., 7.
21  Blier, *The Anatomy of Architecture*, 2.
22  Prussin, *Architecture in Northern Ghana*, 1. While this work is dated and does not necessarily reflect Prussin's mature theories, it is nonetheless one of the first works to address African built form from an academic architectural platform, becoming an unofficial launching point (and a relatively under-acknowledged resource) for many architectural studies of Africa to date. It is also incidentally the only scholarly work available that addresses this area and as such is an important source of preliminary information in an analysis of Larabanga's architectural environment.
23  Amos Rapoport, "On the Cultural Responsiveness of Architecture," *Journal of Architectural Education* 41, no. 1 (Autumn 1987), 11.

24  Geoffrey Broadbent, "Meaning into Architecture," in *Meaning in Architecture*, ed. Charles Jencks and George Baird (New York: George Braziller, 1970), 51.
25  James Ackerman, "A Theory of Style," *The Journal of Aesthetics and Art Criticism* 20, no. 3 (Spring 1962): 227.
26  Ibid., 228.
27  Paul Oliver, *Shelter, Sign & Symbol* (Woodstock, NY: Overlook Press, 1977), 9, 12.
28  Barbaro Martinez-Ruiz, "Flying over Dikenga: The Circle of New Life," in *Inscribing Meaning: Writing and Graphic Systems in African Art*, ed. Christine Kreamer and Sarah Adams (Washington, DC: Smithsonian, National Museum of African Art, 2007), 186.
29  Oliver, *Shelter, Sign & Symbol*, 36.
30  Rapoport, "On the Cultural Responsiveness," 13.
31  Suzanne P. Blier, "Butabu: West Africa's Extraordinary Earthen Legacy," *Icon Magazine: World Monuments Foundation* (Winter 2003/2004), 37, www.wmf.org/sites/default/files/wmf_article/pg_36-39_butabu.pdf.
32  According to Sebastien Moriset of CRA-Terre, this was probably done by Ghana's Public Works Department, even though the Ghana Museum and Monuments Board (GMMB) already existed at the time. The cement probably resisted for several years before showing cracks and signs of deterioration.
33  Blier, "Butabu," 37, www.wmf.org/sites/default/files/wmf_article/pg_36-39_butabu.pdf.
34  Nancy Stieber, "Space, Time, and Architectural History," in *Rethinking Architectural Historiography*, ed. Dana Arnold et al. (London: Routledge, 2006), 171.
35  Al-Hassan Salia was part of the committee appointed to work with both the GMMB and CRA-Terre on this project, and related this narrative to me.
36  Within West Africa broadly, whitewashing earthen structures with lime or a clay plaster mixed with ash as a waterproofing agent was common practice and had been for a significant period of time.
37  Moister, *Africa: Past and Present*, 29.
38  Susan Buck-Morss, *The Dialectics of Seeing: Walter Benjamin and the Arcades Project* (Cambridge, MA: MIT Press, 1989), 112.
39  Philip F. Xie, *Authenticating Ethnic Tourism* (Bristol: Channel View Publications, 2011), 39.
40  Forty, "Concrete and Memory," 75.
41  Peter Probst, *Osogbo and the Art of Heritage* (Bloomington, IN: Indiana University Press, 2011), 7.
42  David Lowenthal, *The Heritage Crusade and the Spoils of History* (Cambridge: Cambridge University Press, 1998), 86, 142.
43  Steven Nelson, "Writing Architecture: The Mousgoum Tòlék and Cultural Self-Fashioning at the New Fin de Siècle," *African Arts* 34, no. 3 (Autumn 2001), 42.
44  Kankpeyeng, Benjamin W. and Christopher R. DeCorse, "Ghana's Vanishing Past: Development, Antiquities, and the Destruction of the Archaeological Record," *The African Archaeological Review* 21, no. 2 (June 2004), 94–96.
45  Arnold, "Beyond a Boundary," 232.
46  Carola Lentz and Paul Nugent (ed.), *Ethnicity in Ghana: The Limits of Invention* (New York: St. Martin's Press, 2000), 8–9.
47  Xie, *Authenticating Ethnic Tourism*, 20.

48  Carola Lentz and Paul Nugent, "Ethnicity in Ghana: A Comparative Perspective," in *Ethnicity in Ghana: The Limits of Invention*, ed. Carola Lentz and Paul Nugent (New York: St. Martin's Press, 2000), 16.

49  Examples of this can be seen in contemporary Ghanaian musical genres such as "hiplife," a style that originated in Akanland and fuses Akan and Twi linguistic styles and proverbs with American hip hop and R&B rhythmic and melodic methods. The hybrid, highly experimental nature of this musical style provides an example of the type of innovation that emerges from contexts "stressed" by intense socio-political and cultural collaboration during which influences are assimilated and mediated by creative interpretation.

50  Lentz and Nugent, "Ethnicity in Ghana," 16.

51  Kankpeyeng and DeCorse, "Ghana's Vanishing Past," 96–97.

52  Ibid., 98.

53  Ibid., 93.

54  Daniel Abramson, "Make History, Not Memory," *Harvard Design Magazine: Special Issue on Constructions of Memory* (Fall 1999), 2.

55  Elvan Altan Ergut, "Presenting Ankara: Popular Conceptions of Architecture and History," in *Rethinking Architectural Historiography*, ed. Dana Arnold et al. (London: Routledge, 2006), 164.

56  National Commission on Culture, accessed October 3, 2015, www.ghanaculture.gov.gh/.

57  Mary J. Arnoldi, "Symbolically Inscribing the City: Public Monuments in Mali, 1995–2002," *African Arts* 36 (2003), 60. Mary Jo Arnoldi observes that critics of this monument building campaign often cited "selection of themes, the costs incurred, and the aesthetic merits of the projects" ("Symbolically Inscribing the City," 64) as the main issues with this campaign. In addition, many Malians felt disconnected from the design process, although others felt that the campaign was an apt way to celebrate the importance of Mali's unique history. Konaré's educational background in history and ethnography make the decisions made within these nationalistic programs even more interesting to consider.

58  Paulla A. Ebron, *Performing Africa* (Princeton, NJ: Princeton University Press, 2002), 5.

59  See Walter Benjamin and J. A. Underwood, *The Work of Art in the Age of Mechanical Reproduction* (London: Penguin, 2008).

60  Xie, *Authenticating Ethnic Tourism*, 2.

61  Ibid., 26, 29.

62  Victor Turner, "Pilgrimmages as Social Process," in *Dramas, Fields, and Metaphors: Symbolic Action in Human Society* (Ithaca, NY: Cornell University Press, 1974), 197, in Ellen Badone and Sharon Roseman, "Approaches to the Anthropology of Pilgrimage and Tourism," in *Intersecting Journeys: The Anthropology of Pilgrimage and Tourism*, ed. Ellen Badone and Sharon R. Roseman (Urbana, IL: University of Illinois Press, 2004), 4.

63  Xie, *Authenticating Ethnic Tourism*, 25.

64  Ibid., 3.

65  "Take the road less traveled with Bradt," Bradt guide, accessed September 15, 2014, www.bradtguides.com/.

66  Philip Briggs and Kim Wilder, *Bradt Guide: Ghana* (Guildford, CT: The Globe Pequot Press, 2010), 377.

67  Clifford, *Routes*, 339.

68  David Leslie and Marianna Sigala, *International Cultural Tourism: Management, Implications and Cases* (Oxford: Elsevier Butterworth-Heinemann, 2005), 183.

69 Bowen, *Religions in Practice*, 198.
70 Badone and Roseman, "Approaches," 5.
71 Ellen Badone, "Crossing Boundaries: Exploring the Borderlands of Ethnography, Tourism, and Pilgrimage," in Badone and Roseman, ed., *Intersecting Journeys*, 184.
72 Ibid.
73 It is always possible that those seeking a cultural experience will end up having a religious revelation as well. In fact, such "chance" experiences are sometimes abetted by suggestive spaces that facilitate an individual's ability to "dwell" transcendentally within it, even if an individual is there strictly in a touristic capacity. This type of experiential engineering has the added benefit of allowing residents to channel tourists and their understanding along particular avenues of realization.
74 Xie, *Authenticating Ethnic Tourism*, 38.
75 Ibid.
76 The power of the gaze is such that many tourists will not even look at each other because the gaze can almost completely deconstruct the illusion of the authenticity of an experience; for many tourists, the experience is only authentic if they alone or a small group of selected compatriots seem to be experiencing it.
77 Xie, *Authenticating Ethnic Tourism*, 25.
78 Ibid., 30.
79 Xie, *Authenticating Ethnic Tourism*, 27.
80 Mary Nooter Roberts and 'Wande Abimbọla, *Secrecy: African Art That Conceals and Reveals* (New York: Museum for African Art, 1993), 58.
81 Because non-Muslims are not allowed to enter this mosque, I was unable to attain a first-hand account of its interior space. However, based on personal interviews with congregants and being able to enter a comparable ancient mosque in the Nakore region, I was able to distill a likely account.
82 There is an open area surrounding the mosque in which people perform ablutions on normal days and gather for events on special occasions. The Ghana Museum and Monuments Board places the possible origin date of the mosque at 1421. Other mosques of this particular style are located in Nakore, Banda Nkwanta, Maluwe, Wuriyanga, Wechiaeu, Dondoli, Bole, and formerly Dokrupe.
83 James Chaffers, "African Architecture as Practical Beauty," paper presented at the *African Architecture Today* Symposium, Kwame Nkrumah University of Science and Technology (KNUST), Kumasi, Ghana, June 2007.
84 Ann M. Reed, "Sankofa Site: Cape Coast Castle and its Museum as Markers of Memory," *Museum Anthropology* 27, no. 1–2 (2004), 16.
85 Clifford, *Routes*, 341.

# Conclusion

## LESSONS FROM LARABANGA

The Future of Islam and the Built Environment in West Africa

This investigation is far from over. In fact, this book is just the most recent addition to a conversation between architecture and Islam in West Africa that has been going on for eleven hundred years. As such, I hope it contributes to the new set of dialogues occurring across the region, ones that focus on a rethinking and reconfiguring of Islamic architecture to accommodate the changing nature of communities that are both firmly situated in their faith and also active within a modern global world. Larabanga's current situation speaks to architecture's relationship with culture as a response to the social, political, and environmental pressures characterizing the present context of the community. Simultaneously, it offers tangible solutions to the problems of existing in a society rooted in the past, present, and future.

The sheer breadth and diversity of architectural form and its response to developing systems of modernity in Africa over the past century has resulted in only a handful of studies that attempt to deal with the subject matter on a categorical scale. Most of the studies address modernity from a primarily constructivist angle, seeking to identify and make "solid" its fundamental components. In her work on trauma and modernity, Sidney Kasfir associates the modern "conditions" of Kenya specifically with three main types of general transformations: the broad acceptance of Western technology and liberal social norms, a willingness to commodify natural and cultural resources, and a greater "awareness" of Kenya's place in the global world.[1] Underlying these components is evidence of an impetus, attitude, or motivation that drives the progression and innovation of this context. By focusing on this underlying drive, rather than its confirmation via technological progression, geographic points of origin, or liberalizing Western norms, it becomes possible to create slippages and blur boundaries between cultures, ethnicities, nationalities, and even historically fixed dualisms like Africa and the West. This push towards progression and innovation also challenges the concept of modernity as an essentially

imported phenomenon, an approach adopted by Charles Piot in his work on the Kabre of Northern Togoland in 1999. Piot pointed out that early explorers like Frobenius dubbed the Kabre people "pure," by which he meant isolated, culturally contained, and therefore ripe to be actively "othered" by the European Orientalizing gaze.[2] Yet what Frobenius, his peers, and even contemporary scholars have failed to realize was that groups like the Kabre have long sustained interactions with their neighbors and, through them, vast networks and circuitries of foreign contact and influence. The Kabre culture seemed static to Frobenius and his peers; yet in actuality, they sustained an impetus towards the "modern" over time via their continuous contact with and response to the wider, global world and its emissaries.

This is just one example in a vast continental narrative where impulses, drives, and conditions from the earliest periods in human history constitute what today has been labeled "modernity." Even with so many "vehicles" of modernity coming into Africa from outside the continent in the contemporary era, individuals continue strategically to reshape the function and meaning of these vehicles towards transforming them into specifically tailored mechanisms for an Afro-centric modernity. The aftershocks of colonialism and the various socio-political upheavals that have plagued the post-independent period have created innumerable problems in the areas of health, wealth, and infrastructure on the continent. Yet there has been no damper placed on this impulse towards innovation; if anything, it has generated increasingly diverse motivations.

Why then, in spite of this progressive legacy, has the image of modernity in Africa, as both an ideology and a practice, remained shrouded in a haze of ambiguity? By and large this derives from a distinct lack of recognition of the fact that there is not just one singular, monolithic African "modernity," but numerous different iterations that have cropped up in recent decades to create a series of socio-political and cultural contexts. Each one is representative of the manner in which incoming cultigens interact with established socio-cultural paradigms. The resultant cultural identities formed by this merger allow individuals to increasingly participate in and even craft their own diverse performances of "modern life." This catalyzes the creation of further, increasingly divergent trajectories of modern identity across the continent in a pattern of collision, formulation, and performance.

The question addressed here is: how does one define modernity through the lens of Islamic identity in the context of Larabanga specifically and West Africa more broadly? Is modernity merely a drive to participate in a "modern life," an impulse to become a working cog in the global machinery, or something more? What about the actual physical tools of modernity, such as technology and infrastructure? What is their role in accomplishing a modern Afro-Islamic ethos? Many argue that the presence and deployment of these elements drives modernity as a universal process, creating the momentum necessary to truly achieve a modern state. However, I must point to a distinction between what we have thus far defined as modernity and what these various physical components promise. *Modernization*, as Kasfir has identified it, is the actual physical process of technological advancement; thus, modernity and modernization do not necessarily

maintain a cause-and-effect relationship. They can and do occur independently, sometimes in spite of each other. This is particularly true in the context of development in contemporary African architectural space. African societies have developed wildly varied relationships with tools of modernization. Some spaces maintain a healthy, sustainable rapport with various selectively introduced infrastructures, while others, particularly urban areas, experience a compression of technological modernization. This often results in a collision of post-industrial problems like pollution, over-crowding, and unsustainable development with developing-world issues like underdeveloped infrastructure and widespread poverty and disease. Urban centers in Africa, which have long acted as laboratories for alternately successful, unsuccessful, and "work-in-progress" spaces, places, and identities, have in some cases become "faked utopias" in the contemporary period, embedded with a profusion of African and Western technologies that collide with cultural norms, and result in urban sites that attempt to function like a global city but without the necessary physical or social infrastructure.[3] The result of these uneven developments is the creation of situations in which a highly dynamic modern ethos stands in contrast to stalled processes of modernization caught in a rut between contemporary ambitions and substandard implementations.

It is informative to look to a potential underlying cause for this failure to launch in terms of "the modern condition." Modernization as it has occurred in various global spaces has, by and large, attempted broadly to eliminate the technologies of the past in favor of those of the present. In contrast, modernity as it has occurred in African spaces has never attempted to eliminate the past *per se*; its primary aim and ethos is the successful incorporation of multiple classical and contemporary elements within a singular paradigm in the spirit of progress and innovation. As such, modernity in many African contexts has recognized the importance of local components of identity and belonging. This element is particularly relevant in the contemporary period, as these localized memberships are being increasingly deployed as anchors or even barriers against perceived instabilities and fluidities in culture and identity brought on by the momentum of globalization. Globalization is nothing new in Africa, given its extensive role in Asiatic, Middle Eastern, and European histories of exploration and trade. But contemporary networks of travel and communication have telescoped incoming social, cultural, and ethnic paradigms within African spaces in an unprecedentedly brief period of time. This has created layers of influence and saturated contexts to the point that it has become increasingly difficult to engage in selective absorption. The identities that are subsequently created are increasingly untethered from one definable point or parameter of origin, an event that leads some to suggest that the idea of identity *itself* is obsolete in a world where "fabrication is the new authenticity, hybridity is now a point of origin, and assemblage has become a natural state of being."[4] Many individuals are increasingly turning to conventional memberships in the African context—the communal, the familial, the ethnic, or the cultural—as a way of generating coherence within one's frame of self-reference, tethering identities to a point of origin to keep them from being set adrift within the sea of appropriative and assimilative possibilities.

Individuals are also recognizing that modern identities and the "conscious identity-producing activities" they promote lead to a "fundamentally unstable and perspectival quality to social life."[5] Thus, tradition-based components are increasingly being evoked as mediators for producing both meaning and unity within one's identity, enabling individuals to participate in modernity from a stable point of origin that they are subsequently able to return to as a touchstone.[6] Modernity as a contemporary African practice, thus, is a hybrid of tradition-based and contemporary values, influences, and motivations that combine to create context-specific matrices through which individuals view the world and govern their own performances of modern life. Modernity and what has previously been called "traditionalism" are in no way counterpoints in the same argument, as they have so often been framed. Rather they are highly collaborative social elements that enable dynamic patterns of interaction and progression within human socio-cultural space and identity.

In Larabanga, the intimate relationship that exists between culture and architecture is largely due to the ability of the built form to respond to the realities of the community's Islamic identity. Architecture, its usages, and its perceptions are closely tied to the ways in which Larabanga's identity is defined, practiced, and lived. In an architectural environment, information is exchanged between actor and form through structural, material, and spatial codes whose collective "statements" suggest actions and protocols within the given space. In this interpretive scheme, selected signifiers are deployed that enhance comprehension, which may include past trends and precedents whose established meanings evoke the necessary cultural memories towards comprehending a space. But all depends on a common architectural language, composed here of an understandable organization of architectural components within a built form that, as an object in the environment, also interacts with other architectural objects in the environment towards constructing arenas of performance. This common language transforms an initial landscape of silent, seemingly anonymous structures into a concert of communicative interaction organized in specific ways to promote dwelling and communal cohesion. This landscape promotes structural and communicative fluidities that define the nature of cultural dynamics at local and national levels, where both architecture and culture act as sites of contact, negotiation, collaboration, synthesis, and interconnectedness. Architecture becomes a text, and deconstructing an architectural sentence involves not only a consideration of the physical units used (organization, building materials, etc.), but also how their placement, function, and utility create a communicative event for the user, or "reader." In architecture, the presence of these components in addition to their arrangement and emphasis plays a major role in suggesting behavior and then coordinating it so it relays messages and information appropriately. Architectural components come together to create a structural performance that can be measured in terms of its effectiveness or, as a textual narrative, its "persuasiveness" in networking and collaborating with the audience.

Islam is both a method of living for the Kamaras as well as a tool deployed to structure their social, political, cultural, and spiritual reality as a type of "conceptual"

architecture. Both the general architectural environment of Larabanga and the specific touchstones of its identity—such as the ancient mosque, the founder's grave, and the Mystic Stone—act as reservoirs from which a sense of communal identity can be drawn. The power of these reservoirs are such that they have breached the boundaries of the village itself, and attracted Muslims from across the region in addition to tourists and heritage organizations to partake in the "authenticity" associated with this environment.

But tensions have come with this breach, as we have seen, particularly with regards to the assimilation of these touchstones into legacies beyond those of the Kamara, who become cast not as authors but as the fortunate custodians of these sites. The nature of heritage has a way of domesticating objects and sites by drafting them into purposes outside of their fundamental realities and imposing regimes of authenticity that single-handedly dictate the value and "virtue" of a site.[7] By transforming Larabanga into a heritage destination, globalization has inserted itself into the definition of a local identity, oppressing and co-opting one of its primary signifiers and redeploying it for consumption by a broader public. This turns Kamara identity into a museumified object through its association with Larabanga's "timeless" architecture. It also raises questions about how architectural forms like the mosque should be understood and who has the power to "authenticate" that understanding. In his discussion of Islamic architecture, Grabar notes that a form "only tends to survive if the associations surrounding it continue to be meaningful."[8] When such meanings disappear, so does the form unless it acquires fresh use value. Accounts of the structure of the Larabanga mosque before it was restored indicate that it was on the brink of irrevocable destruction. One might deduce that the only option for the mosque's survival was its association with ideals of global heritage, a new identity that added a fresh layer of meaningfulness to the structure and the town.[9] Likewise with Larabanga's domestic spaces, new organization and materials are being incorporated into the environment and are assuming tradition-oriented social and symbolic meanings. This allows domestic spaces to continue to be meaningful and purposeful for their inhabitants.

The addition of new tiers of relevance to such structures creates increasingly complex patinas of meaning. Such a process points to an almost infinite number of possible future narratives for architectural environments like Larabanga, whose forms are increasingly becoming untethered from their historic points of origin. The freedom to adapt to changing times, conditions, and realities gives forms the necessary fluidity of identity to move between the agendas of various stakeholders across time and space. As such, architecture has the potential to incorporate any number of dialogues and combine them in different, versatile ways to express different iterations of identity and cultural and communal reality. Architecture mimics current processes of ethnicity in which, according to Carola Lentz, individuals in the contemporary period are able to adjust their identities based on the specific physical, social, and cultural context in which they find themselves.[10] This flexibility is, in fact, the only reason a concept like "ethnicity" is workable in the contemporary period. Identities can also be assumed based on one's participation

or performance within a particular cultural form, act, or infrastructure such as architecture.

Folklorist Henry Glassie notes that the development of these flexible identities, both architectural and ethnic, requires stresses and pressures to catalyze them into being. In twentieth-century Ireland, for example, questions of identity "required ballads and bombs for answers," thus "the more tense the circumstance, the more likely identity is to rise into articulation."[11] As we saw earlier, the presence of tourists in Larabanga during events like Ramadan caused two contradictory cultural and architectural identities to collide and coexist in an uncomfortable and potentially explosive way. These stresses were then transferred to the participants in the situation, as Muslims celebrating the holy period became an anonymous group of cultural performers and "consumables" for the tourist gaze while tourists became intruders, nonbelievers, and at worst infidels infringing on this holy event. The situation actively affected the power dynamics between both parties and created mutual feelings of stress and discontent: for the pilgrims as unwilling participants and the tourists (or researchers) as unwelcome intruders. Such a situation results in a reluctant cross-cultural communication that reveals the contours of the boundaries that exist to differentiate these roles, singling out both people and structures as areas of "hybridity and struggle, policing and transgression."[12] Even in non-religiously motivated situations, tourist presence can act as a stress factor that shifts cultural parameters, whether or not they need to be shifted.

Yet certain physical infrastructures are also capable of grounding these fluctuations by physically manifesting the contents of these identity narratives in the environment as a type of realization. The public, spiritual, and domestic architecture of Larabanga all reflect the changes within idioms of cultural identity, charting them in surfaces, materials, and organizational patterns. People are able to see and track these changes, making cultural identity not just a vague concept but a physical reality. Architectural practices thus in many ways articulate and make lucid cultural ideas and norms, creating something of an idealization or "dream" of culture in material form. These idealizations collect various signifiers towards the creation of a fully symbolic structure existing in space that quantifies and assesses the identities existing within a context at a given moment in history. This is possible precisely because such structures are inherently anticipatory; they incorporate expectations for future as well as present needs and desires, translating them through a specific cultural lens that dictates organization, construction method, and other, more tangible aspects.[13] Such infrastructures ground identity by outlining its composition and evolution, showing the past and present as one construct and even suggesting modes through which the two can be usefully joined. Although some aspects of this merger between past and present are not sustainable such as the cement house with the thatch roof, others like the mosque are headed towards a balance between past, present, and future. This is expressed physically through the mosque's material composition and conceptually through its simultaneous signification as a symbol of communal identity, Ghanaian nationalism, and global heritage.

It is tempting here to dust off the idea of authenticity with relation to culture and identity and put it back into circulation, reconstituted under the premise that the "true nature" of cultural identity is invariably multiplicitous, with numerous elements informing it at any given point in time. Thus framed, cultural identity exists as a perpetually ongoing dialogue between an individual and a number of larger collective paradigms, including the social, cultural, ethnic, sexual, and spiritual, rather than an association established through the largely static entities of geography, genetics, or lineage. Architecture and other material forms could be cast as legitimate expressions of such "authentic" relationships, with structures existing together as similar "types" but individualized by size, ornamentation, organization, and function.

Such an architectural environment mirrors normative states of cultural identity in which individuals live according to set standards and protocols yet individualize the modes through which they participate in these elements. Variations like these undoubtedly contribute to the gradual evolution of cultural models, which in turn affects the built environment, channeling and redirecting human actions towards more adaptive performances of life and culture. These processes somewhat reflect Gidden's idea of "structuration" in which communal social frameworks are being continuously influenced by outside pressures that catalyze a series of minute transformations within the cultural fabric of a society that manifest in larger ways over time.[14] However, in the contemporary period, modernization appears to have collapsed any gradual aspect to this process and created a telescoped contemporary experience where minute transformations are bypassed for more dramatic cultural and material shifts.

This contemporary template takes us back to the issue of authenticity and how it can exist in a space where fabrication and *metissage* are the new points of origin. At its root, authenticity has always been a concept constituted within the contexts of specific historical, social, and political conditions that have shaped it in locality-specific ways.[15] In the contemporary period, authenticity is often deployed in discussions of heritage as a component defined by nostalgic narratives and historic use-values of the past, a backward-looking program that is paradoxically situated in the needs, desires, and ideologies of the contemporary period, which seeks to define how the past should be handled in the service of current formations of memory.[16]

Authenticity is also a mechanism or mode through which a culture imagines itself. Painting the refurbished Larabanga mosque white was an act that not only referenced past traditions but also established agency for Larabanga's people in the contemporary period. They took ownership of and thus assumed authorship over this cultural touchstone in defiance of homogenization-oriented Western ideals. It thus becomes important to acknowledge that authenticity in this context is essentially a "negotiable construct" to be discussed and crafted among the various stakeholders involved. This creates a certain "spurious essentialism" in that ideas of authenticity are largely dependent on the ideological ebbs and flows of society.[17] These shifts in notions of authenticity also point to the fact that tradition itself is

not a static medium, but an ongoing process deployed for different purposes depending on the particular time, place, and cultural condition. As a bridge across time and space, tradition is a paradigm with multiple points of contact in the past, present, and anticipated future. Tradition leads to the continuous reformation and articulation of cultural models, standards, and material practices that combine different elements in multiple arrangements. These arrangements become dominant or recessive in the cultural consciousness depending on their utility within a particular spatial and temporal context.

Such processes are vital to the evolution of culture, particularly in the contemporary period, during which cultural consciousness becomes increasingly subject to the stresses of modernization. The resulting intercultural dialogues and collisions yield a number of possible emergent cultural realities and identities, as Larabanga's built environment and the various types of structural transitions that are taking shape there have shown us. These architectural forms are essentially transcultural processes[18] that merge past and present elements into transitional forms and reflect anticipated cultural, technological, social, and environmental developments in the future.

Because these forms represent new realities emerging within Larabanga's space, their transitional aspect is perhaps precisely what makes them authentic and legitimate expressions of reality; they are the products of a culture in a state of flux. And because such architectural constructs are no longer bound by material, form, or type, they have the potential to assume unpredictable meanings, creating a structural patois composed of past and contemporary materials, methods, and styles and, with them, an almost infinite variety of possible semiotic significations.

As such, the overarching narrative within the architectural history of Larabanga is that it, like the culture it represents, is perpetually in the process of remaking itself, layering itself with new narratives that take physical form in the materials, techniques, and styles that are incorporated into its continuous flow of cultural and architectural history. Both architecture and culture in Larabanga are a collage of influences that create subsequent layers of meaning on top of the "original" ideas of being Kamara or being Muslim. Architecture becomes a witness and an accomplice to these evolutions of being, particularly in the contemporary period as many of these identities progress unpredictably into the future. They do so through new signifiers, such as cement, rectangular modular structures, new settlement organizations, and the evolution of the traditional compound, all qualities reflective of a growing individualism and mobility. Yet, as I have shown, it cannot be predicted which meanings and significations these facets will symbolize in the future, nor how their legibility will be further mediated by new influences and pressures acting on this environment. It is safe to assume that Larabanga's architectural and cultural condition will continue to evolve within the increasingly global environment while retaining a sense of its original self through the architectural languages of the contemporary period.

## Notes

1. Sidney L. Kasfir, "Narrating Trauma as Modernity: Kenyan Artists and the American Embassy Bombing," *African Arts* 38, no. 3 (2005), 75.
2. Charles Piot, *Remotely Global: Village Modernity in West Africa* (Chicago: University of Chicago Press, 1999), 39.
3. Antoni Folkers, *Modern Architecture in Africa* (Amsterdam: Sun Architecture, 2010), 143.
4. Michelle Apotsos, "The Liminal Body: Assemblage and Identity in Maimouna's Female Icons," *Interventions: Borders and the Global Contemporary* 2, no. 1 (Winter 2013), http://interventionsjournal.net/2013/01/29/879/.
5. Arjun Appadurai, *Modernity at Large: Cultural Dimensions of Globalization* (Minneapolis, MN: University of Minnesota Press, 1996), 183.
6. Howard Davis, *The Culture of Building* (New York: Oxford University, 2006), 17.
7. Lowenthal, *The Heritage Crusade*, xi.
8. Grabar, *The Formation of Islamic Art*, 59.
9. With regards to the mosque, this process was potentially easier than it could have been, as the peculiar aesthetic of the mosque actually gives itself more easily to contemporary modernist aesthetic appreciation. In addition, its generally non-referential nature effectively eschews easy interpretation in favor of an abstract aesthetic that evokes an "unmediated response" from the viewer (Abramson, "Make History, Not Memory," 3), an aspect attractive to Western visitors unaware of the structure's regional precedents. As Lowenthal notes, "global popularity homogenizes heritage," making it a digestible language for those initiated into Western dialogues (Lowenthal, *The Heritage Crusade*, 5) and amenable to a "global department store" approach to culture (Clifford, *Travel and Translation*, 215).
10. Lentz, "Contested Identities," 156.
11. Henry Glassie, "On Identity," *The Journal of American Folklore* 107, no. 424 (1994), 239.
12. Clifford, *Routes*, 37.
13. Robert D. Romanyshyn, *Technology as Symptom and Dream* (New York and London: Routledge, 1989), 12.
14. Xie, *Authenticating Ethnic Tourism*, 43.
15. Clifford, *Routes*, 175.
16. Ibid., 183. Regarding cultural empowerment, the Kamaras of Larabanga show a great deal of religious tolerance towards Christianity and are informed on current African and world events; yet, this does not change their inherent social conservatism in terms of politics and social issues, particularly homosexuality, which is largely viewed as a mental disease or the result of too much same-sex contact in schools.
17. Xie, *Authenticating Ethnic Tourism*, 40.
18. Transculturation is a term originally coined by Ferdinand Ortiz to describe the Cuban condition in which cultural contact created shifts in all cultures involved through perpetual simultaneous losses and gains.

# LIST OF FIGURES

## Introduction

| | | |
|---|---|---|
| 0.1 | Ancient mosque, Larabanga, Ghana, renovated in 2002. | 4 |
| 0.2 | Bathroom next to the ancient mosque, Larabanga, Ghana, 2011. | 5 |

## Chapter 1

| | | |
|---|---|---|
| 1.1 | Rock mosque, Larabanga, Ghana, 2011. | 10 |
| 1.2 | Kongo people, Nkisi power figure, nineteenth–twentieth century, wood, glass, glass mirror, leather, feathers, animal teeth, beads, brass, cloth, and string, 11 × 4¼ × 3 in. (27.9 × 10.8 × 7.6 cm). | 13 |
| 1.3 | Aerial view of the ruins of the communal compound of Oum El-Alek, Guelmim, Morocco, date unknown. | 14 |
| 1.4 | Yoruba people, Ile Ori altar piece (House of the Head), nineteenth–twentieth century, cowry shells embroidered on cloth over raffia, 7⅞ × 7¹¹⁄₁₆ in. (20 × 19.5 cm). | 19 |
| 1.5 | Great Mosque, Djenné, Mali, current structure built in 1907. | 24 |

## Chapter 2

| | | |
|---|---|---|
| 2.1 | Plan of the Great Mosque at Damascus, Syria, c. 715 CE. | 39 |
| 2.2 | Theoretical domestic compound, New Kingdom, Egypt, c. 1550–1050 BCE. | 41 |
| 2.3 | Floor plan of Ribat el Monastir, Monastir, Tunisia, c. 796 CE. | 46 |
| 2.4 | Floor plan of the Great Mosque at Kairouan, Tunisia, c. 670 CE. | 48 |
| 2.5 | Tomb of Askia the Great, Gao, Mali, built c. 1495. | 55 |
| 2.6 | Sankoré mosque, Timbuktu, Mali, built in the early fifteenth century. | 57 |

**196** Figures

2.7 *Potige* (façade) of a Moroccan house, Djenné, Mali, date unknown. 61
2.8 Trade routes into the Gold Coast, sixteenth–eighteenth centuries. 65
2.9 *Batakari* (war dress), The National Museum, Accra, Ghana, date unknown. 66
2.10 Palace of the Wa-Na, Wa, Ghana, 2012. 72
2.11 Façade, chief's house/community meeting house, Tanina, Ghana, 2012. 72
2.12 Talking drums, chief's house/community meeting house, Tanina, Ghana, 2012. 73
2.13 Combination of flat-roofed square structures with rounded granary, Bodi, Ghana. 75
2.14 Grand mosque, Bobo-Dioulasso, Burkina Faso, built in the late nineteenth century. 76
2.15 Mosque, Kawara, Côte d'Ivoire, date unknown. 77

## Chapter 3

3.1 Aerial view of Larabanga, Ghan, twenty-first century. 96
3.2 Founder's grave, Larabanga, Ghana, 2011. 97
3.3 Theoretical compound with satellite complexes, Larabanga, Ghana. 99
3.4 Compound composed of formally diverse structural units, Larabanga, Ghana, 2011. 101
3.5 Courtyard of the Gulpke Na (traditional ruler of Tamale), Tamale, Ghana, 2012. 105
3.6 Pointillist decoration on an exterior compound wall, Larabanga, Ghana, 2012. 109
3.7 Domestic space with inscriptions commemorating the *hajj*, Larabanga, Ghana, 2011. 111
3.8 Domestic/business space of a *mallam*, Larabanga, Ghana, 2011. 113
3.9 Timber beams in the roof of a domestic building, Larabanga, Ghana, 2011. 114
3.10 Buttress along the wall of a domestic space, Larabanga, Ghana, 2011. 116
3.11 Men organizing themselves for the morning prayer during Eid al-Fitr, Larabanga, Ghana, 2012. 118
3.12 Arrival of the chief imam Abdalla Seidu for the morning prayer during Eid al-Fitr, Larabanga, Ghana, 2012. 118
3.13 The communal prayer in progress during Eid al-Fitr, Larabanga, Ghana, 2012. 120
3.14 Prayers during Eid al-Fitr continuing at the founder's grave, Larabanga, Ghana, 2012. 121
3.15 Evening celebration/dance in the clearing next to the ancient mosque, Larabanga, Ghana, 2012. 121
3.16 Floor plan of the ancient mosque, Larabanga, Ghana. 124

Figures **197**

3.17  Bamana people, N'tomo mask, nineteenth–twentieth century wood, mud 16¾ × 6⁷⁄₁₆ × 5¾ in. (42.5 × 16.3 × 14.6 cm).   125

## Chapter 4

4.1   Contemporary domestic compound, Larabanga, Ghana, 2011.   139
4.2   A series of half-finished structures and brick piles, Larabanga, Ghana, 2011.   141
4.3   "Libyan boy" house, Larabanga, Ghana, 2011.   142
4.4   Building at the Savannah Lodge decorated with various cartoon characters, Larabanga, Ghana, 2011.   145
4.5   Domestic space of a *mallam* with neon paint, Larabanga, Ghana, 2011.   146
4.6   Window demarcated by neon paint, Larabanga, Ghana, 2011.   147
4.7   "Telecom" house, Larabanga, Ghana, 2011.   148
4.8   Mosque with "pineapple" *mihrab*, Wa, Ghana, 2012.   150
4.9   Mosque built via a standardized contemporary template, Larabanga, Ghana, 2011.   151
4.10  Mosque/gas station, Wa, Ghana, 2012.   151
4.11  Detail of the cement surface of the ancient mosque, Larabanga, Ghana, 2012.   159
4.12  Mural of Larabanga's ancient mosque, Kotoko International Airport, Accra, Ghana, 2012.   163
4.13  Center for Community Development, Bole, Ghana, 2012.   164
4.14  API Mali (Agence Pour la Promotion des Investissements), Bamako, Mali, late twentieth century.   165
4.15  Billboard for Mole National Park on the road between Wa and Bole, Ghana, 2012.   168
4.16  Decorations left behind by Western volunteers on the exteriors of the guest houses at the Savannah Lodge, Larabanga, Ghana, 2011.   170
4.17  Interior of the Salia Guesthouse, Larabanga, Ghana, 2011.   172
4.18  Plan of the Salia Guesthouse, Larabanga, Ghana, 2012.   173
4.19  Plan of the Savannah Lodge, Larabanga, Ghana, 2012.   175
4.20  Round guest houses at the Savannah Lodge, Larabanga, Ghana, 2011.   176
4.21  Visitor price list for the ancient mosque, Larabanga, Ghana, 2012.   177
4.22  Balow and Tete Salia standing in the compound of the Mystic Stone, Larabanga, Ghana, 2012.   178

# IMAGE CREDITS

1.3 © DigitalGlobe, Google, 2015
1.4 Williams College Museum of Art, Williamstown, MA: Gift of Judith Schuchalter (91.46.2)
1.5 Photo courtesy of Barbara E. Frank, 2011
2.1 Adapted from Creswell
2.3 Adapted from Kiracofe
2.4 Adapted from Fikry
2.5 Photo courtesy of David C. Conrad, 2006
2.6 Photo courtesy of David C. Conrad, 2008
2.7 Photo courtesy of Barbara E. Frank, 2011
2.14 Photo courtesy of David C. Conrad, 2011
2.15 Photo courtesy of Barbara E. Frank, 2011
3.1 © CNES / Astrium, Google
3.16 Adapted from the World Monuments Fund
3.17 Williams College Museum of Art, Williamstown, MA: Anonymous gift (93.1.5)

# BIBLIOGRAPHY

## Sources Cited

Abramson, Daniel. "Make History, Not Memory." *Harvard Design Magazine: Special Issue on Constructions of Memory* (Fall 1999): 78–83.

Ackerman, James. "A Theory of Style." *The Journal of Aesthetics and Art Criticism* 20, no. 3 (Spring 1962): 227–237.

Akrong, Abraham A. "Islam and Christianity in Africa." In *Africa in Contemporary Perspective: A Textbook for Undergraduate Students*, edited by Patrick Awuah Antwi (Legon-Accra, Ghana: Sub Saharan Publishers, 2013), 165–180.

Apawu, Jones Kofi. "Senses and Local Environment the Case of Larabanga in the Northern Region of Ghana." M.A. Thesis, University of Ottawa, 2012.

Apotsos, Michelle. "Holy Ground: Mud, Meaning, and Materiality in the Djenne Mosque." *Rutgers Art Review* 27 (2011): 2–16.

———. "The Liminal Body: Assemblage and Identity in Maimouna's Female Icons." *Interventions: Borders and the Global Contemporary* 2, no. 1 (Winter 2013), http://interventionsjournal.net/2013/01/29/879/.

Appadurai, Arjun. *Modernity at Large: Cultural Dimensions of Globalization*. Minneapolis, MN: University of Minnesota Press, 1996.

Aradeon, Suzan B. "Maximizing Mud: Lofty Reinforced-Mud Domes Built With the Assistance of Supernatural Powers in Hausaland." *Paideuma* 37 (1991): 205–221.

Arnold, Dana. *Reading Architectural History* (London: Routledge, 2002).

———. "Beyond a Boundary: Towards an Architectural History of the Non-East." In *Rethinking Architectural Historiography*, edited by Dana Arnold, Elvan A. Ergut, and Özkaya B. Turan (London: Routledge, 2006), 229–245.

———. Preface to *Rethinking Architectural Historiography*, edited by Dana Arnold, Elvan A. Ergut, and Özkaya B. Turan (London: Routledge, 2006), xv–xx.

Arnoldi, Mary J. "Symbolically Inscribing the City: Public Monuments in Mali, 1995–2002." *African Arts* 36 (2003): 56–65.

Badone, Ellen. "Crossing Boundaries: Exploring the Borderlands of Ethnography, Tourism, and Pilgrimage." In *Intersecting Journeys: The Anthropology of Pilgrimage and Tourism*, edited by Ellen Badone and Sharon R. Roseman (Urbana, IL: University of Illinois Press, 2004), 180–190.

Badone, Ellen and Sharon Roseman. "Approaches to the Anthropology of Pilgrimage and Tourism." In *Intersecting Journeys: The Anthropology of Pilgrimage and Tourism*, edited by Ellen Badone and Sharon R. Roseman (Urbana, IL: University of Illinois Press, 2004), 1–23.

Ballantyne, Andrew. "Architecture as Evidence." In *Rethinking Architectural Historiography*, edited by Dana Arnold, Elvan A. Ergut, and Özkaya B. Turan (London: Routledge, 2006), 36–49.

Beck, Linda J. "Reining in the Marabouts? Democratization and Local Governance in Senegal." *African Affairs* 100, no. 401 (2001): 601–621.

Behrens-Abouseif, Doris. *Islamic Architecture in Cairo: An Introduction* (Leiden and New York: E.J. Brill, 1989).

Benjamin, Walter and J. A. Underwood. *The Work of Art in the Age of Mechanical Reproduction* (London: Penguin, 2008).

Blier, Suzanne P. *The Anatomy of Architecture: Ontology and Metaphor in Batammaliba Architectural Expression* (Cambridge: Cambridge University Press, 1987).

——. "Butabu: West Africa's Extraordinary Earthen Legacy." *Icon Magazine: World Monuments Foundation* (Winter 2003/2004): 34–39, www.wmf.org/sites/default/files/wmf_article/pg_36-39_butabu.pdf.

—— et al. *Art of the Senses: African Masterpieces from the Teel Collection* (Boston: MFA Publications, 2004).

Bloom, Jonathan. "On the Transmission of Designs in Early Islamic Architecture." *Muqarnas: Essays in Honor of Oleg Grabar* 10 (1993): 21–28.

Bourgeois, Jean-Louis, et al. *Spectacular Vernacular: The Adobe Tradition* (New York: Aperture Foundation, 1989).

Bowen, John R. *Religions in Practice: An Approach to the Anthropology of Religion* (Boston: Allyn & Bacon, 1998).

Bravmann, René A. *Islam and Tribal Art in West Africa* (London: Cambridge University Press, 1974).

——. *African Islam* (Washington, DC: Smithsonian Institution Press, 1983).

—— and Raymond A. Silverman. "Painted Incantations: The Closeness of Allah and Kings in 19th Century Asante." In *Golden Stool: Studies of the Asante Center and Periphery*, edited by Enid Schildkrout (New York: American Museum of Natural History, 1987), 93–108.

Brent, Peter L. *Black Nile: Mungo Park and the Search for the Niger* (London: Gordon Cremonesi, 1977).

Briggs, Philip and Kim Wilder. *Bradt Guide: Ghana* (Guildford, CT: The Globe Pequot Press, 2010).

Broadbent, Geoffrey. "Meaning into Architecture." In *Meaning in Architecture*, edited by Charles Jencks and George Baird (New York: George Braziller, 1970), 50–75.

Brunskill, R. W. *Vernacular Architecture: An Illustrated Handbook* (London: Faber, 2000).

Buck-Morss, Susan. *The Dialectics of Seeing: Walter Benjamin and the Arcades Project* (Cambridge: MIT Press, 1989).

Caillié, René. *Travels Through Central Africa to Timbuctoo and Across the Great Desert, to Morocco, Performed in the Years 1824–1828*, Vol. 1 (London: Henry Colburn and Richard Bentley, 1830).

Carter, Thomas and Elizabeth C. Cromley. *Invitation to Vernacular Architecture: A Guide to the Study of Ordinary Buildings and Landscapes* (Knoxville: University of Tennessee Press, 2005).

Certeau, Michel and Steven Rendall. *The Practice of Everyday Life* (Berkeley: University of California Press, 1984).

Chaffers, James. "African Architecture as Practical Beauty." Paper presented at the African Architecture Today Symposium, Kwame Nkrumah University of Science and Technology (KNUST), Kumasi, Ghana, June 2007.

Clifford, James. *Routes: Travel and Translation in the Late Twentieth Century* (Cambridge: Harvard University Press, 1997).

Curtin, Philip D. *The Image of Africa: British Ideas and Action, 1780–1850* (Madison: University of Wisconsin Press, 1964).

Curtis, William J. R. "Type and Variation: Berber Collective Dwellings of the Northwestern Sahara." *Muqarnas* 1 (1983): 181–209.

Davis, Howard. *The Culture of Building* (New York: Oxford University, 2006).

Drew, Jane B. et al. *Village Housing in the Tropics: with Special Reference to West Africa* (London: L. Humphries, 1947).

Ebron, Paulla A. *Performing Africa* (Princeton, NJ: Princeton University Press, 2002).

Eglash, Ron. *African Fractals: Modern Computing and Indigenous Design* (New Brunswick, NJ: Rutgers University Press, 1999).

Ergut, Elvan Altan. "Presenting Ankara: Popular Conceptions of Architecture and History." In *Rethinking Architectural Historiography*, edited by Dana Arnold, Elvan A. Ergut, and Özkaya B. Turan (London: Routledge, 2006), 151–168.

Flood, Finbarr B. *The Great Mosque of Damascus: Studies on the Makings of an Umayyad Visual Culture* (Leiden: Brill, 2001).

Folkers, Antoni. "The African House Today: Observations from Burkina and Tanzania." Paper presented at the African Architecture Today Symposium, Kwame Nkrumah University of Science and Technology (KNUST), Kumasi, Ghana, June 2007.

———. *Modern Architecture in Africa* (Amsterdam: Sun Architecture, 2010).

Forjaz, Jose. "Contribution to the Conference on African Architecture." Paper presented at the African Architecture Today Symposium, Kwame Nkrumah University of Science and Technology (KNUST), Kumasi, Ghana, June 2007.

Forty, Adrian. "Concrete and Memory." In *Urban Memory: History and Amnesia in the Modern City*, edited by Mark Crinson (London: Routledge, 2005), 75–98.

Gell, Alfred. *Art and Agency: An Anthropological Theory* (Oxford: Clarendon Press, 1998).

Ghana Museum and Monuments Board. "Ancient Mosques of the Northern Region," www.ghanamuseums.org/ancient-mosques.php.

Glassie, Henry. "Eighteenth-Century Cultural Process in Delaware Valley Folk Building." In *Common Places: Readings in American Vernacular Architecture*, edited by Dell Upton and John M. Vlach (Athens, GA: University of Georgia Press, 1986), 29–59.

———. "On Identity." *The Journal of American Folklore* 107, no. 424 (1994): 238–241.

Goody, Esther N. *Contexts of Kinship: An Essay in the Family Sociology of the Gonja of Northern Ghana* (Cambridge: University Press, 1973).

——— and Jack Goody. "Creating a Text: Alternative Interpretations of Gonja Drum History." *Africa: Journal of the International African Institute* 62, no. 2 (1992): 266–270.

Goody, Jack. "The Overkingdom of Gonja." In *West African Kingdoms in the Nineteenth Century*, edited by Cyril D. Forde and Phyllis M. Kaberry (London: Oxford University Press for the International African Institute, 1967), 179–205.

Gottdiener, Mark. *The Social Production of Urban Space*, second ed. (Austin: University of Texas Press, 1994).

Goucher, Candice et al. "Ordering the World: Family and Household." In *In the Balance: Themes in Global History*, edited by Candice L. Goucher, Guin C. A. Le, and Linda A. Walton (Boston: McGraw-Hill, 1998), 301–305.

Government of Ghana official website, http://ghana.gov.gh/index/php?option=com_content&view=vategory&layout=blog&id=37&Itemid=190.

Grabar, Oleg. *The Formation of Islamic Art* (New Haven, CT: Yale University Press, 1973).

——. *Islamic Art* (New Haven, CT: Yale University Press, 1987).

Guèye, Cheikh. "New Information and Communication Technology Use by Muslim Mourides in Senegal." *Review of African Political Economy* 30 (2003): 609–625.

Gyekye, Kwame. *Tradition and Modernity Philosophical Reflections on the African Experience* (New York: Oxford University Press, 1997).

Haight, Bruce M. "Bole and Gonja: Contributions to the History of Northern Ghana." PhD dissertation, Northwestern University, 1981.

Hall, Edward T. *The Hidden Dimension* (Garden City, NY: Doubleday, 1966).

Hallen, Barry. *A Short History of African Philosophy* (Bloomington and Indianapolis, IN: Indiana University Press, 2002).

Hodgson, Marshall G. S. *The Venture of Islam: Conscience and History in a World Civilization—Volume 1, The Classical Age of Islam* (Chicago: University of Chicago Press, 1974).

——. *The Venture of Islam: Conscience and History in a World Civilization Volume 2, The Expansion of Islam in the Middle Periods* (Chicago: University of Chicago Press, 1974).

Hoffman, Eva. "Pathways of Portability: Islamic and Christian Interchange from the Tenth to the Twelfth Century." *Art History* 24, no. 1 (March 2001): 17–50.

Hopkins, J. F. P and Nehemia Levtzion. *Corpus of Early Arabic Sources for West African History* (Cambridge: Cambridge University Press, 1981).

House of the Head Shrine: Equestrian (Ile Ori), Workshop of Adesina. Metropolitan Museum of Art. www.metmuseum.org/collections/search-the-collections/314971

Ibn Batuta, Said Hamdun, and Noel Quinton King. *Ibn Battuta in Black Africa* (London: Collings, 1975).

Insoll, Timothy. *The Archeology of Islam in Sub-Saharan Africa* (Cambridge: Cambridge University Press, 2003).

Kankpeyeng, Benjamin W. and Christopher R. DeCorse. "Ghana's Vanishing Past: Development, Antiquities, and the Destruction of the Archaeological Record." *The African Archaeological Review* 21, no. 2 (June 2004): 89–128.

Kasfir, Sidney L. "Narrating Trauma as Modernity: Kenyan Artists and the American Embassy Bombing." *African Arts* 38, no. 3 (2005): 66–96.

Kühnel, Ernst. *North Africa: Tripoli, Tunis, Algeria, Morocco: Architecture, Landscape, a Life of the People* (New York: Brentano's, 1924).

LaCapra, Dominick. *History in Transit: Experience, Identity, Critical Theory* (Ithaca, NY: Cornell University Press, 2004).

Lefebvre, Henri. *The Production of Space* (Oxford: Blackwell, 1991).

Lentz, Carola. "Contested Identities: The History of Ethnicity in Northwestern Ghana." In *Ethnicity in Ghana: The Limits of Invention*, edited by Carola Lentz and Paul Nugent (New York: St. Martin's Press, 2000), 137–161.

—— and Paul Nugent. "Ethnicity in Ghana: A Comparative Perspective." In *Ethnicity in Ghana: The Limits of Invention*, edited by Carola Lentz and Paul Nugent (New York: St. Martin's Press, 2000), 1–28.

Leslie, David and Marianna Sigala. *International Cultural Tourism: Management, Implications and Cases* (Oxford: Elsevier Butterworth-Heinemann, 2005).

Levtzion, Nehemia. *Muslims and Chiefs in West Africa: A Study of Islam in the Middle Volta Basin in the Pre-Colonial Period* (Oxford: Clarendon Press, 1968).

Livingston, Thomas W. "Ashanti and Dahomean Architectural Bas-Reliefs." *African Studies Reviews* 17, no. 2 (September 1974): 435–448.

Loimeier, Roman. *Muslim Societies in Africa: A Historical Anthropology* (Bloomington: Indiana University Press, 2013).

Lowenthal, David. *The Heritage Crusade and the Spoils of History* (Cambridge: Cambridge University Press, 1998).

Lydon, Ghislaine. "Writing Trans-Saharan History: Methods, Sources and Interpretations Across the African Divide." In *Sahara: Past, Present and Future*, edited by Jeremy Keenan (London: Routledge, 2007), 41–72.

———. *On Trans-Saharan Trails: Islamic Law, Trade Networks, and Cross Cultural Exchange in Nineteenth-Century Western Africa* (Cambridge: Cambridge University Press, 2009).

Mark, Peter. *"Portuguese" Style and Luso-African Identity: Pre-Colonial Senegambia, Sixteenth-Nineteenth Centuries* (Bloomington, IN: Indiana University Press, 2002).

Markus, Thomas A. *Buildings and Power: Freedom and Control in the Origin of Modern Building Types* (London: Routledge, 1993).

Markwith, Zachary. "The Imam and the Qutb: The Axis Mundi and Shiism and Sufism." *The Journal of Sapiential Wisdom and Philosophy (Sophia Perennis)* 6, no. 2 (2009): 25–65.

Martinez-Ruiz, Barbaro, "Flying over Dikenga: The Circle of New Life." In *Inscribing Meaning: Writing and Graphic Systems in African Art*, edited by Christine Kreamer and Sarah Adams (Washington: Smithsonian, National Museum of African Art, 2007), 186–194.

Massing, Andreas W. "The Mane, the Decline of Mali, and Mandinka Expansion Towards the South Windward Coast (Les Mane, le déclin du Mali, et l'expansion mandingue vers la Côte du Vent méridionale)." *Cahiers d'Études Africaines* 25, no. 97 (1985): 21–55.

McFarquhar, Neil. "Mali City Rankled by Rules for Life in Spotlight." *New York Times*, January 8, 2011, www.nytimes.com/2011/01/09/world/africa/09mali.html?_r=0.

McIntosh, Roderick J. *Ancient Middle Niger: Urbanism and the Self-Organizing Landscape.* Cambridge: Cambridge University Press, 2005.

——— and Susan Keech McIntosh. "The inland Niger Delta Before the Empire of Mali: Evidence from Jenne-Jeno." *Journal of African History* 22 (1981): 1–22.

Mhlaba, Dumisani. "Approaches and Appreciation of African Architecture." Paper presented at the African Architecture Today Symposium, Kwame Nkrumah University of Science and Technology (KNUST), Kumasi, Ghana, June 2007.

Moister, W. *Africa: Past and Present—A Concise History of the Country, its History, Geography, Explorations, Climates, Productions, Resources, Population, Tribes, Manners, Customs, Languages, Colonization, and Christian Missions* (New York: American Tract Society, 1879).

Morris, James and Suzanne P. Blier. *Butabu: Adobe Architecture of West Africa* (New York: Princeton Architectural Press, 2003).

Morton, Patricia A. "The Afterlife of Buildings: Architecture and Walter Benjamin's Theory of History." In *Rethinking Architectural Historiography*, edited by Dana Arnold, Elvan A. Ergut, and Özkaya B. Turan (London: Routledge, 2006), 215–228.

Naji, Salima. *Art et Architectures Berbères du Maroc* (Aix-en-Provence: Édisud, 2001).

## Bibliography

Necipoğlu, Gulru. "The Dome of the Rock as Palimpsest: ʿabd Al-Malik's Grand Narrative and Sultan Suleyman's Glosses." *Muqarnas* 25 (2008): 17–106.

—— and Mohammad Al-Asad. *The Topkapı Scroll: Geometry and Ornament in Islamic Architecture—Topkapı Palace Museum Library Ms H. 1956* (Santa Monica, CA: Getty Center for the History of Art and the Humanities, 1995).

Nelson, Steven. "Writing Architecture: The Mousgoum Tòlék and Cultural Self-Fashioning at the New Fin de Siècle." *African Arts* 34, no. 3 (Autumn 2001): 38–49, 93.

———. *From Cameroon to Paris: Mousgoum Architecture In and Out of Africa* (Chicago: University of Chicago Press, 2007).

Newman, James L. *The Peopling of Africa: A Geographical Perspective* (New Haven, CT: Yale University Press, 1995).

Oliver, Paul. *Shelter and Society* (New York: F.A. Praeger, 1969).

———. *Shelter, Sign and Symbol* (Woodstock, NY: Overlook Press, 1977).

———. *Encyclopedia of Vernacular Architecture of the World* (Cambridge: Cambridge University Press, 1997).

———. *Dwellings: The Vernacular House World Wide* (London: Phaidon, 2003).

———. "The Importance of the Study of Vernacular Architecture." In *Built to Meet Needs: Cultural Issues in Vernacular Architecture*, edited by Paul Oliver (Amsterdam: Architectural, 2006), 17–26.

———. "Tout Confort: Culture and Comfort." In *Built to Meet Needs: Cultural Issues in Vernacular Architecture*, edited by Paul Oliver (Burlington: Elsevier, 2006), 87–108.

Osasona, Cordelia O. and D. C. Hyland. *Colonial Architecture in Ile-Ife, Nigeria* (Ibadan: BookBuilders, 2006).

Osella, Filippo and Benjamin F. Soares. *Islam, Politics, Anthropology* (Chichester: Wiley-Blackwell, 2010).

Owusu-Ansah, David. *Islamic Talismanic Tradition in Nineteenth-Century Asante* (Lewiston, NY: Edwin Mellen Press, 1991).

Ozkan, Suha. "Regionalisme et Mouvement Moderne. A la recherché d'une Architecture Contemporaine en Harmonie avec la Culture." *Architecture & Behavior* 8, no. 4 (1992), Lausanne (Colloquia).

Peterson, Brian. "History, Memory and the Legacy of Samori in Southern Mali, C. 1880–1898." *The Journal of African History* 49, no. 2 (2008): 261–279.

Piot, Charles. *Remotely Global: Village Modernity in West Africa* (Chicago: University of Chicago Press, 1999).

Preziosi, Donald. *The Semiotics of the Built Environment: An Introduction to Architectonic Analysis* (Bloomington, IN: Indiana University Press, 1979).

Probst, Peter. *Osogbo and the Art of Heritage* (Bloomington, IN: Indiana University Press, 2011).

Prussin, Labelle. "The Architecture of Islam in West Africa." *African Arts* 1, no. 2 (Winter 1968): 32–74.

———. *Architecture in Northern Ghana: A Study of Forms and Functions* (Berkeley, CA: University of California Press, 1969).

———. "An Introduction to Indigenous African Architecture." *The Journal of the Society of Architectural Historians* 33, no. 3 (October 1974): 182–205.

———. "Fulani-Hausa Architecture." *African Arts* 10, no. 1 (1976): 8–19.

———. "Traditional Asante Architecture." *African Arts* 13, no. 2 (1980): 57–65.

———. *Hatumere: Islamic Design in West Africa* (Berkeley: University of California Press, 1986).

Rapoport, Amos. *House Form and Culture* (Englewood Cliffs, NJ: Prentice-Hall, 1969).

———. "The Study of Spatial Quality." *Journal of Aesthetic Education: The Environment and the Aesthetic Quality of Life* 4, no. 4 (October 1970): 81–95.

———. "On the Cultural Responsiveness of Architecture." *Journal of Architectural Education* 41, no. 1 (Autumn 1987): 10–15.

Reed, Ann M. "Sankofa Site: Cape Coast Castle and its Museum as Markers of Memory." *Museum Anthropology* 27, no. 1–2 (2004): 13–23.

"Ribat El Monastir: The Bastion of Arab Conquerors." *North Africa Times*, October 20, 2007, www.alarab.co.uk. Accessed November 12, 2011.

Riegl, Alois. "The Modern Cult of Monuments: Its Character and its Origin (1928)." In *The Nineteenth Century Visual Culture Reader*, edited by Vanessa R. Schwartz and Jeannene M. Przyblyski (New York: Routledge, 2004), 56–59.

Rihouay, Francis. "Timbuktu Seeks Rebirth After Islamist Militants' Destruction." *Bloomberg*, March 31, 2014, www.bloomberg.com/news/articles/2014-03-30/timbuktu-seeks-rebirth-after-destruction-by-islamist-militants. Accessed September 20, 2014.

Roberts, Mary Nooter and 'Wande Abimbola. *Secrecy: African Art that Conceals and Reveals* (New York: Museum for African Art, 1993).

Romanyshyn, Robert D. *Technology as Symptom and Dream* (New York and London: Routledge, 1989).

Ross, Eric. *Sufi City: Urban Design and Archetypes in Touba* (Rochester, NY: University of Rochester Press, 2006).

Rowlands, Michael and Charlotte Joy. "Can Djenne Remain a World Cultural Heritage Site? A Rhetorical Question?" Paper presented at the Built Cultural Heritage symposium series for the 33rd Quinquennial Jubilee, Delft University of Technology, 2007.

Rudofsky, Bernard. *Architecture Without Architects: An Introduction to Nonpedigreed Architecture* (New York: Museum of Modern Art, Doubleday, 1964).

Silverman, Raymond A. "Drinking the Word of God." In *Inscribing Meaning: Writing and Graphic Systems in African Art*, edited by Christine Mullen Kreamer and Sarah Adams (Washington, DC: National Museum of African Art, 2007), 117–123.

———. *Museum as Process: Translating Local and Global Knowledges* (New York: Routledge, 2015).

Spence, Betty. *How Our Urban Natives Live* (Pretoria, South Africa: South African Council for Scientific and Industrial Research, National Building Research Institute, 1950).

Stieber, Nancy. "Space, Time, and Architectural History." In *Rethinking Architectural Historiography*, edited by Dana Arnold, Elvan A. Ergut, and Özkaya B. Turan (London: Routledge, 2006), 171–182.

Strecker, Ivo A. *The Social Practice of Symbolization: An Anthropological Analysis* (London: Athlone Press, 1988).

Strother, Z. S. "Architecture Against the State: The Virtues of Impermanence in the Kibulu of Eastern Pende Chiefs in Central Africa." *Journal of the Society of Architectural Historians* 63, no. 3 (September 2004): 272–295.

Turner, Victor W. *The Forest of Symbols: Aspects of Ndembu Ritual* (Ithaca, NY: Cornell University Press).

Weiss, Holger. *Between Accommodation and Revivalism: Muslims, the State and Society in Ghana* (Helsinki: Finnish Oriental Society, 2008).

Wilks, Ivor. "The Northern Factor in Ashanti History." *The Journal of African History* 2, no. 1 (1961): 25–34.

———. "Wangara, Akan, and Portuguese in the Fifteenth and Sixteenth Centuries." *The Journal of African History* 23, no. 3 (1982): 333–349.

——— et al. *Chronicles from Gonja: A Tradition of West African Muslim Historiography* (Cambridge: Cambridge University Press, 1986).

Wiredu, J. E. "How Not to Compare African Traditional Thought with Western Thought." *Transition* no. 75/76 (1997): 320–327.

Xie, Philip F. *Authenticating Ethnic Tourism* (Bristol, UK: Channel View Publications, 2011).

Zaslavsky, Claudia. *Africa Counts; Number and Pattern in African Culture* (Boston: Prindle, Weber & Schmidt, 1973).

Zevi, Bruno. *Architecture as Space: How to Look at Architecture* (New York: Horizon Press, 1957).

## Sources Consulted

Ådahl, Karin and Berit Sahlström. *Islamic Art and Culture in Sub-Saharan Africa* (Uppsala: Almqvist & Wiksell International, 1995).

Adorno, Theodor W. "Functionalism Today." In *Rethinking Architecture: A Reader in Cultural Theory*, edited by Neil Leach (New York: Routledge, 1997), 5–19.

Allman, Jean. "'Hewers of Wood, Carriers of Water': Islam, Class, and Politics on the Even of Ghana's Independence." *African Studies Review* 34, no. 2 (September 1991): 1–26.

———. "Be(com)ing Asante, Be(com)ing Akan: Thoughts on Gender, Identity and the Colonial Encounter." In *Ethnicity in Ghana: The Limits of Invention*, edited by Carola Lentz and Paul Nugent (New York: St. Martin's Press, 2000), 97–118.

Allsop, Bruce. *A Modern Theory of Architecture* (London: Routledge & Kegan Paul, 1981).

Anduandah, James. "The Stone Circle Sites of Komaland, Northern Ghana, in West African Archaeology." *The African Archaeological Review: Papers in Honour of J. Desmond Clark* 5 (1987): 171–180.

Aradeon, Suzan B. "Al-Sahili: The Historian's Myth of Architectural Technology Transfer from North Africa." *Journal Des Africanistes* 59, no. 1 (1989): 99–131.

Archer, Ian. "Nabdam Compounds, Northern Ghana." In *Shelter in Africa*, edited by Paul Oliver (New York: Praeger Publishers, 1971), 46–57.

Bahloul, Joëlle. *The Architecture of Memory: A Jewish–Muslim Household in Colonial Algeria, 1937–1962* (New York: Cambridge University Press, 1996).

Barber, Karin. "Text and Performance in Africa." *Bulletin of the School of Oriental and African Studies* 66, no. 3 (2003): 324–333.

——— and Graham Furniss. "African-Language Writing." *Research in African Literatures: Creative Writing in African Languages* 37, no. 3 (October 2006): 1–14.

Barthes, Roland and Lionel Duisit. "An Introduction to the Structural Analysis of Narrative." *New Literary History: On Narrative and Narratives* 6, no. 2 (Winter 1975): 237–272.

Bascom, William R. and Melville J. Herskovits. *Continuity and Change in African Cultures* (Chicago: University of Chicago Press, 1959).

Baudrillard, Jean. *Simulacra and Simulation* (Ann Arbor, MI: University of Michigan Press, 1995).

Becker, Cynthia J. *Amazigh Arts in Morocco: Women Shaping Berber Identity* (Austin: University of Texas Press, 2006).

Bemile, Sebastian K. "Promotion of Ghanaian Languages and its Impact on National Unity: The Dagara Language Case." In *Ethnicity in Ghana: The Limits of Invention*, edited by Carola Lentz and Paul Nugent (New York: St. Martin's Press, 2000), 204–225.

Blier, Suzanne Preston. "Houses are Human: Architectural Self Images of Africa's Tamberma." *Journal of the Society of Architectural Historians* 42, no. 4 (1983): 371–382.

———. *The Royal Arts of Africa: The Majesty of Form* (New York: H.N. Abrams, 1998).

Bogner, Artur. "The 1994 Civil War in Northern Ghana: The Genesis and Escalation of a 'Tribal' Conflict." In *Ethnicity in Ghana: The Limits of Invention*, edited by Carola Lentz and Paul Nugent (New York: St. Martin's Press, 2000), 183–203.

Bravmann, René A. "Gyinna-Gyinna: Making the Djinn Manifest." *African Arts* 10, no. 3 (1977): 46–87.

Clark, T. J. *Farewell to an Idea: Episodes from a History of Modernism* (New Haven, CT: Yale University Press, 1999).

Colvile, Zélie. *Round the Black Man's Garden* (Edinburgh and London: W. Blackwood & Sons, 1893).

Denyer, Susan. *African Traditional Architecture: An Historical and Geographical Perspective* (New York: Africana, 1978).

Dorfles, Gillo. "Structuralism and Semiology in Architecture." In *Meaning in Architecture*, edited by Charles Jencks and George Baird (New York: George Braziller, 1970), 39–49.

Elleh, Nnamdi. *African Architecture: Evolution and Transformation* (New York: McGraw-Hill, 1997).

Farias, P. F. M. *Arabic Medieval Inscriptions from the Republic of Mali: Epigraphy, Chronicles and Songhay-Tuāreg History* (Oxford: Published for The British Academy by Oxford University Press, 2003).

Fisher, Carrol G. *Brocade of the Pen: The Art of Islamic Writing* (East Lansing, MI: Kresge Art Museum, Michigan State University, 1991).

Frank, Barbara E. "Open Borders: Style and Ethnic Identity." *African Arts* 20, no. 4 (August 1987): 48–55, 90.

Frishman, Martin, Hasan-Uddin Khan, and Mohammad Al-Asad. *The Mosque: History, Architectural Development and Regional Diversity* (New York: Thames & Hudson, 1994).

Geertz, Clifford. *The Interpretation of Cultures: Selected Essays* (New York: Basic Books, 1973).

Goody, Jack. "The Myth of a State." *The Journal of Modern African Studies* 6, no. 4 (December 1968): 461–473.

———. "The Impact of Islamic Writing on the Oral Cultures of West Africa." *Cahiers d'Études Africaines* 11, no. 43 (1971): 455–466.

de Gramont, Sanche. *The Strong Brown God: The Story of the Niger River* (Boston: Houghton Mifflin, 1976).

de la Gueriviere, Jean. *Exploration de l'Afrique Noire* (Paris: Editions du Chene, Hachette – Livre, 2002).

Guven, Suna. "Frontiers of Fear: Architectural History, the Anchor and the Sail." In *Rethinking Architectural Historiography*, edited by Dana Arnold, Elvan A. Ergut, and Özkaya B. Turan (London: Routledge, 2006), 74–82.

Hattstein, Markus and Peter Delius. *Islam: Art and Architecture* (Cologne: Könemann, 2000).

Hiskett, M. *The Development of Islam in West Africa* (London: Longman, 1984).

———. *The Course of Islam in Africa* (Edinburgh: Edinburgh University Press, 1994).

Ibn Batuta, Said Hamdun, and Noel Q. King. *Ibn Battuta in Black Africa* (Princeton, NJ: M. Wiener Publishers, 1994).

Jamieson, Mark. "Review, *Art and Agency: An Anthropological Theory* by Alfred Gell." *The Journal of the Royal Anthropological Institute* 5, no. 4 (December 1999): 672–674.

Jenkins, Paul. "African Architecture Tomorrow: A Research Approach." Paper presented at the African Architecture Today Symposium, Kwame Nkrumah University of Science and Technology (KNUST), Kumasi, Ghana, June 2007.

Kaufert, Joseph. "Situational Identity and Ethnicity among Ghanaian University Students." *The Journal of Modern African Studies* 15, no. 1 (March 1977): 126–135.

Killingray, David. "Imagined Martial Communities: Recruiting for the Military and Police in Colonial Ghana, 1860–1960." In *Ethnicity in Ghana: The Limits of Invention*, edited by Carola Lentz and Paul Nugent (New York: St. Martin's Press, 2000), 119–136.

Lowenthal, David. *The Past is a Foreign Country* (Cambridge: Cambridge University Press, 1985).

Malinowski, Bronislaw. "Introduction." In *Cuban Counter Point: Tobacco and Sugar*, by Ferdinand Ortiz (Duke: Duke University Press, 1995).

Massing, Andreas W. "The Wangara, an Old Soninke Diaspora in West Africa? (Les Wangara, une vieille diaspora soninke d'Afrique de l'Ouest?)" *Cahiers d'Études Africaines* 40, cahier 158 (2000): 281–308.

Mather, Charles. "Shrines and the Domestication of Landscape." *Journal of Anthropological Research* 59, no. 1 (Spring 2003): 23–45.

Mazrui, Ali A. "Islam and African Art: Stimulus or Stumbling Block?" *African Arts: Memorial to John Povey* 27, no. 1 (January 1994): 50–57.

Norberg-Schulz, Christian. *Intentions in Architecture* (Cambridge, MA: MIT Press, 1966).

Nugent, Paul. "'A Few Lesser Peoples': The Central Togo Minorities and Their Ewe Neighbors." In *Ethnicity in Ghana: The Limits of Invention*, edited by Carola Lentz and Paul Nugent (New York: St. Martin's Press, 2000), 162–182.

Oliver, Paul. "Cultural Traits and Environmental Contexts: Problems of Cultural Specificity and Cross-Cultural Comparability." In *Built to Meet Needs: Cultural Issues in Vernacular Architecture*, edited by Paul Oliver (Amsterdam: Taylor & Francis Group, 2006), 55–68.

Otto, Christian. "Program and Programs." In *Rethinking Architectural Historiography*, edited by Dana Arnold, Elvan A. Ergut, and Özkaya B. Turan (London: Routledge, 2006), 50–59.

Ozkan, Suha. "Introduction—Regionalism within Modernism." In *Regionalism in Architecture*, edited by Robert Powell (Singapore: Concept Media/The Aga Khan Award for Architecture, 1985), 8–15.

Ozkyaya, Belgin Turan. "Visuality and Architectural History." In *Rethinking Architectural Historiography*, edited by Dana Arnold, Elvan A. Ergut, and Özkaya B. Turan (London: Routledge, 2006), 183–199.

Palmié, Stephan. "Creolization and its Discontents." In *The Creolization Reader: Studies in Mixed Identities and Cultures*, edited by Robin Cohen and Paola Toninato (London: Routledge, 2010), 49–67.

Parker, John. "Northern Gothic: Witches, Ghosts and Werewolves in the Savanna Hinterland of the Gold Coast, 1900s–1950s." *Africa: Journal of the International African Institute* 76, no. 3 (2006): 352–380.

Plate, S. Brent. *Religion, Art, and Visual Culture: A Cross-Cultural Reader* (New York: Palgrave, 2002).

Pratt, Mary Louise. *Imperial Eyes: Travel Writing and Transculturation* (London: Routledge, 1992).

Prussin, Labelle. *African Nomadic Architecture: Space, Place, and Gender* (Washington: Smithsonian Institution Press, 1995).

———. "Non-Western Sacred Sites: African Models." *Journal of the Society of Architectural Historians* 58, no. 3 (1999): 424–433.

———. "Architecting a Life, a Building, a Nation, and a Conference." Paper presented at the African Architecture Today Symposium, Kwame Nkrumah University of Science and Technology (KNUST), Kumasi, Ghana, June 2007.

Rendell, Jane. "From Architectural History to Spatial Writing." In *Rethinking Architectural Historiography*, edited by Dana Arnold, Elvan A. Ergut, and Özkaya B. Turan (London: Routledge, 2006), 135–150.

Roberts, Allen F., Mary N. Roberts, Gassia Armenian, and Ousmane Guèye. *A Saint in the City: Sufi Arts of Urban Senegal* (Los Angeles: UCLA Fowler Museum of Cultural History, 2003).

Robinson, David. *Muslim Societies in African History* (Cambridge: Cambridge University Press, 2004).

Rutter, Andrew F. "Ashanti Vernacular Architecture." In *Shelter in Africa*, edited by Paul Oliver (New York: Praeger, 1971), 153–171.

Schlottner, Michael. "'We Stay, Others Come and Go': Identity Among the Mamprussi in Northern Ghana." In *Ethnicity in Ghana: The Limits of Invention*, edited by Carola Lentz and Paul Nugent (New York: St. Martin's Press, 2000), 49–67.

Stewart, Charles. "Syncretism and its Synonyms: Reflections on Cultural Mixture." In *The Creolization Reader: Studies in Mixed Identities and Cultures*, edited by Robin Cohen and Paola Toninato (London: Routledge, 2010), 289–305.

Summers, David. "Response: How is the Past in the Present?" *The Art Bulletin* 89, no. 3 (Summer, 2007): 193–195.

Vogel, Susan. *The Future of Mud: A Tale of Houses and Lives in Djenne*. Video. Brooklyn: Icarus Films, 2007. Presented by the Musée National du Mali.

Yegul, Fikret. "Hercules at the Roundabout: Multidisciplinary Choice in the History of Architecture." In *Rethinking Architectural Historiography*, edited by Dana Arnold, Elvan A. Ergut, and Özkaya B. Turan (London: Routledge, 2006), 60–73.

Young, James E. *The Texture of Memory: Holocaust Memorials and Meanings* (New Haven, CT: Yale University Press, 1993).

# INDEX

Abbasid caliphate 37
Abbasid periods 46–7
Abu Ishaq el-Sahili 54
Accra 162, 163
adaptation 51
Agence Pour la Promotion des Investissements (API) 165–6
Ait Yahia O'Thmane, Ksar 49
Al-Bakri 50–1, 53
Al-Ghaba 50–1
al-Hajj Salim Suwari 69–70
al-Idrisi 19
al-Muqawqis 40–1
Amazigh signs 15
'Amr ibn al-'Ās mosque 40–3
ancestral rite of *Awukudae* 67
API *see* Agence Pour la Promotion des Investissements
Arabs, "Land of Arabs" 91–5
Architecture Without Architects exhibition 22
Arnold, D. 20
Asantehene 125
Asante people 64–6, 79
Askia Muhammad 54–6
authenticity 25–6, 159, 175, 177
*Awukudae* ancestral rite 67

Ballantyne, A. 21
Bamana people 123–4, 125
*baraka* blessings 59
barriers *see* borders and boundaries
*batakari* war tunics 66
Batammaliba 153
Beghu 79
Bendugu 122
Benjamin, W. 9
*Bilad al-Sudan* 43–9, 50
black settlement of Timbuktu 58
Blier, S. 153, 157
Bloom, J. 49
Bobo-Dioulasso 75–6
Bondoukou 112–13
borders and boundaries: British colonialism 79; building across 134–85; in context 12–13, 15–17; iconographies of form 70–1; interactive architecture 101–6; shape of discipline 23–4
Bradt Guide 167, 169
Braimah, I. 122, 124–5
brand color of telecom houses 147, 149
bride price (dowry) 103
British colonialism 78–84

Broadbent, G. 154
Burkina Faso 75–6
Butabu 157
Bute 79
buttresses 116

Caillié, R. 79–80
Caliph Al-Walid 37–8
Cape Coast 164
caravan traders 50–1
Carter, T. 22
celebration/dance 119, 121
cement surfaces of ancient mosque 159–60
Center for Community Development, Bole, Ghana 162, 164
ceremony 67, 117–22, 123, 169
Christianity 38, 40, 69
churches 12–13
coexistence 51
colonialism 78–84
Commission on Culture (NCC) 164
communal prayer 118–19, 120
community, interactive architecture 95–113
conical thatched roofs 74–5
corner pillars 61–2
cosmology 58
courtyard of Gulpke Na of Tamale 104–5
CRA-Terre EAG 157–8, 161
Cromley, E. 22, 105

Dagbani clan 160–1
Damascus Great Mosque 37–8, 39
dance 119, 121
*Dar al-harb* 50
decolonizing African architectural studies 26–7
Deetz, J. 23
demarcation 43–4
desert mosques 9
dialogues of style 154–5

Dine, A. 29–30
diviners 125
Djenné 23–4, 28–9, 51–6, 59–63
Djinguere Ber schools 56–9
Dogon people 22
Dome of the Rock 49
dowry 103
drums 73
Dupuis, J. 67, 125
Dyula styles 59–63, 71, 75–7

earth-and-timber mosques 15
earthen mosques 9
earthen pillars 56
economic position 70–1
Egypt 40–3
Eid al Fitr 117–22, 169
El Khorbat, Ksar 49
embedding of Islam 52–3
engagements 103–4
Ergut, E. A. 165
ethnic panopticon 167
ethnophilosophy 25–6
European influence 82–3
evening celebration/dance 119, 121

façades *see potige*
"face" (reputation) 110, 112
familial hierarchies 103
family compounds/units 42, 97–8, 101–2
Faran Kamara 52
festivals 10
Fire Festival 169
flat-roofed square structures 74–5
Folkers, A. 23–4
forms *see* materials
Founder's Grave 97, 119, 121, 160–1, 169
Fourufura 97
Frampton, K. 23–4
Fulani tent architecture 49
funeral rites 123, *see also* gravesites
fusion 51

Gao 51–4, 59–60
gas stations 149, 151, 152
*gbanya* elite class 70
Gell, A. 154
gender identifications 42, 58, 108
Ghana 79–84; national identity 156–66, *see also* Larabanga
Ghana Museum Monuments Board (GMMB) 157–8, 161–2, 164
Gold Coast 63–78
Gonja 68–74, 107, 125–6
Goody, E. 107
*goum hu* mouth arch 61
granaries 74–5
grandfather compounds 97–8
gravesites 97, 119, 121–2, 160–1, 169
Great Mosque in Damascus 37–8, 39
Great Mosque in Djenné 23–4
Great Mosque of Kairouan 47–9
greetings 107
Guelmim 45
Gulpke Na of Tamale 104–5
*gyaasewa* royal retinue 66

*hadiths* 37
*hajj* pilgrimage 95, 97, 110–11, 119, 122, 125, 169
half mosques 149, 151, 152
*Hatumere* (Prussin) 56–7
*hatumeres* 59
Hausa domes 49
heritage 28–30, 156–66, 167, 169
heroic origin narratives 52
Herthouma Ben el-Aien 46–7
Hountondji, P. 25–6
*hu gandi* meeting area/bedroom 61
hybridity 37–9, 73–5
*hyire* white clay 67, 125

Ibn Battuta 19, 51, 52–3, 63
*Icon* magazine 157
iconographies 70–1
identification 42, 58, 70–1, 108

identity: heritage 156–66; Kamara identity 113–16; Larabanga 116–27
ideological integrity 144
Ile Ori altar piece 18, 19
imams 69, 97, 117–19
infidels 50
interactive architecture 95–113
*Invitation to Vernacular Architecture: A Guide to the Study of Ordinary Buildings and Landscapes* (Carter & Cromley) 22
*isims* 112

Jenne-Jeno *see* Djenné

Ka'aba 119, 122
Kairouan 47–9
Kamara 52, 63–4, 107, 113–16, 160–1, 179–80
*karamo* 70–1
*karma* 38
*kasbah* structures 13, 14, 44–5, 58, 71
Kawara style 77
*Kitab Gonja* 68–9
Kofi Kakari 66
Koi Konboro 52
Kongo people 13
Kong styles 75–7
Koranic verse 66–7
Kotoko International airport in Accra 162, 163
Koumbi Saleh 50–1
*ksar* 48–9, 60, 71
*ksour* structures 9, 13, 14, 44–5, 48–9
Kumasi 65–6, 164
Kwame Nkurmah 84

*laife* 103
"Land of Arabs" 91–5
"Land of the Blacks" 50
lapped mud methods 74
Larabanga: aerial view 95, 96; *Bilad al-Sudan* 43–9; buttress along wall 116; compound composed of

formally diverse structural units 100–1; contemporary domestic compound 139–40; in context 8–17; culture/continuity 137–56; domestic/business space of *mallams* 112–13; Eid al Fitr 117–22; evening celebration/dance 119, 121; floor plan of ancient mosque 123–4; Gold Coast 63–78; Gulpke Na of Tamale 104–5; *hajj* pilgrimage 95, 97, 110–11, 119, 122, 125; half-finished structures/brick piles 140, 141; identity 116–27; interactive architecture 95–113; Kamara identity 113–16; "Land of Arabs" 91–5; "Libyan boys" 141–3; locating 8–34; *mallam* with neon paint 146; materiality 113–16; modernization 134–7; moving forward 27–32; Mystic Stones 177–8; Northern region and British colonialism 78–84; pointillist decoration 108, 109; regional shrines 126; road to/short history 35–90; Salia Guesthouse 172–4; Savannah Lodge 145–6, 169–77; setting the stage 35–43; shape of discipline 17–27; telecom houses 147–9; theoretical compound/satellite complexes 97–8, 99; timber beams 113–14; West African crossroads 50–63
leather 67–8
*Lele* henna application 103–4
"Libyan boys" 141–3

MacQueen, J. 83
*madrasas* 56–9
Malians 51–5, 59–60, 68–70, 74, 158
Mali Dogon people 22
*mallams* spiritual healers 63–4, 68–70, 91–133, 146, 149
Mallum Idrissi 59
Mande Islamic influence 64, 68–9, 73–4

*Mandingoes* 82
manifestations of space 17–27
Mankuma (Jakpe) royal burial place 126
*marabouts* holy men 68
marriage 103–4
Masa Ambeli 59
masons 58–61
materials: British colonialism 82–3; in context 10–11; culture/continuity 140–4; Djenné earthen 62–3; leather/textiles/utensils 67–8; materiality 113–16; production 52–3
Mecca, *qiblah* wall 39
*metissage* 126
Mhlaba, D. 25
*mihrab* 17, 39, 117–18, 149, 150
military campaigns 43, 64–5
mini-*hajj see hajj* pilgrimages
MNLA 29–30
modernization 134–7
Mole National Park 167, 168, 171–2
Monastir 46–7
monumental sites 21
Monuments and Relics Commission 161–2
Moorish Muslims 65–6, 83
morning prayer 117–18
Moroccan-style houses 61–2
mosques 91–133; ʿAmr ibn al-ʿĀs 40–3; cement surfaces 159–60; Damascus 37–8, 39; desert 9; Djenné mosque in Mali 23–4; earth-and-timber 15; half mosques 149, 151, 152; Kairouan 47–9; rock mosques 10–11, 16–17; Wa mosque 149, 151, 152
*muezzins* 42
Muhammad (Prophet) 36–8
Mural of Larabanga's ancient mosque, Kotoko International airport in Accra 162, 163
*musalla* 56

Museum Monuments Board (GMMB) 157–8, 161–2, 164
Muslim/non-Muslim dynamics 51
Mystic Stones 91–133, 160–1, 167, 169, 177–8, 179–80

Naba'a (Malian prince) 68–70
National Commission on Culture (NCC) 164
Ndewura Jakpe 68–70
*Négritude* (Senghor) 25–6
Negro African 82–3
Neo-vernacularism 24
Nigerian Hausa domes 49
Nkisi power figures 13
nomadic peoples 9–10
non-Muslim authorities 69–70
non-Muslim/Muslim dynamics 51
non-Muslim practices 60
North Africa, *Bilad al-Sudan* 43–9
Northern region and British colonialism 78–84
*nsumankwaafo* physicians 66
N'tomo mask, Bamana people 123–4, 125
*nyamasi* hierarchy 69–70
*Nyegbari* funeral rite 123

Oliver, P. 22, 143–4
Osei Kwame 66
Osella, F. 35
Other politics 22
Oum El-Alek 13, 14
Ozkan, S. 23–4

"package vacation" 174–5
pan-Africanism 25–6
panopticon 167
permanence 9–12
personal status 70–1
*Phaidon Atlas of World Architecture* (Ballantyne) 21
pilgrimages 171, *see also hajj* pilgrimages

pillars 56, 61–2
pineapple *mihrab* 149, 150
pointillist decoration on exterior compound wall 108, 109
polygamous households 104–5
*potige* 60–2, 71–4
priests 50–1
Prophet Muhammad 36–8
Prussin, L. 49, 56–7, 75–6, 116, 123–4, 153–4
Public Works Department (PWD) 80–1
puddled-mud technique 115–16
*purubee* color 115

*qiblah* wall 39
*qutb* 95, 97

Ramadan 117, 122
Rapoport, A. 22
reciprocation 107–8
rectangular units 139–40
replastering festivals 10
*ribat* 45–9
rock mosques 10–11, 16–17
Romanesque churches 12–13
rounded granaries 74–5
round guest huts 174, 176
roundhouse huts 74
royal burial place of Mankuma (Jakpe) 120
Rudofsky, B. 22

Sahelian kingdoms 51
Sahelian styles 59–63, 71, 75–7
St. John the Baptist 38
*salāt* 56–7
Salia family 169–77
Saney 53–4
Sankoré schools 56–8
*sara fa wey* female pillars 61
Savannah Lodge 145–6, 169–77
schools 56–9, 169–70
Segu, Malian city of 158

Senghor, L. 25–6
Senyon Kupo "commoner" shrine 126
Shaw, T. 161–2
shrines 125–6
Sidi Yaha schools 56–8
Silverman, R. 112–13
Soares, B. F. 35
social contracts 154
Songhai 54–6, 59–60, 74
*soro funey* (latticed windows) 61
space 17–27
square brick methods 74–5
square "European" wares 139–40
Stucco 37
stylistic genres 154–5
Sudanese style 55, 74–5
Sufi city of Touba 30–1
Sundiata Keita 52
surface schemes 108
Suwarian attitudes 69–70

talking drums 73
Tanina's palace 71–3
*Tarikh Ghunja* 68–9
tautological approaches 153–4
telecom houses 147–9
Teleuk architecture of Mousgoum 23
tent architecture 9–10, 49
textiles 67–8, 103
The Monuments and Relics Commission 161–2
timber beams 113–14
Timbuktu 51, 53–4, 56–7, 59–60
time and space 17–27
Tinkpamah 122
Touba 30–1
tourism 166–81

tower houses 79
trade routes of the Gold Coast 64, 65
*Travels in the Interior of Africa* 158
Tugbeni 97
*Tumba* white bridal cloth 103

Umar (Malian prince) 68
Umayyads 36–8, 40–1, 43–9
UNESCO 28–9, 157
universities 56–9, 169–70
'Uqba ibn Nafi 47–9
Ur-phenomenon 9
utensils 67–8

verbal communication 107–8
vernacular 21–4, 144
visitor price lists 177

walls 16–17, 39, 74–5, 108, 109, 116
Wa mosque 149, 151, 152
Wa-Na Palace 71, 72
Wangara 63–4
white clay 67, 125
white settlement of Timbuktu 58
Wilks, I. 79
windows 146, 147
Wiredu, K. 26
World Heritage List 28–9
*wuras* chiefs 73

Yirikpani 97
Yoruba *ibori* (*ile ori*) 18, 19

Zevi, B. 9
"Zongo" 138–9
Zuguni 97

# Taylor & Francis eBooks

## Helping you to choose the right eBooks for your Library

Add Routledge titles to your library's digital collection today. Taylor and Francis ebooks contains over 50,000 titles in the Humanities, Social Sciences, Behavioural Sciences, Built Environment and Law.

Choose from a range of subject packages or create your own!

**Benefits for you**
- Free MARC records
- COUNTER-compliant usage statistics
- Flexible purchase and pricing options
- All titles DRM-free.

**Benefits for your user**
- Off-site, anytime access via Athens or referring URL
- Print or copy pages or chapters
- Full content search
- Bookmark, highlight and annotate text
- Access to thousands of pages of quality research at the click of a button.

**REQUEST YOUR FREE INSTITUTIONAL TRIAL TODAY**

**Free Trials Available**
We offer free trials to qualifying academic, corporate and government customers.

## eCollections – Choose from over 30 subject eCollections, including:

| | |
|---|---|
| Archaeology | Language Learning |
| Architecture | Law |
| Asian Studies | Literature |
| Business & Management | Media & Communication |
| Classical Studies | Middle East Studies |
| Construction | Music |
| Creative & Media Arts | Philosophy |
| Criminology & Criminal Justice | Planning |
| Economics | Politics |
| Education | Psychology & Mental Health |
| Energy | Religion |
| Engineering | Security |
| English Language & Linguistics | Social Work |
| Environment & Sustainability | Sociology |
| Geography | Sport |
| Health Studies | Theatre & Performance |
| History | Tourism, Hospitality & Events |

For more information, pricing enquiries or to order a free trial, please contact your local sales team: www.tandfebooks.com/page/sales

**Routledge** Taylor & Francis Group | The home of Routledge books

**www.tandfebooks.com**